About

The Promise of Paradise

This book is about the dream and the deception, the love affair and the disillu-
sionment. It's about what it means to leave the people you love most in the
world to follow a dream that may turn out to be a con in the end. It's about
the awesome experience of being with a spiritual Master: the risks and the
beauty, the passionate intensity of life, what one gains and what one loses, and
how easily spiritual goals can be perverted when people suspend their critical
judgement in the pursuit of lofty idealism.

It's about my life with the impresario of broken dreams in a temple of total
ruin....

From the Introduction

A woman's story, this fascinating book is about someone who leaves be-
hind everything familiar in her life to pursue an intuition that becomes
an obsession. Eventually she is led back to where she began—to mar-
riage, family, and children, now experienced differently. She is utterly
changed, yet deeply the same.

Jennifer Barker Woolger
Co-author of *The Goddess Within*

The Promise of Paradise

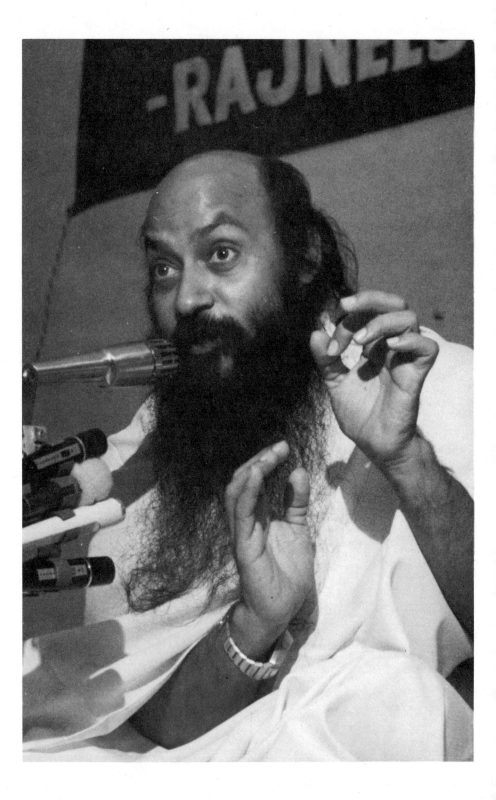

The
PROMISE
of

*A Woman's Intimate Story
the Perils of Life with Rajneesh*

PARADISE

SATYA BHARTI FRANKLIN

Station Hill Press

Published by Station Hill Literary Editions, under the Institute for Publishing Arts, Inc., Barrytown, New York 12507. Station Hill Literary Editions is supported in part by grants from the National Endowment for the Arts, a Federal Agency in Washington, D.C., and by the New York State Council on the Arts.

Distributed by The Talman Company, 150 Fifth Avenue, New York, New York 10011.

Cover photo of the author (1988) by Nick Franklin.
Cover photo of Rajneesh at a Mt. Abu meditation camp (1972).
Frontispiece photo of Rajneesh lecturing in Bombay (1972).
Cover design by Susan Quasha.

Library of Congress Cataloging-in-Publication Data

Franklin, Satya Bharti.
The promise of paradise: a woman's intimate story of the perils of life with Rajneesh/ Satya Bharti Franklin.
 p. cm.
ISBN 0-88268-136-2
 1. Franklin, Satya Bharti. 2. Rajneesh, Bhagwan Shree, 1931-
 1990
 I. Title.
BP605.R334 1992
299'.93--dc20

 91-40881
 CIP

In memory of my son, Billy
And with heartfelt gratitude to
Nancy, Patti, and Kirti

Contents

Author's Note ✺ *xi*
Cast of Characters ✺ *xiii*
Introduction ✺ *xv*
Prologue ✺ *xix*

I **The Seduction** ✺ 1
New York / Bombay / Poona
(1971 - 1974)

II **The Love Affair** ✺ 63
Poona (1975 - 1981)

III **The Separation** ✺ 159
Florida / New York
(1981)

IV **The Dream and the Deception** ✺ 179
Oregon (1981 - 1985)

V **Plots and Counterplots** ✺ 289
Oregon (September 1985)

VI **Coming Home** ✺ 311
Vancouver / New York
(1985 - 1987)

VII **...to the Unthinkable** ✺ 331
San Francisco / New York / Poona
(1987 - 1989)

Epilogue: 1990 ✺ **347**

Other Books by Satya Bharti Franklin

(under the name Satya Bharti)

Death Comes Dancing
The Ultimate Risk
Drunk on the Divine

Author's Note

I've written this book as a narrative: my own story as much as the Rajneesh story, a personal odyssey. While several people have been combined into composite characters in order to create a cohesive narrative, every effort has been made to remain faithful to the facts as they happened. The story that follows is a truthful portrait of my experiences.

Cast of Characters

Please note that, here and in the text, composite characters are signified by an asterisk () following the name.*

Arup: A Dutch banker's daughter and Gestalt therapist; Laxmi's second-in-command in Poona along with Sheela.

Bhagwan: The charismatic founder and leader of the Rajneesh Movement, known in India as "the sex guru," and in America as "the Rolls Royce guru"; now known as "Osho" Rajneesh.

Billy: The author's son, murdered at the age of twenty-one during the writing of this book.

Bodhi: Vidya's husband; a computer programmer from South Africa.

Chaitanya: The meditation master at the Poona ashram, one of Bhagwan's earliest spokespeople and the author's lover during the Bombay and Poona years.

Chinmaya: Sheela's first husband, an American who died in India, presumably of Hodgkin's disease.

Danny: The author's first husband, a successful New York businessman.

Deeksha: Sheela's second-in-command at the end of Poona and at the castle in New Jersey; in hiding since 1981 when she left the ranch.

Deva*: A Jewish-American psychiatrist from New York; married to Premda.

Dipo: Sheela's third husband, a Swiss businessman.

Jay: Sheela's second husband, whose marriage to Sheela provided her with American immigration papers; a former New York banker and businessman.

Kavi*: A therapist from California; one of Bhagwan's mediums in India and a resident of his house in Poona; one of the first people on the "Shit Lists" at the ranch.

Kirti: A mechanical designer from England; the author's ranch lover, now husband.

Krishna: A flamboyantly-gay advertising executive; an early Bhagwan disciple who left the ranch voluntarily after a brief residence.

Kuteer: Once the author's lover; later one of the few non-gay men in Sheela's entourage.

Laila*: A "massage therapist" from New York; later one of the "big Moms" at the ranch.

Laxmi: Bhagwan's first sannyasin and his personal secretary for fifteen years; banished from the ranch in Oregon until shortly before Sheela left.

Nancy: The author's oldest daughter; a choreographer and dancer.

Nirdosh*: A long-time resident of Bhagwan's household and one of his Poona mediums, who escaped from the ranch in the middle of the night and went into hiding.

Paravati*: One of Bhagwan's earliest Indian disciples, who left the movement after a brief stay at the ranch in Oregon.

Patti: The author's younger daughter; presently working in L.A. in the film industry.

Prabhu*: A former Vietnam vet who became one of "Su's boys" and trained sannyasins in the use of firearms.

Premda*: A social worker from Canada and one of Bhagwan's first western disciples; prohibited from joining the Rajneesh community (and her husband) in Oregon.

Puja: Known as the "Dr. Mengeles" of the ranch in Oregon; a Filipino woman from California who was Chinmaya's nurse when he died and went on to head the medical centers in both Poona and Oregon. Convicted with Sheela of attempted murder and various other poisonings.

Ravjiv*: An early Indian disciple of Bhagwan's; the author's "husband" for ten years.

Sampurna*: One of Bhagwan's mediums and a resident of his house in Poona.

Sangit*: A therapist at the Poona ashram; excommunicated and banished from the ranch in Oregon.

Savita: An accountant at the Poona ashram and the ranch's financial genius; Sheela's second-in-command in Oregon.

Sheela: Bhagwan's gun-toting personal secretary and spokeswoman from 1981 to 1985, an Indian immigrant who struck it rich in America by wheeling and dealing and poisoning people; a close friend of the author's in Poona.

Shiva: Sheela's one-time lover and Bhagwan's bodyguard in Poona; later one of his most vocal and vociferous critics.

Su: The cockney former manager of a hotel in Nepal and the "big Mom" of numerous ranch "temples" including her own underground guerilla squad.

Teertha: A leading European therapist, long-presumed to be Bhagwan's most-likely successor.

Vidya: Sheela's and Arup's assistant in Poona and later president of the Rajneesh Commune; a computer programmer from South Africa.

Vivek: Bhagwan's nursemaid, housekeeper, and companion from 1972 on; the author's closest friend for many years.

Introduction

*W*hen the Rajneesh commune in Oregon collapsed in the fall of 1985 in a flurry of accusations ranging from embezzlement to attempted murder, my son Billy felt cheated for the first time in all the years I'd been involved in the Rajneesh movement. The spiritual journey I'd embarked upon thirteen years earlier, leaving him and his two sisters with their father to do it, suddenly seemed like one more con, the sacrifices we'd all had to make over the years stripped of meaning. He felt ripped off. He'd believed in what I was doing and it had turned into a travesty.

I sat down to write a book for my children. To explain to them why, despite the fact that I loved them, I left them. Why I felt I had to and why, despite everything, my only regret was the pain I'd caused them. I thought I'd have all the time in the world to make up to them for what I'd done.

Three-quarters of the way through the writing of this book, Billy was stabbed to death on the street by a stranger, a brutal, senseless murder. He was twenty-one years old, as beautiful and loving a human being as I've ever met. Time ran out, words became meaningless, and all that was left was pain and regret. I wish with all my heart that some of the things I've written about here had been different, yet I know that no amount of wishing can change what was.

For thirteen years I exchanged my upper-middle-class life for a dream that was as fascinating as it was fulfilling and as bizarre as it was ultimately dangerous. I still don't know if Bhagwan Rajneesh was a madman or a messiah, a charlatan or a saint; the choices I made once aren't the choices I'd make now; yet for most of the years I was with Bhagwan, the experiences I had were so mesmerizing and profound that I gave up my children, my career, and everything I had to be with him.

It was 1971 when I first heard about Bhagwan. Separated from my husband, I was living in New York with my three young children, feeling free for the first time in my life, getting to know who I was and what I wanted. I'd recently begun publishing poetry in literary journals and was working on my first novel, taking my career and myself seriously as many women were beginning to do in those days. A year later, as inconceivable as it seemed to me and to everyone who knew me, my children moved in with their father and I went to India to be with Bhagwan.

Known to his detractors as "the sex guru" and to his followers and admirers as a Buddha, Christ, Lao Tzu, Bhagwan spoke like a poet writes, dazzling me with his words and insights, his vision of Buddhahood. I fell in love with him and stayed.

As one of Bhagwan's first Western disciples and a resident of his household for many years, I was under his personal guidance and protection in a way few disciples were, yet I was poisoned by people close to him and nearly died in India; was on a Mafia-style hit list of people to be "dealt with" if I ever left the movement; and later, in Oregon, was on the so-called "Shit Lists" of people to be continually spied on, provoked, pushed, and humiliated. The seeds of what allowed a spiritual path to become an excuse for corruption were planted early on; they were an intrinsic part of Bhagwan's teachings.

Yet it would be a distortion of the truth to deny that anything valuable happened to me during my years with Bhagwan. I feel a peace inside me now, even in the midst of deep mourning, that I know I wouldn't have had otherwise: a resilience and centeredness that not even the devastating loss of Billy's life has touched; a joy in my being that transcends everything. These are no small treasures by anyone's standards.

Bhagwan helped thousands of us awaken from the dreams and illusions of our conditioning. He helped us rediscover joy again. Then he created new dreams for us to believe in, and eager to believe in something, anything, still looking for a meaning to define our lives, we bought it all, willing partners in our own deception.

This book is about the dream and the deception, the love affair and the disillusionment. It's about what it means to leave the people you love most in the world to follow a dream that may turn out to be a con in the end. It's about the awesome experience of being with a spiritual Master: the risks and the beauty, the passionate intensity of life, what one gains and what one loses, and how easily spiritual goals can be per-

verted when people suspend their critical judgement in the pursuit of lofty idealism.

It's about my life with the impresario of broken dreams in a temple of total ruin. The book I wrote for my children that Billy will never read.

Satya Bharti Franklin
Vancouver, 1991

A Note

Bhagwan's death in January 1990 has changed nothing that I've written here. His movement continues to grow worldwide, his ideas continue to spread. An astounding number of therapists and leaders of the human potential movement are current or former disciples of Bhagwan's, although few, if any of them, publically acknowledge it.

Bhagwan may no longer be around to preach and teach, but those who have been influenced by him will be, and people will continue to be drawn to them as they are to spiritual movements as diverse as born-again Christianity and Elizabeth Clare Prophet's Church Universal and Triumphant. The demagogues who would be demigods and the preachers who would be prophets provide a context of commitment, a supportive community of like-minded people in a world gone mad, a refuge from impotence and anonymity.

Bhagwan provided (as movements like his provide) a life that's larger than life itself. It's the most seductive lure there is. The promise of ultimate fulfillment: intellectually, emotionally, spiritually, and (in Bhagwan's case) sexually. Who amongst us is immune to the promise of paradise? Today. Now. Here.

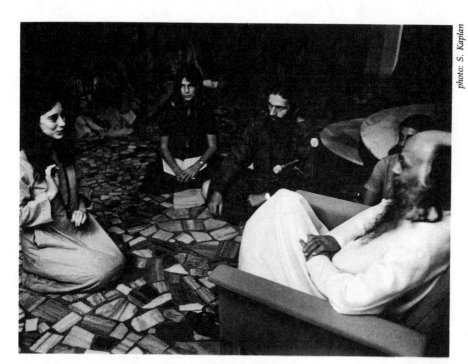

The author at a darshan with Rajneesh in Poona (1977).

R ajneesh Mandir was quickly filling up with people. It was 7:40
in the morning. September 12, 1985.

I sat on the cool linoleum floor watching everyone arrive
for Bhagwan's lecture. Several thousand people stood in small, animated
groups, chatting and joking with one another, holding hands, hugging;
most of them dressed in shades of red and purple, peach and orange. As
they sat down, they began clapping their hands in time to the music:
humming, singing, their bodies gently swaying.

Several dozen people remained aloof from the general mood of cele-
bration. The defenders of the faith. Sheela's militia. Even as they talked
and laughed with one another, they never stopped scanning the crowd,
not missing a thing. Some wore pink and burgundy security uniforms.
Some didn't. Many had walkie-talkies on belts around their waist. Sev-
eral carried guns.

As I closed my eyes, trying to pretend the guards weren't there, my
body started moving subtly, undulating; I began to sing. The tempo of
the music picked up, a sure sign that Bhagwan's long, white Rolls Royce
was on its way.

Soon the helicopter that accompanied the limousine was hovering out-
side the building, the music and everyone's singing nearly drowning out
the sound of it as Bhagwan walked on to the stage: smiling, laughing,
raising his arms in greeting. The music reached a crescendo, everyone
went wild: singing, swaying, ecstatic.

Everyone but the guards, that is. They stood in front of the hall along
both sides of the stage, two of them with Uzi machine guns in their
hands. Stoney-faced. Watching us.

I

The Seduction

New York / Bombay / Poona
(1971 - 1974)

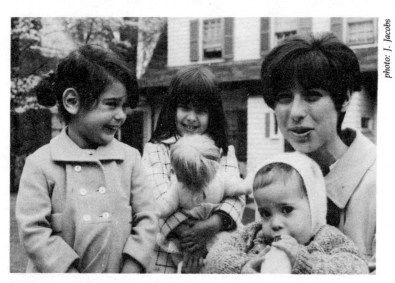

The author with her three children in Mt. Vernon, N.Y. (1967). From left: Patti, Nancy and Billy.

Rajneesh with his earliest disciples in the living room of his Bombay apartment (1972).

*M*ommy, come look!" Patti squealed enthusiastically, pulling me up from the couch where I'd collapsed in exhaustion while Chris continued supervising the moving men; Nancy carried cartons into her room and Billy raced around the apartment wildly, too keyed up to do anything else. "As soon as the movers leave, Chris is helping me build a tent that covers the whole floor!" she babbled effervescently as she dragged me into her new room.

Our move from a large house in Scarsdale to an equally-as-large penthouse apartment in Riverdale was as exciting for the kids as it was for me. A compromise between staying in the suburbs the way my ex-husband Danny insisted ("New York's no place for children. If you think for one minute I'll let you do that to my kids.... I'll get custody of them so fast you won't know what hit you!") and what I wanted.

The apartment was the first place I'd ever lived in that was my own. My choice. My taste. My in-laws had picked out our house in Scarsdale when I was in the hospital having Patti. The only thing I'd liked about it was the porch. Danny tore it down the week we moved in. Termites. Typical. A metaphor for my eight years of married life.

My sister was married to Danny's brother; they'd lived two houses away from us. My parents and in-laws, close friends for twenty years, all lived five minutes away. At least one of them came over every day. Only slightly less often after Danny moved out. He was still at the house three nights a week himself for that matter. Picking up the kids for the weekend, bringing them home, taking them out for dinner mid-week, always making me feel as if I was the one who didn't belong. It was still his house, psychologically if not in fact. I felt like an intruder when he was around.

When I found a house I loved in Hartsdale, Danny "strongly advised

me against it." He said an uncategorical no to the kids and me moving to a Park Slope brownstone. To even contemplate moving to California, Connecticut, or Manhattan proved I was irresponsible, selfish, an unfit mother, incapable of considering my children's welfare first. I took the kids to see the apartment in Riverdale before I told him about it, hoping he'd sign the lease if they loved it as much as I did. I couldn't sign the lease myself; I didn't have a job. Writing didn't count. Having a substantial bank balance didn't count. I was a woman. It was 1971. It was just the way things were.

"Your room's gorgeous, Pats," I beamed happily as she pounced on her unmade bed, her unruly curly black hair sticking out at odd angles around her head, a bubbly, exuberant eight-year old. It was exactly the room she wanted. Antique furniture, frilly curtains. We were all getting what we wanted for a change without anyone telling us what we should be wanting.

"Let's make the bed, okay, poopski?" nuzzling her as she tried to pull me down with her. "Help! You're choking me to death," both of us laughing. "Unhand me, you little ragamuffin," tickling her. "I'll get the sheets. They're in Nan's room."

Earnestly intent on what she was doing, Nancy was unpacking a carton of books when I walked in, her long straight hair hanging in her face. I knelt down to hug her.

"Don't, Mommy," she complained petulantly, pulling away. "I'm not a baby anymore." A year and a half older than Patti, she was a size smaller than her, as petite and shy as Patti was outgoing and rambunctious. Both dark-haired, dark-eyed beauties, the girls were opposite in every other way. It was probably why they got along so well together.

I stood up awkwardly, not wanting to force myself on Nancy. She'd been angry at me ever since Danny moved out two years ago. That it was my fault was something she never doubted. I didn't blame her for blaming me. When I wasn't angry at Danny for trying to dictate how I should run my life, I still castigated myself. It wasn't the way I'd wanted things to turn out.

"Do you like the new apartment?" I asked shyly, tears stinging my eyes. I didn't know how to act with Nancy half the time. I sometimes wondered what it would take for her to forgive me.

"It's pretty nice," she acknowledged reluctantly, her eyes lighting up suddenly as Chris galloped into the room, Billy, five years old and adorable, riding on his shoulders.

"The moving men are about to leave," Chris panted, galloping in place. "What should I tip them?"

"I don't know," shrugging. "What do you think?" Nancy looked at

me disdainfully. It was the kind of decision her father would have made without even thinking. "Five dollars each maybe, ten. Why don't you ask them what they usually get?"

"Good idea," he nodded, prancing off, Billy holding on to him for dear life, shrieking with delight.

No matter what Danny said, I didn't see how it could be bad for the kids to be with Chris. "I don't care how much they like him," he'd tell me threateningly. "I don't want him around. They're my goddamn children!" My lawyer warned me I could lose custody of my kids because Chris was black. Pseudo-black: a light-skinned Jamaican who was studying for his Ph.D. in psychology.

Sometimes figuring out what Danny and the powers-that-be would let me do or not do was too much for me. I felt trapped, suffocated. I wasn't married to Danny anymore, but he still controlled my life. He was rich, conservative, and staid while I was a fringe hippy, fringe radical; he held all the power.

Danny and I had finally come to an uneasy truce about Chris. He could be with the kids during the day: excursions to Coney Island and Bear Mountain, picnics in Central Park; as long as he didn't spend the night with me when they were around. "You can do what you want with your *schvartzer* boyfriend," Danny would shout over the phone, "you can fry in hell for all I care, just leave my kids out of it!" threats hanging in the air like promises of doom, leaving me in constant fear of what Danny would do.

"Are you saying I'm not a good mother?" I'd ask uncertainly, afraid of the answer. I knew I was irresponsible sometimes: late picking up the kids at school, so engrossed in my writing or my own problems that I was often distracted when I was with them. I didn't have the right answer to every situation at my fingertips the way Danny seemed to, groping and stumbling along as a parent, always wondering if I was the perfect paragon of maternal virtue that I wanted to be, seeing all the ways I wasn't.

"I've never said you're not a good mother," he'd back down quickly, qualifying his anger. "I'm not implying that." He just wanted the children to be brought up the way he wanted. Couldn't I see how reasonable that was? They were his kids, too, after all.

When Danny came by that night to pick up the kids, Nancy and Chris were reading a book together, Billy was playing the piano, and Patti and I were drawing pictures. A tablecloth was spread out on the carpet with pizza crust and soda cans on it. Unpacked cartons were scattered haphazardly around the room.

Nancy was the only one who got up to greet Danny without being told. The other kids, preoccupied, kissed him hello dutifully then hurried back to what they were doing as Nancy escorted her father proudly around the apartment.

"You've got quite a mess here," Danny commented dryly after he'd finished his brief, self-conscious tour. No compliments, no good wishes; I wondered why I still wanted them from him. He carefully avoided looking at Chris, though he'd said a crisp hello to him when he walked in. Chris was used to it by now. "You got your work cut out for you this weekend, huh?" he said, implying, I knew, that he trusted I'd spend the time cleaning up. I didn't expect his children to live out of cartons, did I?

"Are your bags packed yet?" he asked the kids restlessly. "Come on! We don't want to hold Mommy up. She's got a lot to do."

"I don't want to go," Billy murmured sadly, looking at me forlornly. "Do I have to, Mommy? I didn't get an alone-time with you today. It's not fair."

"We'll have a long alone-time on Sunday," I promised, hugging him goodbye. "Okay, sweetie?"

He nodded, satisfied, his tiny child's hand already holding on to his suitcase, his eyes no longer filling up with tears the way they had when Danny and I were first separated and he had to be with his father on the weekend. He still didn't want to go with Danny half the time, but he always came back enthusiastic about what they'd done. He was "my" child the way Nancy was her father's, Patti moving easily between the two of us.

Standing impatiently by the elevator waiting to leave, Nancy condescended to let me kiss her. Patti threw her arms around me, smothering me with kisses. "Kiss Daddy goodbye," she ordered imperially, picking up her nightbag; her crayons and drawing pad clutched in her other hand. I pecked Danny's cheek. He scowled.

ᔥ

"Love you, Dads," Patti said, hanging up the phone and skipping into the kitchen where I was making the two of us an afternoon snack. Danny called the apartment twice a day: after school and again at night. At least he wasn't around all the time anymore.

"I never saw two people so opposite as you and Daddy," Patti said as she nibbled absently on a piece of brie. I'd just gotten home from the mental hospital where I worked as a writing therapist two days a week.

Billy was at a music lesson, Nancy at a dance class. "Take off the crust, Mom, it tastes like puke. Why'd you ever marry him anyway?"

"Because I wanted to make love to him." The words slipped out of my mouth before I could stop them.

Patti burst out laughing. "If you want to fuck someone," she giggled giddily, "you just fuck them. You don't *marry* them. God, were you dumb, Mommy!"

I'd thought often over the years about why I'd married Danny. Sometimes the only reason that made sense was so Nancy, Patti, and Billy could be born. We made beautiful children together.

The thing I remember most is not knowing how to avoid getting married, not wanting to hurt Danny. Feeling obligated to marry him because he wanted me to.

I'd spent most of my youth vascillating between rebellion and conformity, wanting to be like everyone else, always feeling that I wasn't. When I was ten, I wanted to join the circus. At fourteen, I wanted to become a nun so I could marry God. I was never going to settle down and have an ordinary life like my mother. I was going to be an artist, a writer: do something different, be something different; break out of my Jewish upper-middle-class mold; escape. My physician father seemed to admire my rebelliousness as much as he hoped it was just talk. He needn't have worried.

I wrote for the school paper in high school, and I was cheerleading co-captain and an honor society scholarship winner. One of the "popular" kids at school, inside myself I felt timid and shy, only pretending to be the vivacious person I appeared to be.

Every time I brought home a report card with a 98% average, my father asked me why it wasn't 100%. It didn't occur to me that he was teasing me. When I got the highest S.A.T. scores in school, I assumed it was a mistake. No matter how well I did at anything, I always felt I'd failed.

I dated the school president: athletic, good-looking, bright; a relationship that was more companionable than it was passionate (years later he decided he preferred men); and I was in love with a black football player whom my parents wouldn't let me date. When he graduated the year before I did and went into the navy, his weekly letters from Germany were the highlight of my life.

One night while Danny's parents were in Europe, my mother invited him to the house for dinner. Danny had already graduated from college and was working on Wall Street: an experienced older man. Inexperienced myself, hopelessly insecure, I was flattered by his attention.

Danny and I went out twice before I started at Brown University as

an applied math major and dated occasionally during school vacations. I had few dates at college—most of the boys in my advance placement classes were gawky, gangly youths who were more interested in their studies than they were in dating, or at least appeared to be—and was sure no one attractive would ever like me again. I didn't drink or smoke, I was shyer than ever, mousey; I didn't know how to handle myself with boys.

Danny didn't seem to notice. To him, I seemed excitingly different; a kooky, adventurous nonconformist. Still a virgin, horny, and impatient, I threw myself at him with all my repressed adolescent sexuality. He was safe because he liked me. I could do anything I wanted without being afraid of rejection.

After we'd dated a half dozen times, Danny slipped a diamond ring around my finger. I didn't want to get married. I didn't know how to refuse. Our parents were thrilled.

I spent the next five months telling Danny all the reasons why I couldn't marry him. He didn't understand, he didn't hear me; I didn't know how to just say: no, I'm sorry; it's impossible.

Feverish for days before the wedding, I prayed my parents would suggest we postpone the ceremony; but it wasn't until the guests were in the chapel, the wedding march playing, that my father turned to me, teary-eyed, saying, "It's not too late to change your mind, baby." Years later, he admitted he'd wanted to get me married "before that colored fellow you were writing to" returned to the States. All I knew was that I felt trapped.

Nancy was born a year later. If I was going to be married, I'd decided, I might as well have kids. I'd loved taking care of my brothers when they were little. Having a baby was like playing house, a game; it made me feel grown-up even if people always thought I was the babysitter. Danny's romantic interest in me waned once I became a mother; our sex life became sporadic and perfunctory. I was twenty years old. Obsolete. A has-been.

When I wanted to join the civil rights march in Selma, Danny refused to let me go. I was a mother now, he said; I had a responsibility to my child. Making financial contributions to the civil rights movement instead of standing up to be counted, I felt like a classic hypocritical liberal, hating myself for it.

Danny and I turned out to have little in common. Our opinions about the way things were and the way they should be were totally different. I thought about getting a divorce, then suddenly, unexpectedly, when Nancy was seven months old, I was pregnant again. With two infants and no marketable skills, divorce seemed out of the question.

Billy was born three years later. Still in my early twenties, I convinced myself that I was happy, persuading myself that sex wasn't love any more than common interests were; growing up meant accepting that.

As the years went by, the differences between Danny and me grew. We were five years apart but from different generations. We didn't like the same food, movies, plays, or music. I read vociferously: *Ramparts*, literary quarterlies, and "good literature," while he read the newspaper. He believed in law and order; I believed in confrontation politics. While the people I'd gone to college with were out in the world doing things I believed in, changing things, I was living a cloistered, protected life in the suburbs, dying of boredom, married to a man who'd been attracted to me because I was "different" and then expected me to live a white-picket-fence life.

When I began writing seriously (short stories, poetry, satire), Danny couldn't bring himself to read anything I wrote. "I can't get through this crap," he'd complain peevishly when he finally agreed to try. "It's bad enough I gotta read the newspaper every day. If you want to do something creative, why don't you take an art class? We could use some pictures on the wall," priding himself forever after for his encouragement of me; he'd never been a male chauvinist. I was supposed to feel grateful, and felt hurt instead.

Every week Danny bought me flowers that I was allergic to ("Couldn't you buy another kind, Danny?" sneezing nonstop; hating myself for my ingratitude) and vacuumed the house right after I'd done it, always making sure everyone knew how much he helped me. While I spent my nights crying, he spent his reading *The Wall Street Journal*; the only thing we had in common was our kids.

When I went back to college part-time, I felt as if I'd finally found my milieu. Artsy and ultra-liberal, Sarah Lawrence was filled with people like me, and, by the end of my first year, I was in love with a middle-aged black intellectual who read everything I wrote, encouraging me, and made love to me as if it were something that mattered.

Knowing my marriage was coming to an end, desperately wanting it not to, I'd lay in bed beside Danny at night crying, my whole being aching with tenderness for him. As much as I didn't want to hurt him, I knew it was inevitable. There was no way I could go back to a numb, sexless existence where my desires and opinions were ignored or belittled; it was too late.

Consumed with guilt, I alternated between catatonia and despair for months, writing anguished poetry while I contemplated suicide, Billy, at two-and-a-half, my comforter and saviour. Aware that what I was doing to him was unfair, unable to help myself, I'd lay my head on his lap for

hours crying, Simon and Garfunkle playing on the hi-fi as Nancy straightened up the house and got dinner ready, protecting me; not wanting Danny to know how incapable I'd become of functioning. I don't remember where Patti was in all this. She couldn't have been oblivious to it.

At Danny's insistence, I finally began to see a therapist. To say that it helped immeasurably is an understatement: it saved my life. When I finally had the courage to ask Danny for a divorce—we hadn't spent time together, or slept in the same bed, for months—he was shocked. Divorce didn't run in his family, he told me bitterly. My sister had been divorced, my grandparents were; it was obviously the kind of thing my family did. He was hurt before he was angry.

By the time I met Chris a year later, I'd had several brief affairs and thought of myself as sexually liberated. As the two of us romped and played together, exploring sex like children with a new toy, I felt myself blossoming into a happy, vibrant woman. Chris was as loving to me as he was nurturing, helping me heal the bruises of a lonely marriage and a painful separation. We had the same attitudes and opinions, we liked the same things, we had fun together, something I'd only had with Danny in relation to the kids.

The Pulitzer Prize-winning poet with whom I'd been doing a tutorial at Sarah Lawrence that year assured me that I was another Sylvia Plath, Ann Sexton: the anguished female poet, mixing diapers and despair; that I was sure to win that year's Yale Younger Poet Award for which he was one of three judges. My interracial love imagery "made an important political statement." They wanted a woman to win: "Preferably one with good legs. Yours are smashing." Too proud to submit a manuscript under those conditions (another woman, presumably with smashing legs, won), I felt encouraged nonetheless by my various teachers' appreciation of my work and was soon publishing poetry in literary quarterlies and working on a novel, happier than I'd ever been.

ّ

"You don't talk to your father about fucking, do you?" I asked Patti curiously that afternoon as we sat eating our crackers and cheese.

She looked at me, shocked. "Are you kidding, Mommy? Daddy doesn't even know what fucking is. Don't you know anything about him after all these years? He's not the type."

Mumbling something innocuous—Danny's refusal to have lovers around when he was with the children seemed as unnatural to me as my being with Chris seemed licentious to him; our morals and standards of

behavior were diametrically opposite—I thought about how schizophrenic our kids' lives were. Danny encouraged their good behavior while I encouraged their outspokenness; they tried to please us both. I worried endlessly about how confusing it must be to them, both of us convinced "our" way was right, the other's way wrong: two stubborn extremists living in two different worlds, our kids bouncing between us like hapless balls at Wimbledon.

It was snowing by the time Patti and I picked up Billy from his music lesson and Nancy from dancing school, the four of us heading into Manhattan to have dinner with Chris at our favorite Chinese restaurant. The kids waited in the car outside Chris' apartment while I buzzed him to come down. I'd taken them up to his fifth floor walk-up once. Danny was livid. I didn't dare do it again.

It continued to snow heavily as we gorged ourselves on Chinese food, the upper west side turning into a fairyland. By the time we left the restaurant, there wasn't a car on the road, the streets were deserted. Someone started a snowball fight: Billy and Chris against the girls and me, all of us laughing and excited, having the time of our lives, till Nancy panicked suddenly. What time was it? Her father would be calling the apartment. He'd be worried. We had to hurry home. "Let's go, Mommy! I don't want to play anymore, Billy! Stop it!"

Driving back to Riverdale at ten miles an hour took forever. Nancy called Danny as soon as we got inside; I could hear her whispered assurances to him as I got Billy into bed and Patti into the bath. "It was fun, Daddy! Mommy drove *very* slowly. That's why we weren't home when you called. I already did my homework"—she hadn't. "I'm not even tired. Chris wasn't there. We met Mommy's friend Mary from Sarah Lawrence. Remember her?"

Danny called the next morning to chastise me for keeping the kids out till 9:30 on a school night. "I don't know where your brains are sometimes, Jill. You're so goddamn irresponsible I can't believe it. You're supposed to be so smart and you don't even know enough to listen to the weather report? The kids tell me you're writing political speeches for Shirley Chilsolm. It figures. Who else would waste time on a colored Congresswoman who's running for president? You got your brains up your ass, lady. I'm picking up the kids early tonight. Have them ready."

Danny was the personification of my conditioning, my judge, and nothing I did met with his approval. He'd even taken a poem of mine to his lawyer recently to prove I was an unsuitable influence on the children. I should have been used to his condemnations by now, but I wasn't. They hurt.

2

It was at an afternoon tea party in Larchmont shortly before I moved to Riverdale that I heard about Bhagwan for the first time from a woman in one of my yoga classes. Dressed in a long orange robe with a necklace around her neck that had a picture of Bhagwan attached to it, the woman told me happily that she'd met Bhagwan in India and had become a disciple of his: a sannyasin.

I'd never seen such a remarkable change in anyone before in my life. A beautiful sophisticated jet-setter who was always impeccably made-up and expensively dressed, the woman was suddenly devoid of lipstick, mascara, and any pretense of glamour, but she was as radiant as a Flemish master's madonna; glowing. She'd "fallen in love with Bhagwan" was the way she explained it to me, telling me about her three-week stay in India and what she called "the meditation": a combination of bio-energetics, primal therapy, and traditional meditation techniques. Despite my instinctive aversion to guru-trips, Dynamic Meditation sounded intriguing, and when the woman invited me to her house to try it ("There's nothing to believe in; it's just a technique"), I went, not knowing what to expect from the experience.

Beginning with ten minutes of deep, fast breathing through the nose (hyperventilating obviously, though it was always vehemently denied), "the meditation" awakened both unconscious memories in me and a remarkable storehouse of vibrating energy that I was told to channel, in the second ten-minute stage of the technique, into catharsis: crying, shouting, screaming, laughing, allowing whatever "wanted to happen" to happen without censoring it; an out-pouring of repressed emotions and experiences; a purging of the past.

While it took most people several sessions of Dynamic before they could "allow" the second stage to happen spontaneously, the technique was extraordinarily powerful for me the first time I did it. Sitting on the floor of a luxurious Mamaroneck house, flailing my arms wildly, crying hysterically, regressed to a childhood state of consciousness by the intense breathing I'd just done, I suddenly felt as if I was learning to walk for the first time; knowing I could do it; wanting desperately to show my mother I could. Every time I tried to stand, I fell; frustration and anger competing with determination till I was suddenly doing it ("I'm walking! I'm walking!"), tears of joy streaming down my face.

The third ten-minute stage of the technique began, the vigorous repetition of the phrase *Who am I?* (later changed to the Sufi mantra: *Hoo*). Repeating the phrase as loudly and intensely as possible, nonstop, forced the body/mind away from catharsis, giving it something else to concentrate on, and, by the time the final ten-minute stage began (the meditation itself: silence, stillness, peace), it happened effortlessly.

Dynamic was hardly the boring, stultifying activity I'd always imagined meditation to be: sitting silently, watching my navel as I watched my thoughts come and go. It wasn't long before I was reading every discourse of Bhagwan's that I could get my hands on. Caught.

ॐ

"You are in prison," Bhagwan said. "Closed within yourself, dead. Life can't come to you. You create barriers to life because life is dangerous and uncontrollable. In your narrow, closed existence you feel secure. But the more closed you are, the less alive. The more open you become, the more alive."

The appeal of his words to someone like me was obvious. They made me want to dance, sing, shout hallelujah out my penthouse window. He talked repeatedly about the need for a balance between the rational and the irrational; the need to let the opposite sides of one's being be expressed. "Only if you're open to life in all its dimensions—the physical, intellectual, emotional, and spiritual—do you live life totally. Transform yourself. Open some doors in your being. Jump out of your mind, your past. Then you'll not only know the divine, you'll live it."

I loved everything Bhagwan said. To live joyously, without oughts and shoulds, accepting every part of oneself, loving it no matter what it was; but it was months before I thought about doing the meditation again. When I did, I was hooked: fascinated by what emerged from my unconscious and awed by the feelings of peace that followed. As I relived scores of childhood traumas that I'd long since forgotten, express-

ing the emotions they'd evoked in me, one by one all my psychological blocks seemed to dissolve. I went through hell in session after session of Dynamic: writhing in pain, screaming, remembering, purging myself; then, cleansed and exhausted, I was filled with a humming, alive stillness inside me that was blissful beyond description.

As angers, fears, jealousies, and resentments dropped away, I began to see where all my insecurities and self-judgements came from. I stopped condemning myself for everything I did, stopped worrying if I was a good mother, a good human being; constantly in need of reassurances. The wide swings of emotion that I'd always had, moving from euphoria to despair and back again, changed to a continual feeling of well-being. I felt a new equilibrium inside me, content within myself.

That Chris found Bhagwan's words simplistic and Dynamic unappealing ("I'd rather drop acid if I want to get into a trance state. This voodoo stuff isn't for me") mystified me. It wasn't until years later that I understood what he meant. While Dynamic (as well as Bhagwan's later techniques) clearly induced a trance state in me that was similar to what shamanistic religions evoke through hypnotic music, drumming, frenzied dancing, and the use of intoxicants and hallucinogens, I didn't see it that way at the time. I don't know if I'd have been disturbed if I had. Haitian rituals, the Holy Rollers' ecstasies, evangelical revivalist meetings, and the transcendental states that medicine men induce in themselves had always fascinated me. While I was too unsure of my emotional stability to take acid (my one mescaline trip had turned into a nightmare), I was drawn to the mystical states of consciousness that people experienced with drugs: visions of the past, the future, and a distorted present, magnified to mythic proportions; a sense of omnipotent knowing. Dynamic was safe, a risk-free high. Despite the pain and (later) ecstasy that I went through when I did it, a part of me was always in control: a detached observer who could stop the scenario at any moment. And the calm serenity that invariably followed was exquisite.

One weekend while the kids were with Danny and Chris was studying, I visited the new Rajneesh center in upstate New York...and from one moment to the next, my life changed utterly.

≥≥

I was sitting by myself in the wood-panelled meditation room at the center after an early afternoon session of Dynamic, stoned on my own energy, buzzing, my body throbbing with intensity, when suddenly out of nowhere a blinding white light filled my head, my body, and my

being. Tears streamed down my face. I felt as if I were seeing God, even though I hadn't believed in Him for years.

The light was as benign as it was intense and as comforting as it was extraordinary. I fell to the ground in front of the altar where a silver-plated, life-sized cast replica of Bhagwan's feet sat like a statue of the Buddha, surrounded by flowers.

I lay in front of "the feet" for hours, while the room grew steadily darker and I was filled with light from within, then crawled to my knees and bowed down at the altar, gratefully embracing "the feet" that I'd regarded with embarrassed disdain a few hours ago. By the time I finally left the meditation room, it was past midnight. I'd missed my dinner and Bhagwan's taped lecture. I was tranquil and subdued. I could scarcely speak.

"It happens that way in front of 'the feet' sometimes," one of the center residents commented gently as I sat down at the kitchen table to nibble on a plate of salad she'd saved me, and instead of me muttering cynically to myself ("Come *on*! Who are you trying to kid?") as I undoubtedly would have done before—I was no guru-worshipper—I nodded knowingly.

As the weeks went on and I continued to do Dynamic daily, I wondered vaguely how one became a disciple of Bhagwan's (a sannyasin) but never asked.

❧

Bhagwan called his unorthodox version of *sannyas* a rebirth: dying to the old and moving into the unknown; a decision to live life to the optimum. It wasn't that one "surrendered" to Bhagwan as a spiritual Master (as in most traditional Teacher/disciple initiations), but to life itself, living moment to moment, accepting whatever life brought. In renouncing what was false, borrowed—the conditionings and habits of the past—one's own uniqueness could begin to flower. Bhagwan was a teacher, a guide, nothing more. He'd experienced a truth that philosophers only talked about. He could help others to experience it.

Despite myself, I found the idea of sannyas intriguing. There was no question in my mind that Bhagwan knew more about human consciousness than anyone I'd ever heard about or read. If anyone could help me to know myself, it was obvious that he could.

Provocative and unconventional, Bhagwan's approach to spirituality seemed more psychological than it was religious. He even advocated free sex, calling one of his early books *From Sex to Superconsciousness*. "Religion that denies sex denies love," he said, "because with love there is

every possibility that sex will follow. If sex is not denied but trans-
formed, there is no need to deny love. I do not deny anything because
ultimately it is bliss that is being sought. Sex transformed becomes di-
vine."

Sannyas didn't remind me of any guru-trip I'd ever heard of. While
Bhagwan's sannyasins (about twenty of whom were in America at this
point) obviously loved and respected him, they made irreverent jokes
about him and their own disciplehood; there was nothing holier-than-
thou about them. Unlike Hari-Krishna people, Divine Light premies,
Moonies, and traditional yogis, they didn't seem to take themselves (or
sannyas) very seriously. Exuberant intellectuals, they laughed constantly,
hugging each other and everyone else in long, timeless, body-to-body
hugs. They were fun-loving, funny people, bawdy and down-to-earth;
real.

It was at a week-long meditation camp at the upstate Rajneesh center
in August 1972 that Chaitanya, a bearded, freckled-faced, all-American
Buddha from Boston, the local sannyasin-guru, told me that he thought
it was time I thought about taking sannyas.

I hesitated long enough to allow myself to be convinced. "I know
how powerful Dynamic's been for you," Chaitanya said as we sat in the
renovated farmhouse kitchen at the center, drinking herb tea. He led the
meditation classes in New York that I'd been going to for several
months, "but if you think Dynamic's a good technique," taking my hand,
squeezing it, "you should try sannyas. It's an even better one." Wearing
orange clothes all the time was a technique; the *mala* necklaces that
sannyasins wore around their necks with Bhagwan's photo attached was
a technique; there was nothing to believe in or not believe in. Can't hurt,
might help, I figured as Chaitanya added, grinning, "Besides," clinching
it for me—I had a crush on him—"you look great in orange."

Everyone at the camp was invited into the meditation room for my
initiation ceremony. Several people played hand-held Indian drums; others,
tambourines and bells, flutes, and wooden wind-pipes. Soon we were all
singing and dancing with enthusiastic abandon.

As Chaitanya stopped his frenetic drumming, I sat down opposite
him in front of the altar where a floor-to-ceiling photo of Bhagwan's face
hung on the wall behind "the feet," everyone else sitting in a half-circle
around us. "Your new name," Chaitanya pronounced somberly in the
now-silent room, placing a *mala* around my neck, "is Ma Satya Bharti.
Ma," looking at the paper on his lap with my new name on it, then
looking back at me, grinning impulsively, "means divine mother," trying

to keep a straight face, losing it. "*Satya* means truth. And *Bharti* means of the east, of India. The divine truth of India."

Shaking with silent irrepressible laughter, Chaitanya leaned forward to hug me, his long auburn hair tickling my face. The next thing I knew, as music played all around me and everyone scrambled to their feet, dancing and celebrating, I was rocking from side to side on the carpet, laughing uproariously.

My laughter went on half the night; I couldn't stop it. I didn't want to. The whole world suddenly seemed hilariously funny to me. *Jill* had died. I was *Satya* now: truth. I didn't need to live a thousand lies anymore; I felt reborn. It was gloriously, refreshingly funny somehow.

At a "divine healing" experiment on the back lawn the next afternoon—everyone hyperventilating like hippopotami in heat, then "allowing the energy to be released" in a mass primal therapy session—Chaitanya reached out unexpectedly and touched me. Our arms were suddenly around each other, his tall, sinewy body pressed against me as the two of us collapsed to the ground, shaking as violently as if we were having a joint epileptic fit. As the music came to a crescendo and stopped—the other meditators' screams abruptly subsiding, everything becoming silent, still—Chaitanya and I shook and trembled in each other's arms, unable to control the surging energy that was moving between us.

When we finally got up some indeterminate time later, we were alone outside. I was too embarrassed to look at Chaitanya, convincing myself that what had just happened between us wasn't sexual; I didn't want it to be. It was obscene in its power, uncontrollable; I felt as mortified by it as if I'd been caught making love to a stranger in the middle of Times Square.

When I had to leave later that afternnoon to pick up the kids at Danny's, I didn't say goodbye to Chaitanya. I didn't want to see him again, touch him, hug him, frightened that I'd start to shake like a leaf again. I'd be a menace on the highway, a menace to myself; I'd never make it home alive.

The simple truth was, I didn't understand any of it. Energy. Meditation. Sannyas. Who Bhagwan was, who Chaitanya was, who I was even. Clutching on to the locket on my *mala* as I drove home, laughing to myself, singing Indian *kirtan* songs at the top of my lungs, all I knew was that I felt wonderful.

ॐ

I spent the next week dying all my clothes orange and giving away

everything that couldn't be dyed. The inside of my washing machine turned orange. My jeans didn't. I gave them away.

"I preferred having a hippy mother!" Patti complained constantly, while Billy tugged absentmindedly on my *mala* continually till it broke. When he came with me to sannyasin events though, he seemed to enjoy them. Sannyas gatherings invariably ended with singing and dancing; anything with music appealed to him.

When the therapist I'd been seeing for several years suggested that I stop therapy, it felt like an affirmation of the new me. Jill had been her patient, she said; Satya wasn't. She didn't think Satya needed to be in therapy. I'd changed immeasurably. I wasn't neurotic anymore, hopelessly insecure. Jill's problems weren't Satya's.

A few weeks later when I nervously taped a picture of Bhagwan to the wall above my bed, Chris was furious. "Either you sleep with him or you sleep with me!" he shouted, tearing the photo down.

"I sleep with him," taping it back up again.

Chris and I broke up finally, painfully, regretfully; we still loved each other. He wasn't interested in Bhagwan, the meditation, or sannyas, though. We had nothing in common anymore.

ॐ

Chaitanya soon became my lover as well as my mentor. Looking into each other's eyes for hours at a time, spellbound, the energy between us was so intense we shook and tremored at the slightest touch; sex between us was as powerful as an earthquake.

"I think it's time for you to go to India to meet Bhagwan," he told me one afternoon after we'd made love on the floor of his apartment, incense burning, pictures of Bhagwan everywhere. My body was tingling with energy, gingerale racing through my veins. "Bhagwan's giving his first English lecture series in December. It'll be a perfect time to be there. Why don't you see if Danny can take the kids early for Christmas vacation and go then?"

With or without Chaitanya's encouragement, I was eager to meet Bhagwan. I'd been having what I assumed were "past life" experiences of him ever since taking sannyas. Past lives (the endless cycle of birth and death that Eastern religions believe in) were hardly part of my conditioning, but I didn't know how else to account for the vivid memories I was having of a childhood, centuries before, when Bhagwan was my father. I wrote to him about it, receiving a letter back from his secretary Laxmi telling me to: "Feel blessed to remember your relationship with Him. Yes, we've all been related in the past...."

When Danny agreed to take the kids early in December, I booked a flight to Bombay, feeling like the prodigal daughter about to return home.

As I lay on the floor of my bedroom one morning while the kids were at school, my eyes closed after doing Dynamic, the late-fall sun shining on my face, a voice inside my head that had been "talking" to me ever since I took sannyas said firmly and decisively: "It's time for the children to move in permanently with their father."

I was appalled. It was out of the question, impossible, the last thing in the world I'd ever do was give up custody of my kids; but the voice inside my head that I thought of as Bhagwan wouldn't stop. "It's time, Satya!" the voice nagged me incessantly for days as if the decision had already been made without me and I wasn't accepting it.

Thrown off balance suddenly, upset, and obsessed, I couldn't think about anything else, couldn't sleep, as I endlessly analyzed my doubts and insecurities as a parent. Was I capable of taking care of my kids? Was I doing a good job of it, wrapped up as I was in my writing, in sannyas, and in Chaitanya? Would the kids be better off with Danny after all? He was mature and consistent. I wasn't. I'd never be able to give them the stability he could give them.

Was anything worth what felt like an inevitable custody battle between us? "Don't you dare involve the kids in that *mishuggana* Eastern religion of yours!" "I don't want...." "Where were you?" "They're my goddamn kids!" Sannyas would be as detrimental to me in court as my politics, poetry, or lovelife, I knew. I had no way to fight Danny.

I loved the kids so much, though. We were closer than most mothers and kids; we had crazy-fun times together. Wasn't that worth anything?

I didn't know what to do. I couldn't think straight, couldn't stop crying when the kids weren't around; the voice inside my head wouldn't stop hammering at me. I phoned Danny finally. "How do you feel about the kids moving in with you permanently?" sobbing; I could hardly believe what I was saying.

"I think it's a good idea." Calm, cold, unfeeling. "They don't need to be around every bizarre new trip you get into. God knows what it'll be next. You're making the right decision, Jill."

Panicking, my heart pounding with fear, I wanted to back out, change my mind, tell Danny it was just a crazy idea I'd had; I didn't mean it. Couldn't we talk about it rationally, calmly; discuss what we both thought would be best for the kids: the pros and cons, the alternatives; but as far as he was concerned it was already decided on, done.

"I just meant maybe we should...."

Danny cut me off abruptly. He only wanted to discuss logistics. How soon could I get the kids ready? Could he pick up their things that weekend? The girls both went to private school in Manhattan anyway. Billy's prep school had bus service from the city. Living in New York wouldn't be so bad for the kids after all, apparently, as long as they were with their father.

They loved Danny, I told myself over and over again; he loved them. They were strong enough not to be diminished by his judgements the way I'd been; they'd be all right. We'd still have joint custody of them. They'd be with me on weekends, vacations; nothing much would change. It was time.

๖

"I have to talk to you kids about something," I announced anxiously after dinner that night as Billy lay on the floor playing with a puzzle and watching TV, and Nancy and Patti sat doing homework, one eye on the TV screen. "Why don't you girls come into my room for a minute?" tears in my eyes, my voice shaking; I'd been willing myself not to cry ever since they got home from school. "Finish your program, sweetie," I murmured as Billy looked up at me, concerned. "I'm okay, really. I'll talk to you later."

"What's the matter, Momsels?" Patti asked, nestling into me as we walked into the bedroom, Nancy trailing reluctantly behind.

"It's nothing. It's just.... I have to tell you something," sitting down on the floor, Patti flopped affectionately against me. As I tried to draw Nancy closer, she pulled away.

"Your father and I have decided...," I stammered; I couldn't go on. "You're going.... We've decided that it would be better if you kids moved in with him. I don't know how long I'll be in India and...."

"We already know that, Mommy," Nancy sighed impatiently. "You told us that weeks ago."

"I don't just mean for three weeks, sweetie. You'll be living with Daddy from now on."

"Good," smiling blandly, shrugging; at least one of the kids would be happy about the move. "It'll be closer to school. I've got homework to do, Mom," standing up; leaving.

"Billy, too?" Patti mumbled disconsolately, tears in her eyes. I nodded, trying not to cry. "But we'll still see you, right, Mommy? Just like we see Daddy on...."

"I'll be in India for awhile, but after that...."

"You go to see Bhagwan next week, right?" she smiled hesitantly, wiping her eyes. "When I'm older can I...."

"Is it my turn yet, Mommy?" Bounding into the room with all his little-boy energy, Billy jumped on my lap, throwing his arms around me. "What do you have to tell me? Is it something good?"

Bewildered and confused by what I said, tears welled up in Billy's eyes but he didn't cry. He nodded bravely, his pain so palatable I could feel it. It echoed everything inside me.

Couldn't he come with me, I thought for the umpteenth time as I held Patti and Billy in my arms, crying. The girls could go with Danny— they loved being with him—and Billy could stay with me.

I knew Danny wouldn't let it happen, though; we'd already discussed it. It wasn't healthy to separate the kids, or for Billy to be alone with me. We were too close as it was. I knew all about what doting Jewish mothers could do to their sons; I didn't need Danny to tell me. I adored Nancy and Patti and worshipped Billy. It was my problem, not his.

Within minutes, Billy was comforting me instead of me, him; telling me that everything would be okay. Life was a school. Our not being together was a lesson we had to learn. He sounded like a young Buddha. He was always so much wiser than I was.

The day before I left for India, the kids moved in with their father. Billy was six and a half; Patti, nine and a half; Nancy, nearly eleven. It was painful for all of us; beyond understanding almost. I still didn't know why I was doing what I was doing. I felt as locked into change as I'd once felt locked into stagnation, helpless to delay or avoid what seemed inevitable.

3

The plane I took to Bombay that December was like a stage setting: welcome to India. The walls of the plane were decorated with Indian motifs, Indian music played cloyingly over the PA system, the smell of Indian spices was everywhere. Families stood in the aisles chatting loudly in various Indian dialects, the men in business suits, the women in silk sarees or Punjabi tunics. Light-skinned children with huge, mournful eyes hung on to the arms of parents, grandparents, and *ayahs* as the saree-robed stewardesses passed out mints and supari, alternating between speaking English to the few westerners on board and Hindi, Gujarati, Marathi, Bengali and Punjabi to the Indian passengers. It was a spruced-up-for-the-west view of India: there were few dark faces and no beggars. Before the fourteen-hour plane journey was over though, the bathrooms would look like India at its worst: the toilets clogged with paper and excrement, the sinks disgusting; a revolting glimpse, I was afraid, of things to come.

"Hmmm, Rajneesh," a middle aged Indian man in a brown tweed jacket and v-neck sweater said as he watched me stuff my orange coat, sweater, and shoulder bag into the overhead rack. I realized suddenly how conspicuous I must look to the other passengers in my orange clothes. Even if my jeans and turtleneck were decidedly untraditional, it was the color religious renunciates wore in India. "You're going to see Rajneesh?" the man asked, pointing to the picture on my *mala*.

I nodded, pleased that he'd recognized the picture. Few people in America did. "Do you know Bhagwan?" I asked.

"We people do not call him *Bhagwan*," the man huffed irritably. "To us he is an *acharya*, a teacher, nothing more. He speaks like one of the gods, your Rajneesh—his talks on Mahavir and Krishna, there's never

been anything like them; pity you don't understand Hindi—but he's no god, no *bhagwan*. He talks about sex! He allows nudity at his meditation camps! I've read about it in the paper. No true *bhagwan* would do that. It's for you westerners to call him *Bhagwan*. You don't know what the word means to us. To us, he's just a great *acharya*, a very wise man.

"He should stop talking about sex," the man continued. "We Indians don't like it. It's not fitting in a holy man. You should tell him so when you see him. Tell him his own people do not approve of this kind of talk," and pressing his hands together in a prayer position (a *namasté*), smiling benignly, "*Namasté*, ma!" the man proceeded down the aisle.

Long before the plane arrived in Bombay, seventeen people gave me their unsolicited opinions of Bhagwan (some respectful, some not), while almost as many bombarded me with intimate questions about my family, love life, sex life, religious training and inclinations, an interrogation that was repeated often over the years by strangers on the streets of Bombay and Poona, always in the most matter-of-fact way possible as if it was their right to ask and my obligation to answer.

"I see you're one of Rajneesh's so-called sannyasins," an attractive, grey-haired woman in a silk saree said as we stood in line to disembark in Bombay. "I suppose you believe in sex, then?"

"Well, I...," but like my other inquisitioners, she was more intent on purging herself of her questions than in me responding.

"Are you married? Do you have children? Do you believe in this so-called free sex we read about? I suppose you have lots of boyfriends, a pretty young thing like you. Do you have oral sex with them? Do western men do it to you or do they just expect you to do it to them? Don't you worry about disease? I understand western men are not so clean in their personal habits as our Indian men. Will you take an Indian lover while you're here? I don't suppose that's against your Rajneesh's religion, is it? Quite the contrary from what I hear. Hrmph!"

As she turned her back on me with an indignant snort, we began moving slowly down the aisle, everyone as weighed down as I was with gifts and parcels. A gust of hot air hit me in the face as I stepped out of the plane and down the precarious steps to the runway with my two huge shopping bags filled with ketchup, mustard, shampoo, hair conditioner, Oreo cookies, Hershey bars, potato chips, spaghetti, and rolls of plastic Baggies; requests from American sannyasins who were living in India.

Even in the midst of all the airport noise and confusion that morning, I had the sudden strange feeling that I'd arrived home finally after lifetimes and lifetimes. I had all I could do not to throw myself down on

the runway and hug the earth: Mother India. It wasn't a place I'd ever imagined myself visiting until recently, but there it was: home.

A tall, bearded Sikh in orange clothes and a bright orange turban embraced me the minute I passed through customs, our clothes and *malas* instantly identifying us to each other. "How is my good friend Chaitanya?" he asked, leading me to a waiting taxi.

As we drove through littered streets that were teeming with people, everything seemed oddly familiar to me. The smell of cow dung and human excrement in the air; the heartbreaking poverty; lepers, beggars, deformed children in filthy tattered rags; cows slowly ambling along the road or lying on it, traffic veering around them. Women in faded cotton sarees and men in draw-string pajamas shouted to each other in sing-song voices while the driver of every vehicle (from trucks that belched out streams of black soot to Ambassador cars and taxis, bullock-drawn wagons and the ubiquitous bicycles that weaved their way around every obstacle) seemed to have his hand permanently on his horn; the sound was deafening. I could hardly hear my amiable Sikh companion as he babbled away to me goodnaturedly.

"What's that?" I asked as the taxi drove slowly past a funeral procession, the dead body, blanketed by a profusion of flowers, passing so close to my window that I could have reached out and touched it. I nodded solemnly at a crowd of scantily-clad, emaciated men, their faces grotesquely painted in bright colors, who were leering into the taxi window, grinning obscenely at me, red juices dripping down their mouths. "They're not all spitting up blood from TB, are they?" repelled, despite myself, by what looked like an epidemic of bleeding gums, but that I knew couldn't be.

"They're chewing *paan*," my effusive companion laughed heartily. "Betelnut mixed with various things. Sometimes narcotic, usually not; it's innocuous. Very good for the digestion, some of it. You'll have to try it, Satya-ma-ji."

As we approached the center of the city, the rusty tin shacks along the road with their cardboard/movie-poster roofs were replaced by seedy lowrise buildings and tiny, cramped storefronts; and further on, by tall, modern skyscrapers. "Look, Satya-ma-ji!" my escort suddenly exclaimed, pointing proudly to a luxury highrise building. "Bhagwan's apartment! Woodlands!"

I was stunned. I'd expected our taxi to continue through town to the outskirts of the city where Bhagwan lived quietly with a few disciples in a secluded woodland retreat. Then, a moment later, I was amused. Who was I to know how or where a spiritual Master would live? Woodlands was perfect for Bhagwan: my first expectation of him nipped in the bud.

An hour later, freshly showered and dressed in a floor-length orange robe I'd borrowed from another sannyasin, I walked the two blocks from my hotel to Woodlands. Even in the affluent Malabar Hill district of Bombay, the sidewalks were as congested as a subway station at rush hour; there were beggars everywhere, and it was a relief to finally reach the spacious, three-bedroom apartment where Bhagwan and several close disciples lived. Shelves of books lined every wall in the huge reception area while sparse modern furnishings, a sky blue carpet, and a huge picture window that looked out on well-manicured lawns gave the place a feeling of expansiveness after the claustrophobic intensity of the streets. The apartment was quiet and peaceful, a tasteful refuge.

"He can't see you till this afternoon," Bhagwan's secretary Laxmi told me after she'd greeted me with a warm smile, her dark eyes twinkling. An effervescent woman in her early forties, Laxmi was as tiny and perky as a nine-year-old. "It's better that you wait," she said. "Let your energy settle. The plane ride...," her nose wrinkling in disgust. "So dirty! His allergies. The smells aren't good for Him." I could hear the capital "H" in her voice as she spoke.

I nodded understandingly, giddy with excitement just to be in Bhagwan's apartment. I couldn't keep still: dancing, laughing, twirling around the room; I felt like I was drunk.

As the buzzer on Laxmi's desk rang, she scurried down the long corridor to Bhagwan's room like a tiny, orange-robed Disney mouse, her matching shoulder-length head scarf flying in the air behind her. Two minutes later, she was back again. "You go now," she told me, laughing as I danced my way out the apartment door. "No, ma. Into Him. He wants to see you."

Bubbling, ecstatic, I skipped and twirled my way down the corridor, not feeling the least bit shy or hesitant the way I'd expected to be, devoid of my usual self-consciousness and timidity. As I reached out to open the door, all my exuberant energy rushed inside me. I began vibrating, tingling; I could hardly move.

Half-dazed, I entered Bhagwan's large, stark room with its single bed, chair, and table-height bookcase, its bare linoleum floor. Sitting in an armchair beside the window, dressed in a simple white robe, one leg crossed over the over, Japanese sandals on his feet, Bhagwan looked exactly like what God would look like if there was a God and He chose to look like someone. I was dumbstruck; spellbound.

"Come, Satya," he chuckled, motioning me towards him with a graceful gesture. What little hair he had was black, his beard was black, he

was awesomely beautiful; he could have been Hollywood typecast as the perfect guru. "I've been waiting for you."

Running towards Bhagwan eagerly, surprised at my sudden desire to prostrate myself in front of him, I knelt down shyly instead, touching my head to his feet as if it was something I'd done a thousand times before.

"Your flight was good?" he asked convivially when I finally lifted my head and sat up; then he asked about my children, Chaitanya, and various other sannyasins, murmuring, "Hmmm?" continually; he could hardly hear my mumbled responses. My voice sounded intrusive to my own ears; I could barely speak. I felt like I was in a church, a temple: a holy place. I wanted to sit silently beside Bhagwan and gaze into his eyes, or close my eyes and imbibe him through the air. The energy that was running through me was amazing. I felt like a thousand volts of electricity had been shot through me, like I was making love. Every sensation seemed heightened as if I were existing on twenty different levels of reality at once, all ecstatic.

"How long you will be staying?" Bhagwan asked kindly.

Forever, I wanted to say, forgetting about my children, my career, Chaitanya; not wanting anything in the world but to be there with him. I finally understood what people meant when they said they were in love with Bhagwan. If he let me, I'd follow him to the ends of the earth.

"Hmmm?" he asked again when I didn't answer; my vocal chords wouldn't work. "Good, Satya," looking at me lovingly, laughing. "Very good."

As I bent forward to touch his feet, our meeting obviously over, he patted me gently on the head and the whole world disappeared: him, me; my thoughts and feelings; nothing but bliss existed. I was nothing and everything; there wasn't any "me" anymore. I didn't feel blissful: I *was* bliss.

Holding on to the corridor wall for support, the body that was no longer "mine" made its way back to the reception room and, melting, sunk to the floor, my back resting against one of the glass-enclosed bookcases. Oblivious to everything around me, eyes closed, totally absorbed in myself, tears of joy streamed down my face, enough tears to bottle and send home to my children: souvenirs of India.

ತ

Taken in immediately as one of the family at Woodlands, I was given special privileges, watched out for and taken care of. No matter how often I asked to see Bhagwan, Laxmi always managed to squeeze me in. I went into his room once or twice a day, a unique privilege that no one

else but Vivek (a young English girl who lived in the apartment) seemed to have. While Bhagwan humored me with his endless patience, Laxmi and the other Indian sannyasins made sure I was never far from his side whenever it was possible to be near him.

"Be here early tomorrow morning," Laxmi told me as I was leaving Woodlands on my second night in India. "Come before the doors open so a good seat can happen, okay? Thousands will be coming from all over India for His birthday."

By the time I got to the apartment the next day, dressed in one of the long, loose robes I'd had made overnight and wore with little variety for the next seven years, the place was transformed beyond recognition. The walls were covered with mosaics of intricately-woven flowers patterned into designs of great complexity. Musicians sat on the raised stage in front of the picture window playing sitars, harmoniums, and veenas while dozens of Indian sannyasins in brilliant, gold-embossed silk sarees and *kurtas* conversed excitedly with one another. The doors wouldn't officially open for another hour, but the apartment was already half full, the energy in the room electric.

I sat down in an empty space near the front, closed my eyes, and immersed myself in the vibrating energy around me. It wasn't long before the room was filled to overflowing with the tightly-packed bodies of everyone who had been lucky enough to get inside. As Bhagwan emerged from the bedroom he rarely left—passing slowly through the singing, dancing crowd; *namastē*ing everyone; smiling; a calm, serene presence in the middle of the chaos—the mood in the room suddenly grew more impassioned. He sat down gracefully in an armchair on the stage, surrounded by musicians, singers, and a few privileged sannyasins, and began to greet the endless stream of people who had lined up to receive his blessings, hypnotic insistent music playing in the background.

I couldn't take my eyes off Bhagwan, awed by how beautiful he was. Every time he looked at me, my body began to shake violently. Before long I was laughing and crying like everyone else, singing *kirtan* songs I'd never heard before.

Yet all the while, a small cynical part of me remained unmoved: I found the hysteria in the room ridiculous. As I watched, appalled, scores of people passed out in front of Bhagwan and were carted away. The whole thing was bizarre, outlandish; frightening in a way. Only Bhagwan's calm, accepting presence made it seem all right.

"You wish to go up, Satya?" a lovely Indian woman whispered in my ear, crouching down beside me. "It will be finishing soon."

Nodding, I got up unsteadily to my feet and joined the line of people who were waiting to greet Bhagwan. Standing in front of him finally,

namastéing, the energy in the room at a peak as the festivities ap-
proached their end, I suddenly felt my mouth stretch in an overjoyed
grin that was so broad it made the muscles of my face ache. Kneeling
precariously, I touched my head to Bhagwan's feet. I wasn't going to
faint. I absolutely wasn't.

The next thing I knew, comatose but conscious, someone was carrying
me out of the room on my back, above people's heads.

Later that day, back down to earth again finally, I began to feel con-
temptuous of the celebration. It had been nothing but group psychosis,
mass hysteria, an orgy of excess; a cheap, crass mockery of devotion. I'd
seen people laying money at Bhagwan's feet and handing Laxmi small
silk envelopes that obviously contained rupees. My own reactions had
been tricked into me by the atmosphere; I'd been conned into bliss. What
a scathing, glib magazine article I could write about it!

"He is saying, does Satya want to write an article about the celebra-
tion for the next *Sannyas* magazine?" Laxmi asked innocently a moment
later as I sat on the sofa beside her desk thinking my heretical thoughts.
"If you're wanting to do it, ma, it will be beautiful, isn't it?" laughing
gaily as she handed me a cup of the sweet milky *chai* (Indian tea) that
was a Woodlands specialty.

My article turned out to be gushingly worshipful in the extreme. Not
just because it was what was obviously expected; I wasn't lying as I
wrote it. Sitting in Woodlands that day writing, the ecstasy I'd felt dur-
ing the celebration filled me again. It seemed like the only reality there
was. My cynicism was just my mind, my conditioning; an old habit.

જ઼

Several days later, I was asked to interview Bhagwan's cousin for an-
other *Sannyas* article. A somber-faced woman in her early forties who'd
been living with Bhagwan since his college days, Kranti had apparently
been "difficult" for a while, intensely jealous of the western women who
were coming to Bhagwan. He'd finally instructed a young Indian disciple
to be with her. ("When the Master says," the young swami confided
sheepishly to me one day, "one must do. It is a great gift, no? His own
cousin! The sharer of his bed all these years!") It had obviously helped.

With her boyfriend as interpreter, the three of us sitting crosslegged
on his narrow bed in the crowded bedroom he shared with three other
swamis next door to Bhagwan's room, I interviewed Kranti about the
night that Bhagwan, at the age of twenty-one, presumably got enlight-
ened. It was the beginning of a new phase of Bhagwan's work, my arti-
cle the first public acknowledgement of his enlightenment.

While the concept of enlightenment, Buddhahood, Christ-consciousness (becoming the ultimate perfection of yourself: totally one with existence, totally aware, egoless) is hard for most westerners to accept, it was something I seemed to understand intuitively. "What's wrong with having a goddamn ego?" my friend Mary would yell at me angrily whenever I tried to talk to her about Bhagwan. "You spent thousands of dollars on a therapist trying to build up your ego and now you don't want to have one? Egoless? If you ask me, your guru has the biggest fucking ego I've ever seen! Wearing his picture around your neck! I ask you!"

Yet there was clearly something special about Bhagwan. He exuded love; his power and charisma was astounding; something extraordinary happened to me whenever I was with him. Fifteen years later I still don't know how to account for the stoned, blissed-out feelings he evoked in me and thousands of others. To call it hypnosis is to miss the point. Utterly at peace, more than myself, he seemed to bring me up to his level till I felt as if I were enlightened, too.

If a Buddha or Christ existed once, I didn't see why he couldn't again. To Bhagwan, we were all gods and goddesses in exile, Buddhas and Christs, waiting to get rid of the social conditionings that prevented us from realizing it. He was an example of what we could all become. "Surrender and I will transform you," he proclaimed, as Masters had throughout the ages. "This is my promise."

ả

Long before the three weeks I was scheduled to stay in India were over, I knew I had to extend my visit. I needed to be near Bhagwan while I learned to spread my wings, fly, soar, so I'd be whole and strong when I returned home again. Meditating intensely three times a day— crying, laughing, freaking out and blissing out, staring blindly into space for hours, healing myself and being healed—was so compelling that even how my children were doing without me seemed very far away most of the time, another world.

When I phoned home to ask if it was all right to extend my trip, Danny said to stay as long as I wanted, the kids were doing great, while they assured me they were having a wonderful time: "Stay if you want, Mommy." I didn't prod any further: I wanted to stay.

ả

The most unsettling thing to me about my day-to-day life in India was my contact with the hoards of beggars I saw everywhere.

"I hate them!" I finally cried to Bhagwan one day in anger and frustration. The runny-nosed urchins who stuck the stumps of their amputated limbs in my face, the lepers, blind children, and legless men on wheel-carts who'd filled me with pained compassion when I first arrived soon enraged me, their sheer numbers overwhelming me, the hopelessness of helping them. No matter how many rupees I stuffed into their cups, hands, and stumps, it was an ocean of such decrepitude that my money quickly disappeared, barely making a dent at what was needed as more beggars demanded money from me, wheedling and cajoling, not letting me pass them on the street till I searched my robes for one last ten-*paisa* coin that they'd throw back at me, disgusted; it wasn't enough. I couldn't eat a meal without feeling guilty, couldn't buy an ice cream or a bar of chocolate, the presence of the beggars a constant judgement and affront. "I hate them, Bhagwan! I hate them!"

"Good," he chuckled. "Go on hating them, Satya."

"But you don't understand," moaning in despair. "I don't *want* to hate them. I feel sorry for them. I want to help them."

He gave me a technique: to take a pillow and imagine that the pillow was the beggars. "Beat the pillow," he said. "Destroy it. Kill all the beggars. It will be helpful."

And it was and wasn't. No matter how much I killed the beggars in my mind, they still existed. The Indian sannyasins tried to teach me how to handle them, giving them money only when I wanted to, dismissing them with a flick of the hand ("*Chello, chello!* Go, go!") when I didn't, but I couldn't do it. At best I learned to make friends with some of them as I passed them at their habitual posts on the street early every morning after Dynamic, *namasté*ing, bowing my head, nodding, and smiling as they *namasté*d back. If they saw me later in the day, I knew, they'd hustle me as much as they did anyone else, but in the early morning hours we greeted each other with gentle reminders of our shared humanity.

�

Whenever I wasn't meditating, eating, or sleeping, I spent my time in Woodlands with Laxmi and Vivek, the young English woman who was clearly one of Bhagwan's favorites and had quickly become a close friend. When Laxmi was busy with visitors, and Vivek with Bhagwan for one of her long, twice-daily sessions, I sat by myself in front of the picture window, eyes closed, and tuned into the vibrating energy that had been alive inside me ever since I got to India.

"At first it was mostly business people who were interested in Him," Laxmi told me one morning as she sat at her desk drinking *chai,* her tiny legs tucked underneath her. The reception area was empty except for us; most people preferred to come to the apartment in the afternoon when it was unbearably hot outside. "As Laxmi sees it," calling herself, as always, "Laxmi" instead of "I," "some of them still want Him to be a political leader. But this is the fun of it, isn't it?" grinning impishly; I adored her.

"Bhagwan a politician?!"

Laxmi laughed at the incredulous expression on my face. "But the way He used to talk, ma! You should have heard Him!" Bhagwan's eyes and ears into the world, and the arbiter of everything that happened around him, Laxmi was an inexhaustible source of gossip about "the early days." "For twelve years, while He was a philosophy professor," she said. "He lectured everywhere on politics and religion, religion and politics. Always going, going: traveling, lecturing, pushing the people's buttons. Everyone was either for or against. To be indifferent was impossible!"

When I asked her why Bhagwan decided to give people sannyas, she was shocked. "It wasn't a decision, ma. It was a happening. It started at his first meditation camp. He didn't initiate or encourage. People just began calling themselves disciples."

"And you?"

Laughing gaily, Laxmi told me that she'd been a strict Gandhian for years. "Wearing white all the time like Gandhi-ji. Living with the family in a big house, very rich, and weaving all the clothes by hand. Such hypocrisy!"

"Were you married?"

"*Laxmi?*" Years later when I asked her if she'd ever had sex with anyone, she nodded solemnly. "We tried it once," she admitted. "We didn't like."

When her brother dragged her to a lecture of Bhagwan's one evening, the ascetic little Laxmi fell in love with the so-called sex guru and Gandhi was dropped on the spot, dismissed.

"Laxmi was the first to wear the orange," she grinned proudly. "After the first meditation camp, eating stopped. No clothes could be worn on the body. Staying-in-the-room-only happened. We tried every color to see if something clicked. Then we tried the orange." She wore the same orange outfit every day, the same matching scarf over her head; still an ascetic in her own way.

"Laxmi went to the train station to meet Him," her tiny face lighting up at the memory. "He was going somewhere to lecture. Laxmi was

going with Him to be the secretary. He saw the orange clothes and laughed. 'So Laxmi has become my first sannyasin,' He said. And like this, the whole game started!"

Over the years, Bhagwan's discourses had become increasingly more spiritual. Yes, he was a religious teacher, he finally admitted: enlightened. All I knew was that he was a master psychologist, a magician. And I was in love with him.

৯

The love wasn't romantic or sexual in the least though, despite my occasional hope that it would be. When Chaitanya warned me before I left for India not to expect anything to be the way I thought it would be, I assumed he was talking about something sexual (didn't all Indian gurus make love to their disciples???), but Bhagwan seemed totally asexual to me. Only ten years older than I was, he seemed as ageless as an old sage who'd been around since the beginning of time. Despite his insistence in lectures that sex be explored to the fullest ("Sex is the seed, love is the flowering, and God is love!"), there was something virginal about him.

"Sex drops spontaneously when one experiences something higher," he said. "If you're holding pebbles in your hand and someone offers you diamonds, you drop the pebbles. It's not a renunciation, a sacrifice," describing enlightenment as a constant state of orgasm. I thought of him often as a tantric Master: "working" with sexual energy, teaching techniques that use sex as a path to God; but I couldn't imagine him having sexual needs. While there were vague rumors that he'd had sex with numerous sannyasin women (I even heard he made love to young Scandinavian boys!), it sounded more like people's fantasy than a reality.

A wealthy Indian woman whose home I moved into after I'd been in Bombay a week told my young Brazilian roommate and me repeatedly that Bhagwan "gave energy" to all the western ma's, "giving energy to" obviously being the Indian euphemism for "having sex with." When my roommate finally asked Bhagwan tearfully why he hadn't made love to her yet, he asked her what she was talking about, laughing delightedly when she told him.

"I have to give my Indian ladies something to gossip about," he chuckled. "They love gossiping. You do one thing, hmmm? Tell everyone I gave you energy today. Anything you want to say, you say. Fantasize. Make a good story out of it."

"I knew it!" our hostess/landlady shrieked excitedly later that afternoon when my roommate told her about the ecstatic experience she'd just had with Bhagwan. "The minute you walked in the door I could tell

he gave you energy today; I could feel it. You feel *exactly* like him!" getting a contact high as she hugged her, swooning in her arms. "Don't worry, Satya," she assured me. "Your turn will come soon. I'm sure of it."

It wasn't until a friend swore to me recently that she'd had sex with Bhagwan in Bombay that I realized the rumors about his sexual encounters with disciples might be motivated by more than idle speculation or jealousy. I'd assumed when I first arrived in India that Vivek "practiced tantric techniques" with Bhagwan when she visited his room for long periods of time every day, but when she told me he was a virgin, I believed her.

When I was alone in his room with him, he often touched my breasts playfully over my robe with his toes. My only reaction was to giggle; it felt like something a naughty little boy would do. Even when he knelt down beside me on the floor one day and touched my breasts with his hand and then moved down my robe till he reached my vagina, it felt as impersonal as if he were a doctor taking my pulse. I assumed he was checking my *chakras*: energy centers.

He told an Italian friend of mine in Bombay to lie on his bed and masturbate. He stood above her, watching, then calmly gave her various meditation techniques to do "to break through the blocks in her energy." After thirty-one years of burdensome virginity, the techniques changed her life totally. She began having lovers, falling in love finally, glowing with happiness.

When I first arrived in India, Bhagwan gave me a private meditation technique to do. With my eyes closed, I was to sit crosslegged on my bed and concentrate on my sex center while I repeated his name in my head. Looking back on it, it seems like an obvious attempt to direct my sexual energy towards him, but at the time it seemed perfectly natural: he was lecturing on tantra and the use of sexual energy on a spiritual path. If the technique had had any affect on me, perhaps I'd have had sex with him eventually as various other western women apparently did, but I found the recitation of a mantra (his name) more boring than stimulating.

After I moved into the wealthy Indian ma's house, Bhagwan gave me another tantric technique to do. For twenty minutes I was to "make love to myself" by caressing my body everywhere but my genitals; then, fully aroused, was to "allow the energy" to move to the crown *chakra* on top of my head. It wasn't to be masturbation, Bhagwan emphasized. After awakening my sexual energy, I was to use it to move into a state of meditation.

I had no idea how to "move the energy upward," though. Frustrated and horny, feeling like I had a gaping hole inside me that needed to be filled, I'd twist and turn and writhe on the bed, crying out for Bhagwan, Chaitanya, *someone,* to enter me. Desperate and enraged, I'd scream and cry outloud, not caring who heard me, till I'd calm down finally, "the energy" miraculously diffusing through my body, melting me. In an instant, I'd be floating blissfully off somewhere, lost in an exquisite nothingness.

Embarrassed and self-conscious, I finally told Bhagwan that I longed for him to enter me when I was doing the technique. It was probably my way of asking him to make love to me, but it was hardly an impassioned plea. Face to face with him, I didn't have any sexual energy. It's little wonder he ignored my offer.

"Hmmm," he murmured pensively as he closed his eyes. "Who you are friendly with?" he asked finally.

"Only Vivek, really." Laxmi hardly counted as a friend.

"No one else?"

I mentioned my roommate and a few other women, Bhagwan continually asking, "Anyone else?" till I finally realized what he was getting at. Were there any *men* I was friendly with?

"I wish Chaitanya was here," weepy-eyed suddenly. "I...."

"If he's not here," Bhagwan cut in sharply, "it's as if he doesn't exist. If you want to be here, Satya, be *here*; not living in your head, dreaming. There are any men you are friends with?"

When I reluctantly whispered the name of a German swami, Bhagwan chuckled, pleased. "He will be perfectly good. You be with him now."

That "being with" meant "being with sexually" was obvious. At any other time in my life I'd probably have been attracted to my gentle Jesus-look-alike German friend, but I wasn't now. The only time I had any sexual energy was when I meditated.

"Bhagwan says we have to have sex together," I told my friend that evening as we sat drinking yogurt *lassies* at a dairy bar.

He was as horrified as I was. Celibate for five years, he had every intention of remaining that way.

"I can't do it," I told Bhagwan the next day. "He's not even attracted to me."

"Seduce him then. He's ready not to be celibate. Help him."

Day after day, I explained to Bhagwan all the reasons why I couldn't do it, till he got angry finally, or pretended to be angry, telling me I couldn't see him again till I'd "done it." "You know how to seduce a man, Satya. All woman know how. It's just your mind that's saying no. Do it!"

My German friend and I went to an ashram in Lonavala for a few days and his premature celibacy came to an end; he soon had a multitude of new lovers. The experience had the opposite effect on me: I suddenly stopped longing for a man to enter me when I meditated. My energy could "move upward" more easily when I was alone, I discovered.

I didn't stop being sexual, quite the contrary, but I stopped being controlled by sex, learning to move my energy in any direction I wanted: meditation, sex, writing, work, or play. It was my choice to make suddenly. A whole new way of playing the age-old game.

*W*elcome back, ma," Laxmi greeted me breezily when I returned to Bombay after my brief trip to Lonavala. "Missing Him happened, isn't it?" she grinned. "Laxmi told Him the sparrow would be back in two days," clearly delighted at the accuracy of her prediction.

"Come on, child," she ordered cheerfully, jumping up from her desk and patting her shoulder. "On the back!"

"Huh?"

"Come on! Laxmi wants to show the sparrow how strong she is," hoisting me up and carrying me piggyback around the empty reception room as she gleefully bragged about how strong she was even though "the body" subsisted on nothing but *chai*, soda crackers, and cookies; she lived on her love for Bhagwan.

"Is Vivek inside?" I gasped when she finally let me down, both of us breathless and giddy. I collapsed on to the sofa beside her desk.

"Five, ten more minutes she'll be in there," she nodded as the phone rang. "Can you wait till this afternoon to see Him? It will be time for His lunch when she comes out," and picking up the phone, she switched automatically into Hindi as she answered.

As Laxmi chatted away incomprehensibly, I closed my eyes and tuned into the humming, alive energy inside me. It wasn't long before I felt Vivek's pulsating presence beside me. Her energy always felt exactly like Bhagwan's to me after she'd been with him. She had almost the same effect on me sometimes as he did. I could have sat silently by her side forever.

"I'm so glad you're back!" she squealed as she leaned over to hug me, a rare gesture for the normally reticent Vivek who was very proper and

English with everyone but me. I reminded her of her only childhood playmate, she'd told me once. I assumed it was why we were friends.

After a month of knowing Vivek, I was still fascinated by her. Delicately beautiful, with long, silky auburn hair and creamy white skin, she was as silent and still as a sage, ethereal, not really "there" somehow. She'd sit and stare into space for hours at a time, then suddenly tune in again and want to gossip and play, shifting from one gear into another without a moment's notice.

"Did you 'do it'?" she asked me animatedly. I had no secrets from her. When I nodded, she burst out laughing, her dimpled face crinkling with delight. "Tell me everything!" she insisted, and before long we were giggling together like teenagers, comparing notes on our various lovers of the past, neither of us ever having been particularly promiscuous.

"That phase of my life is finished now, though," she remarked earnestly; she was all of twenty-three. "I'm through with men now that I'm with Bhagsie." She was sure she'd be with him forever, she said, even though she'd almost dropped sannyas a few months ago when she returned to India for the second time.

Feeling rebellious and cut off from Bhagwan, hating orange clothes, refusing to wear them, she'd been at Woodlands one day when he sent a box of chocolates out to her in the reception room. Furious at what she considered an attempt to manipulate her, she stormed down the corridor to his room, opened his door, and threw the box of chocolates at him. It was unheard-of, not even Laxmi went into his room without being paged, but he laughed, loving it, and before long Vivek was taking care of him more than his cousin Kranti: nursemaid and housekeeper, companion and shadow. Despite her obvious love for Bhagwan, she seemed less in awe of him than anyone else. I suspected it was part of her charm for him.

"I mean," she was telling me now, lowering her voice and talking in a hushed, reverential tone, "if I can have an orgasm just sitting next to him during *lectures*, why bother?" When Vivek finally took a lover years later, everyone was shocked. She'd been a vestal virgin for so long, guarding the portals of the temple, Bhagwan being the temple.

"Are you seeing 'B' this afternoon?" she asked as I got up finally to leave for lunch.

"I don't know when, though," nodding.

"I'll see you after, okay? I have something to give you. A dress Bhagsie designed for me. I got too fat to wear it."

I laughed. Bhagwan had tapped me on the buttocks a week ago and told me to put on some weight: "We Indians like more fat on our women!"

By the time I got back to Woodlands that day, showered, shampooed, and changed for my appointment with Bhagwan, Vivek was inside with him again and the apartment was slowly filling up with the afternoon rush of people. Laxmi was buzzing around like a mother hen, in twenty places as once: answering the phone, answering visitors' questions, philosophizing endlessly. I sat in front of the picture window and closed my eyes, breathing slowly and evenly, feeling more than thinking.

"Satya? Now, ma!" Laxmi called out suddenly. I scrambled to my feet, smoothed out my long, loose robe and hurried down the hall as Vivek emerged from Bhagwan's room carrying his tea tray. She smiled, not saying anything, as he called to me to come in.

"Your trip was good, Satya?" he asked after I'd touched my head to his feet and was sitting up again. "You are glad to be back, hmmm?"

"Very, Bhagwan. Yes."

"Everything was good?" I shrugged, not knowing what to say. "Tell me."

But I couldn't, not yet; and instead, avoiding what was on my mind, I told him about my disastrous sexual experience the night before. *German soldier*, I'd written on the train coming back this morning / *your sword was made of rubber.* / *I have never fucked a corpse before....*

"He lay there like he was dead," I murmured self-consciously. "I couldn't believe it when he had an orgasm. I didn't even think he had an erection."

Bhagwan chuckled. "A time will come when you will make love as if you are a corpse too, Satya. Not moving. Perfectly motionless. Only then will sex reach it's ultimate peak."

It was seven years before I finally understood what he meant. At the time it sounded ridiculous. I didn't know why anyone would ever want to make love like that. It didn't sound like much fun.

"There was something else you wanted to tell me, hmmm?" he asked as if he knew perfectly well there was. I wondered for the umpteenth time if he could tune into his disciples telepathically, if he'd tuned into me two nights ago.

"It happened the first night we were away," I stuttered as the memory/experience came rushing back to me. "I was.... We were...," crying, I couldn't go on. I lowered my head to my lap, sobbing.

"Hmmm, tell me."

It was minutes before I could bring myself to speak. "I'm so sorry, Bhagwan," I sobbed finally. "I didn't want to do it, I really didn't. Will you ever forgive me?"

"There's nothing to forgive," he said kindly, taking my snot-wet, tear-

wet hand lovingly in his and stroking it. "You're not responsible for something you did twenty years ago," continuing as if he knew exactly what I was talking about, "so how you can be responsible for something you did twenty lifetimes ago? A child is not responsible for his actions. Only when you become conscious, aware, are you responsible for your acts."

I lay my head on his lap, crying despondently; remembering what I'd remembered.

I'd been sitting on an army cot in the bare, tiny room my German friend and I were staying in. He was sitting crosslegged on the floor, his back to me, singing *kirtan* songs to a picture of Bhagwan, the tin foil wrapper of the candy bar beside him barely visible in the dim candlelight.

Suddenly I wasn't in Lonavala anymore; I was somewhere else. A holy man, his back to me, was sitting by the side of the road meditating, his small bundle of possessions beside him. I was a young boy, standing with a group of older boys a few yards away from where the holy man sat.

My brother-of-then thrust a knife into my hands. "Do it!" he commanded, his hating, blazing eyes glaring at me. "Now!" But I didn't want to. The holy man—no!

Suddenly I was alone on the road. No longer one of the circle of boys. Chosen. Me! The knife was in my hands. In the dim light I could see the fiery, angry eyes of my brother compelling me. I was terrified, more afraid of my brother's eyes than of what I was about to do.

Tears pouring down my face, I raised the knife above my head, my hands shaking violently. The holy man was sitting on the ground in front of me; I could feel his shawl against my leg. To the right of him lay the meager, pitiful treasure I was about to kill him for, something I didn't even want.

There's nothing to be afraid of, I told myself. All I have to do is do it. He won't try to stop me; he doesn't care.

My arms descend, the knife descends. I'm stabbing him again and again. And suddenly—oh god, no!—I recognize this holy man from some lifetime before this; when he cradled me in his arms, when I sat at his feet and played.

Dear god, what am I doing? My god, my god, what have I done?

I look down at my hands. They're covered with blood. I'm crying profusely. My German friend is still sitting there singing, oblivious to what's happening to me. I'm in a room in Lonavala with him; I'm somewhere else, hundreds of years ago.

I can't stop crying. My hands are covered with centuries-old blood, the memory of murder still in them.

It could have been any holy man, it could have been a dream, a metaphor, but I was sure it was Bhagwan. In a lecture soon afterwards, he talked about his last life seven hundred years ago. A holy man, he'd been murdered as he sat along the side of the road meditating. "It's good I was killed," he said in what I was sure was an attempt to assuage my guilt. "Otherwise I'd have been enlightened in three days; that would have been my last life; I wouldn't be here now. You should feel sorry for Judas. Judas acts in the service of Jesus; he's Christ's instrument."

But no matter how readily Bhagwan forgave me, it was years before I forgave myself. "Forgive me, Bhagwan. Please, forgive me," I pleaded over and over again as I lay my head in his lap crying and he patted me on the head, comforting me.

I had no idea if past lives were memories of previous incarnations or metaphors for something else: waking dreams with hidden messages. All I knew was that memories I couldn't account for were coming up in me with a vengeance these days. Remembering things I had no way of knowing, places I'd never visited, people I'd never met was as bewildering as it was fascinating.

Being with Bhagwan was like being on another planet. The charismatic power of his presence, like his eclectic meditation techniques, made me as stoned as any drug. Every thought seemed like a revelation, every word or gesture seemed filled with a multitude of meanings as if I'd said and done the same thing hundreds of times before in different lifetimes and contexts. There were so many levels of reality to every casual act, random conversation, or meditation "memory" I had that doing nothing was an all-consuming preoccupation: sometimes blissful, occasionally frightening, always intense.

ॐ

It was 10:30 before I realized it was time to leave Woodlands that night. Laxmi had already left. The apartment was quiet.

"It's silly to leave when it's so late," Vivek said casually. "Why don't you sleep over? It'll be so much fun. Please!"

"You sure it's okay?" I asked skeptically; I'd never heard of anyone sleeping over before; but she was positive. Bhagwan had told her to invite me.

While I never moved all my things to Woodlands, I never slept anywhere else after that, living with Vivek in the crawlspace under the

raised floor in the reception room. As Vivek took over more of Kranti's role with Bhagwan and became increasingly more isolated from the rest of the world, she seemed to need a friend; and with Bhagwan's obvious encouragement, I was it.

When I eventually stopped seeing Bhagwan every day, Vivek remained a daily avenue into him for me, asking him questions for me constantly, bringing me constant messages from him. Laxmi was everyone else's avenue into Bhagwan. Vivek was mine.

٭

"It's time to get up for the meditation," Ravjiv's* soft Indian voice whispered as he scratched on the window along the wall above my bed, trying to wake me up without disturbing Vivek, whose mattress lay on the ground six inches away from mine. "It's almost 5:30; we're late. Are you coming, Satya-ma?"

"Yes," whispering softly. "In a minute."

Lifting myself cautiously over Vivek's body, I crept to the stairs on all fours and climbed out of the cramped crawlspace we shared with musty trunks, piles of books and stacks of folded chairs. Ravjiv, one of the Hindi editors of Bhagwan's books, a slight, scrawny, boyish-looking accountant in his mid-twenties, sat on the couch in the foyer waiting to lunge at me as I raced towards the bathroom near Bhagwan's room. "I made mistake," he whispered hoarsely, grabbing my hand and trying to pull me down with him. "It's only five o'clock. We have plenty of time."

Ravjiv's hands were all over me, his attempt to "cop a feel" (as they said in my high school, but undoubtedly not in his south Indian village) was more pathetic than alarming. "Ravjiv!" pulling away from him abruptly, annoyed. "I could still be sleeping! I wish you wouldn't do this every morning!" Apologizing sheepishly, he returned to his room.

"If Bhagwan tells me to be with Ravjiv," I'd warned Vivek a few days ago—not taking any chances; he wasn't my type at all— "I'll leave India. Tell him that for me, will you? In case he's thinking of suggesting it." Meditation used up all my energy anyway. In the environment of the notorious sex guru, sex seemed like the most irrelevant thing in the world.

It was still dark at Chowpatty Beach an hour later as Ravjiv and I walked gingerly over the sand, trying not to step on the human excrement that lay scattered about, or trip over the bodies of homeless families who huddled together under flimsy blankets, bony limbs entwined. Most of the twenty-some-odd meditators who'd gathered for Dynamic

were Indian, and, at Ravjiv's announcement in Hindi, we all blindfolded our eyes and began breathing, our thunderous snorts breaking the early morning silence.

Long before the breathing stage was over, I was lying on the sand kicking the air with my feet, flailing my arms frantically, screaming, crying, shouting: "No, no! Get away from me! Stop it! Stop it!" I fought the air, growling, memories coming up in me too fast to catch hold of. Scrambling to my knees, retching, convulsing, vomiting, I covered my mess furiously with my hands, hiding my shame. My nose was running; my face was covered with the outpouring from my eyes, nose, and mouth. I blew my nose noisily on the hem of my skirt, leaving a sticky mess behind.

Sitting crosslegged on the sand, weeping like a helpless abandoned child, my right hand began slowly caressing my left upper arm. "I want my baby back!" I sobbed. "I want my baby back! Please, please," pleading desperately. "I want my baby back!"

"*Hoo!*" the other meditators began shouting. "*Hoo-hoo....*"

Jumping to my feet, forcing myself to shout as loudly and intensely as I could, nonstop ("*Hoo-hoo-hoo!*"), it wasn't long before I was singing the sound, laughing, twirling around like a dervish, anguish miraculously transformed into hilarity. "*Hoo*—oh, god—*hoo!*" It was ecstasy; it was uproariously funny; it wasn't serious at all. "*Hoo*"—laughing and laughing—"*hoo*" until, exhausted finally, I fell to the ground and lay there absolutely still. Meditation "happened." There was no way for it not to happen. Bliss without words.

No matter how many times I told myself that my children were all right, dealing with the pain of missing them by talking about them constantly, writing them, sending them stories that Vivek and I made up, my sense of loss at not being with them surfaced agonizingly whenever I meditated. Re-experiencing lifetime after lifetime of losing them in pogroms and on the battlefield, through suicide and murder, a long history of the most devastating loss imaginable, the pain was excruciating. If I was chosing to lose my children this time around—doing it *my* way, not leaving it up to fate—my anguish was no less real because of it.

"I miss my kids so much," I sobbed to Bhagwan when I couldn't take it anymore, tragic dreams haunting me at night when I slept, fears masquerading as memories that I prayed weren't premonitions. "I can't stand being away from them. I don't know what to do."

"If you want to go back," he said calmly, "it's perfectly good. You go."

But I knew I didn't want that either. I wasn't ready to leave yet. I just wanted Bhagwan to take the pain of it away. To promise me my kids

were okay, take the responsibility of my choice away from me, absolve me.

"Their father loves them?" he asked finally. I nodded, wiping my eyes on the back of the hand that desperately clutched his hand. "He's a good father? He's happy to have custody?"

"Yes," softly.

Bhagwan closed his eyes, silent, tuning in, then looked at me lovingly. "There seems to be no problem, hmmm? If they're happy with their father and he's happy about it, let it be. You be here for awhile longer, hmmm? It will be good."

"But, Bhagwan, I...." He stroked my hair, my head resting on his lap. *I want my baby back*, I cried silently. I wanted Bhagwan *and* my kids; I wanted everything. "Greedy bitch!" Danny called me even though I'd never asked him for a penny. He was right. *Please! Please! I want my baby back!*

By the time I left Bhagwan's room that afternoon, my anguish had all but disappeared. He seemed to drain it out of me. It seeped away, oozing out, as he patted my head gently, saying, "Good, good. Everything is good, Satya." Lying on my mattress afterwards, exhausted, spent, all thoughts disappearing from my consciousness, I felt calm and blissful, vibrating with energy, at peace.

Bhagwan's look and touch, the unconditional love he exuded, seemed to change the negative into the positive, my fears into insights, pain into acceptance. And slowly, day by day, all my self-condemnations and judgements dissolved. For the first time in my life I was glad to be me and grateful for everything that had brought me to where I was: Bhagwan.

*H*urry, Satya. If you don't go quick you'll be late," Laxmi warned as she rushed down the corridor from Bhagwan's room and raced down the stairs to start the engine of his orange Impala; he was beginning a series of public talks in Hindi that evening at a park in town. As I ran to catch a taxi, Laxmi drove slowly past me; Bhagwan *namastéing*, Vivek waving and grinning, Kranti ignoring me. Half-wondering if I'd be offered a ride, it didn't surprised me when I wasn't. A cab pulled up beside me a moment later, three Indian sannyasins I'd never seen before motioning to me to get inside, our orange clothes and *malas* all the introduction we needed. The cab quickly sped past Bhagwan's car on the road.

"What's happening?" I asked in dismay a few minutes later as we approached the park, the taxi weaving its way though a crowd of angry protesters who were carrying placards and shouting what were obviously obscenities.

"Five, ten groups, many religious groups, have vowed to kill Bhagwan," one of my benefactors answered good-naturedly as we got out of the cab near the front of the area that had been cordoned off for the lecture and pushed our way through the crowd looking for seats. "Everyone's against our Bhagwan," he grinned. "Muslims. Hindus. Christians. Buddhists. If Jainas believed in killing anything, they'd want to kill Bhagwan, too."

"But *why*, swami?"

"For a religious man in India not to condemn sex," the man snorted dismissingly. "They can't stand it. They'd rather kill Bhagwan. This is our so-called Indian morality."

"Satya-ma-ji, come!" I heard Ravjiv's voice suddenly calling to me

from the stage a few feet away. "A seat has been saved for you," his long, bony arm reaching out to grab me. "In the front, next to where Bhagwan will be. Go on," he insisted when I hesitated. "A shawl is there for you to sit on."

My momentary pang of guilt mitigated by gratitude, I tiptoed past the mostly-western disciples on stage and sat down next to Vivek's cushion. Tens of thousands of Indians, a sea of dark, expectant faces, were squeezed tightly together on the ground below, more people than seemed humanly possible in the space available. Only a few of them were sannyasins. Bhagwan's public lectures attracted as many of the curious as the devout, all of them waiting to be prodded, amused, and outraged by his audacious unorthodoxy.

"He uses everything," Laxmi had told me once. "The minute He talked about sex, like that," snapping her fingers, "half the false ones left. We bought the Impala for Him," snapping her fingers again, "more rubbish gone," she laughed delightedly.

I didn't understand a word Bhagwan said that evening when he spoke, but it didn't seem to matter. As mesmerized by his eloquent hand gestures as I was captivated by his voice, I sat silently beside him, filled with bliss.

It was the first time I'd ever seen Bhagwan in anything other than a long, white turtleneck robe. Bare-chested, he wore a white *lunghi* wrapped like a skirt around his waist and a white shawl over his shoulders. Every time the shawl slipped, I swooned as if he was making love to me. My body began shaking and tremoring, tears pouring down my face, as minutely detailed memories of the two past lives I remembered having with Bhagwan came back to me. No wonder I felt so at home in India. I'd spent lifetimes there.

When the discourse ended and Bhagwan got up to leave, someone placed a necklace of flowers around his neck. Taking it off, he slipped it over my head as I stood beside him; dancing, singing, laughing.

Several minutes later, as I lay with my head on Bhagwan's cushion, off in another world, an announcement was made over the P.A. system that money was about to be collected from the audience to help defray the lecture costs. Whatever people "felt to give," they were told in both Hindi and English, they should now give. When a group of Indian sannyasins had collected donations at Bhagwan's last series of public talks, half the money didn't reach the lecture organizers, so Laxmi had enlisted several western ma's and a young Indian woman from the States to move among the crowd tonight with collection baskets. People were counted on to contribute what they could: from each according to his, etcetera.

As I fought my way reluctantly through the crowds, they fought their way towards me: tugging at me, pulling my arms, forcing money on me. My collection basket, hands, and pockets were soon full, but people kept begging me to take their money. "Take, ma!" "Take!" "Here, ma!"—looking hurt when I had no hands left to receive their offerings.

I'd never seen people so eager to give, even obviously poor people pressing crumpled rupee notes on me. It was frightening. I wondered if they were trying to buy Bhagwan's blessings, if "Take!" meant "Give!"

"It was fun, ma?" Laxmi asked when I got back to Woodlands an hour later, her face lit up with pleasure at the amount of money that had been collected.

"Fun?" I laughed hollowly, sinking to the couch, drained and shaken.

ॐ

A few days later, Laxmi asked me to ask the pretty young Indian woman who'd collected money with us that evening to help Vivek and me re-organize Bhagwan's library. Stylishly western after several years in America, Sheela had short-cropped, thick black hair, huge, dark eyes, and a dazzling smile. As friendly and boisterous as a puppy, I found her energy abrasive in the quiet tranquility of Woodlands, but Laxmi had asked me to make friends with her when she arrived: to find out what she was doing in America, how long she'd be in India, why she'd come to see Bhagwan (she wasn't a sannyasin), so I did. It was a thing I was asked to do often: to talk to people and report to Laxmi what I'd learned. It seemed like a perfectly natural thing to do; I never questioned it.

Sheela had known Bhagwan since she was a child; he stayed with her family when he lectured in Baroda. Her parents had sent her to college in America (where her brothers and sisters all lived), and she'd married a Jewish physics major from New Jersey. When Marc learned he had Hodgkin's disease and was given six months to live, Sheela came to Bombay to see if Bhagwan could cure him.

I couldn't help wondering what was so special about Sheela. Why Laxmi (Bhagwan?) wanted her to spend time with Vivek and me, giving her an excuse to hang around the apartment, be close to Bhagwan's energy. She didn't like Vivek any more than Vivek liked her. I couldn't imagine the two of them being together for five minutes.

"And talk to her about sannyas, hmmm, sparrow?" Laxmi added.

When Sheela arrived at Woodlands later that day, looking chic in tight jeans and an expensive shirt, Vivek was still inside with Bhagwan. "Come on, Sats," she said breezily, motioning to me with her hand and

an impatient tilt of her head, "let's go shopping. It'll be another hour before the old boy can see me. I wanna pick up some things for Marc. He'll be here in a couple of days."

As Sheela pulled me to my feet and dragged me out the door with her, it was obvious that it didn't occur to her that I might not want to go. That she wanted me to was enough. It was all that mattered. As we rushed from store to store, Sheela making rapid-fire purchases while she kept up a running conversation with me, she told me how much she loved America; she couldn't wait to go back. She didn't understand what I liked about India; she hated it. "Marc's health's the only thing that would keep me here," she said emphatically. "I can tell you that right now. I'm not gonna let him die no matter what those stupid doctors say." If anyone could save Marc's life, she was sure it was Bhagwan.

"Have you ever thought about taking sannyas?" I asked her as we hurried back to Woodlands for her appointment.

She looked at me like I was crazy. "No way, Sats! I've got other things to do with my life than be a religious freak. I'm a potter. I told you that before, didn't I?"

"I'm a writer. A person can...."

"I'm a *serious* potter, though," she cut in impatiently, oblivious to the implied insult. "I'm only here because of Marc."

When Sheela saw Bhagwan again the following day, she came out of his room with a *mala* on, bouncing up and down with excitement, hugging me and talking at the same time. She had more energy than she knew what to do with. I recognized the symptoms.

"I told him it was ridiculous for him to give me sannyas," she squealed happily. "I don't meditate, I told him, I hate meditation; I'm not a religious person at all. And you know what he did? Laughed at me! He told me I don't have to meditate. 'When the time comes,' he said, 'I'll push you in through the back door.' What do you think he means by that, Satsie?" laughing gaily. It was something I had occasion to ask myself often as the years went on. "He's such a rascal that one!" grinning.

Sheela never helped Vivek and me with Bhagwan's library. Maybe it wasn't necessary anymore. She was hooked.

გ

A few weeks later at an evening lecture in Woodlands, a man threatened to kill Bhagwan, shouting angrily at him in Hindi, a drawn dagger in his hands as several swamis at the door tried to restrain him and Bhagwan sat in his chair twenty feet away, totally unconcerned.

Bhagwan said something in Hindi and the man was suddenly released. Staggering to the front of the room, tripping over people's bodies, he threw himself at Bhagwan's feet, sobbing; the knife dropping out of his hands. Bhagwan bent forward and touched him gently on the head, then leaned back nonchalantly and continued his discourse.

I sat on the ground beside Bhagwan's chair; the man who had wanted to kill him sat up beside me. Tears poured down his face as he listened, enraptured, to Bhagwan speaking. An hour later, Bhagwan got up, went back to his room, and that was that. There was no such thing in the world as evil, only ignorance. It was all so simple.

I lay my head on Bhagwan's chair after the lecture, melting. The outside world, no matter how dramatic, seemed very far away. Inside myself, I was buzzing.

ॐ

"I'm going crazy," I moaned pitifully to Bhagwan three weeks before I was finally scheduled to return to the States, my three-month excursion ticket and visa about to expire. "I know I am," crying softly. "I don't know what to do."

It was a thing I'd been afraid of for as long as I could remember: feeling like I was always perched precariously on the edge of insanity, that at any moment I could slip over to the other side, lose my mind, be "gone" forever.

As I sat beside Bhagwan's chair that day, images of wanting to throw myself in my grandfather's grave when he died alternated with images of me during my marriage. I'd almost lost it totally once when Danny and I went to Mexico for a vacation that I'd pleaded with him to take me on. It was my fault we'd gotten lost. I was bad; I didn't deserve to live. Looking at me with silent loathing, smoldering with rage, Danny drove recklessly along the twisting mountain roads in the dark as if he were trying to kill us. When we finally found a small, dingy hotel to spend the night in, I ran into the closet in our room and hid, sobbing hysterically till I got frightened suddenly that Danny would institutionalize me, put me away, that he/they/the-definers-of-sanity-in-their-white-coats would shoot electricity through my brain, killing my mind and my memories, turning me into someone else.

Terrified of Danny's power over me, I "took my mind back" like it was a separate entity floating above my head. If I could lose my mind, I realized suddenly, I could take it back again, stuff it inside my head so I wouldn't be locked away in a loony bin and forgotten. No one would ever get inside my brain and turn me into a vegetable; I wouldn't let

them. Working in a mental hospital years later had been reassuring. I was part of the staff: one of the certified sane. Now, suddenly, after years of therapy and meditation, working diligently on myself, I was losing it again.

"I can't handle it, Bhagwan," sobbing pitifully. "I don't even know what century I'm living in anymore. I'm going crazy."

"How you can go crazy when I am here?" he said sharply, raising his eyebrows and looking at me sternly. "When I tell you to go crazy, you go crazy, hmmm? Not till then."

I nodded, sniffing back my tears, trusting him.

"At the meditation camp next week," he said, "it will be time for you to lose your mind totally. Then you'll never be afraid of being crazy again. Do it, and be done with it once and for all, hmmm, Satya?"

I kept a tight rein on myself all that week. It was easy to do; I'd been doing it my whole life. I kept busy, not allowing myself to space out in any way. Besides doing Dynamic every morning and seeing Bhagwan occasionally, I lived like a tourist for the first time: shopping for my kids every day, having new clothes made up for myself, eating in fancy restaurants. Vivek and I even went to the Taj Hotel in town once for a proper English tea, her first time out in months.

Several days before the meditation camp was scheduled to begin, Laxmi told everyone who came to Woodlands regularly that an ashram was about to be built on the camp grounds for Bhagwan and anyone who wanted to live there with him.

"You have 3,000 rupees to give, ma?" she asked me later that day when we were alone together, a down payment of that amount being requested from anyone who could afford it for eventual housing at the new ashram. While the Indian Army apparently owned the camp grounds (a few acres of barren, undeveloped land on the outskirts of Bombay that had been rented for the camp), it was years before any of us knew that. "If you don't have," she went on lightly, "it's okay. The sparrow will be taken care of, not to worry."

"No, it's...."

"But if you have," laughing playfully as she stuck out her hand, palm up, "give! Now we need."

While I didn't have an unlimited amount of money (I'd refused to take alimony from Danny), the $300 equivalent of what Laxmi was asking for seemed insignificant.

"You're sure, child?" she asked with a surprised look on her face when I offered it to her. "No need to give if it pinches the pocket, ma."

In exchange for my contribution, I was promised private accommodations at the camp, housing that turned out to be as primitive as the makeshift dormitories that were set up for everyone else: a tiny shack with flimsy bamboo walls and roof, two impossible-to-sleep-on army cots for a roommate and me, and nothing else. Nearby was a well for water and several small enclosures for private cold-water-bucket showers and "toilets" (shallow squatter pits that were soon revolting beyond description and never cleaned). Indian basic.

Despite the brutal heat and crude accommodations though, the camp was one of the most incredible experiences of my life. Bhagwan spoke twice a day in Hindi and English, conducted three daily group meditations, and suggested various individual meditation techniques for everyone to practice. For ten days, he told the 700 mostly-Indian camp participants, nothing was to exist but our own inner, solitary search.

Early every morning as the sun rose, I silently bathed in a bucket of cold water (I'd decided to do the camp in silence), then dressed, brushed my teeth, and strolled down to the meditation area, crossing cautiously over a narrow plank that had been placed across a ditch where a gargantuan cobra lived.

No matter how early I arrived for Bhagwan's discourse, Sheela and Marc were always there already, motioning to me animatedly to sit down beside them on the parched, dusty ground, Sheela looking more frumpy than chic in the loose orange robes she'd begun wearing since she took sannyas, Marc pale and sickly-looking in jeans and alligator shirts that seemed inappropriate in the context of a meditation camp.

While we waited for Bhagwan to arrive, Sheela would complain petulantly about her husband, a tall, skinny, red-headed Groucho Marx with freckles. The two of them bickered constantly and obviously adored each other. "You wouldn't believe what that schmuck did last night, Sats," she'd gripe. "It's not enough he's dying of cancer, he has to catch cold, too? I don't have enough to worry about?" But as soon as Bhagwan's car drove up, she'd suddenly grow silent, the two of us gazing at him like lovesick teenagers.

"Get ready for the meditation," he'd say finally in both Hindi and English after he'd been talking about an hour. "Take off your clothes if you want," all of us standing up and blindfolding our eyes. "So you can be naked. As you really are."

While the Indian press delighted in sensationalist reports of the nudity at Bhagwan's several-times-a-year meditation camps, there was nothing very erotic about doing Dynamic naked. It felt as innocent as the joys of skinny-dipping, a glorious freedom.

The Indians at the camp (few of whom took their clothes off while

most of the westerners did) were convinced that Bhagwan told several of the western ma's to do Dynamic in front of him. "So he can watch their naked bodies while they dance!" Paravati*, a beautiful Indian ma, told me disparagingly. "Him! As if he'd care! And they call themselves disciples!"

Without being asked myself, I did Dynamic as close to Bhagwan every morning as possible anyway, as drawn to his energy as a moth to light, and in his presence the meditation was more powerful for me than ever. For hours afterwards I'd walk around in a daze till Sheela dragged me to the pup tent she and Marc were staying in, stuffing homemade Indian delicacies into my mouth as the two of them joked and gossiped for my silent, laughing benefit; or Paravati and some of other Indian ma's beckoned me to their huts, where I'd listen contentedly to their lively incomprehensible chatter, feeling like a young, preverbal child: mothered, taken care of, loved; petted, patted, my hair rubbed with oil, feet massaged, sweets handstuffed into my mouth.

"She's an Indian, this one," the women would comment complacently in English, pointing at me, then revert back to Hindi or Gujarati, still obviously discussing me. "Hmmm, the *kundalini*," someone would invariably add, all of them nodding their heads profoundly. My shaking and tremoring during Bhagwan's Bombay lectures seemed to have impressed them all tremendously. My *kundalini* (the so-called "serpent power" of spiritual energy) had been awakened, they were sure. It was the dream of every Indian meditator and, to them, the cause of my epileptic-like response to Bhagwan's presence. I was an old soul, a deep meditator, an old Indian. More comfortable with the Indians at the camp than with most of the westerners (hippies, freaks, and Goa-bums; housewives from Copenhagen, Munich, and London; echoes from my past, no longer me), I certainly felt like I was Indian. That I'd marry an Indian sannyasin some day, settle in India, and make it my home seemed inevitable.

Vivek was staying at a nearby hotel with Bhagwan in-between meditations and Laxmi was back at Woodlands doing "His work," so except for my visits with Sheela and Marc or the Indian ma's, I spent most of my time alone, a luxury I'd rarely allowed myself before. I felt like I was on a twenty-four-hour-a-day drug trip: stoned, mellow, quietly blissful. Each day was more intense than the day before, each meditation more intense, and halfway through the camp it happened. "It." Satori. A cosmic orgasm.

In a cordoned-off area of the crowded, awning-covered enclosure that had been set up to shade everyone from the brutal afternoon sun, Bhagwan sat in an armchair, protected from the throbbing mass of gyrat-

ing bodies in front of him, Vivek sitting unobtrusively on the ground beside him as cacophonous Indian music played and we all lost ourselves in it.

Dancing wildly, carried along by the pulsating rhythm of the music and the energy of Bhagwan's presence, the top of my head suddenly exploded with the most powerful orgasm I'd ever experienced. It flooded every recess of my body; I fell to the ground, people dancing over me and around me. I was stepped on, kicked; it didn't seem to matter. I was "off" somewhere. Ecstatic; in bliss.

Long after the silent, passive part of the meditation ended, I was still lying on the ground blissed out, my being hovering somewhere above my head, enjoying the freedom of not being confined to my body. Anxious observers knelt down beside me, touching my head and heart. "Make room," a man's authoritative voice commanded. "Give her air."

There was panic, dismay. They couldn't feel my heart beating. Someone called for a doctor. Floating above the scene, I watched in amusement; assuming I was still alive, unconcerned if I wasn't.

Paravati knelt down beside me. "She's all right," she said. "Leave her alone. I'll take care of it."

As people inched away, still crouched curiously around "the body," Paravati touched my forehead gently. "Breathe, Satya," she ordered. "Follow my breathing. It's time to come back."

Nothing is required of me, a voice inside my head whispered. *I don't have to do anything. Nothing is required of me*—the thought was a blessing. I could lay there forever, blissed-out.

"*Breathe!*" Paravati repeated over and over again. "Breathe, Satya!" and before I knew it (*I don't have to do anything. Nothing is required of me.*) I was breathing in unison with her, entering my body again. She was stroking my forehead. I could feel it suddenly as well as see it.

I opened my eyes, smiled, closed them again. It was like coming out of an anesthetic. I wasn't sure I wanted to return.

"Keep breathing," Paravati commanded, stroking my head. "I know it's beautiful, Satya. I *know*," whispering softly, "but you have more to do in this life. Don't go back. Keep breathing."

The bliss of the experience stayed with me for the rest of the camp, permeating everything I did. Breathing was exquisitely sensuous. Touching anyone or anything felt like an act of love. If Paravati hadn't kept reminding me to eat, sleep, shower, go to the lectures and meditations, I wouldn't have done anything; just to "be" was enough. I was in love with everything and everyone. Every rock. Every blade of grass. Every bird.

"Satya-ma?" Ravjiv came to pick me up after the evening meditation

the first night after "it" happened as he'd been trying to do ever since the camp began. He touched my head, stroking my arm as I lay on the pebbly ground zonked out, with no desire to do anything but lay there. "Come, Satya-ma," bending down and kissing my forehead.

Opening my eyes finally, looking at his dark, handsome face and soft, pleading eyes, I thought: why not? If I was in love with the rocks and trees and birds, how could I not be in love with Ravjiv too?

I smiled, he smiled. He pulled me to my feet and led me to the grassy fields several yards away. He spread out a shawl, we lay down and slowly, gently....

I could hardly believe it—skinny, bony Ravjiv a tantric Master?!—as he brought me to peak after peak of ecstasy; I had one shattering orgasm after another. Shuddering and trembling, feeling totally in love with Ravjiv suddenly, I wondered in a quick flash of intuition if I was going to marry him, wanting to desperately.

We made love every night after that and never saw each other during the day. It was the way we both wanted it.

Several days later, on the last day of the camp, Sheela dragged me to a private interview she and Marc were having with Bhagwan. Marc had finally decided to take sannyas. He'd slowly metamorphosized into an Indian over the last ten days, his jeans replaced by an orange *lunghi* skirt and his alligator shirts by a loose orange shawl that he wrapped around his frail, skinny torso. It wasn't long before Laxmi and Bhagwan nicknamed him *the rabbi*, then *the professor* (Sheela was *the atom bomb*, me *the sparrow*; the nicknames a gesture of intimacy). Marc looked decidedly more attractive as an Indian.

Bhagwan initiated people into sannyas every afternoon before the midday meditation, Vivek always at his side. I sat on the floor in front of him, my eyes closed, as still as a Buddha, as he gave Marc his new name and answered his nervous, tentative questions. As Sheela and Chinmaya-who-had-been-Marc bowed down at Bhagwan's feet and left, I stayed where I was, perfectly content.

"Good, Satya," Bhagwan laughed heartily, "very good." I sat there, not moving. "Good, good." He was laughing, Vivek was laughing. I opened my eyes, looked at him, and sat there. "Good, Satya," chuckling and patting the air with his hand as if he were patting my head.

And getting it finally—"Oh!"—it was the first word I'd said since the camp began—I scrambled to my feet, bowing graciously and dancing out of the room, Bhagwan's and Vivek's laughter trailing in the air behind me.

At Woodlands the next day, Vivek handed me a present from

Bhagwan: the sandals he'd worn at the camp; a rare treasure, I knew, fraught with symbolism: "the foot of the Master."

"He said to tell you that you did perfect at the camp," she grinned, her blue-grey eyes twinkling. "You lost your mind just like he said you should!"

"Lost my mind? Oh my god, yes! That's *exactly* what I did. I didn't know *that's* what he meant!" laughing and crying, hugging the sandals to my chest and collapsing to the couch; instantly off somewhere, eyes shutting.

I'd misunderstood Bhagwan totally when he told me to go crazy at the camp. He'd never meant "crazy" in a nightmare-in-Bedlam, insane-asylum way; he was a spiritual Master not a psychiatrist. When he said to lose my mind, he meant to transcend it: to drop my incessant inner chattering so I could see, know, feel. I was still stoned out of my mind, living in perpetual orgasm, blessed.

"So, Satya," he chuckled later that day when I went into his room to see him, "the camp was good? You went crazy like I told you?" both of us laughing at the joke of it. "You're leaving in two-three days, hmmm?" he inquired.

"On Wednesday," nodding. I couldn't wait to see my kids again. It was time.

"Good," he smiled. "See your children, say goodbye to them and close everything up, hmmm? In three weeks you be back again to stay. I have much work for you to do here. Editing, this and that. You and Vivek have a nice room now"—we'd just moved into the bedroom next to his, most of the other apartment residents having moved elsewhere before the camp—"or you can stay with Ravjiv and the other editors. Visit their new place before you go, hmmm? See how you like it." I laughed, wondering how he knew about Ravjiv and me when I hadn't even told Vivek yet. "You can be back in three weeks? It will be possible?"

"I...," nonplussed. In three *weeks*? *Forever*? What about my kids? I nodded uncertainly. If Bhagwan said....

"Bring many people with you this time," he added. "Chaitanya. My other sannyasins. You have many rich friends and family, yes?"

I nodded uneasily, wondering what he was getting at.

"Good, Satya," he chuckled. "Bring many of the rich people you know to me too, hmmm? Very good," patting the air, beaming; the interview over.

I touched my head to his feet, willing myself not to think about what he meant. The rich deserved to find God, too. Maybe some of the people I knew were supposed to be with Bhagwan for some esoteric reason.

Maybe he was trying to push my buttons. I wouldn't think about it. I owed him my life.

As he placed his hand gently on my head, I stopped worrying about leaving my kids for good: what it would do to them, to me; stopped judging why I was to bring my rich friends to India. Only Bhagwan's hand on the top of my head existed. Whatever he wanted was fine with me.

*I*t was five weeks before I returned to India. Chaitanya had stalled: he needed to find someone else to run his meditation classes. "If you don't want to come," I told him finally, "don't come. I'm leaving." Four days later, we were ready to go.

While part of my urgency to leave was Bhagwan's instructions to return in three weeks, the other part was my kids. The longer I was with them, I knew, the harder it would be for all of us when I left. I couldn't afford to let myself get hooked into their day-to-day lives again for any of our sakes or I'd never be able to leave. Bhagwan wanted me back. I had to go.

I made my abandonment of my children into a moral principle, clothing it in spirituality. What could I offer them that was more important than my own Buddhahood? If I wasn't free, how could I hope that they would be? Rationalizing, justifying. The fact was, Bhagwan told me to come back to India for good; his words were my only reality. Addicted to the ecstasy I found with him, being by his side was the only thing in the world I wanted.

I tried to be matter of fact when I told my kids I'd only be home for a few weeks. There was no way to explain it. It was just the way it was.

"You'll be all right, won't you, sweetie?" I asked Billy as I bent down to hug him at the door of Danny's apartment for the last time before I left. "You like it with Daddy, don't you?" both of us crying, pretending we weren't. "Whenever you want to be with me, you can come visit. You know that, don't you?"

He nodded, holding back his tears. "I'll be fine, Mom," he said. "Daddy and I are getting along much better now. Don't worry about any of us. We'll all be okay."

Patti was angry that I was leaving, Nancy indifferent, neither of them interested in long, tearful farewells. I was leaving, abandoning them. They had their friends, cousins, father, two sets of grandparents, private school, dancing school, a place in the country. They could get along without me very well, thank you.

If they'd pleaded with me not to go, would I have stayed? Perhaps out of guilt, then resented them for it. They made it easy for me, though. Go. Have a good time. I don't need you anymore. I set you free.

I left, ignoring my own pain and refusing to see the hurt and bewilderment in my kids' eyes.

à.

"Have you seen your friend yet?" Bhagwan asked amiably as I sat beside his chair two days later, enraptured at being back with him. Sitting at his feet was ecstasy, bliss.

I nodded, smiling. "I told her last night you'd be back today," he chuckled. "'How do you know?' she asked. But I knew!" I beamed up at him happily. "How long you will be staying, hmmm?" he asked.

"How *long*?" I gasped. What was he talking about? He'd told me to come back forever.

"You do the camp in two...three weeks," he said, "then go back; start a center. You have much work to do for me in America."

"But...." I was numb, in shock. I'd closed everything up, sold everything I had, told my kids I might never see them again. Was he kidding?

"Many people will have to be introduced to me," he went on casually. Had it been a test of some sort? Had I passed? Failed? "The work has to begin. You will have to bring many new people to me now."

I'd brought Chaitanya with me, and a half-dozen other sannyasins, paying all of their plane fares so they could come. I'd even tried to convince an aunt of mine to join us, and my friend Mary, who was the heiress to one of the largest fortunes in America. My aunt (one of the rich people Bhagwan was "calling"?) was the only relative of mine who was sympathetic to what I was doing. Mary did yoga regularly. She finally came to one of Chaitanya's meditation classes, hating it, spending the whole second stage of Dynamic lecturing people: "Catharsis should be used for the sake of Art!" she shouted angrily. "This is sacrilege! Profanity!" I'd tried my best. I was here to stay.

"Any messages from my sannyasins?" Bhagwan was asking me now. I giggled, shaking my head shyly. I was as easily distracted as a five-year old around him. "Hmm, Satya? Tell me."

"Premda* said to bite your toe," I blurted out abruptly, blushing.

"Do it, then!" he laughed, thrusting his foot in my face. "A message has to be delivered! Bite the toe! Premda has said!"

For the next two weeks, every time I went into Bhagwan's room to see him, I'd suggest the name of someone else who could run a center in New York and "do his work."

"Junk people!" he'd say each time, dismissing my suggestions with an impatient flick of his hand. "You will have to do my work in America, Satya. Chaitanya will be with you, hmmm? It will be good."

That I was supposed to be with Chaitanya now, not Vivek, was obvious. "True lovers are mirrors of one another," Bhagwan would tell me whenever I complained to him about Chaitanya. We'd been fighting constantly ever since we got to India: verbally, psychologically, physically; I was covered with black and blue marks all the time. But whenever Bhagwan asked me how Chaitanya was—and I'd dramatically throw off the shawl I was wearing to cover my bruises, saying, "*That's* how he is!"—he'd laugh heartily: "Good, good. Tell Chaitanya to hit you more." He didn't take our fighting seriously, he didn't take me seriously. He treated me like I was an amusing, petulant child.

"You and 'that one' can go in to see Him now," Laxmi told me one afternoon, nodding towards Chaitanya. He'd been treated like someone special once, too. Now he was "that one," nameless, the little sparrow's friend, loathing me for it.

We sat on the floor on either side of Bhagwan's chair while he played with us: laughing and friendly with Chaitanya, stern and insistent with me.

"My god, he's really angry today," I murmured uneasily as we left his room.

"Angry?" Chaitanya looked at me like I was crazy. "What are you talking about? He couldn't have been more loving. Zapping us with his energy. Pouring himself into us."

I felt chastised, though. Bhagwan wanted me to go back to America and I didn't want to go.

But went. .

෴

Chaitanya and I spent the next two years commuting between the land of my birth and the land of my heart. For over a year, we ran a meditation center in my former Riverdale apartment.

Billy came to the center frequently during the week to visit; his prep school was nearby; but the only time I saw Nancy and Patti was when I took them out to dinner once a week. They were all supposed to be with

me on weekends, but there was no way I could compete with Danny's plans for them: excursions to their country house, sleep-over dates with their cousins and friends, outings of all sorts. I didn't even have a place for them to stay: Danny wouldn't let them sleep at the center where I lived. Our joint custody was a sham. The only place I could be with the kids for any length of time was in their apartment (and, later, house when they moved back to Scarsdale).

I probably could have threatened court action and fought it, insisting on my "rights," but I didn't. Not even Billy wanted to miss a baseball game or a trip to Massachusetts to sing *kirtan* songs in Central Park with a group of sannyasins. The children had busy, full lives. I was at best an interference and as time went on—I couldn't help noticing—a decided embarrassment in my long orange robes and *mala*. And the children grew further and further away from me.

Sheela called the center regularly to talk to me and visited occasionally, turning me into a referee in her constant battles with Chinmaya. His Hodgkin's disease had gone into remission after their trip to India (Bhagwan's doing, we were all convinced) and he was teaching physics in New Jersey while Sheela waitressed, bartended, and sold hotdogs out of the back of a van. Neither of them were active in sannyas affairs, Sheela rarely wearing orange or a *mala*, a continual source of contention between them.

When Chaitanya and I set up a charitable trust in Bhagwan's name so we could function as a tax-deductible church in New York, Sheela asked if she could do the same in New Jersey. "In case me and Chimney ever feel like running meditations," she said. The New Jersey affiliate she set up of our New-York-based "church" offered her the legal means of financial wheeling and dealing in the States and eventually became the religious organization around Bhagwan when he moved to America.

੨▲

It was in early 1974, during Chaitanya's and my first long visit to India, that Bhagwan moved to Poona, a city-village 75 miles from Bombay. Told to return to America immediately ("There is more work for you to do there, hmmm, Satya?"), we began travelling throughout the States and Canada, teaching meditation classes and introducing Bhagwan to anyone who would listen, while other sannyasins did the same thing in Europe.

When we'd finally managed to create a sizable market for Bhagwan's books in America, an Indian sannyasin arranged to ship them to us as

gift parcels through his family in Flushing. The books left India, the money to pay for them stayed in the States; everyone seemed happy with the arrangement. While it's obvious now that we were helping someone smuggle money out of India, I didn't think about it in those terms at the time. "All import/export runs this way," I was assured, and I believed. What business was it of mine anyway?

While Chaitanya and I lectured at universities and ran programs at growth centers (where most of the people in our groups ended up in India), our relationship fluctuated a dozen times a day between love, hate, and a debilitating indifference that was worse than either. No matter what was happening to us personally though, as soon as we opened up our mouths to talk about Bhagwan something magical seemed to happen. People fell in love with us; and through us, with him.

Treated like minor gurus in the groups we ran—asked for advice, counselling, solace; our words clung to like gospel—our families and pre-sannyasin friends remained skeptical and angry.

"How in god's name could you leave your kids?" my friend Mary would yell at me whenever we talked. "You of all people, Jill! Can't you do anything in moderation for godsakes?! Wear sexless orange robes and that stupid necklace if you have to, but be a goddamn mother again. What's wrong with you? When's the last time you even saw your kids?"

"Last night. For chrissakes, Mary," sighing. I flew to New York to see my kids periodically from wherever I was. "I phone every few days. I'd see them more often if they weren't so busy all the time," making it sound easy, just-the-way-it-is; crying myself to sleep at night because I missed them was my own business. Every time I heard Paul Simon sing: *My mama loves me like the rock of ages / she loves me*, I broke down, sobbing uncontrollably. It was something I had to "work through"; I was too attached to my kids. Attachment meant suffering; Buddha was right.

"They want a mother," Mary chastised, "not a goddamn camp counselor or occasional playmate."

My writer friends told me that I was wasting my talent, running away, chosing not to be successful; while my radical friends accused me of selling out, abdicating my responsibility to the world. The general consensus was that I was bad, selfish; at best, hopelessly misguided. Only other spiritual seekers understood the pull. Is it any wonder that as time went on I saw less and less of my old friends? and, cut off from them, had only Bhagwan and other sannyasins to measure my life against.

Bhagwan didn't tell us to renounce the world, but the world, inevitably perhaps, denounced us and the effect was the same. I was living in the world, but I could have been a monk in a monastery. Absorbed in

Bhagwan and "his work," I carried an invisible religiosity around me like an aura, immune to the charms of the world: untouchable.

ૐ

"You have arranged for my books to be published in America?" Bhagwan asked as I sat on the front porch of his house in Poona with a dozen other sannyasins. It was my first night back in India after being away several months and my first meeting with Bhagwan who no longer saw anyone but Laxmi and Vivek alone. (His cousin Kranti had angrily dropped sannyas after Vivek took over her role completely, sharing Bhagwan's bed and board.) Evening *darshans* where Bhagwan met with small groups of disciples and visitors had replaced our private meetings with him. I couldn't cry in his arms anymore or hold his hand. Things had changed.

The Poona ashram (two large adjoining Koregaon Park estates that had been built during the British Raj) was blossoming slowly in the fall of 1974, beset by constant financial problems that Laxmi dealt with by asking sannyasins to empty their pockets when bills came due. To raise additional money, she rented out rooms at exorbitant prices in what was soon known as Krishna House, the rest of the building taken up by guest rooms (for people like Chaitanya and me who were doing "his work" in the west), office space, and storage.

Bhagwan and a few sannyasins, including Vivek and Laxmi, lived in the other sprawling mansion, Lao Tzu House, which was off-limits to most people except during Bhagwan's now-daily morning lectures and evening darshans. Since Vivek never left the Lao Tzu compound, I was allowed to come and go as I pleased. Still my closest friend, my visits to Poona were visits to her as much as anything else.

"Harper & Row is interested?" Bhagwan was asking me now. He'd wanted me to approach them in particular.

I shook my head, blushing. "They didn't think anything I gave them was suitable. They asked me to write a book on meditation for them instead," whispering, embarrassed.

"Hmmm?"

"They want me to write a book about meditation for them. Is it okay?"

"There's no need," Bhagwan remarked brusquely, dismissing the idea immediately. "You do one thing, Satya, hmmm? Take the book you gave them, reorganize it, restructure it, anything you have to do so it's what they want, and give it to them again. There's no need to write anything yourself."

So while Chaitanya and I continued travelling, I rewrote several of Bhagwan's books, ghost writing as much as editing as I turned his early English-language discourses into something palatable and commercial. (His English was very rudimentary in those days.) Before long, the books were being published by Harper and Row and a dozen other publishing companies worldwide, making Bhagwan increasingly well-known amongst the intelligentsia everywhere.

On our next trip to Poona, we were told to finish up what we were doing in the west and make arrangements to stay in India permanently; it was time to become part of the newly burgeoning ashram community. "Many Americans are staying with no visa problems," Laxmi informed us discreetly. "Find out how they manage and do the needful so the lion"—Chaitanya—"and the sparrow can stay. Okay, ma?"

It was easier said than done, of course. Most of the Americans at the ashram had Canadian passports that they'd gotten illegally; Commonwealth citizens and their spouses could stay in India indefinitely. I didn't want to do it that way, but Bhagwan said.... There didn't seem to be any other alternative.

A girl in one of our Toronto workshops offered to get me a passport in her name but I couldn't go through with it—I'd never done anything illegal before—and couldn't go through with it again after I'd paid a sannyasin $1,000 for what he promised were risk-free papers.

When Chaitanya and I finally returned to India without having "done the needful," it didn't seem to matter though. "Laxmi can handle from this end," she assured us. We were back in India for good. Forever. Or so we thought.

II

The Love Affair

Poona
(1975 - 1981)

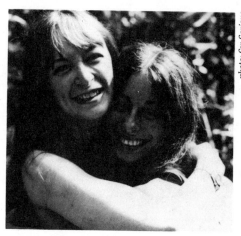

The author with her long-time companion Chaitanya in Poona (1977).

The author with Vivek (on left) in Poona (1980).

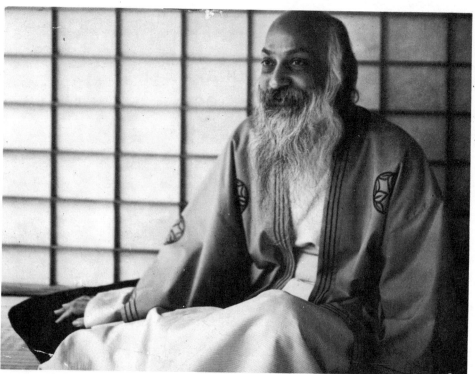

photo: Rajneesh Foundation, India

A studio portrait of Rajneesh in Poona, some time between 1976-1981. While Rajneesh wore a variety of costumes (like this kimono) in photographic sessions, in public he always appeared in a simple white turtleneck robe.

*O*ur room at the ashram was large; it was musty; it smelled like mildewed clothes that had been packed inside a trunk for years. Chaitanya and I were lucky to have it. Sheela and Chinmaya, who'd arrived from the States two days after us, were living in a newly-built one-room hut at the end of the front garden with several other people and no bathroom. I was surprised they'd been given a place at the ashram at all; only a few dozen sannyasins lived there. Chaitanya and I were in our fourth room in six weeks. I knew it wouldn't be our last.

"Satya-ma?" Ravjiv opened the door as he knocked. "Sorry to bother, ma," he apologized, scarcely looking at me lying on the bed as he went to open a tall metal storage cabinet that housed office records. "Some accounting papers are needed."

Fiddling with the combination lock, Ravjiv clanked open the door, pulling dusty file after file out of the cupboard and thumbing noisily through it, humming incessantly; pretending I wasn't trying to sleep while I pretended he wasn't disturbing me.

"Satya!" The loud staccato knocking on the door as it opened this time was Laxmi. I wondered why I ever bothered trying to rest at lunch time; Krishna House was like a subway station.

"Come on, sparrow! Up! Out of the bed! This is where Ravjiv is hiding, hmmm?" she laughed. "You, too," she said as he looked at me guiltily, shrugging his shoulders. "Come! Everything has been arranged. On the front lawn, quick! Bring Chaitanya for the best man!" and in a flurry of red—Laxmi still wore the same outfit every day, but it was red now—she scurried out the door.

"What was that all about?" I asked as Ravjiv hurried to put away the

files. He shook his head, frowning, busying himself, slamming the door behind him as I quickly brushed my teeth.

"Hurry, Satsie!" Chaitanya motioned to me impatiently when he saw me outside the office a few minutes later. Bare-chested, an orange *lunghi* wrapped around his waist, he was standing at the entrance to a canopied, enclosed area on the front lawn. "Everyone's waiting for you."

"Good, the sparrow," Laxmi nodded with satisfaction when we walked in. Sheela, Chinmaya, Ravjiv and a score of other ashramites were standing in small groups nearby, talking animatedly.

"Five brides, five grooms, isn't it?" Laxmi beamed happily; Chaitanya squeezed my arm. My god, was I about to get *married*?!

"Find the partners," Laxmi instructed. "Someone big is there for Arup?" looking at five Indian swamis who, embarrassed and obviously wishing they were somewhere else, were presumably the grooms-to-be. "Sant," she nodded to a tall, stocky Punjabi, "you and Arup...."

But Sant was shaking his head, protesting; no, he wouldn't do it. He had a beautiful English girlfriend. If he was going to marry anyone, it was her.

Persuasion didn't work, appeals to his conscience didn't work. It was for Bhagwan, Laxmi said. He didn't care. He shook his head, shrugging off Laxmi and Ravjiv and everyone else who was trying to pull him towards his "intended"; he refused.

Sheela, standing between Chinmaya and me, was making no attempt to hide her laughter. "Even a shotgun wedding and the old cow can't get a man," she giggled, nudging me with her elbow. "Right, Sats? Who'd want to marry *her*??" A large, plain-faced Dutch woman who was Laxmi's assistant along with Sheela, Arup was bossy and officious, not many people seemed to like her, but with Sheela it was more than not-like; Arup was her rival and her nemesis. "The only way she'll ever get a man is if someone wants to do a favor for the old boy," Sheela scoffed, running her thumb over the tips of her fingers, meaning: loaded, rich as Croesus. Arup was the founder of a successful growth center in Europe, her father a wealthy banker.

As Sheela continued to make loud, sarcastic remarks about her, Arup walked calmly over to Ravjiv and took his hand: she'd found her man. There were four incongruous couples standing beside Laxmi now, all of them laughing self-consciously, looking vaguely uncomfortable: why *not* get married?

"Where's the sparrow?" Laxmi asked. "Five couples. We need another man. Sheela, get what's-his-name at the front gate. Go!" and while Sheela hurried off, she turned to me. "You and Ravjiv are good friends, no? From.... When? Laxmi's remembering."

I looked at Chaitanya, looked at Ravjiv. Whenever I wasn't getting along with Chaitanya, I still went to Ravjiv for comfort, his German girlfriend notwithstanding. "I guess," I mumbled.

Laxmi pulled me by the arm, pulling Ravjiv away from Arup. "He's too little, ma. It doesn't look good. Sheela's finding."

Ravjiv and I stood beside each other shyly. What the hell? I always thought I'd marry him anyway. "The right size," Laxmi said, nodding, satisfied.

What's-his-name from the front gate turned out to be even slighter in build than Ravjiv, but there were few Indian men working at the ashram; no one could think of any other suitable bridegrooms. I hoped for Arup's sake she wouldn't be required to consummate her marriage with him. I liked her a lot better than Sheela did.

An elderly sannyasin "priest" married us couple by couple. An orange shawl was put over my head (the same one worn by each of the other brides); a necklace of flowers was placed around my neck (likewise shared) and one around Ravjiv (ditto). With a knotted kerchief perched on top of his head, he looked ridiculous. I assumed it was part of some esoteric tradition. Someone stuck a *tilak* between my two eyebrows. I was a Hindu-cum-sannyasin bride.

Photos were taken of the marriage ceremony and of Ravjiv and me feeding each other wedding cake. When Bhagwan saw them, he was delighted. "My people are wonderful," he told Vivek. "Such perfect actors. Anyone would think they were deeply in love."

Anyone but my parents, that is. I never told them about my marriage. How could I? They knew I was living with Chaitanya. He was Jewish, he was white; after two and a half years he was like a son-in-law. How could I suddenly say, "Well, you see," and explain to them that I'd married a man who.... Let's face it: Ravjiv's skin was dark, his hair was oily, he looked like a lower-caste rickshaw driver even if he was an accountant. He'd been born into abject poverty. For all his higher education, he still had the aura of it.

Mom, Dad, let me tell you about my husband. Kids: surprise! Your new stepfather! Sending them photos of Ravjiv at our wedding with a knotted kerchief on his head, explaining why I hadn't told them about it earlier. The sudden impulse! The passion that couldn't wait another day! And Chaitanya, Mom? Funny you should ask. Of *course* we're still living together. What does my being married to someone else have to do with that?

Ravjiv and I had an ideal marriage. We never fought, never argued; we hardly ever saw each other. Once a year, Arup and I bought our husbands cakes to celebrate our anniversaries. From time to time, shyly af-

fectionate with one another, Ravjiv and I went to the immigration office in town to extend my visa. While other ashram-arranged marriages were viewed skeptically over the years by government officials, Ravjiv's and mine never was. We went so well together. The right size and everything.

<div align="center">&</div>

"Can I take the first shower?" Sheela asked drowsily, crawling out of the bedding on the floor that she and Chinmaya were sleeping in. He had a cold, she had a urinary infection; they'd been staying in Chaitanya's and my latest room for the last few nights so they'd be near a bathroom. Our room was wall-to-wall mattresses. It felt like being at summer camp as a child, the four of us whispering and giggling together for hours at night before we fell asleep, then tripping over each other in the morning as we hurried to get ready for the discourse. I had a reserved seat in the front row for the lectures. I could afford to let the others use the bathroom first.

"Save some hot water," I murmured sleepily to Sheela, burrowing my head under my pillow as the music of the last stage of Dynamic played outside the window, our daily morning alarm clock.

I hadn't been to a single session of Dynamic since Chaitanya and I moved to India. Living and working at the ashram and going to daily lectures and evening darshans were my meditation. Perpetually high all the time anyway, Dynamic suddenly seemed irrelevant to me.

By the time Chaitanya got back from leading the meditation, Sheela was already gone. "There must have been 150 people there today," he remarked cheerfully as he bent down to kiss me, his nose wet and cold, his hands freezing. If he had any sense he'd bundle up when he left the room at 5:45 every morning, but he never did: yogi-proud; nothing to spoil his guru image. "God knows where they all came from. Germans, Japanese, Swedes. *Jawohl.* Ve haf vays to make you breathe deep und fast. You *vill* breathe!"

"English lectures'll be starting soon, no?" I asked.

He glanced at his watch quickly. "Three more days of Hindi," he said then nodded towards the bathroom where the shower was going full force. "Chinmaya?" he asked as he stripped. He was shivering, his penis and balls shrunken from the cold like a little boy's.

"Yeah. Sheela said to tell you that she's saving a place in line for you."

He grimaced, annoyed that he wouldn't be able to sneak into the lecture hall through Bhagwan's house with me this morning. "It's as cold

as a witch's tit out there," he grumbled, galloping towards the bathroom to pee and brush his teeth while Chinmaya showered.

It was late by the time I was finally washed and dressed in two floor-length robes, two sweaters, a jacket, a heavy shawl, and three pairs of socks, a pillow tucked discreetly inside my longjohns so I wouldn't feel the numbing coldness of the floor in the lecture hall. As I rushed towards the Lao Tzu gate, my hair dripping wet from a freezing cold shampoo and shower, a few stragglers dressed in bright fire colors were running in the rain down the curvy path that weaved its way outside the house to the auditorium. Leaving my sandals at the back door of the house, I hurried inside and down the hallway, reaching the door to the auditorium just as Vivek emerged from Bhagwan's room with his tea tray. Good, I sighed with relief, relaxing. It obviously wasn't as late as I'd thought.

I opened the door to Chuang Tzu Hall slowly. The open-air auditorium, surrounded on three sides by a lush tropical garden that sparkled in the monsoon rain, was mobbed this morning. Red-people, orange-people, an occasional dot of uncommitted blue or black scattered here and there like blemishes on a polished apple. It was the biggest crowd yet; Chaitanya wasn't exaggerating. Bhagwan didn't seem to be the best-kept secret in the world anymore.

Walking self-consciously past Bhagwan's chair, my head down, eyes focussed on the ground, the pillow inside my longjohns making me feel like I was wearing a loaded diaper, I sat down at the far end of the auditorium near Bhagwan's flamboyantly redheaded bodyguard Shiva, my eyes closing automatically as I sunk inside myself. Within seconds, I felt calm and blissful, totally at peace.

There was absolute stillness in the hall, no one whispered or moved; the energy was as intense and cohesive as if we were one silent, reverential whole, not 500 individuals. Only the wind moved, only the rain spoke; I could have been alone there.

As Shiva opened the door in front of me, there was a slight stirring of movement in the hall, an air of expectancy. An irrepressible smile spread over my face. I opened my eyes and *namasté*ed. The big moment. A choir could have sung "Hallelujah!" and the mood wouldn't have been more ecstatic.

Laxmi floated in. Gliding behind her, hands in prayer position before his face, Bhagwan followed; Vivek a few paces behind him. As Shiva closed the door and Bhagwan sat down, Laxmi handed him a copy of the religious *sutra* he was lecturing on and then sat on the marble floor beside him.

"Tea today?" Vivek mouthed silently when I glanced at her, giving me a quick smile as she squatted beside Shiva along the wall catercorner to me. I nodded, then closed my eyes as Paravati began singing the *sutra*.

It wasn't long before my body was crumpled over like a rag doll, my head resting against the floor in front of my folded legs. Bhagwan's words surrounded me like a subtle perfume as I disappeared: floating, flying; gone.

"*Ah jettena*," Bhagwan intoned suddenly, signalling the end of the lecture ("Enough for today!") after what was presumably two hours but felt like two minutes. He stood up, *namastéing*. Lifting my head up, I *namastéd* back. As he walked towards the door to leave, he looked at me and smiled. My eyes flickered shut, my head was on the floor again; I was out for the count.

By the time Chaitanya came over to pick up the pieces and put me back together again, we were the only ones left in Chuang Tzu Hall. "Breathe along with me, Sats," he murmured, bending down beside me. "In.... Out," Bhagwan having recently instructed him on how to revive me after the lectures. A polarity of energy was apparently needed: male, female; something to ground me.

Soon we were making our way down the path outside the house, Chaitanya supporting me like I was an invalid. Feeling as wobbly and insubstantial as jello, my knees buckling underneath me, I made an effort to keep my eyes open, tripping and stumbling, then holding on to the gate for support while Chaitanya ran across the driveway to get my sandals from the back door of the house. It was pissing with rain. My socks were sopping wet. I was chilled to the bone. I felt wonderful.

える

By early afternoon, the sun was shining. Everyone at the ashram except Bhagwan and Vivek were gathered on the front lawn for Premda's* and Deva's* wedding, Sheela and I standing in for their respective mothers. A Catholic social worker from Toronto, Premda wanted a typical Indian wedding. Her marriage to the Jewish psychiatrist from New York whom I'd fixed her up with two years ago and she'd been living with ever since was only partially motivated by visa considerations. Love marriages were rare enough at the ashram to be a cause for celebration.

A glorious Amazon of a woman, Premda was regally outfitted in a gold-embossed silk *saree*, with gold jewelry on her neck, arms, ears, and nose. Her tall lanky husband was equally resplendent in a red silk *kurta*, orange silk pajama pants, and purple velvet prayer cap. There were

flowers and food, music, and an ornately-decorated elephant that danced its way around the tree-lined streets of Koregaon Park after the ceremony, Premda and Deva in tow, the rest of us dancing jubilantly behind. Every time the elephant shit, a dozen beggar kids ran to fight over it. Elephant dung (like cow dung) was in great demand: huts were built and heated with it, meals cooked, religious rituals enacted.

A half-block of ecstasy was all I could handle, I found. As the bridal procession continued past the sedate estates of our wealthy Indian neighbors, I slowly made my way back to the ashram. My days of wild dancing seemed to have disappeared ever since my last satori two years ago.

Halfway through a meditation camp at the luxurious Mt. Abu Palace Hotel in Rajasthan, I'd been lying quietly on my bed between meditations when a bolt of energy suddenly shot through my body like a live electric current, the pain so excruciating I felt like I was being electrocuted. As suddenly as it had hit me, the pain subsided, waves of bliss miraculously flooding my body; utter relaxation, joy. On and on it went, waves of bliss following waves of energy, each more intense than the last, till someone entered the room unannounced, saw me lying on the bed as stiff as a board, shaking and trembling, and ran off to get help.

For months afterwards, pulsating waves of bliss permeated everything I did; they were still there every time I closed my eyes. Ecstasy had become a quiet private thing for me ever since.

As I walked past the office on my way back to my room now, Sheela suddenly hollered out the window to me. "She's coming back tonight, Sats!" she said cryptically. Sheela's dislike for meditation extending to an antipathy towards any kind of exuberant celebration (besides the ashram's three annual celebration days on Bhagwan's birthday, the day of his enlightenment, and Guru Purnima Day, day-long festivities that brought tens of thousands of people, and huge amounts of money, to the ashram), she'd hurried back to the office with Laxmi immediately after the wedding ceremony.

"Pig face," Sheela elaborated, pretend-gagging, when I looked at her blankly; meaning, I knew, Arup. "Pack your things," she said. "We'll put you into Premda's and Deva's room while they're on their honeymoon. Don't bring anything in till they leave. There's no need to freak them out."

So after dinner that night, Chaitanya and I moved out of Arup's room, which had been our room for two weeks while she was in Holland, and moved into the dark, dank room that Premda and Deva had been in, surrounded on two sides by construction noises that went on day and night, drills chiselling into the wall beside our bed while we tried to sleep as scores of Indian workers shouted back and forth to each

other in ear-piercing shrieks. The ashram was literally doubling over night as more and more westerners came and asked if they could stay.

I freaked out. Our new room was a nightmare. I couldn't work, couldn't think, couldn't *not* think, couldn't sleep. I got dysentery, barely recovering from it before Chaitanya got a worse case and landed in the hospital. After washing bloody stools off his ass twenty times an hour—the nurses were never around to do it—I came home at night exhausted, only to not sleep with all the noise, chaos, and acrid smells around.

When Premda and Deva got back from Goa, it was their turn to freak out. There was no room at the ashram for them anymore, Laxmi told them apologetically. "Sorry, ma. Not even a little place is available. Soon."

It was two and a half years before they moved back into the ashram. Who lived there, and under what conditions, was a constant button pusher, a seemingly deliberate spiritual technique. We all tried to use it that way at least. Everything that happened was designed for our growth. The ashram was a mystery school, Bhagwan said. No one expected the search for the holy grail to be easy.

I finally got used to the noise in our room, even managing to write a novel in twenty-one days, working on it for a half hour every morning after the lecture. Bhagwan was talking in Hindi again. While he spoke, a funny, intricately-plotted story came into my head that I wrote down virtually verbatim. When Bhagwan read it and loved it, I signed over the copyright to the ashram; it seemed like the appropriate thing to do. It wasn't until a contract for the book had been signed with Grove Press that Laxmi decided it shouldn't be published. It was black humor, she told me disparagingly. People would think that was the way the ashram was.

"That *is* the way the ashram is, Laxmi!" I'd barely exaggerated. I didn't have to in a place where heiresses happily cleaned public toilets, mass group catharsis took place in the front garden before sunrise every morning, and sexual promiscuity was considered a path to God, but there was no arguing with her. If I was disappointed, it was just my ego. "Leave your shoes and egos at the gate" an ashram sign advised. I was a good sannyasin. I surrendered. What had my ego ever done for me anyway?

Since a contract had already been signed for the book, I had to write another one to replace it. When the ashram moved to America years later, my aborted novel (as well as all the other writing I'd done in India that hadn't been published yet) was allegedly "lost at sea." I chose to accept it as fact, unwilling to acknowledge the obvious: that my work was deliberately destroyed. It was years before I was ready to admit it.

"I have to talk to you, Sats!" Sheela barked, storming out of Laxmi's office to the front porch of Krishna House where a few desks had been set up for the English editors to work. "Come!" she motioned imperially, her dark eyes blazing with fury.

Sighing reluctantly, I put down the lecture I was working on and followed her down the porch stairs, hardly in the mood to listen to the details of her latest outrage. After a mini-satori during the lecture two days ago, I was barely functional, mellow almost to the point of comatose; I couldn't even talk. Sheela's angry energy was the last thing in the world I felt like being around.

As we paced up and down the path in front of the office, Sheela raged on endlessly about what Laxmi had done and how Arup had had the gall—"The *chutzpah* of that shithead! Where does she come off to...."—and how Laxmi had supported Arup, making a fool of Sheela, countermanding what she'd told Ravjiv, etcetera.

It never ceased to amaze me that Sheela and I were friends. She didn't get along with Arup or Laxmi; she seemed to do battle with everyone at the ashram except Chinmaya and me. Abrasive and bullheaded (Chaitanya called her spiritual path "the path of unconsciousness"), she could be warm and loving when she wanted to be, but it was impossible to have an intelligent conversation with her. Her only saving grace sometimes was an audacious spontaneity that felt refreshingly innocent and childlike somehow. She was who she was: a brash, spunky kid. She made no bones about it.

If Sheela adopted me as a substitute for her closely-knit family—I was mother and sister to her as much as friend; she even called me "Mommy"—I adopted her as a substitute child, loving her the way a mother loves a bratty, spoiled four-year-old, humoring her. Few people seemed to like Sheela in those days. I settled for loving her.

As her litany of complaints continued ("Laxmi's a little Hitler! She favors all the westerners! Did I tell you about...?"), I watched three children playing in the front garden, having no trouble communicating in three different languages. A Danish swami with long, stringy hair and ragged clothes sat playing his flute while several people silently practiced tai chi and a young man and woman gazed intently into each other's eyes as if the meaning of the universe were there. Couples strolled in and out of the ashram gate holding hands. Two men embraced in a long, timeless body-to-body hug, merging and melting into each other.

"Fuck you, you fucking Nazi bastard pig!" a bearded swami near the gate shouted suddenly at the man beside him. As the two men started

slugging each other, Sheela paused momentarily in her indignant tirade, distracted; duty called: she should be over there breaking up their fight; then in mid-sentence, she picked up where she'd left off when the guard at the gate stopped them.

"Come on, you *Scheisskopf*," the first man said. "I'll buy you a cup of coffee," and with arms around each other like best friends, the two swamis left the ashram, a dozen beggars kids crowding around them with outstretched hands as they climbed into a rickshaw. Quick fights, fast friendships. Ever since the ashram therapy groups started several months ago, scenes like this were common.

"There's only one thing to do," Sheela told me finally: the point of her whole conversation. I'd have to speak to Vivek for her, tell her what was going on so she could tell Bhagwan. "It's the only way, Sats," she insisted, not knowing or caring that I was in silence; I hadn't said a single word the whole time she was talking. "Will you speak to her for me? You can have tea with her this afternoon. It's the only way around Laxmi. *Please!*"

And reluctantly breaking my silence, knowing I shouldn't do what Sheela wanted, I agreed. It was too hard trying to say no to her. She always wore me down in the end anyway.

As Vivek and I sipped *chai* and nibbled on Scottish biscuits later that day in the empty Chuang Tzu auditorium, the atmosphere around us silent and holy, I told her everything Sheela had asked me to say, remembering her own battles with Laxmi in the early days of the ashram. She and Laxmi had been at loggerheads for months till they'd finally resolved what their respective roles were. Vivek took care of Bhagwan; Laxmi of everything else. It was a division of labor that seemed amicable.

Sheela was called to darshan unexpectedly that evening. Running into my room afterwards, crying hysterically, she threw herself on my bed, sobbing, telling me how bad she'd been, how bad we'd both been. "He wants you to go to darshan tomorrow night," she sobbed. "He said to tell you. He's mad at you, too."

With a sudden sinking feeling in my gut, I wondered what Sheela had told Bhagwan; if she'd defended herself by blaming me. I knew I was going to get "hit" for what I'd done. It was backroom politics, tattle-taling; inexcusable. Bhagwan's verbal hits might be motivated by compassion, but they always hurt: a teaching lesson I invariably didn't want to hear.

る

Sitting with thirty other people on the darshan porch the next evening, Vivek on one side of Bhagwan's chair, Laxmi on the other, I listened as Bhagwan gave sannyas one by one to a Swiss banker, Czech waiter, Italian poet, Australian geologist, French hooker, and couple from California. A college professor, an actor, a psychologist and an architect came up to the front to say goodbye, all of them promising Bhagwan they'd be back soon, hopefully to stay forever.

When an Irish ma who worked in the ashram canteen told Bhagwan what was happening to her during Dynamic, he told her not to do it anymore; her work would be her meditation. An American woman complained that the more meditative she became, the more sex she wanted while her husband was becoming progressively less sexual as he meditated. Bhagwan told them to move into celibacy, then five minutes later he told another couple with the same problem that the woman should be with other men while her husband "allowed" it to happen and "watched" his jealousy. His advice depended on whom he was talking to; he had no set answers. It gave his teachings an air of tailor-made authenticity. Nothing was right or wrong in and of itself; it depended on us.

All too soon he motioned me towards him. "Hmm, Satya? Come." Vivek's head was down, her long, silky hair hiding her face.

"Your gossiping isn't good," he told me sternly when I was sitting down in front of him. "You don't mean it, but people can be hurt by it. It's time to drop it, hmmm?" I nodded, tears stinging my eyes. There was nothing I could say to defend myself; he was right. Sheela had gotten into trouble because of my gossiping, Vivek probably had, Laxmi as well. I felt ashamed of myself.

"Hmm, Satya?" he said, looking at me lovingly and smiling. "Everything else with you is good," patting my head gently as I bent down to touch his feet. "I'm very happy with you."

It wasn't until Vivek and I had both been victims of poisoning attempts ten years later that we ever discussed the incident again. We simply stopped being friends, and Sheela and I became increasingly inseparable. She, Chinmaya, Chaitanya, and I were soon a constant foursome that people spoke of in one breath: "the four of us"; the clan.

Vivek stopped being an avenue into Bhagwan for me, obviously. It wasn't long before Laxmi ceased to be the only channel into him, though. Sheela became one, too, and to a lesser degree so did Arup, till Sheela successfully ousted Arup, then Laxmi, and was the only avenue left into Bhagwan.

8

"W hen you surrender, everything happens," Laxmi said as Kavi* sat at the desk opposite her, tears pouring down her face. "Fighting is the struggle; saying yes is the magic. Then everything can happen, hmmm? How is this month's primal group doing?"

"Good," Kavi sniffed, her long, frizzy hair framing her face like an electrified halo gone crazy. A therapist from California, she thought she'd given up running groups when she left her child and her budding practice to move to the ashram. She'd resisted for months—couldn't she work in the garden, clean rooms, edit books, write them; anything but do therapy again?—finally begrudgingly "surrendering." Moving into the overcrowded ashram seemed to be her reward. "Everyone's getting into it," she mumbled. "I can see that it's important."

"It's His work," Laxmi went on gaily as I sat on the floor of her crowded office waiting to talk to her; she'd paged me. Sheela was perched on a stool on one side of Laxmi's desk, Arup on the other. "No need for Kavi to 'do,'" she said. "Only be a vehicle for Him. Soon thousands will be coming. The ashram will be the largest growth center in the world. Laxmi predicts!"

As Kavi got up, teary-eyed and smiling, an elderly Scots couple inquired about the best way to bring money into India. They were "buying a room at the ashram," Laxmi's latest fundraising scheme. "Sheela will advise," she told them benignly. "She knows all the ways with money."

As the couple moved over to Sheela's side of the desk, a flamboyantly dressed advertising copywriter from Montreal took Kavi's empty seat.

"Swami-ji!" Laxmi beamed with delight at the sight of an old Bombay face. "You've come to stay?"

"I give up!" Krishna intoned dramatically, flinging his arms above his head. "There's nothing out there in the decadent world for me anymore; he's ruined it for me. I'm here to stay!"

"Good, good," Laxmi grinned. "Your friend has come, too?"

"He's outside," Krishna nodded. He, his lover, and his lover's ex-wife had lived next door to Chaitanya and me in Bombay once. A year later he married his lover's ex-wife. Now he was back with his wife's ex-husband again.

"Bring him in!" Laxmi ordered grandly. "Arup, get what's-his-name from outside. You know him? Blond hair with those eyes. And *chai* for everyone, ma."

By 5:15 only Laxmi, Sheela, Arup, and I were left in the office, all of us happily sampling the Swiss chocolates Krishna had brought, Arup putting two pieces aside for herself for later ("Greedy bitch!" Sheela mouthed), and Sheela taking two for Chinmaya.

"Take some for Chaitanya, Mommy," Sheela offered. "Another one. Go on. You know how much Fuck Face loves chocolate. Someone else'll only take them if you don't," glancing pointedly at Arup.

Laxmi shook her head, smiling indulgently. Ever since her recent battle with Sheela over the running of the ashram canteen (Bhagwan supporting Laxmi, Sheela finally tearfully surrendering), the two of them had developed a harmonious working relationship. Laxmi was the boss. Sheela seemed to accept that finally.

"So, ma," Laxmi turned to me abruptly: time for business. "You have the money to buy a room?"

"I, what?" surprised at the question. Aside from the $300 I'd given her in Bombay before my first meditation camp, she'd never asked me for money before, refusing it whenever I offered.

"Sheela was saying this morning that the sparrow might be interested. It's not a donation. $10,000 for one of the new rooms we're building. One more is left. If you and the lion want, you can have. Soon we'll be asking $20,000. $50,000. So, ma?"

"Sure," assuming the money was urgently needed. "I'll have to...."

But Sheela had already figured out how to do it. "It's 8:30 New York time," she said. "If you call your parents now, the money can be here by the weekend."

As Laxmi hurried off to shower for darshan, I called my parents, who had power of attorney for me—Sheela sitting beside me coaching me—and told them that I was buying a condominium in India. Yes, I already had a room at the ashram, I admitted, but this was a whole apartment, with my own kitchen, own bathroom. It never occurred to me, in fact,

that I'd actually get a room in exchange for my money. If Laxmi could "sell" the same apartment to someone else, I was sure she'd do it.

"But if you decide to leave," my mother protested. She didn't want to send the money.

"I can't imagine leaving here, Mom. This is my home. Besides," switching tactics midstream, Sheela whispering to me what I should say, "I'll be able to sell the apartment for twice as much in six months; it's a great investment," as if I'd ever given a damn about things like that. "Can you wire the money to me this afternoon? If I don't hurry, someone else'll get the place and with the way prices around here are skyrocketing...."

I conned my parents that day. I knew I was doing it. The idea of me giving $10,000 to the ashram would have horrified them. To me, it was no big deal. I'd always felt guilty about having money anyway. I was mortified as a kid when my grandfather's liveried black chauffeur picked me up at the movies in a stretch black Cadillac, opening up the car door for me and calling me, to my undying embarrassment, "Miss Jill." I'd been giving away money ever since, acting like a miser with myself, then offering the money I'd saved to the first person who asked for it.

If Laxmi had tried to wheedle money out of me, I'd have probably had my guard up, but I was handled with adroit diplomacy: we don't need your money, we don't want it; till year by year I'd given it all to the ashram. When I left the Oregon ranch penniless years later and asked my parents if I could borrow some money from them temporarily, they asked me why I didn't sell my apartment in India. Glib, facile, accustomed to deceit by now, I tried to explain: the ashram had gone into bankruptcy, bad investment; more lies—still not ready to admit the truth.

I didn't enjoy deceiving my parents on the phone that day; it made me feel cheap and shoddy. Then justifying my lies to myself, I suddenly felt incensed that I'd been forced to stoop to deceit. It was my own money I was asking my parents to send me. What business was it of their's anyway?

Two months later, to our amazement, Chaitanya and I moved into a new studio apartment in Krishna House. We had a tiny kitchen alcove (with no appliances) and our own bathroom. It was an incredible luxury by ashram standards.

Over the next few years, we were the visible, often-touted proof that a new period of integrity had begun at the ashram. Unlike earlier promises of housing that never materialized, the ashram was honoring its pledges now. It wasn't long before Laxmi was "selling rooms" in neighboring houses that the ashram only rented, didn't own. The desire to be-

come an ashramite was so great that people probably wouldn't have cared if they knew. "Buying a room" made them an instant ashramite; it bought their belonging.

While ashram workers who had no money eventually began to move into renovated servants quarters and huts on the ashram grounds, anyone who was suspected of having access to private sources of money soon had little chance of becoming an ashramite if they didn't buy a room. Long-time workers who were continually denied ashram housing looked at what it meant for them spiritually, "pointing the finger" at themselves as Laxmi advised. Were they unsurrendered, holding back; unworthy, untrusting? They were being hit, challenged. The ashram was a therapy group; they had something to learn through it. Money meant surrender.

ঌ

Several weeks after Chaitanya and I moved into our new room, Sheela and I were sent to the States on ashram business: me to contact publishers and book distributors, her to go shopping. She'd recently cooked up a scheme to provide bank-saving facilities at the ashram, convincing people that their money would be safer with her than anywhere else, and between "bank" deposits, donations, lecture tickets, group fees and book sales, there was a surfeit of money at the moment; enough for Sheela's shopping spree, not enough for Laxmi to feel comfortable about it.

"The purse strings Laxmi puts in charge of the sparrow, hmm?" she told me as Sheela said a boisterous goodbye to people outside the office the morning we were leaving. "If we let that one spend freely, nothing will be left. We've given the list. Nothing else you let her buy, okay?" If only it had been that easy.

"There's a place in Hackensack where they have fantastic bargains on towels," Sheela told me enthusiastically later that day as we buckled ourselves into our plane seats. "Bhagsie'll love 'em. The best quality. Half price. I'll get a set for you and Chaitanya."

"We don't really...."

"My treat," she grinned good-naturedly. I knew she didn't have any money of her own. "To make up for all the times you and Fuck Face have taken me and Chimney out to dinner."

"But do...?"

"And cheese for Chinmaya," she went on cheerfully. "A wheel of Jarlsburg and a wheel of—what do you think? Gouda maybe? I can keep it in Laxmi's fridge. Some Velveeta, potato chips, M&M's...," her fantasies

flying as wildly as a canary just released from its cage. From Irish linen for Bhagwan's robes to "White Out" for the typists, she had it all figured out. She'd stay with her in-laws in New Jersey, use her mother-in-law's car, go to every wholesaler in the tri-state area. "And Saks for Bhagsie. Or Bonwit's. What do you think, Mommy? You used to be rich."

"Do me a favor and wear this for awhile, will you?" she winked suddenly. Looking around to make sure no one was watching, she lifted the sleeve of her robe, where a $100,000 diamond watch of Bhagwan's encircled her wrist. She was taking it to the States to get some links removed. "It weighs a ton," clearly dazzled by it. "I don't know how Bhagsie can stand it."

Bhagwan had been devouring watch catalogues for as long as I could remember, asking wealthy sannyasins to bring him Rolexes, Omegas, Piagets, the latest and the best, then giving them away as soon as he got them, invariably to someone the giver of the watch didn't like. I assumed it was a deliberate button pusher, more than one person dropped sannyas because of his watches: a symbol of surrender for anyone "attached" to money. The watch Sheela was fastening around my wrist now (better for me to take it through customs than her presumably, though I didn't think about that at the time) was a gift from a sannyasin dope dealer who was a particular favorite of Laxmi's. Bhagwan had been wearing it for months, offending people by his ostentatious display of wealth. The Pope could wear jewels, all the maharajas of India could; an enlightened Master wasn't supposed to.

"Why don't you stay at the meditation center in New York with me?" I asked Sheela as our trays of food arrived. There was no way I could keep track of her spending if she stayed in New Jersey.

"After that fling I had with Daya?" she snorted incredulously. "You must be kidding!"

"I don't understand how you could have been with him, Sheela, honestly. You have the strangest taste in men, I swear."

"If I do, you do, Mommy!" she laughed playfully. "Chimney and Fuck Face could be brothers. Same tall, skinny bodies, freckly skin and circumsized you-know-whats," giggling.

"I can see why you're with Chinmaya, but not...."

"Shiva?" Sheela was indignant. "You don't think he's sexy? I don't even like sex and he...."

"No, Daya."

"I only fucked him twice, Mommy. You think he'd be running the center if I hadn't? I only did it for Bhagsie; I don't even like him. Shiva though," sighing. With Bhagwan's bodyguard it was the real thing: sex, lust; the birds and the bees.

When Shiva moved into Bhagwan's house a few months later, Sheela stopped sneaking out at night to be with him. She still had a soft spot in her heart for him though, she told me constantly. Six years later, when she set out to make his life at the ranch a hell for him, she presumably no longer did. Much water had flowed down the Ganges by this time. Shiva had risen to power and lost it. Sheela had risen to power and hadn't.

ô

Being in the States for three weeks was emotionally exhausting for me. The work went smoothly. Being with my kids didn't. My attempt to be as lighthearted with them as if I'd just been vacationing in the Caribbean for a few weeks ("I'm back, kids! Aren't you glad to see me?") didn't work after a seven-month absence. They didn't trust me.

Every time I went to see them, Patti tried to engage me in psychological analyses of "what I'd done" and why I'd done it. "Daddy says you left because you're sick," she said. "We should feel sorry for you. You're not capable of dealing with reality. You're a baby.

"Don't you even feel guilty for leaving us?" she'd ask me accusingly as we cried in each others' arms. "For what you're doing to your own *self*?!" If I was ready to repent and come back home—or at least admit that I was sick, that India was the loony bin I'd had myself committed to—Patti was ready to forgive me.

Nancy kept her distance meanwhile, answering my inquiries in monosyllables ("No." "Yes." "I don't know."), never letting me hug her or touch her, while Billy assured me repeatedly that everything was great, talking to me about school and sports and everything that was inconsequential to his feelings about me.

"I still cry at night for you sometimes," he admitted finally the day before I was to leave; it was the last time I'd see him.

"Billy love," hugging him. What was there to say? I still cried at night for him, too. Lying in bed beside Chaitanya, the ashram quiet finally, I'd long for my kids, ache for them. It wasn't going to change, though. We both knew that. I was going back to India. "Promise me you'll come visit," was all I could think of to say. "Please, Billy! I want you to so much."

"Yeah, sure," shifting into another gear, his tears disappearing as quickly as they'd come. "I told you my soccer team's in first place, didn't I, Mom? If we don't lose the next two games, we'll go to the all-state competition." He was nine and a half. I was losing him to soccer and suburbia. How could I expect not to?

Billy, Billy, I wanted to cry. I wanted my baby back, wanted them all back. On my terms, though. In India, not Scarsdale. The land of amoebas and dysentery, hepatitis and disease. Joint custody or not, I knew I had no right to sacrifice their health by forcing Danny to let them visit me, but that didn't make it any easier. I still wanted my babies back.

By the time my mother drove Sheela and me to the airport for our trip back to India, I was a psychological wreck, ready to return to the ashram where no one made emotional demands on me that I couldn't fulfill or asked anything of me that I couldn't give them. Ashram life was simple and uncomplicated, conflicts superficial, reasons to judge myself all but nonexistent.

Despite Laxmi's request to keep my eye on Sheela, I'd only seen her a couple of times since we'd been away. Spending the ashram's money with enthusiastic abandon, she was loaded down now with overweight contraband that she meticulously packed in the extra suitcases my mother brought, hiding tape recorders and expensive camera equipment between our clothing, her packing a miracle of inventiveness.

"You've got too many pieces," the man at the ticket counter told us as we checked in. "It'll cost you over $1,000 in overweight. Why don't you send your excess on as unaccompanied baggage?"

At the airline shipping office, my mother took over, the helpless damsel in distress, charming the fat middle-aged shipping clerk till he couldn't do enough to help the beautiful lady and her "daughters" (Sheela had been calling her "Mom"), and we ended up paying a fraction of what we would have otherwise.

"Your mother's terrific!" Sheela gushed enthusiastically. It was a lesson she learned well, the steady traffic of goods between the ashram and the west soon becoming a sophisticated science, and an increasingly dangerous one.

ৰ

"*One, two, three o'clock, four o'clock rock.*" Chinmaya's and Chaitanya's voices rang out over the quiet stillness of Koregaon Park as Sheela and I, a few paces behind them, discussed the new refinements she'd come up with in the ashram "sniffing" routine. The four of us had been out to dinner, Sheela's treat; she'd received some money from her brother the day before.

"*Nine, ten, eleven o'clock, twelve o'clock rock.*" Chinmaya started doing the stroll. Chaitanya, arms raised, was Sufi twirling.

"It's not enough to sniff their hair and armpits," Sheela was telling me

earnestly now, "sniffing" having begun a year earlier in an effort to protect our hyperallergic, asthmatic Master from the perfumed smell of shampoos, soaps, and deodorant. Every morning and evening before lectures and darshans, Shiva and Kavi carefully "sniffed" everyone entering the lecture hall, turning away anyone with any body or perfume smell (or if the odor was mild, asking them to sit in back).

"You wouldn't believe the breath of some people!" she went on disgustedly. "Bhagsie says it's the toxins they release in groups. Then they sit in front and *breathe* on him! Groupies!"

I laughed, remembering the smell of curried farts in the closed quarters of the Mt. Abu meditation camps. Breathing deeply during Dynamic had been a revolting experience, one Sheela had been spared no doubt; she never meditated.

"Starting tomorrow we're checking people's breath," she said as the Shree Ashram Tabernacle Choir of two kept singing. "Anyone with real dragon's breath...."

"Sats?" Chinmaya held out his hand to me. "*Let's go strolling,*" he and his choirmate sang, "*strolling down the lane.*"

We strolled through the grotesquely ornate ashram gate, facing each other, our backs to each other, the beggars and *beedie wallahs* sitting by the side of the road laughing, Sheela laughing; then we strolled past the bookstore and down the path in front of Krishna House till we reached Laxmi's office.

"We were wondering where all the friends were tonight," Laxmi grinned happily as we strolled inside. "Movies? Some James Bond?"

The four of us never missed an evening with Laxmi if we could help it. As soon as the office was empty except for us (and occasionally Arup), Laxmi would fill us in on all the innuendos and asides of ashram life: what Bhagwan had said that night at darshan to whom; what new policy was about to be instituted and why; who was fighting with whom or having an affair with whom; who was coming to the ashram or leaving; what Bhagwan had told her to tell what government official; what he'd told her privately at their post-darshan conference about someone who'd been at darshan.

"Laila* was there tonight," she commented, offering us some chocolate. People continually brought Laxmi treats from the west that ended up in our mouths. "The 'massage therapist.' You know her? The one doing hand jobs," delighting in her new hip slang. "So beautiful the way He talked to her," eyes sparkling. "Blah-blah-blah about being the witness when she gives the hand job. Put her to work tomorrow, Sheela. Tell Arup.

"And Deeksha sent a message: she wants to give up running the cen-

ter in Geneva and come. This is the cunning mind. She thinks to go via-via, around Laxmi. First she pays the money back, then the coming can happen."

Premda's mother, visiting the ashram for the last three weeks, had been at darshan that night as well. Scores of parents who came to Poona to visit their children ended up taking sannyas. Arup's and Kavi's mothers had. Fathers did less often. Premda's mother didn't.

"A perfect Catholic lady," Laxmi sighed, shaking her head sadly. "'I love Jesus,' she told Him. 'He's given me everything.' So blind these people! An alive Jesus is sitting in front of them and they miss! The atom bomb's parents are coming after the camp, isn't it?" she grinned impishly.

"Yeah and they better be wearing orange this time or they're not staying with me!" Sheela exploded; her parents had been (lax) sannyasins for years. "No one can tell that old man anything, I swear! He's as bad as Bhagwan!"

An Oxford-educated revolutionary who'd once reputedly accompanied Gandhi to England, Sheela's father was an exuberant rascal who loved outraging people, but compared to Bhagwan he was a harmless old eccentric. When Premda's pious Catholic mother arrived at the ashram, Bhagwan started calling Jesus a 4'8" hunchback, probably homosexual, clearly a drunkard. When Kavi's Jewish parents came, he praised Hitler as a spiritual being: "Mad in a way, yes, but a vehicle for higher forces." Sprinkling his talks on Buddha, Lao Tzu, Jesus, and Mahavir with snippets from *Playboy*, the profound tempered by the profane, Bhagwan delighted in pushing people's buttons, trying to shock us into waking up.

"And the brother comes next month, too, isn't it?" Laxmi added innocently.

"He's *certainly* not gonna stay with me!" Sheela retorted indignantly. She and Chinmaya were moving into my room so her parents could have the new room they'd moved into down the hall from Chaitanya and me; we were one big happy family. Her brother, on the other hand, could stay at a nearby hotel, pay for it with his gambling winnings. He wasn't even a sannyasin.

Sheela's brash, volatile brother turned out to be so much like her that, despite myself, I couldn't help liking him. A loud-mouthed caricature of an American tough guy and a greedy-for-the-best-of-everything Indian, Bipen reeked of fast money and sleazy deals even if there was nothing concrete I could put my finger on to prove it. One look at the ashram, with foreigners from all over the world pouring in with their money,

and dollar signs seemed to light up in his eyes like the bonus 100,000-extra-points counters in a pinball game.

When Sheela insisted that Bipen go to darshan to see Bhagwan on his subsequent trips to the ashram, he protested vehemently that he had "nothin' to say to the guy. You holy types can go sit on the fuckin' marble floor for two hours and freeze your butts off, but I got better things to do. You know that redhead with the big tits, Sats? My little sister's too busy being important to introduce us. Maybe you could...."

"Just get that stinking aftershave off your face or they won't let you in," Sheela cut in peevishly. She'd handed hundreds of thousands of dollars of the ashram's money over to Bipen to invest by now. It was only fitting that he saw Bhagwan occasionally.

With a *Playboy* bunny girlfriend by his side, both of them dressed in long, white Arab burnooses, Bipen finally took sannyas one evening. It looked better that way. Religion is for the devout and for the mercenary. It's the best scam around sometimes.

It wasn't long before the Chicago newspapers were writing glowing stories about the Indian financial wizard who was driving a taxi one month and the next month had his own Rolls Royce and was frequenting every glamorous nightspot in town. Interviewed about the secret behind his meteoric success, Bipen was unaccustomedly closed-mouthed. He had a way with money, was all he'd say. Investing his pennies wisely (no mention, of course, of where he got the "pennies" in the first place), he'd turned nothing into a fortune...and become a man to be reckoned with.

ã

"Sats! Chimney! Mr. Hot Shot Meditation!" Sheela shouted one evening from halfway down the hall as the three of us lay on Chaitanya's and my bed playing poker for Smarties (ersatz Indian M&M's). Sheela had dashed out a few minutes before in the middle of a hand when she heard Laxmi's voice outside. She had terrible cards anyway.

"Hey, you guys," opening the door abruptly. "Didn't you hear me calling for petesakes? Come on!!"

"What do you...?"

"Come *on*! I'll meet you downstairs in Laxmi's office. We have to move fast!"

"The raid must be happening," Chinmaya muttered testily as he scrambled to his feet and stuffed a handful of Smarties into his mouth. "Fucking government bureaucrats!"

By the time we got downstairs, Sheela was already pulling papers

haphazardly out of the filing cabinets in Laxmi's office, the curtains discreetly closed. "Take everything out of the files in the outside office, Sats," she ordered. "No lights. Chinmaya, the ones in Premda's old room. Use a flashlight. Chai: find wood, I don't care where; anything that burns. Get a fire going over by the old canteen. We have twenty...thirty minutes, tops."

"Some of these are financial records," I stage-whispered to Sheela from the outer office a moment later. "Shouldn't we...?"

"Take everything!" she hissed back impatiently. "I don't care what it is, we burn it!"

Chaitanya's bonfire was soon blazing as merrily as a Ku Klux Klansman's cross as we rushed back and forth from the office, feeding it a steady supply of papers.

"Nothing's irreplaceable," Sheela murmured, dumping an armful of papers in the fire. "There's no time to figure out what's important. Everything goes!"

I had no idea what the government was looking for—it was obviously a case of political harassment; Laxmi had been forewarned by a sympathetic government official—but we burnt every office record we could find, doing American Indian war dances around the blazing fire.

"Satya-ma-ji." Ravjiv walked over to the bonfire cautiously. "What you are doing?" He and his girlfriend could see the fire from their bedroom window.

"Nothing," Sheela answered tersely, patting her mouth with her hand ("Wa-wa-wa!") and dancing around the fire; Chinmaya joining her; Chaitanya, letting out a spontaneous war cry, joining.

"It's an ancient American Indian custom," I explained lamely. "Done every year on this day."

"Wa-wa-wa!" the three of them chanted as Sheela motioned to me to get rid of Ravjiv.

"Part of our culture."

"Strange this is," Ravjiv commented. "Anyone can join?" hardly the fool we were making him out to be. "There are spiritual benefits from this? Your redskins are...."

"Just go to bed, Ravjiv," leading him away gently. "It's...."

"Americans only!" Sheela cut in sharply as she danced past us. "It's a sacred dance! No observers allowed! Satya!"

As I walked Ravjiv determinedly back to his room, Sheela raced back to the office to empty out another file; Chaitanya followed her, Chinmaya wa-wa-wa-ing for all he was worth.

It wasn't a job Laxmi had trusted Arup with, and it certainly wasn't

one she wanted anyone else to know about. In quasi-legal matters, Sheela was her aide-de-camp.

I never thought about the episode again. I was at the ashram for my spiritual growth, for Bhagwan. Anything else that happened was a means to an end, an irrelevancy. If Indian officials wanted to destroy the ashram—religious prejudice seemed to be as rampant in Indian as anywhere else—I'd do what I could to prevent it. Unquestionably. Whatever Laxmi/Bhagwan said was needed.

"*Wa-wa-wa....*" Why not?

*L*ove is possible only if there is no possessiveness," Bhagwan said. "You love the person, but you renounce possessiveness. You don't make a slave out of them; your love doesn't become an imprisonment. You love tremendously, yet you remain unattached; you don't cling. This is renunciation."

Shivers ran up my spine as Bhagwan talked. Half the time I didn't listen to his words anymore. After a year and a half of drinking him in every morning, wallowing in him throughout the day, editing his words, proofreading them, going over them again and again till they were as familiar as a nursery rhyme, I felt as if I knew everything he had to say. "I use words only to take you to a place that is beyond words," he'd said. They'd long since ceased to be the most important part of his teachings for me.

Moving in and out of the calm, pulsating space his presence always evoked in me, Bhagwan's words forced their way into my consciousness this morning. "To love the world but not be attached to it is what I call sannyas: a great harmony between love and renunciation, this world and that; the body and soul." By the time the lecture ended, there were half-comatose bodies scattered all over the hall: blissed out casualties, the love-wounded.

Barely coherent enough to begin work a half-hour later, I sat on my bed surrounded by piles of manuscripts. I'd been up till two the night before getting two books of Bhagwan's ready for the printers. Three typists were working on manuscripts for me: Hindi lectures I was revising, a book of my own I was trying to finish; I had deadlines for everything.

Arup knocked on my door. "Laxmi wants to see you, Sats," she said,

assuring me as we hurried over to Lao Tzu House that it was something good, "good" being all in the interpretation, of course.

"So, sparrow," Laxmi greeted me with a chirpy smile as she sat in her oversized chair drinking *chai*. I sat down on the floor beside Sheela, who was diligently massaging Laxmi's foot; Arup sat on the bed. "Your passport's in order?" Laxmi inquired. I nodded, wondering why she was asking. "Good," she said. "Pack your things. You leave for America tomorrow."

"I, *what*?!"

There was much work for me to do, she told me over my feeble protestations. That I didn't know the first thing about "the work" anymore—I'd been writing and editing full time for months; Sheela had gone back to the States by herself six months ago—was something she obviously knew. "The atom bomb went last time," she said. "It's the sparrow's turn now. Three months Satya can...."

"Three *months*!!" I exploded. Laxmi wasn't talking about a business trip. It was a banishment; exile.

"Or it can take six weeks," she laughed airily. "It depends on the sparrow. However long it takes to do the work, hmm, ma?"

"Oh." Sighing deeply, I closed my eyes and let myself tune into Bhagwan's presence in the room next door. What was there to say? The whole thing had obviously been decided on already; it wasn't up to me. All I had to do was say yes.

A slow smile spread over my face. A grin burst its way out of me. My heart started dancing a hot gavotte with all the chilies and peppers on it, the no in me suddenly a yes, a hallelujah. After nearly a year, I'd see my kids again!

"What am I supposed to do?" I asked Laxmi finally.

"This we don't know," she admitted. "He said the sparrow will know when it happens. Whatever Satya does is the work. Only a few suggestions are there. You have the list, ma?"

As Arup handed Laxmi her clipboard, Sheela told me enviously how much she wished she were going with me. I could eat whatever I wanted, sleep late, watch Marx Brothers movies on TV.

"Why doesn't Sheela come, too?"

"Only the sparrow this time," Laxmi said, glancing at her notes. "It's Satya's kind of work." I was to see the people at *Playboy*, she continued. Who? Why? It would be clear when I got there. Arrange to meet Werner Erhard. "If you're feeling to invite him to Poona, it would be good. Whatever Satya's feeling is." See publishers and book distributors; whoever, wherever. Sannyasins all over America were being written to expect me; I'd be taken care of. "So little one, tomorrow the plane, hmmm?"

It was three weeks before I left. The P.R. brochures I was to bring with me kept taking one day longer, then another. Day by day the trip was delayed till it got embarrassing to say goodbye to people anymore. I sometimes wondered if I was going at all; the whole thing seemed like an exercise in living in the here and now.

Finally, the brochures back from the printers, scheduled to leave the following day, I waited at the Lao Tzu gate with fifty other people for my farewell darshan, as excited to be leaving as I was eager to return.

Shiva called my name, sniffed my hair, and asked if I was using a new shampoo; there was a decided perfume smell on me. "Try again tomorrow," he mumbled indifferently. "Next name, Kavi."

"For chrissakes, Shiva!" What was wrong with him?! He knew damn well I was leaving in the morning! "My hair always smells like this. I don't know what you're...."

"Then maybe you shouldn't sit in front anymore," he commented coldly. "I'll have the guards check you more carefully from now on."

"Shiva!!" I couldn't believe him! I was being banished from the goddamn kingdom of god, going to do "His" goddamn work in America, and they weren't going to let me go to a goddamn darshan!

"Run upstairs and get a scarf," Kavi whispered quickly. "I'll help you put it on. Hurry, Sats! It's getting late."

As I raced back to the gate three minutes later, people were already going into darshan. Thank god I had a reserved seat in front, I thought gratefully as Kavi wrapped a scarf around my head till I looked like a sheik, a miniature maharaja, a joke.

"There's still some smell coming through," Shiva pronounced somberly as he sniffed my turban-wrapped head. I wasn't going to get into darshan at all! The whole thing had been planned, I knew it had. "You can sit in the back since it's your last night," he relented finally as if he were doing me a big favor. "You better hurry. It's almost time for Bhagwan to come out."

A fine last darshan! I was infuriated! Hurrying through the house, the end of my scarf hanging in my face, I felt like a fool; I knew I looked like one. I wondered if I'd be called up front to see Bhagwan, or if Shiva had crossed my name off the list.

I fumed throughout darshan. By the time my name was called my scarf had slipped halfway down my forehead. Walking to the front, I pulled it angrily over my head till it was around my neck. Fuck this; I didn't care; my hair didn't smell anyway. Bhagwan started chuckling as Shiva gave me a stern, chastising look.

"I wondered where Satya was tonight," Bhagwan said as I sat down in front of him. "All the way back there!" laughing.

As I touched my head to his feet and he rested his hand lightly on my head, all my rage suddenly disappeared, the energy of it moving inside me, flooding me. I began trembling and shaking as he kept his hand on my head, charging me up; readying me for my trip; giving me a six-week-to-three-month supply of Bhagwan-juice to take away with me. It was almost more than I could take. I needed every bit of it. It was an earthquake, orgasmic, and a quiet, still pool of calmness all at once.

"You are ready to go?" Bhagwan asked when he'd finally stopped zapping me and I was looking up at him.

"Yes," whispering softly.

"Anything to say?"

I nodded. "I don't know what I'm supposed to do," voice cracking, "so how will I know when I've done it?"

"You'll know," he said. "If you think you've finished in less than six weeks, it's just the mind; more will be there to do. But after three months, if there's still more to do, drop it. It will just be the mind again, wanting to complete things. There's no need for the mind to be there. Just do my work. I will be with you."

The trip was extraordinary for me; doors opened up everywhere I went. Strangers on planes, trains and in publishing companies poured out their hearts to me, inviting me to their homes. Taxi drivers refused tips, thanking me profusely for something; I had no idea what. A woman I met in an elevator begged me to be her teacher. I told her to go to India to meet Bhagwan. He had something to teach her. I didn't.

Moment to moment, what I was supposed to do became clear, "the work" happening effortlessly. With New York as my main base so I could be near my kids, I travelled extensively, staying with Sheela's family in California and with sannyasins I hardly knew elsewhere.

I spent hours with Werner Erhard (who visited the ashram with Diana Ross several months later), introduced two *Playboy* editors to Bhagwan (articles on the Rajneesh movement eventually appearing in the magazine), lectured and officiated at the opening of several new Rajneesh centers, and met with book publishers and distributors as well as the parents of wealthy sannyasins who were living in Poona, convincing the former to buy Bhagwan's books and the latter to buy their children rooms at the ashram.

I saw my family, obviously. If strangers greeted me with open arms, my kids didn't. Oblivious to the halo I was wearing around my head, it took weeks to break down the defenses they'd built up against me. I could hardly have expected it to be otherwise.

Embarrassed and concerned by his indifference, Billy told me that if he

never saw me again it was okay. I had my life; he had his. "I love you, Mom, you know that, but I don't really care that you're not here any-more. I have a good life with Dad. I'm happy." Humoring me? I prayed it was true. "I used to think the way you do," he said, his eyes twin-kling, "but I grew up," half-teasing, half not probably. "Don't you think it's time you grew up, too?"

Patti alternated between affection and anger. Nancy was still aloof, but a bit more communicative than she'd been before, her teenage rebel-lion against Danny making her more sympathetic to me than she'd been in years. As absent as I was from my kids' lives, I gathered that I was a constant image Danny held up to them ("You sound like your mother, you know that?"—always a criticism) and an image they held up to themselves: "I don't care what Daddy says. Mommy would...." My ab-sence had more reality to them than my presence. They were used to me not being around.

With the last of my money, I bought a $20,000 IBM composer for the ashram, office supplies, cassettes, photographic equipment and medicine: the best modern technology could provide.

"Trust." "Life provides." "Sannyas means to live in constant insecur-ity." I built my life around Bhagwan's words. "Trust in God but tether your camel," he also advised. I was good at trust but not so good at tethering my camel. Sheela derided me for years afterwards for making myself financially dependent on the ashram, having to beg for everything I needed. She had no intention of doing the same thing; she was nobody's fool. Maybe I was.

In many ways, I think I gave away the last of my money out of spir-itual greed. Money gave people an escape route I didn't want to have. It was only when someone had no more options, Bhagwan said, that he could really work with them, forcing them to see truths about themselves that they'd rather not see. As long as one held onto money, career, fam-ily (all obvious escape routes), true surrender was impossible.

I never questioned Bhagwan's insistence on surrender. One surrenders to a lover joyously, willingly. It's only when the love affair ends that you notice the paunchy jowls and sagging muscles, the cruelties and indiffer-ence, and suspicion creeps in.

੩**ੳ**

"Did that dumb-ass sister of mine finally get some life insurance for her old man?" Sheela's brother Bipen asked abruptly one evening as we sat in a trendy New York restaurant eating dinner.

"They're still trying," I murmured, dipping an artichoke leaf into butter.

"I told her a thousand times to contact the Teacher's Union. They got a group plan. I checked. Chinmaya's eligible. I bet he has it already and they don't even know it." He stuffed an artichoke leaf greedily into his mouth. "You really eat this crap?"

"You have to...."

"She's got a fortune there," lowering his voice to a conspiratorial level. "I don't care if he's better now; the guy's got cancer. One of these days he's gonna croak. She should at least make some bucks from it."

"Bipen!"

"Don't get so high and holy on me!" he grinned roguishly. "They don't need to know Chinmaya has cancer. Tell Sheela to move on it, will ya? Do I have to do all her thinking for her?!"

When Bipen called the meditation center two days later to talk to me, he was in a panic. "Jesus Christ, Satya! I've been tryin' you for ten minutes. Thank god you're not at some stupid meeting. Listen, you know what's-his-name, right?" mentioning the name of the dope dealer who'd given Bhagwan the diamond watch.

"Uhuh," distracted. I was due somewhere in twenty minutes.

"He's gonna call. I don't care what else you gotta do, wait. You hear?"

"Sure, but...."

"All you gotta do is tell him I'm Sheela's brother, okay? Fuckin' guy doesn't believe me. He's gonna call. Wait."

When Swami Dope Dealer called a few minutes later, he was far more cordial, a nice guy, drug (ex-drug?) dealer or not. After inquiring after my family and mutual friends in Poona, he asked if I had a message for him from Laxmi; he'd been trying to get through to the ashram all morning. It could take hours, he said, days, both of us laughing; it could indeed. "I hate to involve you in this, Satya, but since you're the ashram's representative...."

Oh god, no, I thought apprehensively. What did he want? What did it have to do with me?

Facts: I knew Bipen had a sizable amount of the ashram's money to invest. I knew Swami Dope Dealer was (or had been) a dope dealer. I had no value judgement about what people did with their money or their lives. Drug deals didn't imply the corruption of minors outside their junior high school to me. I thought of dope as an occasional recreation, less harmful or addictive than alcohol. For the ashram's money to be involved was another story, though. I didn't approve. No!

"All I'm asking," the voice on the phone said gently, "is whether the guy's Sheela's brother?"

"I, ah...," stalling; knowing Laxmi wouldn't say no; for all I knew she could have set up their meeting herself. "Yes," sighing finally. "Can't you tell? There's a strong family resemblance."

"Can't see it myself," he laughed. "I just wanted to make sure." And wishing me a good trip back ("My love to Bhagwan and Laxmi!"), he hung up.

"It was a mistake." Laxmi said sternly as I sat on the floor of her bedroom the night after I arrived back at the ashram. "It isn't what He wanted."

We were alone in her room after her post-darshan meeting with Bhagwan. I'd spent the afternoon typing up a ten-page report of everything I'd done in the States, Bhagwan presumably having read it by now and spoken to Laxmi about it. I hadn't written anything about my conversation with Swami D Dealer, it was a non-event in the overall trip, but had just mentioned it to her. How I'd second-guessed what I thought she'd do even though it went against my own instincts.

"Wouldn't you have...?"

"That's not the point, ma!" Laxmi said. "If He wanted Laxmi's decisions to be made, He would have sent Laxmi. He sent Satya because He wanted Satya's decisions made. The only thing He expects of us is to be true to ourselves. If you didn't feel right about what you were doing, you failed both Him and yourself."

For years afterwards, Laxmi's "hit" was the proof I gave myself that Bhagwan knew nothing about the drug deals the ashram was rumored to be involved in, that he wouldn't have condoned them if he knew. And yet....

Bhagwan said often that it was his responsibility to know what decisions his disciples would make. "I'm perfectly aware of everything that goes on here; nothing is out of my hands. Each person is in the role they're in purposely, deliberately. I know their problems and their limitations. I know exactly how they'll distort what I say."

There's no way he could not have known what his "ladies" were capable of doing. I don't think he cared so long as "the work" happened, his movement was growing and expanding. Several swamis have alleged that he personally advised them of auspicious dates to do their drug runs in Bombay and Poona. How explicit they were about what they were doing (did they say they were embarking on drug runs, or just assume he knew?) isn't clear, but none of them questioned his support at the time.

It was common knowledge that Laxmi solicited donations from every-

one she could, including (ex?) dope dealers who were now sannyasins. Jokes about the Poona ashram being built on drug money were rampant in the early days. Hippies, never particularly welcomed in Woodlands, were suddenly cleaning up their acts and living at the ashram. Whoever had money, and however they'd gotten it, Laxmi's hands were always open, no questions asked. Give, and all your sins will be forgiven.

Two years after my trip to the States, Sheela's lover and two other swamis were arrested in Yugoslavia with fifty kilos of marijuana hidden in the frame of their mini-bus. Clearly on an ashram-sponsored esca-pade—I had no idea of the nature of it till they were arrested—the three had been given warm farewells by Sheela and Arup the day they left. Released from jail (one immediately, the others a year later), they re-turned to the ashram like war heros home from the battle.

Unbeknownst to most of us at the ashram, meanwhile, other sannyasins were being picked up as drug couriers in France, Germany, and elsewhere. It wasn't until three English ma's were arrested in Paris in 1980 on dope smuggling charges, claiming they'd been brainwashed into doing it in an ashram therapy group, that the story reached us in India, Laxmi publicly denying the ashram's involvement. Putting Bhagwan on trial in essence was a shrewd defense, but I was sure it had no connection to reality. People might have been "brainwashed into sur-rendering" in groups (though I hardly thought of it in those terms at the time), but I couldn't imagine the subject of drug smuggling coming up; it was inconceivable in a therapy group context.

Which isn't to say that I didn't know sannyasins in Poona were doing dope runs. Westerners had been smuggling drugs out of India for de-cades. A relatively safe way to get-rich-quick, it had obvious appeal for middle- and upper-class drop-outs who hadn't earned money in years yet were continually being pressured to buy rooms at the ashram, make donations, do meditation camps, groups and therapist-training courses, buy books, tapes, and wall-sized photos of Bhagwan. More than one ash-ram worker asked to borrow money from me to do a dope run so they could buy a room. Being broke made it easy to refuse.

Was the ashram responsible? Did Laxmi suggest that this ma talk to that swami who "knew all the ways with money"? Did anyone else in the office suggest "...strictly off the record, swami," nudge, nudge, wink, wink, "if I were you I'd..."? Sannyasins on drug runs seemed to have few qualms about what they were doing, convinced Bhagwan would protect them from both "bad karma" and the authorities. Anything they did "for him" was pure; blameless.

"He's very pleased with Satya's work," Laxmi commented as she handed me back my ten-page report with its carefully thought-out anal-

yses of why the ashram could do this in America and couldn't do that, and a dozen alternatives. "The western rational mind," she laughed. "The sparrow doesn't think like an Indian, like Laxmi. He says to do, Laxmi just does. It doesn't matter how."

Laxmi's approach to the work was clearly Sheela's as well, and she soon took over completely as the liaison between the ashram and America, making repeated trips back and forth between the two countries. Nothing Bhagwan asked her to do was impossible. If she wanted to do something, she did it, even if it meant stretching the law to suit her purposes. She loved the drama and intrigue of high finances, international wheeling and dealing, loved flaunting her audaciousness, while I preferred writing and editing books. Sheela was everything Bhagwan wanted. And then some.

ॐ

"It's your Jew-nature coming up," my Reubenesque Italian friend, Deeksha, said several weeks later as she sat on my bed and brutally massaged my foot, pooh-poohing my pained protests. "You dress like an ascetic—the poor little rich girl: a typical Jew syndrome!—and someone else buys enough clothes to feed half the beggars in Poona. It's your Jew nature upside down, eh, *bella*?"

"I still don't see what an expensive boutique is doing at the ashram," I muttered, extricating myself from Deeksha's knead-and-torture solicitations so I could stir the spaghetti sauce I was making on my tiny one-burner stove. I'd been cooking dinner every night for Sheela, Chinmaya, Chaitanya, and myself since my return, Chinmaya's Hodgkin's disease having started up again after years in remission. Canteen food had little appeal to him; he was losing weight quickly. I was trying to tempt him with his favorite meals.

"Bhagwan wants to attract all the rich Jews," Deeksha commented dryly. Rumored to be the granddaughter of one of Mussolini's generals, she was part-Jewish herself, her lover was Jewish; Bhagwan even talked about himself as an old Jew. "Laxmi and Sheela are perfect Jews," she said. "Wherever there's money, they put their energy. That's why there's a fancy new boutique here and I can't get a hundred lousy rupees to buy some decent pots for the canteen. It's pathetic, no?"

I laughed, lying down and surrendering myself to her painful steel-grip hands again. After presiding over the Rajneesh center in Geneva for years, Deeksha had finally been allowed to move to the ashram, running the canteen ever since she arrived. Accused by Laxmi of diverting funds intended for the ashram to her center in Geneva (something she swore

she didn't do), she had a reputation for being stubborn and full of ego. She never surrendered without a fight when Laxmi hit her for something; shouting matches between them were a common occurrence. Eventually Deeksha stopped trying to get funds out of "those women" for the canteen, using her own money to do what she wanted. After the restaurant she started became one of the ashram's major money-makers, she finally earned Laxmi's and Sheela's begrudging respect, the private ashram empire she set up for herself (and ran like a feudal kingdom) rivalling the office's power by this time.

"The only thing that surprises me as much as the boutique—ouch, Deeksha, you're killing me!—is Vivek having a boyfriend."

"It's beautiful, no, *amoré*?"

"But *Vivek*? Who would have believed it?"

"You think she doesn't have a warm pussy like you, Satya? Don't be such a ascetic. Vivek hasn't looked so good in years. Can you imagine being with that man day and night? She deserves...."

"Mail, Satsie!" Laila interrupted, opening the door abruptly and tossing a letter from Danny on my bed. "Sorry I couldn't bring it up earlier. I put a shitload of letters on your desk downstairs, one of them from a German guy who wants to make a movie here; you better get down there." Writing and editing half a day, I spent the rest of my time working on copyright matters and arranging for Bhagwan's books to be published commercially.

"I'll be down as soon as I read this," I said as I ripped open Danny's letter eagerly. He'd promised to write regularly and let me know how the kids were. It was the first time he had.

"I go, *amoré*," Deeksha mumbled, leaving discreetly as I read Danny's letter over and over again, incredulous at what I was reading, tears streaming down my face.

I don't want you to try and see the kids anymore, Jill. I have too much trouble with them when you leave. India's your home? Good. Stay there. I can't stop you from writing obviously, but I'm not so sure it's a good idea. I hope you won't feel....

That he was being vindictive? Cruel? Saying the one thing I wasn't prepared to hear? This wasn't part of the script, goddammit! —sobbing and sobbing, feeling like my heart was about to break. I wasn't much of a mother, god knows, but I loved my kids; I knew they loved me. The idea of never seeing them again, of losing whatever peripheral contact we still had, was out of the question. Goddamn Danny! Wasn't it enough for him that I'd absented myself this much? If I hadn't given him virtual custody of the children, the courts would have done it. He'd

have tried to prevent me from seeing them; I knew he would have. They were *his* kids. Well, goddammit, they were mine, too!

I wasn't going to take it! I ran down to Laxmi's office and thrust the letter at her, crying pitifully.

"Tell me," she said, ignoring my outstretched hand.

"It's my...." I could hardly talk. "My kids. Their father...."

"Satya and her kids," Sheela sighed peevishly. "Why don't you just drop them, Mommy? You're too attached to them. She is, Laxmi. You should hear her. Always missing them, suffering. Everyone at the ashram knows more about your three kids than...."

What did she know, goddammit? She wasn't a mother.

"He doesn't want...," I tried again as Laxmi got up to leave to get ready for darshan, Sheela pushing out her chair for her while Arup waited patiently by the door.

"We have to go, ma. Sorry. Laxmi needs the bath. Give the letter. We'll talk to Him."

"It'll be okay, Mommy." Sheela reached out suddenly to touch me as if she'd just realized I was upset. "He'll take care of everything, you'll see. Vidya," turning to her and Arup's new assistant, "get Satsie some tea. I'll come over and make a nice dessert for us when I finish with Laxmi, okay?"

As I wept inconsolably, my head on Laxmi's desk, Vidya brought in some tea and sat down beside me. "I don't have kids myself," she stammered self-consciously, "so I can't really.... Did I tell you what Bhagsie said when Bodhi and me told him we wanted to have kids?" she went on awkwardly, patting my head shyly. "To try it first, you know? Borrow a friend's kid, see how we liked it. After three days," she laughed nervously, "help! Bodhi thought I was gonna have a nervous breakdown! We had to give the kid back. No way I could have kids. Can you see me as a mother, Sats, honestly?"

"Well you certainly have the tits for it," I laughed despite myself. Chaitanya called her Two Watermelons on a Stick; she could have nursed the entire Indian army with her mammoth glands.

"You gotta to be crazy to want a kid," the tall, blond, beak-faced computer whiz from South Africa commented. "I don't know how you mothers do it. I swear to god I don't."

When I went to darshan the next night, Bhagwan talked to me about my kids as if we'd been having a running conversation about them for years, remembering everything I'd ever told him about them, including a letter Patti wrote once about a dream she'd had of him: "Tell him to get out my mind! I don't even believe in that sannyas stuff!"

It was the first time he'd spoken to me about anything but work for as long as I could remember. "You know you have no problems," he'd laugh whenever I went to darshan to see him, patting me on the head, zapping me, as if he were telling me it was time to connect with him in a different way: in silence.

"Your children are my responsibility," he said as I sat in front of him crying, as I'd been doing virtually nonstop since I read Danny's letter. "You have to listen to your husband. He knows what's happening; you don't. Everything is happening the way it should; I am taking care," touching my head, my tear-streaked face pressed against the marble floor. "Not to worry, everything is good. When the time is right, they'll come to Poona. This is the preparation, hmmm?"

The next day, I began practicing "death meditations" in my room: visualizing the death of each of my children, watching their bodies being burned, watching them be born again and die again; trying to make myself detached from the inevitabilities of life, detached from them. I watched myself lying on my own funeral pyre, waiting for my body to be burned; burning; my soul released. My own death was easier to accept than my children's.

Slowly, day by day, I got used to the idea of not seeing my kids anymore, content with writing weekly letters that they never answered. And finally, the intolerable became acceptable...as long as I didn't think about it too much.

10

*T*he next time Sheela went to the States, she promised to visit my parents (as she always did on her trips) and threatened to visit my kids. "It's high time I met them. If Danny won't let you see them, it's the least I can do. Seduce Danny while I'm at it...."

"Sheela!" She'd been urging me for months to take Danny to court, claiming that I'd been brainwashed by a Indian cult when I refused to take alimony. I was back in my right mind now, I'd seen the light: give!

"...And bring him to Poona. I'd only do it for you, Mommy. I know how to get someone like Danny to fall for me. Isn't that want you want? You'll have your kids and we'll have his millions!"

While Sheela was gone, Chinmaya was hospitalized; he had TB as well as cancer by now; and I rarely left his bedside. Deciding that there was no need for Sheela to rush home, Laxmi didn't tell her he was sick. When she returned to India, she was furious.

"I can't believe Laxmi didn't once tell me, even hint," she wept as we paced up and down the corridor outside Chinmaya's hospital room while he slept. "You could have finished the work in the States; it didn't have to be me. What if Chimney...?"

"If he'd gotten any worse, Laxmi would have told you, Sheel...."

"I'm so scared he'll die one day while I'm away," she sniffed miserably. "I told Bhagwan to find someone else for the work. He said no. Just to stop worrying. I don't see how.... Chimney could go on like this for years."

It went on for three years in fact, Chinmaya remaining Sheela's lifeline as much as she was his. Even when they finally separated and began to live with their respective lovers, she continued supervising his

medical treatment; they were together constantly. Every time Sheela went away on ashram business, she left Chinmaya reluctantly. He was her best friend, her sanity...and, apparently, her conscience.

≈

As soon as I heard Chaitanya's voice over the PA system outside explaining *Kundalini* Meditation for what was easily his 4,000th time, I cut Krishna off. "You have to go now. I'm sorry. I have to do my crying."

Krishna got up from my bed, still talking. His vibrant silks and satins of the past had long been replaced by subdued cotton clothes; he looked almost respectable for a sannyasin these days. "This is it for me," he intoned somberly as he slipped on his sandals; he'd stopped by to tell me about his love affair with Nirdosh*, a bubbly American ma who cooked for Bhagwan. "'B' always said I wasn't a homosexual. The labels we imprison ourselves with, honestly!" sighing. "Have a good cry, love," closing the door behind him.

As *Kundalini* music began to play in the meditation hall beneath my room, I wrinkled up my face in an expression of pain, trying to force myself to cry as I'd been doing every day for the last two weeks. It was a technique that the ashram hypnotherapist had given me to do to alleviate the sinus headaches I got every year before the monsoons. When shiatsu sessions, Alexander technique, Rolfing, and acupuncture hadn't worked, Bhagwan suggested I consult Sangit*.

It was at my second session with Sangit that the memory of being sexually abused when I was two-and-a-half suddenly emerged vividly from my unconscious. The face of the young soldier at the airforce base where my father was stationed who gave me the "toy" he kept in his pants to play with while he was babysitting for me and then tried to put it inside me (stopping when I cried, "Don't touch me there! Don't touch me!" and stroking himself instead till he suddenly collapsed in the chair, deathlike) was as clear to me as if he was standing in front of me; it was as if the whole thing was happening again. I'd been more bewildered at the time than hurt, frightened only because of the fear that I'd done something wrong, bad; that I was bad because of it. The soldier told me that I was, crying and yelling at me, then promising he wouldn't tell if I wouldn't. I never had.

As I lay on my bed sobbing, Sangit sitting beside me, a silent witness, past life memories began replacing childhood memories, other times when innocence and ignorance had made me label myself bad, evil; condemning myself to hell. Sangit gently suggested alternative ways for me

to look at the experiences I was seeing, and, as I forgave myself over and over again, my month-long headache miraculously disappeared.

I'd been crying twice a day for an hour each time as a technique ever since, dredging up every painful memory I could to help me. It wasn't easy, no matter how many past lives I could remember or invent, or how many wounds to my ego I'd experienced.

Contorting my face that afternoon, hunching my shoulders over pitifully, looking for a memory to spur me on, I suddenly began laughing; the whole thing was ridiculous. Was anything in the world worth suffering for? I'd lived a thousand times, died a thousand times, been victim and aggressor, wronged and wronging. It was part of the *leela* of life, an ever-changing game, little more than illusion. Rolling back and forth on my bed, I howled with laughter till the muscles of my face hurt, my chest hurt, till *Kundalini* ended and Chaitanya was back in the room.

"What do you think you're doing?" he asked angrily as if it weren't perfectly obvious: I was having the time of my life! "We could hear you all through the meditation!" I laughed uproariously; there was no stopping me.

Chaitanya tried everything. Nothing worked. All night long I lay on our bed convulsed with laughter as if I'd just cracked the cosmic egg and was sliding around in the yoke, as if the world was one big cosmic gag and I was the only one who got it. Everyone in the ashram heard me. It was impossible not to. I tried to quiet my cackles down so Chaitanya could sleep and finally fell asleep briefly myself, waking up at daybreak laughing.

I went to the lecture laughing, stopping only when Bhagwan came in. While he spoke, I sat in front of him with a stillness that was as deep as my laughter had been explosive, bursting into laughter again the minute he stood up to leave.

At darshan the next night, Bhagwan told me that I was getting ready for a big satori. A few days later, he spoke about me in the morning lecture. "Satya's in a laughing space," he said. "A great alchemical change has happened. She's moved from the negative to the positive: tears have become laughter. Soon laughter itself will disappear and there will be great tranquility. This is the goal. She's pouring like anything!"

"So Satya-ma-ji has become enlightened!" Ravjiv beamed with pride when Bhagwan talked about me again a few weeks later in a Hindi discourse. While the Indian sannyasins decided I'd been reborn, twice-born (what Hindus call *advaita*), to both Chaitanya and Sheela my laughing satori was an annoyance at best. I preferred to be alone these days, not part of a convivial foursome.

After several days of giddy hysteria, all I'd wanted to do was to sit qu-

ietly by myself when I wasn't working or at a discourse, enjoying the cosmic joke that only Bhagwan and Laxmi seemed to understand. Chaitanya felt superfluous in my life, an interference in my blissful quietude. It wasn't until he began wanting to be with other women that I was thrown back into my ego again, all my old insecurities and fears abruptly awakening.

My satori ended, as other satoris had. None of them ever totally disappeared, though. Each one left me with a precious legacy: peace and contentment, waves of bliss, laughter. Something to return to.

ૐ

As Bhagwan began to speak extensively in lectures and darshans about love and freedom ("The more lovers one has, the richer one's life is. Be true to love, not to a relationship."), dozens of long-term relationships at the ashram began to fall apart, the swamis "moving with their energy" (fucking around, let's face it) while their wives and lovers suffered.

While Chaitanya seemed to "have energy" for more than one ma these days, he contented himself with mild flirtations and long passionate hugs that I stumbled on occasionally, jealousy coursing through me like a poison. I'd try to think of it as "just energy": impersonal—getting high on the intensity of it—but rarely succeeded.

Chinmaya (who was recovering from major surgery after having a lung removed and was confined to his room except for an occasional darshan) was no more immune to the rampant eroticism Bhagwan seemed to be encouraging than anyone else at the ashram.

"Do you have any idea what it feels like to walk into my room and see Chimney lying on the bed with one of his whores?" Sheela sobbed bitterly to me one night as she curled up in a wicker chair on my balcony, a heavy shawl wrapped around her shoulders. "I take these women under my wing"—most of Chinmaya's girlfriends worked for her in the office—"and before I know it, they're coming on to my husband. And men are so stupid! His ego gets built up by some slut, and the next thing you know his thing is up, too!"

"It's not serious what he's doing," I murmured sympathetically, stroking her hand gently. Still too weak to do anything about his sexual impulses, it was scarcely surprising that Chinmaya wanted affection from other women. Sheela had been having an affair for months, expecting Chinmaya to be happy that she was happy; her lover was congenially entertaining Chinmaya every time I visited him. "He adores you. You know that."

As Sheela nodded soulfully, wiping her eyes, I thought about the time she'd been raped by a friend of her father's when she was sixteen, wondering if it accounted for her generally derisive attitude towards men. She'd gotten pregnant and had an abortion, something she talked about as nonchalantly as if it was just one of the things that could happen to a person: inconsequential. Her refusal to be a victim was one of the things I admired about her.

"Why shouldn't he love me?" she asked defiantly. "I'm the best thing that ever happened to that man!" Then suddenly unsure of herself again, vulnerable, asked pleadingly, "Do you think he knows he's so lucky? Huh, Mommy?"

ᶻᵃ

Vidya and her husband Bodhi joined the four of us for dinner in my room several nights later. It was the first time I'd cooked for Chinmaya since my laughing satori, Deeksha having been preparing special meals for him in the canteen meanwhile.

"Did you guys hear about the CIA?" Sheela asked after we'd all finished eating and she was setting up the backgammon board for her and Chaitanya. The rest of us were stretched out on the floor and bed, munching on chocolates.

"Stupid buggers!" Vidya spat out angrily. "They're trying to get sannyasins to spy on us for them! Can you believe it?"

A French ma had come into the office in tears that morning while I was working with Arup on a publishing contract, telling Laxmi that CIA agents had approached her. "It isn't the first time it's happened," Laxmi had responded calmly. "No need to worry, ma. Ignore. If they keep bothering, send them here. Laxmi will handle."

"The creeps have been spying on Bhagwan since the Bombay days!" Vidya continued, enraged. "What the hell business is it of theirs what a group of meditators in India do? The Yanks get their stinking nose into...," but no one wanted to defend America, not even Sheela. "If we can't fight 'em, let's join 'em, huh, gang?" Vidya grinned finally. "What do you say?" bursting into a warbly, off-key version of *The Internationale*, all of us laughing.

It was an idea Sheela seemed to love: being a star in her own James Bond movie. She dragged us to every spy thriller that came to town before Chinmaya got sick, pointing out scams the ashram should try. "It would work, Sats. All we have to do is...." Schemes to make money, beat the authorities. I thought she was kidding.

"If the CIA wants to know what's going on so badly," she joked,

"maybe we should tell them. We got nothing to hide. At least we'd make some money from it!" It seemed funny at the time.

While Sheela argued with Chaitanya over his last backgammon move ("Off the board, Shit Breath! Do over!"), the conversation moved on to Laxmi's search for land for a new ashram. A deal for some property in Gujarat had recently fallen through, Sheela's brother confiding to me on his last visit that he was sure Bhagwan hadn't wanted the place. "You could be on that land right now if the old boy sent you or Arup to close the deal. I know those Gujarati people. My sister and that *mataji* of yours were bound to piss them off, had to. The old boy knew that."

America was the only place for the ashram to move to, Sheela insisted adamantly. It was India's fault that Chinmaya got T.B.; the country was disease-ridden. "I don't know why Laxmi doesn't give up. Bhagwan would love it in America. He'd...."

"Don't be ridiculous, Sheela. He'd never go the States." I couldn't believe how stubborn she was sometimes! "He's said that a hundred times."

"Don't worry, Mommy," she grinned impishly, winking at me. "I could convince him. How can I run an ashram with all you westerners sick constantly?"

"You mean Flagyl's not supposed to be the fifth course on everyone's thali?" Chaitanya commented, bursting into song: "*Every leetle breeze seems to whisper disease,*" Chinmaya joining in, Vidya cracking up with laughter. Repeated courses of Falgyl that were as debilitating as the ameobic dystentery they were supposed to cure were a way of life for most westerners at the ashram.

"What's so funny, Vidsie titsie?" Chaitanya asked innocently. "Ma Yoga Titsie with the size 48 knockers. Don't laugh, you guys. She's a perfect 48-28-28. Where do you think the ashram gets its milk from? If it wasn't for Titsie the Borden's milk cow...." Vidya was laughing hysterically by now. "Sorry, Tits. Stroke her udders for awhile and calm her down, will you, Bodhi, Chinmaya, Sats; there's enough for everyone."

As Vidya scrambled giddily to her feet, gyrating her hips in a ludicrous travesty of a burlesque queen, bumping and grinding, I burst out laughing, too.

"Now look what you've done, Fuck Face!" Sheela grumbled. She loathed my laughing, loathed my propensity to sit by myself and bliss-out, loathed the fact that we spent so little time together these days. "Once Satsie gets going...." But Vidya and I were off and running, convulsed with laughter.

When we quieted down finally, Sheela asked us all what we thought

Bhagwan would use to outrage people in America the way he used sex to press their buttons in India.

The answer was obvious: money, the American fixation. He'd spend a fortune on frivolous things, mock the whole consumer trip, conspicuous consumption to the nth degree. More and more; he'd infuriate everyone. None of us was thinking about America's other fixation: violence.

"Cars...," someone suggested.

"Diamonds...."

"Jewels...."

"Waste."

"Doubles, Shit Breath!" Sheela shouted exaltantly to Chaitanya. "I'm gonna cream you this time!"

And always good to her word, she did.

uck, fuck, fuck, all we ever do is fuck!" a five-year-old ashram kid complained to his friend in the front garden where I was interviewing a Vietnam vet from Minnesota for a book I was writing. "I'm getting bored with it."

"Me, too," his friend replied breezily. "I'm not fucking any more till I get that white stuff my dad has. Let's find some sand to play in. I'm tired of playing with girls."

"Fucking's a sissy girls' game!" "Yeah," the two boys skipping out of the garden, arm-in-arm, giggling and laughing.

"That's why I got interested in yoga," Prabhu* was saying earnestly now. "When you're that close to death every day...."

Distracted by the kids' conversation, I was finding it hard to stay focussed on Prabhu while he talked. Bhagwan's theories on sex education were unusual to say the least. Children should be exposed to sex as early as possible, he said, watching their parents and other adults making love. "In a better world, mothers would initiate their sons into sex, fathers their daughters. This happens in certain cultures. These people are more intelligent than you. They don't have modern man's sexual perversions; things are more natural."

It was the first thing he'd ever said that pressed my buttons since his shocking praise of Hitler years ago in early talks, sentiments I'd judiciously altered as I edited his books for commercial publication: he must have *meant* "this" even if he said "that." I could hardly be expected to agree with every statement made by a man who loved being outrageous.

While the ashram kids' attitude towards sex was undoubtedly healthier than the attitudes I'd been brought up with (don't touch your genitals! don't look! don't feel!), I wasn't so sure I'd want my children to be

as uninhibited. As idyllic as total permissiveness might be, I had my own prejudices to contend with. One six-year-old ashram girl delighted in grabbing men's genitals through their robes. Another offered to suck the penis of every man she saw in the public showers. Privately appalled by their behavior, I rationalized it away. Repressed in the past, the kids were acting out their rebellions the way adult sannyasins at the ashram did in therapy groups. It was hardly what I'd want for my kids, though.

"I think my father was an alcoholic," Prabhu went on as blandly as if he were talking about someone else. "He beat the shit out of me every day and I'd just think...." Serious about everything (meditation, growth, Buddhism, yoga, spirituality; himself), Prabhu's childhood had been diametrically opposite in every way to the ashram kids' upbringing. Uptight and constricted, he wasn't a very good advertisement for the virtues of traditional moral values and conditionings. I couldn't think of many people who were.

"Did Bhagwan give you more groups to do at darshan last night?" I asked finally, interrupting Prabhu's somber soliloquy; I had another interview to do that morning. I usually went to darshan every evening to take notes for my book, only missing last night's darshan because of a cold.

"Encounter," Prabhu grimaced. Bhagwan often recommended as many as twenty-five groups to people before they were deemed "ready" to work at the ashram. If their money ran out sooner, they were ready sooner: their work could be their meditation. It was a subtle enough consideration not to be obvious at the time.

"He said I'm holding on to something: my energy's blocked," Prabhu continued. Doing therapy groups was hardly what he'd come to Poona for. Bhagwan was the boss, though. He didn't question that for a minute. "The group starts on Wednesday. Will you be there?"

Nodding absentmindedly, I checked my schedule. "I'm not sure what day, though." Besides interviewing dozens of people and visiting the groups they were in, I was still running the translation and foreign publishing departments and editing my last book.

"Do you have to go?" Prabhu asked anxiously a moment later as I stood up to leave. "I was hoping...."

"I'm late already," glancing at the young Dutch woman who was waiting for me.

"I just thought...." Tears were suddenly running down Prabhu's face. He lowered his head to his lap, his long hair shrouding him.

Fifteen minutes later (the hell with my schedule!), he was still crying in my arms. Not talking "about" for once: feeling. The young Dutch woman waited patiently nearby, understanding.

ই৯

I wasn't visiting Prabhu's encounter group the day his arm was broken. In the no-holds-barred groups run by Bhagwan's soft-spoken presumed successor Teertha, broken bones (noses, wrists, ribs, an occasional arm or leg) were a frequent enough occurrence that I wasn't shocked by it anymore. People came to the ashram with a lifetime of violence stored up in them, the theory went. Only by acting it out in a supportive atmosphere could they get rid of it. Prabhu swore it was the best thing that ever happened to him. He seemed softer afterwards, more in touch with himself.

In Teertha's next group, Prabhu's exquisitely beautiful black girlfriend was raped by a middle-aged swami from Munich. Almost raped: he lost his erection halfway through, collapsing on top of her, sobbing desolately like a lost child as she held him in her arms, comforting him. No one had interceded, the other group members "using" the situation for their own private paroxysms of rage, anger, fear: male-hatred, female-hatred.

"It was every nightmare I've ever had come true," she told me afterwards, insisting it was something she'd needed. "You live in fear of something for so long: the black chick amongst the wolves in Paris." She was a fashion model. "The man was a sannyasin. How could anything that happens at the ashram ever be bad for me?"

When Richard Price, the director of Esalen (the well-known growth center in Big Sur), came to the ashram for the first time and did the encounter group—he'd taken sannyas through the mail two years earlier after reading some of Bhagwan's books—he was so outraged by the sex and violence in the group that he dropped sannyas, writing to Bhagwan about what he called dangerous, irresponsible therapy. "The expert always misses," Bhagwan responded in the next morning's lecture, deriding "the great therapist" for his inability to participate in the group without preconceived attitudes. "Only innocence is fresh, alive, receptive."

It wasn't until the Jonestown debacle occurred and the press began comparing the blind devotion of Jones' followers to sannyasins' unswerving commitment to Bhagwan (a patently absurd comparison to sannyasins) that the violence in the groups finally stopped, Laxmi publicly announcing that it had served its purpose; it wasn't needed anymore. Years later, reading about it, Billy was disturbed by what he considered Bhagwan's lack of integrity. "If Bhagwan felt people needed a safe environment where they could act out their violence, he shouldn't have stopped it, Mom. His playing politics is what ruined your whole movement!"

The therapy groups at the ashram created their own reality. In the dreamlike atmosphere of the group rooms, bizarre confrontations that would have been inappropriate in any other context seemed natural. Group sex, often instigated by the therapists themselves, seemed neither salacious nor depraved on the several occasions that I witnessed it while researching my book. People played with each others' bodies with an innocence that felt more nurturing than exploitative. Even the occasional violence that I saw seemed more therapeutic than harmful. Releasing the demons inside oneself (as I'd done through various meditation techniques) seemed to be a necessary prerequisite to religious experience.

On a tantric path like Bhagwan's, nothing in life was to be denied. Everything was to be used, transformed, transmuted; an inner alchemy: changing the lower into the higher. It seemed to work. People had satoris in the groups; they became more sensitive, loving, alive. As dramatic and intense as the therapy groups were, a broken bone was the worst thing that ever happened to anyone. It could happen on a ski slope. It was no reason not to go skiing.

Or am I deluding myself again, forgetting?

ꝫ

"Are you there, Mommy?" Sheela asked, opening the door to my room where I was stretched out on the bed trying to make sense out of the notes I'd taken that day. "How can you read this junk?" she asked derisively, glancing at my notebook.

"It's speedwrit...."

"When are you gonna stop going to these stupid groups anyway? I never see you anymore. Hey, did I tell you what happened to that Japanese ma?" she laughed suddenly. "The one who went crazy after Kavi's last group, remember? She was running around the ashram naked, shouting god knows what in Japanese. She was enlightened or something dumb like that. Anyway, listen to this! Me and Laxmi just found out the latest. We shipped her back to mama-san and papa-san in Tokyo; it's their fault she's cuckoo, not Bhagwan's; so what does the girl do? Tells the newspapers," eyes twinkling with merriment, "you won't believe this, Sats. She tells them Bhagwan," giggling, "*Bhagwan*, mind you, 'entered' her. And of course the newspapers...."

We were both giggling by now. How could the press be expected to know that the girl meant it metaphorically—spiritually?

"...get it into their pea-brains that Bhagwan raped her and now all the newspapers in India are...."

Scandal hits the ashram! We were both laughing uproariously, neither

of us believing in any other possibility than the press' understandable misinterpretation. Isolated in his room every day, never seeing anyone privately except Vivek and Laxmi (or one of her assistants), Bhagwan was being accused by the media, if not by the poor Japanese ma herself, of behaving in a decidedly unholy manner. The sex guru rides again! Would it never end? It was years before I wondered if there was any more to the story than that.

"Hey, I almost forgot," Sheela commented offhandedly as she got up to leave, "we're opening up a bank account in Switzerland. For in case Bhagsie ever leaves India. I told you, right, Mommy?" grinning. "You're gonna be one of the signatories, okay? I'll bring up the papers later for you to sign. It's okay to tell Shit Breath, but don't, you know." I nodded. "Oh, and I arranged for you and me and those schmuck faces we live with to have Deeksha's crew do our laundry."

"Why should...."

"Why not? They do Laxmi's. I'll bring up the papers."

She never did though, someone else obviously becoming the signatory on an account that was allegedly soon worth several million dollars, the first of many Swiss bank accounts that Sheela opened with Deeksha's help over the next few years. When the ranch in Oregon closed, Sheela was estimated to be in control of twenty-three Swiss bank accounts with untold millions of dollars in them. On further reflection, I wasn't considered trustworthy enough to have my name on that first account. I was on my way out.

ટ▲

"Laxmi wants to see you, Sats," Laila said as she walked past my desk with an armload of opened letters to Bhagwan, Laxmi, and the various ashram departments. I was going over the intricacies of a Portuguese contract for one of Bhagwan's books in the overcrowded main office where accountants, office personnel, and department heads worked, desks jam-packed against one another. My assistant handled most of my office work these days, but I still had to oversee everything she did.

"Could you take this in with you?" Premda asked, handing me the art work for one of the Bhagwan's books. "Tell Laxmi I'll have the other two cover designs ready by 5:30." Several people were hovering around Premda's desk; she was even busier than I was.

Ever since the ashram had signed a second contract for one of my books, I was writing virtually full time again. Few ashramites worked at the jobs they'd been trained to do, Ph.D.'s collecting garbage, architects

working as handymen, filmmakers as shoemakers, and ex-junkies as department heads. Ravjiv (an accountant) was a glorified delivery boy; Premda (a sociologist) co-directed our massive in-house publishing program; Deva (a psychiatrist) repaired office machinery. People tended to move from one job to another, playing out all the different aspects of themselves: the things they could do well and the things they were hopelessly inadequate at.

"You better bring these in, too," Premda added, handing me a photo of Bhagwan in a kimona and another of him in a floppy velvet hat; he was probably the most photographed man in history.

"Good!" Laxmi chirped happily a moment later as I walked into her office. "The sparrow's here!" she grinned, turning resolutely away from Sheela who'd been in the middle of telling her something. "The sparrow's good today? The new book is coming along?"

"Laxmi!"

"Later, child," dismissing Sheela with a flick of her hand.

"But Laxmi, we have to...."

"Can't you see Laxmi is blah-blah-blahing to the famous writer," she said loftily, cutting Sheela off as she chatted away merrily to me about nothing in particular.

Sheela sat beside her, fuming. I tried signalling to her ("I'm sorry. What can I do?"), but she glared at me, storming out of the room finally.

"Your friend seems upset about something, isn't it?" Laxmi laughed gleefully, obviously relishing the scene. I wondered what kind of mischief she had up her sleeve.

When I tried to apologize to Sheela later that day, she wouldn't listen. She was furious.

For the next two weeks, Laxmi continued her game with Sheela and me, calling me into the office for no reason, then determinedly cutting Sheela off from what she was saying while she gossiped gaily with me. It was how she'd played with Sheela and Arup years ago, pitting them against one another, then sitting back and watching the fireworks. Her "game" was so blatant that it was obvious to everyone but Sheela. After awhile, all I had to do was walk into Laxmi's office and Sheela would start yelling at me.

She never forgave me. "You sit in your room all day writing your little books, while *I'm* doing all the work around here," she'd accuse me angrily, enraged, "and *you're* the one who's going to get famous! It's not fair."

She tried to get me back into the office full time, tried to send me to the kitchen "to do some honest work for a change," but Bhagwan wanted me to keep on writing: to finish the manuscript I was working

on, start another one, get several of my books published abroad every year. The translation department had recently begun translating my books as well as Bhagwan's; foreign-language contracts were being signed for them. Sheela was incensed by it all.

"I'll sign your name to my books if you want," I'd offer, trying to pacify her, till she'd finally look up at me winsomely from her stool beside Laxmi's desk.

"Will you at least write about me?" she'd ask plaintively. "Huh, Sats? Have you written anything about me yet? Promise me you will?"

Over and over again she'd ask me the same question. Would I write about her? Had I written anything about her yet?

When I was invited to move into Bhagwan's house a few months later, it was the last straw. Sheela stopped speaking to me. I'd become "one of those Lao Tzu House snobs." The other camp. The enemy. Our five-year friendship ended.

*M*y three years in Bhagwan's house were an intensely beautiful time for me. When I wasn't suffering over some trauma in my love life, I was flying, blissful; in love with everything around me. While Lao Tzu residents didn't see Bhagwan any more than anyone else—he never left his room except for lectures, darshans, and an occasional dentist appointment—his energy and vibe permeated the atmosphere, turning it into holy ground, sanctified. The power of suggestion? Perhaps. It felt like a palatable reality.

The invitation to move into Lao Tzu House (which always came directly from Bhagwan, via Laxmi) didn't seem to include Chaitanya at first. "You're ready to make the move?," Laxmi had asked Kavi and me as we sat at her desk, giddy with excitement, assuming we were about to become roommates. "There is any hesitation in the mind?"

Kavi and I glanced at each other, both of us closer to our lovers than we'd been in years, then laughed, shaking our heads, nodding. If we had to leave our boyfriends to move into the house, so be it. Being close to Bhagwan's energy was all that mattered.

It turned out to be another game, a test. Our lovers moved in with us.

While the overcrowded ashram sometimes felt like a carnival causeway (tai chi classes happening in one area; Sufi or African dancing somewhere else; group meditation after meditation with the pulsating music that accompanied each; intense spontaneous laughter and catharsis; the screams and cries of rooftop therapy groups punctuating the air; constant construction noises as facilities were expanded and a new football-field-sized lecture hall was built in the vacant lot next door), once inside the Lao Tzu compound it was as serene and meditative as a temple. I felt like I was perpetually stoned: what one feels after smoking the perfect

amount of grass or drinking the perfect amount of wine; a mellow state of calm contentment. As time went on and I handed over the last of my office work to someone else, I began spending my whole day in the house, as addicted to ecstasy as a junkie to his fix and as unwilling to see anything that might shatter the dream world I was living in.

My father's insistence over the years that I was being hypnotized ("Bhagwan's a damn good hypnotist. That soft droning voice. He puts you all under every morning. Why do you think he lectures every day? He's got you all in the palm of his hands!") was incomprehensible to me; I didn't know what he was talking about. I was ecstatically happy. It was cynics like my father who seemed to be the losers. As bombed out as I undoubtedly got at lectures and darshans, I could always bring myself out of it when I had to, accomplishing more work in an hour than I'd once done in a day. Life with Bhagwan was heaven. Whatever conflicts happened around me were insignificant compared to the waves of bliss inside me, the humming of my heart.

As a resident of Lao Tzu House, I was under Bhagwan's personal protection in many ways, isolated from a steady increase in rules and regulations at the ashram, abuses of power, and capricious administrative decisions that often resulted in sudden job and housing changes. When hundreds of ma's (including several scarcely pre-pubescent girls) were subtly coerced into being sterilized after Sheela, Arup, Vidya, and numerous office women had been—the emphasis shifting to vasectomies after one of the teenage girls almost died—the women in Lao Tzu House were notably exempt from both the pressure and the procedure. Bhagwan decided what work we did, not the office staff. Our questions and letters went into him through Vivek, not Laxmi. We sat in front for lectures, darshans, and celebrations, a situation that seemed to be an unending source of irritation to Sheela.

"How come those snobs get to sit in front every day?" she complained bitterly to Laxmi on more than one occasion. "No one should have special privileges. It's not fair. Ask him."

"Spiritual dispensation," Laxmi responded good-naturedly. "Sorry, ma," she grinned. "Nothing can be done about it."

As Laxmi's search for land for a new ashram took her away from Poona more and more often and Sheela began running things, one of the first things she did was to allocate reserved seats for herself and her subordinates at lectures and darshans. There was nothing inherently wrong with favoritism, apparently, as long as she was the one who dispensed the favors.

If Lao Tzu residents were a spiritual elite, and Sheela and her staff a temporal elite (the church and the state), Deeksha's restaurant-construc-

tion empire was soon a third source of power at the ashram (big business: often in alliance with the state, occasionally not). When Bhagwan moved to America, Sheela made sure that the state owned all businesses and controlled all access to the church. President, pope, and director of every business in the community, including medical and legal facilities, her control was finally absolute, her authority unchallenged.

ॐ

I walked into Laxmi's office after the discourse one morning to find Vidya sitting by herself crying, her tall, thin body crumpled over dejectedly. Kneeling down to hug her, I asked what the matter was. She could hardly speak. "It's.... It's...," sputtering and sobbing.

"Bodhi?" I queried. Everyone at the ashram seemed to be having relationship problems again. It happened in waves.

"Sheela!" she wailed despondently. "I can't stand it anymore, Sats! Everything I do is wrong! Whatever Arup tells me to do, Sheela hits me for! I'm suppose to be working for them both, but...."

"Vidsie! There are people here to see you!" the receptionist at the front desk called out airily as she stuck her head inside the door. "Oh, sorry," she apologized immediately. "I'll tell them to come back later."

"No!" Vidya sat up abruptly, wiping her eyes. "Give me two minutes," she said. Reaching for a tissue, she blew her nose noisily, then stood up, straightening out her robe and fluffing her hair. "How do I look?" she asked me.

"Your eyes are a little...."

"Fuck it!" she interrupted impatiently. "I could have been crying at the lecture, right?" Striding purposively around the room rearranging things, Vidya suddenly became Miss Efficient: the personal secretary to the two personal secretaries to "His" personal secretary. "Tell them to send the first person in, Sats," she said, totally recuperated. It hadn't taken her two minutes.

It was hardly the first time I'd seen Vidya crying about her job. Laxmi had asked me once years ago to take care of Sheela and Arup the way they took care of her: making sure she ate properly, getting her clothes washed and ironed and new ones made for her, packing her suitcases when she went away: m'lady's lady-in-waiting and personal maid. I hadn't taken the request seriously. Be their nursemaid when I had books to edit and write, contracts to draw up, a thousand and one more important things to do? Then Vidya came along and did it instead, trying to juggle her two bosses' requirements, constantly on the firing line for it.

As the receptionist ushered in a group of Italians, I went into the small meeting room behind the office where I was finishing up the manuscript of my book on groups. An hour later, Sheela walked in with a pretty young American girl, barely looking at me as she told me to stay where I was; they wouldn't be long.

"Facts we know," she said unceremoniously as soon as she and the girl were seated. "The man made a pass at you, didn't he?"

The girl nodded uncertainly.

"We've got that bastard by the balls this time!" Sheela grinned. "Let's see the prick try to get out of this one!"

As I listened over the next two days, pretending to be concentrating on my writing, the girl and her mother were carefully coached on what to say in court about the girl's attempted molestation by a government official who'd offered to extend her visa, she was to testify, if she granted him certain sexual favors. The man had apparently been extorting money and making similar propositions to sannyasins for some time, denying visa extensions to anyone who refused him.

This time he'd taken too big a chance; the girl was fifteen. Teary-eyed and distraught, her mother would testify to her shock at the man's behavior, while the girl would play up her innocence and naivity for all it was worth. The man was bound to be fired from his job, jailed possibly.

I had no idea to what extent the allegations were true. The mother and girl both told me privately that they were "based on truth: just a little, well, exaggerated." For the sake of the cause naturally. The man deserved it.

Why then, I wondered, the extensive coaching, the this-is-the-way-it-happened, remember? The girl, whose virginal innocence was the crux of the case, was in fact the lover of a thirty-year-old Lao Tzu resident. Virginal she wasn't. Innocent, perhaps.

I forgot about the incident for years until I read an article in an Oregon newspaper about similar claims of sexual harassment that the ashram had made: men who were considered adversaries of the ashram accused of sexual misconduct by attractive western women who'd apparently sought them out deliberately. The men's positions against the ashram were compromised by their allegedly prurient behavior. They stood accused.

The ashram was beginning to fight back with every weapon it had against what it saw as official discrimination and private bigotry. While Indian Premier Moraji Desai allegedly intervened to prevent Laxmi from purchasing land for a new ashram in northern India, the public response to the community in Poona rapidly went from bad to worse. Threats against Bhagwan's life increased. A Muslim entered the new Buddha

Hall auditorium one morning with a knife that he threw at Bhagwan, barely missing him. When the local police refused to promise adequate protection in the future, a new policy of "frisking" people before lectures and darshans was inaugurated. Samurai guards (trained in martial arts and affectionately known as "Guardian Angels") made their appearance on the scene, karate classes soon joining the other activities in Buddha Hall.

Violence against the community soon became a favorite Poona pastime. A young Brazilian ma was raped by several local youths. Sexual taunts and threats became commonplace, one enterprising Indian exhibitionist habitually waving his erection at sannyasin women as they left the ashram, then getting on his bike and riding several yards up the road, getting off and waving his penis again, continuing the routine until another ma temptingly appeared in the opposite direction. Even more disturbing were the rocks that were routinely thrown at sannyasins from speeding cars and trucks, and before long we were all being urged to remain at the ashram as much as possible.

"A closed commune is needed," Bhagwan said during the lecture one morning. "The masses can't understand what is happening here. We are trying to penetrate into the deepest layers of consciousness. More has to be done, but then things will become more bizarre. You need to be surrounded by a soothing energy field that keeps you anchored to me. A secluded atmosphere is needed so we can move into the deepest experiments in consciousness that have ever been done."

Yes, Bhagwan, the whole ashram seemed to breathe in unison. We were ready to move into the unknown, to disappear. Bhagwan called his work a mystery school, a temple of total ruin, where one could die to the old and be reborn. The world would never understand; privacy was needed. All that was necessary was for Laxmi to find a new location for the ashram, and Bhagwan's work would explode.

ॐ

Explode it did, in February 1979, when Bhagwan started giving nightly "energy darshans." While he continued to lecture every morning and still spoke to people when he initiated them into sannyas, he began to work more directly with energy now and less through words.

With live music, flashing strobe lights, dancing, singing, swaying, and peaks of orgasmic frenzy, the energy darshans were like mixed-media theater events where sexual energy was transformed into spiritual energy. Bizarre powerful happenings, like everyone else at the ashram I was shaken to my roots by them.

"Raise your arms above your head," Bhagwan told everyone one night as I sat with my back to him; he'd called me up unexpectedly for a "surprise" energy darshan. It was to be the last darshan of the evening: a special treat.

Vivek sat opposite me, holding my hands, her eyes shut. Already stoned from the previous energy darshans, ready to explode, my eyes closed automatically. I wondered how much more energy I could take; I could feel myself sinking, fading away. Several of Bhagwan's *mediums* (the dozen or so women he'd selected to be conduits for his energy, temple goddesses as it were) stood to either side of me; I could sense the humming vibrations of their energy. My head arched backwards, my hands vibrating and tremoring.

"You can all join in," Bhagwan instructed. "Let the energy move upward."

The lights went out, melodic darshan music playing softly in the background, my body vibrating like the engine of a car in rough idle. As the tempo of the music increased, lights flashing off and on, Bhagwan touched his finger to my third eye. People all over the hall were moaning, screaming, shouting. There was pandemonium everywhere as Bhagwan's finger pressed against my forehead, flooding me with blissful sensations; I was filled with light.

The music reached a climax. My body shuddered as if I were having an orgasm. The music stopped.

"Let the energy move within," Bhagwan said. "Stop everything. Be still." He put his thumb on my forehead again. I wasn't "there." I was a hundred thousand light years away; on another planet.

"Come back, Satya," he said finally. "You did good. Your screams even woke Sheela," chuckling. "This is almost a miracle!"

I opened my eyes groggily and stumbled back to my seat; I could hardly walk. Darshan ended. I was passed out on the marble floor. Oblivious to everything but the feelings inside me.

⁂

"Do you have darshan tonight?" Kavi asked one afternoon several weeks later when I got back to my room after shampooing my hair to find her waiting for me.

"An energy darshan," I nodded, already feeling pleasantly nervous at the prospect.

"Lucky you," she smiled warmly. Like all the mediums, most of whom were Lao Tzu residents, Kavi went to darshan every evening.

"Lots of people from the house are coming tonight," she said, putting her arms around me tenderly. "It's gonna be a good one."

Ever since the energy darshans started, people were spending more time than ever hugging. The mediums were particularly partial to it: long, timeless after-lecture hugs, after-darshan hugs, any-time-of-the-day-or-night embraces. The ashram was infused with a new energy these days that was sensual if not sexual, loving and erotic without being lascivious. Everyone seemed to be in love with everyone else. People held hands, touched those they hardly knew, were as affectionate as lovers to yesterday's enemies.

Women caressed each other openly, freely, with no innuendo of homosexuality, no judgements. Even the swamis seemed to be over their inhibitions against touching each other. Shiva and Chaitanya would sit at the guard booth inside the Lao Tzu gate—one of them an ashram stud, the other one wishing he were—and absentmindedly massage each others' hand or thigh without thinking anything about it. There was a sharing of energy all around; Bhagwan's love seemed to be filling us all.

Like most ashram women, I longed to be a medium. The depth of my longing appalled me. No matter how much Bhagwan had given me, I wanted more: greedy, full of spiritual ego, still wanting to be the prodigal daughter: special.

"We better get on with our interview," Kavi murmured finally, letting go of me. We stretched out lazily on my bed, making ourselves comfortable. "Bhagwan said it was all right for you to talk about your last life with him," she said softly. "I spoke to Vivek about it. She asked him. I have a feeling it's why he selected you for the book"—a series of interviews with Bhagwan's first western sannyasins. "It'll be good for you to talk about it. It's what he wants."

When Kavi first asked me about Bhagwan's last life (and his death), I refused to talk about it. I'd never spoken about it to anyone, not even Chaitanya, though I'd written about it obliquely in a manuscript and several people seemed to know the story. When Bhagwan mentioned in a recent lecture that he'd be assassinated by one of his closest disciples, Arup turned to me and hissed, "Just make sure it's not you this time, Sats!" making a nervous joke out of it. I didn't find it very funny.

The emotions that my apparent "last lifetime" with Bhagwan evoked in me were as painful now as they had been when I first "remembered" them. The fiery, intense eyes of Krishna, who'd been my brother then: urging me to kill the holy man by the side of the road, compelling me with his eyes to do it, still filled me with irrational terror whenever Krishna was angry at me for nothing more significant than some advertising copy he'd expected me to be finished writing.

Despite my resistance to talking about the subject, Kavi's probing questions soon had me doubled over on the bed in pain, remembering not only the murder of the holy man but what happened to his murderer (me) afterwards: the grief and despair; the guilt and self-condemnation that I'd lived with for lifetimes.

"You could have seen the whole thing differently," she said gently, playing therapist as she led me step by step to a new interpretation of what had happened. "I don't think it's that you want Bhagwan's forgiveness; I think you're angry at him. He was almost enlightened; you weren't. The responsibility was his. 'Judas is Jesus' instrument, remember,'" quoting our Master. I had to forgive Bhagwan; not him, me. It seemed so clear suddenly.

It took a week before I was ready to do it. My energy darshan that night helped, the morning lectures helped, sleeping in the powerful vibrations of Lao Tzu House helped. With all that Bhagwan had given me over the years, how could I not forgive him? I was ecstatically happy most of the time thanks to him, vibrantly alive; living in the Garden of Eden.

"Thank you," I mouthed silently at discourse one day, tears streaming down my face. "Thank you, thank you, a thousand thanks."

From that moment on, the nature of my connection to Bhagwan changed. For the first time since I'd met him I didn't seem to want anything from him. I didn't feel like a needy supplicant anymore, silently pleading for his attention: a look, a mention during the lectures, a surprise energy darshan. No unfinished business seemed to be left between us. Tit had been paid off by tat, our shared slates wiped clean.

It suddenly occurred to me that Bhagwan had so many disciples because he had so much unfinished karma to clean up. In the endless circle of birth and death that eastern religions believe in, enlightenment is the last life. He had thousands of people to pay back for favors along the way, more perhaps than most enlightened beings; he'd probably always been a rascal.

"You can only be given that which you can accept, digest," he commented in a lecture a few days later. "I would like to give you so much more, but in the very nature of things it cannot be given. I can only go on calling you, 'Come closer!' Then slowly, slowly my energy field will start vibrating your energy field. And when my heart and your heart are pulsating with the same beat, in the same rhythm, the real communion has started."

I opened my eyes with great effort, wanting to see Bhagwan, to drink in his eloquent gestures as he spoke. *He's done it!* I thought to myself jubilantly. *The rascal's really done it!* Whatever miracle he was, the ashram

community itself was now, too. He'd planted the seed; we were the flowering. The community around Bhagwan had *become* Bhagwan; it had his vibe. He'd really done it!

So elated I could barely sit still, I glanced over at Shiva who was standing beside Bhagwan's dais with several other samurai guards, awestruck at how beautiful he was. All the Guardian Angels stationed along the perimeter of Buddha Hall looked like virile Buddhas in their burgundy karate robes and wide-legged trousers; Bhagwan had transformed everyone around him. Even Prabhu (the Vietnam vet), standing on the opposite side of the dais, a new samurai, was a changed person now: the toad had become a swan.

Glancing at one person after another as they sat, silent and still, eyes closed, listening enraptured to Bhagwan, I found each one more dazzling than the next. Arup looked radiantly beautiful. It was hard to believe I'd ever found her unattractive. Kavi had lost her old bitch-goddess air. There was an incandescent softness about her now. Nirdosh had the face of an angel. I could have stared at her all day long, mesmerized. The ashram women, devoid of makeup, fancy clothes, and pretense, were all exquisitely beautiful, while the men, in their long floor-length robes, long hair and beards, were so graceful and elegant it was breathtaking.

"A few of you are dropping your egos," Bhagwan was saying now. "Becoming more silent." It wasn't the way people looked that was significant, of course; it was the way they felt. Bhagwan's luminosity shone out of a thousand faces. Everywhere I looked, people were alight with God-energy.

"Such an energy field has not existed for centuries. As you become more ready, I will be showering more and more. It has nothing to do with me. I'm simply a hallow bamboo, available to existence. Whatsoever song it sings, I am ready to sing it."

The tears pouring down my face this time were pure joy. To be with this man! In this Buddhafield!

As I closed my eyes, letting myself disappear into nothingness, drown, Bhagwan continued: "Whether Chinmaya lives a few more years isn't important anymore," his words filtering in and out and around me. I heard them and didn't hear them. "If he lives, good. If he goes, he can go with joy in his heart. His life has not been futile, meaningless; he has learned the lesson. The first flowers have begun to blossom."

Even Chinmaya (confined to his bed where he listened to Bhagwan's daily discourses over the sound system Sheela had set up for him) was growing more beautiful every day. The miracle of Bhagwan's promise: "Surrender, and I will transform you!" was happening to everyone; there wasn't a person at the ashram who didn't seem to be affected by it.

As the lecture ended and Laxmi drove Bhagwan and Vivek back to Lao Tzu House several hundred yards away, I collapsed into a heap on the cold cement floor, devastated by too much of a good thing. Someone hugged me from behind. All around the hall, people lay in each others' arms, blissed out.

Struggling to my feet finally, I stumbled to the staircase behind Bhagwan's dais to get my sandals. Kavi slipped her arm around me, the two of us walking slowly back to Lao Tzu together, my head on her shoulder, her head on top of mine.

"Breathe, Satya!" she said majestically as the birds sang and the sun shone on our faces. "It's a glorious day! Take it all in!" filling her lungs with air and exhaling exaltantly. "Don't be such an ascetic, Satya!" laughing. "Take a deep breath! Enjoy!"

Laughing myself, I began to breathe in unison with Kavi. My god, the lush trees! The brilliantly-colored flowers! The sunshine! How magnificent everything was! And the trouble started.

*I*t was really Chaitanya who began it, of course. I can hardly blame it on Kavi, the spring weather, or my new habit of breathing deeply. The energy darshans were partly responsible no doubt, but in the end it was him: his desire to be with other women and his need not to hurt me while he was.

"Why don't you go out with the Mad Italian?" he urged me earnestly one day after he'd finally dated someone else. If I were dating as well, there'd be no need for him to feel guilty.

"I'm not interested in being with anyone," I told him coldly. "You're the one who wants to fuck around, not me!"

Wincing at my choice of words, Chaitanya wasn't about to be discouraged. "How do you know you're not attracted to the Mad Italian if you don't even give him a chance?" he asked hopefully. A photographer, journalist, and notorious Don Juan, the Mad Italian had been trying to seduce me for months.

"I haven't had any sexual desire since the energy darshans began," I said. "You know that as well as I do."

"Just try," he pleaded. "Even if it's not happening sexually with us anymore, it doesn't mean it won't with someone else."

Annoyed and disgruntled, I couldn't help thinking about the interview Kavi did a year ago with Chaitanya and several other ashram men who were in long-term relationships. The swamis had all boasted proudly that they'd moved from lust to love, from the genitals to the heart. They were more in love with their partners than ever, they claimed; consequently, sex had become less important to them. It was a sign of spiritual growth, of the oneness between them and their lovers, a

cause for celebration. What unmitigated bullshit it was! They were all "moving with their energy" these days, or wanting to.

"Do what you have to do, Chai," I murmured finally, trying not to cry. "Just leave me out of it."

"If love makes a prisoner of the other," Bhagwan had said, "what is left for hate to do?" I had no right to stand in Chaitanya's way. He was entitled to do what he wanted. It didn't make it any easier though.

As the weeks went by and Chaitanya continued to go out with other women, I continued to feel jealous about it. Finding someone else to bolster my ego (tell me I was attractive, desirable, worth loving), as I'd done my whole life, seemed impossible to do when I didn't feel at all sexual. My energy was blocked, I was convinced; I was repressing something. Miserable and confused, I finally asked Teertha if I could have a therapy session with him in my room one evening while Chaitanya was at darshan.

"People tell me constantly that they've transcended sex," Teertha commented that night with a bemused smile on his face after he'd "checked my chakras," one hand on my heart, the other on my back, his eyes closed, "and all they've done is repress it. You insist you *haven't* transcended it, and you're one of the few people I know who has."

"But...."

Teertha shook his head, smiling. Darshan energy was filling the room as darshan began on the other side of the house. "Your energy's absolutely nonsexual, Satya," he said. "There's not a trace of it left. You're lucky. It's the state we're all hoping to attain."

I scowled grimly; it wasn't what I wanted to hear. When Bhagwan had told me two years ago after my laughing satori that I was ready to transcend sex, I went on a sexual rampage with Chaitanya to prove he was wrong. I was thirty-seven years old! In the middle of my sexual prime! I wasn't ready to drop sex yet!

"If you find it hard to adjust to," Teertha continued, "talk to Sampurna* about it. She's been celibate ever since we've been together. She can help you."

I sighed, smiling blandly. For all of Teertha's insights into other people, he was obviously as blind as everyone else when it came to what was close to him. Sampurna was anything but celibate these days; she just wasn't attracted to him. When Bhagwan told her years ago not to worry about her lack of sexual interest in Teertha, she was ready to be celibate, she dutifully pushed sex out of her mind. She'd been making up for lost time ever since Bhagwan made her a medium. Teertha seemed to be the only one at the ashram who didn't know it.

"You're a joy to be around these days, Satya," he smiled warmly, gaz-

ing at me with his penetrating eyes. "You used to creep and crawl around the house all the time as if you didn't belong. Everything's different about you now. It's a joy to see."

"But I'm suffering, Teerth...."

"It's just the record unwinding, ma," he said as he stood up, a long-robed druid from another era. He wanted to be upstairs in his room before the energy darshans began. "The electricity's been shut off; there's no more input happening. It just takes time for the record to stop. Have patience with it, ma," closing the door gently behind himself as he left.

Within moments, the lights went out all over the ashram. I could hear energy darshan music playing in the background. The blackouts were a time for everyone at the ashram to share in the energy transmissions that were happening in darshan. To stop what we were doing, close our eyes, be silent, still. It was, I heard, the most beautiful time of all to make love: a half hour of spontaneous meditation; magic.

৯

Several weeks later, I finally agreed to go out to dinner with the Mad Italian. And fell in love—how could it have been otherwise? My God-crazy, woman-crazy lover was impetuous and wild, I sometimes wondered if he really was mad. One thing was clear, though. I hadn't transcended sex yet.

After years of aceticism, the Mad Italian goaded me into being as outrageous and unpredictable as he was. We danced on the tables in the ashram canteen at lunchtime and made love at night sitting on the stone walls outside various Koregaon Park houses, our long robes a perfect camouflage. During work hours, he lured me into private cubicles in the public shower-room, bringing me to orgasm after orgasm till I was so weak I could barely stand up.

When Bhagwan got a cold and lectures were cancelled for the first time in five years, I sat in the back of Buddha Hall with the Mad Italian during the silent meditations that took their place. As darshan musicians played and five thousand people silently meditated together, the feeling of holiness in the hall almost as potent as if Bhagwan was there, I lay in my lover's arms, his hand up my robe, my hand tucked discreetly inside his loose harem pants, as he masturbated me to climax and me, him. I was as shocked at myself as I was delighted at my audacity. When the discourses began again, I stayed in the back of the hall with the Mad Italian instead of returning to my seat in front.

"Because you can't understand silence," Bhagwan said as I lay in the

Mad Italian's arms, "I have to talk. Otherwise there is no need. Truth cannot be said, has never been said, will never be said....

"You are moving with a dangerous person"—the Mad Italian's erection was pressed against my buttocks as he snored in my ear—"but the journey will be tremendously beautiful. Dangers don't make a journey ugly; they make it beautiful. The journey will be tremendously alive. Each moment will be precious."

When the Mad Italian finally resumed his obsessive pattern of habitual seduction, sleeping with every woman and teenage girl he could while he assured me that he loved me, I went through hell, my jealousy revolving around my mad Italian lover now, not Chaitanya. It was clearly time for us to separate.

When Laxmi told Chaitanya that he'd have to move out of Lao Tzu House, he cried for days, pleading with me to reconsider. Couldn't we live together like roommates, he asked. The Mad Italian could sleep over whenever he wanted; Chaitanya would sleep in a bamboo hut on the roof. He and the Mad Italian were friends; we could all co-exist together.

Our separation was off-again, on-again, off-again. Only in Lao Tzu House was the privilege of indecision allowed. Whenever Laxmi or Sheela authorized a move, people were out of their rooms so fast they didn't know what hit them.

Chaitanya finally moved out of the house and a beautiful American heiress (one of Bhagwan's mediums and an ex-lover of the Mad Italian's) moved in with me. Another medium, who'd left her psychiatrist husband when she fell in love with the Mad Italian, moved in next door with Kavi, who was also separating from her lover. The ashram was Peyton Place in burgundy: an x-rated movie.

ॐ

My separation from Chaitanya was more painful for me than I'd expected. After being together for seven years, I still thought of him as my best friend, "owning" him in my mind. When I went to visit him in his new room two hours after he'd moved out and found him in bed with someone, I had no right to feel hurt and abandoned; I was the one who'd wanted the move, not him; but I did. Tears stinging my eyes, half-blind with anger (Chaitanya certainly hadn't wasted any time!), I ran out of his room, knowing how irrational my reaction was without being able to change it. Ever since the energy darshans had begun, I'd been on an emotional roller coaster: my highs higher than ever, my lows lower.

As I slumped miserably against a tree on the path outside Chaitanya's

house, shaking and crying, Deeksha walked by. "What's the matter, beautiful, eh?" she asked. "Come!" putting her arms around me. "It's that crazy Italian again? I'm gonna kill him!"

"It's Chaitanya. I just.... He's with...," sinking into Deeksha's soft billowy body as she held me tightly, comforting me. *This* was what was so special about the ashram, I thought gratefully as I relaxed into her arms. Someone always there when you needed them, unfailingly.

"Forget Chaitanya, eh, *bella*?" Deeksha murmured gently. "It's Satya who needs to be taken care of now." Holding me as tenderly as if I were a battered child that she was protecting from the world, she led me past Buddha Hall, past the endless construction that was going on everywhere, and up to her room in Krishna House.

"Take care of Satya, eh?" she told the young French ma she'd paged upstairs as I lay on her bed sobbing. "Let her undress you, *amoré*. Relax. Don't do anything." Deeksha went into the bathroom and filled the tub with hot bubbly water and then left.

As the young French woman bathed and oiled me, pampering and massaging me, I wept inconsolably, then relaxed and "allowed it to happen," then wept some more. I felt like a newborn baby: allowing myself to be helpless, not doing anything: trusting. Letting someone give to me. Receiving it gratefully. I'd never felt so nurtured before, so loved.

My hair brushed and combed, a new robe put on me, I was finally led downstairs to Deeksha's office behind the restaurant.

"I think she needs a haircut," the French ma commented.

"Tomorrow," Deeksha nodded in agreement. "We cut your hair before, didn't we, *bella*?" she asked as she offered me and her assistant some imported chocolate from her office safe. Deeksha could curse out her hundred-some-odd workers in five different languages, slap them around, break up their love relationships, tell them who they should go out with and who not, demand that they get sterilized, buy themselves new clothes, cut their hair; but whenever anyone needed her, she was there for them. People hated her imperious, high-handed behavior, but it was hard not to love her, too.

"Bring Satya some *chai* and a piece of pastry," she told the French ma. "The strawberry *mille feuilles* with some extra whipped cream," then, turning back to me, she asked if I were going to darshan that evening. "It doesn't matter," she said when I shook my head. "Have dinner with us after anyway," rattling off the menu her staff was preparing that night for her and her lover, Sheela, Chinmaya, Vidya, Bodhi, and Arup. She invited me to the gang's three-times-a-day banquets often despite Sheela's hostility to me, but I never went, offended by the blatant display of elitism (linen tablecloths, imported china and cutlery, wine and li-

quors, Deeksha's staff waiting table) when everyone else at the ashram was served boring, unimaginative food slopped on to stainless steel *thalis*: beans, and more beans.

"Sheela won't be here tonight," she assured me. "She's having dinner with what's-his-face." Sheela's lover was never invited to their banquets. "We're sending food up to Chinmaya; he's not well enough to come down. Have you seen him today?"

"Not yet. I...."

"It'll just be a few of us; quiet. It'll be good for you to be with the old gang again. Go see Chinmaya after you eat your cake, eh, beautiful? It'll do you both good. And show up tonight after darshan, hear, or I'm gonna come slap that big ass of yours," laughing heartily.

"We're gonna start putting some fat on your bones, eh, *amoré*? Ever since that crazy Italian came along, you're too thin. Poo!" making a face. "You think even Bhagwan likes that fashion model shit? Look at the mediums. All big mamas like Deeksha," laughing disparagingly. "A slight exaggeration. Go eat your pastry, *bella*. I'll see you tonight. You come!"

*K*rishna sat on the floor in Chuang-Tzu Hall, facing his
girlfriend, Nirdosh, his left shoulder against Bhagwan's knee.
They were holding hands, their eyes closed.

My roommate sat behind Krishna, her hands on his shoul-
ders, her knees on either side of him. Another medium sat behind
Nirdosh while Kavi stood to the right of Bhagwan, Vivek to his left, four
other mediums nearby, eyes closed, arms raised above their heads, their
frumpy burgundy "medium robes" all but obscuring their graceful vo-
luptuousness. I'd expected Bhagwan to tone things down for the Italian
video crew that was filming darshan tonight, but it was business as
usual.

"Everyone join in," Bhagwan instructed. "Don't hold anything back.
Let it be a wild dance, a celebration." The mediums all looked ecstatic.

As the lights went off and the darshan music began (sitars, flutes,
drums, a harmonium, and balalaika), my body started swaying, arms
waving in the air. As the music built up in intensity, strobe lights flash-
ing off and on, my hands went into spasm, curling up as if they were
palsied. Soon my body movements were overtly sexual, I was gyrating
on my pelvis, flailing my arms uncontrollably, losing myself in the en-
ergy. By the time the glaring video lights went back on again, I was
slouched on the ground in a heap, my body drenched with sweat.

"Good, Krishna," Bhagwan chuckled. "Your energy goes very good with
Nirdosh now. Tomorrow you move in with her, hmm? No more running
away!" a tittering of laughter greeting his words as I lifted my head and
opened my eyes. Collapsed against Krishna's chest, Nirdosh had a look of
blissful beatitude on her face. She'd been Krishna's mother in a past life,
Bhagwan had told them recently; he'd been his male ex-lover's mother. It

made as much sense as any other explanation of Krishna's convoluted relationships.

"Vivek," Bhagwan was saying now, arranging another tableau of mediums around the four people who'd been called up for the next energy darshan, "stand to the left of Sampurna. Satya," calling me to join them, "stand over there," motioning me to Vivek's other side. "Raise your arms," he intoned.

When the energy darshans first began, Bhagwan instructed the mediums at a private meeting to "allow" their sexual energy to be awakened during darshan and to use it for "the work." All energy was sexual energy. Once awakened, it could be raised to a higher level. He also had Vivek instruct the mediums not to wear anything under their darshan robes at night, allegedly putting his hands under their gowns when the lights went out. Warned not to discuss it (we'd all been trained for years to keep the secret, the faith, keep our mouths shut; the highest teaching from Master to disciple in all eastern religions, the so-called transmission beyond words, always happens in utmost secrecy), I doubt if I'd have been shocked if I'd known.

That everything Bhagwan did was for our benefit and spiritual growth was something I never questioned. If I'd known he was touching the medium's naked bodies beneath their robes, I'd probably have envied them for it. While he could hardly have been titillated by a ten-second caress, it must have had a profound affect on them. If his hand on my forehead filled me with ecstasy, his hand on my naked body, especially during the orgasmic frenzy of an energy darshan, would undoubtedly have been astounding.

Bhagwan's apparent use (or abuse) of sexual energy is something only my own recent experiences with tantra have made me aware of. The energy phenomena that my husband and I experience with each other when we engage in tantric sexual play are similar to what I experienced with Bhagwan. His ability to manipulate sexual energy to bring large groups of people to peaks of ecstasy I took as proof of his enlightenment. It's unquestionably a remarkable talent, but probably no more indicative of Buddhahood than any other power: psychic, learned, or intuitive. Tantra has always been a secret path, open only to initiates. The potential danger inherent in the misuse of tantric power is presumably the reason for it. All this is obviously hindsight, though. In the years when I was in daily contact with Bhagwan, his charismatic presence was as necessary to me as the air I breathed. The energy darshans magnified the intensity of his esoteric "work" on us. As strange as they were, they were extraordinarily powerful.

Sometimes when Bhagwan called me up to be a guest medium at

darshan I felt like a woman faking orgasm: play-acting; trying too hard to "surrender" to the energy, but I was totally caught up in it the night the Italian video crew was there. As the music built up to a frenzy, I felt myself losing control of my body and mind, shaking violently, tears pouring down my face as my arms danced gracefully around my palpitating body.

"Stop everything," Bhagwan said suddenly. "Be still. Let the energy move inside."

I fell to the ground, my legs buckling underneath me as people all over the hall moaned and screamed. One of the mediums was on the floor beside me; I had no idea who it was. Our fingers touched. A moment later we were lying deliciously in each others' arms, melting. There were hundreds of people around, video cameras everywhere; I didn't care, enveloped as I was in a warm, sensuous other world.

As my next door neighbor (the Mad Italian's occasional lover) released me and hurried back to the mediums' area, I stumbled back to my place, half-drunk. It was hardly surprising that the Mad Italian was attracted to this beautiful earth mother, I thought contentedly when I realized whose arms I'd been lying in. She was as peaceful as a harbor on a stormy night. We smiled at each other warmly, hearts filled with love. It was the kind of thing that was happening all over the ashram these days: everyone learning to love the people their lovers loved, drop their jealousy. If ever there was a miracle, it seemed to me, this was it.

By the time Bhagwan got up to leave (two energy darshans later), I felt as if I'd been through the battles and victories of a thousand lifetimes, as wiped out as I was blissed out.

Bhagwan made no attempt to hide the bizarre nature of the energy darshans. Darshan photos soon graced every book the ashram published. Visitors were welcome to attend darshan; the press was welcome. If outsiders saw the energy darshans as group orgies, and Bhagwan as a hypnotist who controlled his disciples through paranormal powers, aided by mesmerizing music, flashing lights, and ordained frenzies of undisguised sexuality, it was fine with him. The darshans weren't something I wanted my parents or children to know about, though. To experience them was one thing. To try and explain them, something else.

When Barney Rossett and his wife, Lisa (my editor and publisher at Grove Press) visited me while they were on their honeymoon, Laxmi invited them to darshan. It was obvious that they didn't like the ashram with its ubiquitous guards and stringent rules about where they could and couldn't go, and the overt appearance of a distinct, privileged hierarchy (that included me). They were "closed," I told myself—blind in the Garden of Eden. New York intellectuals, imprisoned by their preconcep-

tions, they "missed." I felt sorry for them. Yet I was immeasurably re-
lieved when they turned down Laxmi's invitation. They'd have been ap-
palled by the energy darshans.

Bhagwan didn't seem to care whether people's attitudes toward him
were positive or negative as long as their feelings were intense. While
the ashram relentlessly pursued favorable publicity (promotional displays
toured India extensively, as did an ashram Shakespearean theater group,
a rock band, and a widely acclaimed fashion show), Bhagwan himself
seemed to openly seek publicity that could only turn out to be negative.

After encouraging a German filmmaker to do a documentary on the
ashram therapy groups, Bhagwan did his best to make sure the film was
as shocking as possible, staging scenes to make the groups seem even
more violent and blatantly sexual than they were. While the public was
outraged by the movie *Ashram!*, and sannyasins were incensed by its ex-
ploitative sensationalism, it was exactly what Bhagwan wanted, as I
knew from my involvement in the project. He courted controversy. He
always had.

ॐ

"It's about time," Premda said when I finally staggered out to the Lao
Tzu gate that night, the Mad Italian holding me up, or trying to; he was
as devastated by the darshan as I was. "Deva and I were about to give
up and leave. Good darshan?"

I nodded, too numb to speak.

"You coming with us, *paisano*?" she asked the Mad Italian as Deva
ran to the back door of the house to get my sandals.

He shook his head no. "I have to go out with the film crew again to-
night. Old friends from Milano. They leave tomorrow." Kissing my fore-
head lightly, murmuring, "*Ciao, amoré*," he slipped out the gate to where
his latest infatuation, a thirteen-year-old German girl, was waiting for
him.

"We should hurry," Deva said, handing me my sandals. "They were
supposed to start right after darshan."

"I don't think I feel like...," I protested.

"You'll love it, Sats," Premda insisted, putting her arm around me,
my head scarcely reaching up to her shoulder. "When's the last time you
went to a *Rosh Hoshana* service? It'll give you something to write to your
kids about."

As Deva, Premda, and I strolled slowly over to the Jewish High Holy
Day services that were being held in a nearby Koregaon Park house, I
gradually began to feel grounded again and the three of us were soon

giggling like school kids as we gossiped about who was going out with whom, whose relationship was breaking up, what an unexpected bacchanalia Bhagwan had created with his crazy energy darshans. Even Premda and Deva had had their little flings away from each other: inconsequential, just to prove they had the freedom to do it. Sheela and Chinmaya had just partitioned their room down the middle so they could live with their lovers. Even Vidya's husband Bodhi was beginning to be seen with other women. Premda and I were sure nothing would come of it: Vidya would kill him. Deva was sure something already had.

"And the Mad Italian?"

I shook my head, laughing. "You know what that nut did when we were out with the film crew last night? Wearing a long robe wasn't outrageous enough for him, so he dolled himself up in a 1950's pink organdy prom dress. Black eye makeup, high-heeled clogs. Then he sat at the restaurant like a tarted-up transvestite and lectured to them in Italian, so dazzlingly brilliant, one of them told me, that they were all spellbound.

"It might have been funny if I wasn't his date!" Premda and Deva were roaring with laughter. "He was wearing bright red nail polish. No lipstick only because he couldn't find a color he liked. Then in the rickshaw coming home, he tried to fuck me. 'I can't walk you to the Lao Tzu gate in this get-up with an erection,' he said. 'It spoils the lines of the dress.' He should have worn a girdle!!"

We were still giggling as we opened the door of the house where the services had already begun. There were hundreds of people inside, all sannyasins: Italian Jews, Danish and Dutch Jews, English, Irish, American, Canadian, Australian, South African, and South American Jews. Austrians and Germans with one Jewish parent, a black Israeli woman, and an Ethiopian Jew. All of them reciting the prayers as if they'd been doing them their whole lives. They probably had been.

With a sudden thrill of recognition and belonging, I squeezed in beside a middle-aged Baghdadi Jew who'd been arranging sannyasins' visa extensions for them since the Bombay days. "Jew York!" he mouthed when he saw me, beaming. He'd helped me out a couple of times in the past. No charge, ever, for his little friend from Jew York. I smiled back at him warmly.

"*Boruch ato adonai*," the roomful of people recited. I knew the words less well than most; I'd had little religious training and had absorbed even less of it. I was learning from Bhagwan what it meant to be Jewish.

"*...Eluhanu meloch cholum....*" I was glad I'd come.

Life at the ashram went on passionately and idyllic
Despite missing my kids, there was never a moment w
be anywhere other than where I was. I was never bo
never wondered: is there more to life than this? The "more was
was living. Bhagwan seemed to have the answers to all my questions. If
there was any purpose to life, it was to become a Buddha: enlightened.
And Bhagwan's Buddhafield was clearly where it could happen.

In the outside world it was easy to forget about spiritual goals; there
were too many distractions. Family responsibilities. Monetary considera-
tions. Political and social abuses that had to be confronted. Movies, tele-
vision, books, hobbies, drugs, alcohol, travel. Life at the ashram was
simple; there were no escape routes, no ways to avoid looking at myself.
While I didn't sit and contemplate my navel all day, I contemplated it on
the run: at lectures and darshans, working and playing.

The Mad Italian was my guru-of-sorts. Only his compulsive game of
seduction and rejection ever took me down from my euphoric equilib-
rium. Every time I thought I was immune to him, he'd try another tactic
to win me over and I'd be caught unaware again and suffer again. If this
was what "abandonment" was, the pain of it was excruciating. But not
devastating ultimately. I'd survive, my kids would survive. Leaving the
womb was the only authentic abandonment, according to Bhagwan: an-
other philosophical premise to justify my life. Everything had something
to teach me, teach my kids; life was a school as Billy (and Bhagwan) al-
ways said. Even the Mad Italian's continual rejections were a gift.

When Nancy wrote me in the spring of 1980 and asked me to come
home for a dance performance she was in, it was partially because of the
Mad Italian that I didn't want to go. Him, and the energy darshans and
lectures I didn't want to miss, the day-to-day intensity of ashram life.

In the two-and-a-half years since I'd last seen my kids, their needs
and reality had become more and more distant to me. Nancy was the
only one who ever wrote, and then only rarely. My letters went unan-
swered, my phone calls were always frustrating and inadequate. My own
reality and needs, my pathetic fear of losing what I thought I had at the
ashram: my "position" and security, were more important to me than
anything else. I hadn't looked at anything but what *I* wanted for years;
my spiritual search was the ultimate in narcissism: self-absorbing, self-
centered, selfish. Nothing existed but I, me; my needs and fears. It
sounds so ugly now and felt so spiritual then. The rest of the world dis-
appears when you contemplate your navel.

While leaving the ashram wasn't forbidden, it was virtually unheard-
of amongst Lao Tzu residents. When Vivek went back to England for the
first time in eight years to see her father who was sick, she was ready to

return the minute she stepped off the plane in London, sending tearful taped messages back to everyone in the house about how lucky we were to be with "Him," what a mistake it had been for her to leave. She was back within a week. Anything that took us away from Bhagwan was a meaningless distraction no matter what it was. It always seemed significant to me that nearly a third of the women considered to be "closest" to Bhagwan (i.e., Lao Tzu residents and mediums) were mothers who'd left their children at birth or given up custody of them. It was an astounding percentage.

If I went back to the States, my neurotic/insecure/greedy/selfish mind was afraid, my room in Lao Tzu House might be given to someone else. Another new phase of Bhagwan's work might begin and I'd miss out on it. The Mad Italian might find another "permanent lover" and I wasn't ready to give him up yet. My whole life could change. I didn't want to go.

"If you don't come," Nancy had written, making her request into an ultimatum that I felt manipulated by, "this is it, finished. You're not my mother anymore."

She'd never asked anything of me before, none of my kids had, giving me the freedom to do whatever I wanted, making it as easy for me as possible. All she wanted now was my token presence in her life for a short time, and I didn't want to go. There's no way to justify it. It's simply a fact.

I wrote a dozen letters to Bhagwan asking him what I should do, and then I didn't send them, knowing he'd only tell me to do what he thought I wanted to do anyway. His responses were invariably affirmations of what we wanted to hear: Bhagwan says I should have an abortion, have a baby; leave my husband, not leave him; go back to the States, not go. He was our justification to do whatever we wanted to do without having to take responsibility for it. It seemed so dishonest suddenly. I couldn't do it anymore.

As I wrote to Nancy to tell her that I wasn't coming home—I didn't try to explain it; there was nothing to explain—my abandonment of my children became a reality to me in a way it hadn't been before. I hadn't lived with my kids for seven years, it had been over two years since I'd seen them, but I'd always had scores of excuses. Bhagwan was "calling" me. The children would be better off with Danny. I did what I had to do; I had no choice. The fact was, I'd left them. For purely selfish reasons. Because of what I wanted. Freedom. Buddhahood.

The stark reality of "Satya: Jill: mother-of-three-who-abandoned-the-kids-she-loved" suddenly stared me in the face every time I looked in the mirror or sat quietly by myself. This is who I am. Fact.

The next few weeks were deeply troubling ones for me. Filled with self-condemnation and guilt, I looked at myself, looked at "what I'd done," till slowly, painfully, I was finally ready to acknowledge it without making excuses for myself. For better or worse, I was who I was. And stopped judging it finally, or thought I did.

૨ֈ

On Patti's seventeenth birthday—my mind on my kids the way it always was on their birthdays: knowing I'd be a nervous wreck till I got them on the phone, *if* I got them—Chinmaya finally "left his body."

He'd had a champagne party in his room the night before to say goodbye to his friends; he knew he was about to die. Sheela "forgot" to tell me about it, Chaitanya assumed I knew and didn't mention it; I wasn't there. I didn't even know Chinmaya was on his deathbed. It had been weeks since I'd last seen him, kept away by my distaste for the Filipino nurse who'd been taking care of him for several months.

There was something about Puja that sent shivers of revulsion up and down my spine the moment I met her. There was nothing I could put my finger on beyond her phony, sickeningly sweet smile; it was years before she became widely-known as the Dr. Mengeles of the sannyas community, the alleged perpetrator of sadistic medical practices that verged on the criminal; my reaction to her seemed irrational. Chinmaya liked her. Sheela trusted her implicitly. I avoided her.

Ashram activities were suspended for the day while a special celebration for Chinmaya took place in Buddha Hall. The sannyasin way of death was to celebrate the occasion with music, dancing, singing; helping the soul to leave the body joyously, with no regrets. Death, in theory, wasn't considered a cause for suffering. The soul was moving on to a new adventure.

As Chinmaya's flower-strewn body was carried into the hall and placed in front of Bhagwan's dais, a group of musicians played and five thousand people, most of whom didn't know Chinmaya, sang ashram-written love songs to Bhagwan in his honor. Tears running down her face, Sheela left her place beside "the body" and walked over to where the musicians were. The music stopped.

"Enough of this crap," she mumbled into the microphone, laughing, crying; looking radiant. "It's great, it really is. But let's give Chimney...." She broke down suddenly, sobbing. All of us who were sitting beside "the body" were crying. Chinmaya looked totally at peace: calm, accepting. After so many years of pain it was probably a relief to him to be

"out of his body" finally, but we'd all miss him. In the absence of my family, he'd been like a brother to me.

"Let's say goodbye to Chimney," Sheela tried again, voice cracking, "in a way he'd love. Chaitanya! Arup! Come here and help the music guys. Chinmaya loved rock and roll, songs of the fifties. Let's send him on his way with them!"

"One for the money, two for the show, three to get ready now go cat go...." It was the most fitting, appropriate farewell I could imagine.

As Sheela squeezed in between Chinmaya's lover and me, she put her arms around us both. "He looks gorgeous, doesn't he, Satsie?" all three of us hugging each other and crying. "I'm sorry about last night. Chimney kept asking where you were."

We sang songs of the fifties all the way to the burning ghats, then sang them while Chinmaya's body slowly turned to ashes on the funeral pyre, dancing wildly, saying goodbye in the only way we could.

I didn't get to call Patti all day. I couldn't. And couldn't stop thinking about her, thinking about all my kids. Death could come at any moment: to me, to them, to anyone when we least expected it. I longed to see them.

The next day everyone was told that Chinmaya had died while he was listening to Bhagwan's morning lecture in bed. Bhagwan told a joke about cancer. Chinmaya laughed, shut his eyes, and "left his body."

"I was in the room when they killed him," Deeksha alleged when I spoke to her several years later. She'd left the sannyas community and been in hiding for five years by this time, afraid for her life.

"Who killed...?"

"Sheela and that woman. Don't be stupid, Satya. It's not becoming. And don't think it wasn't Rajneesh—I won't call him 'Bhagwan' anymore—who set it up. How do you think they knew he was going to die so they could have that party? They knew it because Rajneesh said...."

"He was on his deathbed, Deeksha!"

"Come on, *amoré*! How many years you knew Chinmaya he was always about to die, eh? Rajneesh said it was time. What you think? He had a lot of work for Sheela to do. He needed her."

"But...?"

"I was there, *bella*. I'm telling you. It was ugly."

Did I always know? Suspect? Sheela seemed to come into money suddenly, I remember; she began dressing nicely for the first time. I assumed she'd finally managed to take out life insurance on Chinmaya. And she was certainly freer now for "the work" than ever. I knew all that. In retrospect it seems suspicious. But she loved Chinmaya. I knew that, too. Was Deeksha crazy? Was Sheela? Puja? Bhagwan? Am I crazy

to be even considering the possibility that Deeksha was right? Was Bhagwan's joke about cancer a cue to Chinmaya's loving caretakers that they should "do the needful," the moment was at hand?

After Sheela fled Rajneeshpuram many years later, accused by Bhagwan of attempted murder and scores of other illegalities, I talked to Chinmaya's mother on the phone. She was hysterical, convinced suddenly that her son had been killed. The accusation sounded irrational to me. There had never been any whisper of foul play, any innuendo of suspicion. Chinmaya was sick, he had cancer, he died. He became a sannyasin folk hero in death, a video of his funeral celebration shown in Rajneesh centers all over the world, photos of him prominently displayed next to photos of Bhagwan in the medical centers in both Poona and Oregon. No one had killed him. Why would they? I'm not so sure anymore.

Chinmaya's death may well have been the first of the organization's nefarious "medical experiments." We'll probably never know. What seems clear, though, is that from the time of his death on, ever since Puja's crocodile-smiling appearance on the scene in fact, things at the ashram began to get progressively more bizarre, much of it stemming from the medical center that Puja was soon coordinating under Sheela's supervision. At the time, though, we all took Chinmaya's death at face value; there was no reason not to.

Sheela broke up with her lover shortly after Chinmaya's death and moved into Laxmi's room in Lao Tzu House. Nominally one of those Lao Tzu snobs herself now, she finally seemed to forgive me for being one too, and was friendlier than she'd been in years. I wondered if we'd become friends again; she loathed everyone else in the house; but she was increasingly wrapped up in her work, our lives were totally different. Laxmi was rarely around anymore, constantly involved in legal battles in Delhi when she wasn't busy looking for land for a new ashram. Sheela was the principal administrator of the ashram now. Her whole life was her work; mine wasn't. We had little basis for relating, and even less reason to.

੩੪

Sampurna moved expertly around my body, touching me everywhere as she gently frisked me, a prerequisite to entering the lecture hall these days along with "sniffing." It was more like being caressed than frisked. Some days I went to one of the male friskers, some days to a woman, depending on my mood and who was free. We made jokes about it

("Wanna come up to my room for some deep, fast frisking?") so we wouldn't feel unnerved by the procedure.

Bhagwan's lectures had been getting progressively more powerful over the last year as if he were preparing us for a new stage of his work. Separating the wheat from the chaff, the gold from the dross, the lions from the camels. He spoke about how close many of us were getting to enlightenment. "Whenever it starts happening, many of you will become awake simultaneously. This is how it happened in Buddha's time. Just one person, and immediately a chain. Slowly, slowly, you are getting ready."

The following month he said that only those who were courageous enough to move beyond the boundaries of the mind, beyond all limitations, would remain with him. Those who were not courageous enough would leave. "Thousands will come, but only a few will be transformed. It's up to you. You can use this opportunity that I am making available or you can miss it. I have opened the door. I am standing there welcoming you. Come in!"

A few months later Bhagwan shocked everyone by announcing that three-quarters of his sannyasins would leave him within the next two years. Incapable of moving to the next level, they'd reject him and everything they'd experienced in his Buddhafield.

I couldn't imagine him ever doing anything I wouldn't be able to accept. I'd risk my life for him if I had to, I told myself; whatever was required. Me, leave? *Over my dead body*, flashed through my mind. *They'd have to carry me out in a stretcher to get rid of me.* It turned out to be a wheelchair.

As I walked to the front of Buddha Hall and sat down in my place, an Italian woman who would later become one of my bosses at the ranch and do her best to "break" me, leaned over and hugged me. Kavi took my hand and squeezed it. The three of us sat crosslegged on the concrete floor holding hands, our eyes closed, stoned on the energy in the hall as we waited for Bhagwan.

The long, white bullet-proof Rolls Royce that Sheela had recently had sent over from the States—a stretch limo for two hundred yards; I thought it was ridiculous—drove slowly around Buddha Hall. As Shiva opened the car door for Bhagwan, dozens of samurai stood by attentively. Bhagwan climbed the stairs to the dais, *namastéing* in each direction and smiling at someone in the first row. Vivek handed him his notes and then walked sedately to her place in front of me and sat down. Unchanging rituals. Part of every morning's subtle pageantry .

"My sannyas is risky," Bhagwan said. "It has always been so. To be with a living Master means to be in tune with truth; and truth believes

in no traditions, no conventions, no conformities. It is rebellious. Unless you are a rebel, unless you are ready to die for rebellion, you cannot be with a living Master; you cannot afford to be. You can worship a dead Master, you can create a fiction around him; whatever you want, you can impose on him; but real Masters are totally different."

Bhagwan's words appealed to our egos—we were the special ones, "the chosen few"—and made our enlightenment contingent upon our acceptance of him as our Master. Yet everything he said seemed irrefutable. Most sannyasins had been spiritual seekers for years. We'd all found more with Bhagwan than we had anywhere else. We were happier than we'd ever been, more fulfilled. Bhagwan called his sannyasins his biography. We were the proof that he was a Master of Masters; he'd transformed us all.

When I finally went back to the States six weeks later to see my kids, all I wanted to do was to share Bhagwan with them. It was the only thing I felt I had to give them, the only thing that seemed worth giving. I brought my Bhagwan-borrowed knowings back with me on a silver platter: here, take. I didn't understand why my kids didn't want them.

15

"hat's in those packages, lady?" the customs inspector at JFK asked, pointing to two gift-wrapped parcels in my suitcase.

"Huh? Oh, sorry." I'd been waving enthusiastically to Billy and my parents who'd just arrived; I could see them looking for me through the glass enclosure upstairs. Tears in my eyes, I'd barely recognized Billy; he looked so grown-up. He was fourteen years old. I'd missed his whole childhood. He was a young man already.

"Presents," I muttered casually, hoping to god the man wasn't going to ask me to open them. "For my family. That's my son up there. I haven't seen him in three years," chatting away convivially as if I didn't have a care in the world, trying to distract the man. "I've got a couple of blouses in here, too." Reaching into my suitcase, I pulled out the two silk *kurtas* I'd bought for Nancy and Patti. "And some cheap jewelry. I didn't itemize any of it 'cause it only adds up to $50."

Jovial innocence, nonchalance, suburban bullshitting of the friendliest sort usually worked going through customs. I was a perfect courier for the ashram. A typical middleclass housewife even in my red robes and *mala*.

The customs official picked up one of my gift-wrapped parcels and began opening it. My heart sank as I kept up a running, casual monologue.

"Whew!" He took a sharp intake of air. "Quite a present, lady," he said as he opened up the candy box cover. "You must be pretty fond of your family."

Inside the box were thousands of dollars in traveller's checks, one of twenty similar packages Sheela had given me to bring to the States, de-

posit in my bank account, and transfer to several people in various parts of the world, none of whom I knew.

"Oh, sorry," I laughed apologetically. "I thought that was the book I got for my sister. I must have mixed them...."

"Let's see what's in this one," he said calmly. Another cache of checks. "Hey, Joe," he called to another customs man, "come on over and lookee what we got here. Whooee!!"

While the people behind me were shifted over to another line, my suitcases searched and all my gift parcels opened, I explained matter-of-factly why I had $100,000 in traveller's checks with me.

"The money belongs to a charitable organization I work for in India. We buy everything from the States: office equipment, cameras; the Indian stuff's terrible. It seemed silly to deposit American funds in an Indian bank and lose money on foreign exchange in both directions when I was coming to the States anyway."

The men nodded sympathetically as they continued their systematic search. "It makes sense to me," one of them shrugged casually. "It's no sweat off our backs if you bring American dollars into the country. If they don't like you taking it out of India, that's their problem." My suitcases had gone through as VIP luggage in India, courtesy of an airline executive who was a sannyasin. "You're supposed to declare it, though. That's the only thing we got against...."

"The customs form said American dollars. I didn't think traveller's checks...."

"Check it with the boss, will you, Joe? I'll go through the rest of the boxes and see how much it amounts to.

"Hey, Joe! Wait a second! I found something else!" pulling out a reel of 16mm film that was hidden between my clothes in my second suit-case. "What's this, miss?" he asked politely.

"A movie of my teacher lecturing in Hindi. I'm bringing it to some Indian disciples in Flushing."

The two men opened the metal container and looked at the first few feet of film: pictures of Bhagwan sitting in his armchair talking.

They mumbled to each other. "Snuff movie." "A lot of this porno crap coming in these days."

"It's just Bhagwan lecturing," I said as Joe walked off with the reel of film and one of the candy boxes.

"I believe you, lady. You don't look like the type to get involved in that kind of filth. Someone could have pulled a fast one on you, though. It happens all the time. We got no way of knowing what's in that reel; they all got harmless runners on them. We gotta check it."

The money suddenly paled in significance as the customs people's at-

tention was diverted to the film. It would have to be carefully reviewed, I was told. If it was what I said it was, I could pick it up the following day.

Three hours after starting through customs, I was finally allowed through, the traveller's checks in hand. Billy and my parents were anxiously awaiting me.

"It was just a misunderstanding," I told them casually after we'd greeted each other; Billy and I with a long ecstatic hug, my parents and I with their customary kisses-in-the-air and bodies-not-touching embrace. "About the $100,000 I have with me. And a Hindi film of Bhagwan's that I have to pick up tomorrow."

"About the *what?*"

I explained to my parents what I'd explained to the customs inspectors about the money. It was what I assumed was the truth. If I'd been worried for a moment that I might end up in jail, it was just my paranoia. I had the money with me now. No one seemed very disturbed by it. Even in my brief moments of apprehension, I hadn't been scared. Bhagwan was with me. Whatever was supposed to happen would happen.

The scene had the same unreality to me as the time I'd been held up at knife point in the hall of Chris' apartment years ago, something that wasn't really happening to me: a movie set I'd inadvertently walked onto and had to play out my role in. It was over. I didn't want to think about it. Being with Billy was the only thing that mattered. I wanted to feast my eyes on him, hug him forever, forget about all the years I'd been away.

"You look great!" I told him as we walked arm-in-arm ten feet in front of my parents, lugging my suitcases along with us. He was almost as tall as I was. Amazing! "Really great. How are the girls doing? I can't wait to see them."

"Patti's not back from Brazil yet." His voice had changed, too. Was this really my *baby?* "She gets in tomorrow. We can pick the film up when we come to meet her. Nancy should be home when we get there. She's dying to see you."

That Billy's reception of me was warm and loving came as no real surprise. He never seemed to blame me for leaving him. "I had a great life with you," he told me years later, "and a great life with Dad. I just wanted you to be happy."

"But didn't you wish...?"

"I was grateful for the years we had together," he said, touching my hand and ignoring my tears, loving me with his eyes. "They were very

special. I never regretted any of it." He was so much more than I deserved.

It was Nancy's warm welcome that surprised me, though. I was afraid she'd never talk to me again, but she was more open than she'd been since Danny and I separated. She'd decided that I wasn't her mother anymore so we could be friends, with no hard feelings, no expectations. Nearly nineteen now and in her second year of college, she'd read various books on the frustrations of women in the '50's and '60's. She understood why I left, she told me. She didn't blame me.

We related more like contemporaries now than we did like mother and daughter; people asked us if we were sisters. There was a closeness between us that we hadn't had before. We had fun together: girl-talk, gossiping, comparing notes on how we saw the world. It was only my romantic idealism that Nancy seemed to hold against me.

When Patti came back from the student exchange program she'd been on in Brazil, she was in a state of culture shock and emotional upheaval that was undoubtedly magnified by seeing me for the first time in almost three years. She talked about her Brazilian "mother and father" as if they were her parents. From one day to the next, she'd moved to another family and another life; another reality.

"Help me, Mommy!" she cried desperately. "I need you!"

I led her in several sessions of Dynamic. It was all I could think of to do for her. She screamed, shouted, raged, and sobbed heartbreakingly, as I'd done for years during the meditation, and seemed to feel better for it afterwards.

We lay on her bed together while she cried pitifully in my arms. "I have a knot inside my heart that hurts so much, Mommy," she wept. "Help me get rid of it, *please!*"

"What do you think it is, honey?" feeling her pain inside me.

"I think—oh god, Mommy," she whispered furtively, embarrassed. "I think it's joy. But joy covered up by so much shit it feels like pain. I have to get rid of the shit so I can feel again. Why can't I feel anything, Mommy? What's wrong with me?"

"It's just the way you've been brought up, sweetie," I murmured soothingly, thinking all the while, in my rose-colored myopia, how beautiful Patti was, how alive. "The way we've all been brought up. Condemned. Told we're wrong for being who we are. Bhagwan's helping everyone at the ashram to rediscover joy again. You'd be so happy there. Come back with me, please!"

Pulling away from me abruptly, Patti sat up on the bed, her coal black eyes flashing. "Don't talk to me about your stupid Bhagwan!" she hissed. "I don't trust him! Who does he think he is, anyway, taking a

mother away from her children? He doesn't sound like a very nice man if you ask me!"

As I reached out to touch her, she flicked my hand away peevishly. "I'm not so sure I trust you anymore either," she snapped. "This is my home. I've got to be able to function here. Can't you understand that for petesakes? Daddy's right. You're nothing but a baby," throwing herself down on the bed again and letting me hold her, both of us crying this time, not knowing who was comforting whom.

"I can't believe how out of touch you are with reality," Nancy accused me as she drove me to the Scarsdale station later that evening. I was staying at my parent's house in Chappaqua at night. "Patti's so confused right now and all you can think of to help her is Bhagwan. It's stupid. There's no way in the world any of us are ever going to go to In...."

"Billy's coming soon. Daddy promised him when he gets a little...."

"That's not *now*, Mommy. *God!* And Patti's certainly not in any condition for you to preach to her. Can't you see that? Just lay off, okay, Mom? You're not helping anything."

Meanwhile, Billy watched Patti going through what she was going through: trying to comfort her, neither judging her, nor me. "She'll get over it," he kept reassuring me. "Don't worry, Mom. She has her whole family here to help her."

That her whole family didn't include me was understood. The family circle of cousins, aunts, uncles, grandparents, siblings, and father had closed up whatever gap I'd left in it years ago. My presence was hardly missed anymore; my absence hardly noticed. The kids' lives had gone on for too long without me.

When I was scheduled to return to India after two weeks in the States, I went. I didn't seem to be helping anything by staying. Not when my stay was only temporary, a visit. And no matter how much I felt Patti's anguish, it didn't occur to me not to go back. India was my home. I felt like a fish out of water anywhere else, an alien even with my own children. We spoke different languages and had different dreams.

The children may have forgiven me for leaving them, but they didn't understand me. And I didn't understand why they couldn't. If I hadn't found Bhagwan, I'd have been hopelessly neurotic, suicidal; no good to anyone. Couldn't they see that? I hadn't been strong enough seven years ago to handle the guilts and responsibilities of motherhood.

I still wasn't.

I don't think I'd ever appreciated the ashram as much as I did after I got back from my trip. To my own surprise, I'd missed the ashram as much as I'd missed Bhagwan. The radiance and joy I saw in people's faces, the piercing clarity that everyone seemed to have from time to time: a loving community of occasional Buddhas.

"How was your trip?" Vivek asked warmly as we sat on my bed after discourse on my first morning back, eating the Oreo cookies I'd brought her. In the two-and-a-half years that I'd lived in Lao Tzu House, she and I had become distantly friendly if not friends. "Are your kids okay?" she inquired, nodding sympathetically when I told her about Patti. "Don't worry, love, they'll all be here soon. Bhagwan said they'd come, didn't he? Trust him."

When Sheela asked about my trip later that day, I didn't say anything about my children—I didn't think she'd be interested—telling her instead about my disconcerting encounter with the customs officials, a story I'd blithely repeated dozens of times by now, always to a hilariously appreciative audience. There was scarcely a sannyasin at the ashram who hadn't carried contraband of one sort or another between India and the west at one time; it was something everyone could identify with.

"They forgot all about the gift parcels and got excited about the film," I laughed gaily as Sheela and I stood outside her office where scores of people were waiting to see her. "One of those poor men had to watch ten hours of Bhagwan lecturing in Hindi!" enjoying the story for the dozenth time. "He was furious! He said it was the most boring ten hours he ever spent! Meanwhile, the $100,000 you gave me...."

Grabbing my arm abruptly, Sheela pulled me inside her office, glaring at me. "Are you that stupid, Satya? Jesus!"

"I.... What...?"

She led me into the back room, fuming. "I hope you haven't gone around with that big mouth of yours telling everyone I gave you $100,000!"

"Well, sure. I didn't...."

Sheela closed her eyes, took a few deep breaths, then opened them, smiling warmly. "It might be better if you didn't talk about it anymore, hmm, Sats?" she winked conspiratorially. "You know how suspicious people are. They always like to think the worst."

"Okay," I mumbled nonchalantly, not understanding what she was so upset about. The American authorities hadn't been concerned about the money. Why should she be? No one at my bank had even questioned my request to wire the money I'd just deposited to various numbered bank accounts in Europe.

When I thought about the incident years later, I assumed that Sheela

had been worried about the Indian authorities finding out that the ashram was smuggling money out of the country, something that ultimately became an important legal issue. Ravjiv (who was promoted from errand boy to head accountant after Bhagwan left for America) only escaped imprisonment for it by leaving the country. Most middleclass Indians seemed to send money out of India constantly. Half the shopkeepers in Poona bought U.S. dollars from sannyasins to send to relatives abroad, more wealthy Indians merely circumventing the law in more sophisticated ways. It seemed less like a crime than a custom: a time-honored tradition. The ashram obviously sent money abroad often. Sheela's brother managed an investment program for us. We had numerous bank accounts in Switzerland. Goods from abroad arrived at the ashram daily.

Perhaps there was more to Sheela's fear of my babbling than that, though. I wonder now about drug deals, bribes, pay-offs, tax evasion; anything's possible. Sheela didn't trust me enough to tell me what was going on, and I was too naive to know what I shouldn't talk about. Maybe that's why she did what she did to me a few months later. It was years before I made the connection, though. I had too much invested in my dreams and no world left outside them.

ཨ

"Did you see the notice, Sats?" Chaitanya pointed to a small note that was pinned to the wall near the back door to Lao Tzu House. He'd moved back into the house a few months ago, but we spent little time together these days, our relationship fraught with unacknowledged resentments from the past. "I have a feeling it's meant for you and Kuteer," he said as he slipped on his sandals to leave. "Better read it carefully, Satsie-pots. *Ciao.*"

The note was a "loving reminder" from Arup (who was a Lao Tzu resident) that everyone in the house who was enjoying "rapturous bouts of lovemaking" at night should tone down their sounds after 10:30: put a pillow over their heads, a plastic bucket, gag their mouths. With Bhagwan urging everyone day after day to be totally free in sex ("Let the neighbors hear you!! Scream! Shout! Make it a joyous celebration!"), few of us were making any attempt to be quiet. The Lao Tzu roof, where many of us had bamboo huts, was constantly filled with the sound of lovemaking. Kuteer (my new Italian lover) and I were hardly unique. Chaitanya, in a hut three feet away from mine, made every bit as much noise with his lover as we did.

In the weeks before I met Kuteer, I'd spent endless, agonizing nights listening to Chaitanya make love. He and his new lover always sounded

as if they were having a much better time together than we'd ever had with each other, their operatic raptures making me feel horny, jealous, and undesirable as I lay alone in my hut trying to fall asleep, wishing they'd have orgasms finally and get it over with, loathing them for the peaks of ecstasy that Chaitanya brought his lover to in sessions of love-making that seemed to go on forever. He was hardly the one to talk about me and Kuteer. The note was probably intended for him.

I'd started dating Kuteer a few days before I left for the States. A gentle, loving man who'd had little formal education, Kuteer's English was almost as bad as my Italian was non-existent; we could barely carry on an intelligible conversation with each other. He'd listen to me talk on and on endlessly, muttering encouragements, then confess sheepishly that he hadn't understood a word I said.

Being with Kuteer was a totally new experience for me. We had an energy connection not a mind connection; he didn't conform to any image I had of the kind of man I was attracted to. But every time I was with him, something magical seemed to happen. The second he touched me, I'd sink into a state of deep harmony within myself, utterly at peace.

Once, during a brief period when ashram workers were given a day off, Kuteer and I spent nineteen hours lying in each other's arms, both of us pulsating with an electrifying energy that was as calm and blissful as God. Utterly motionless, our limbs entwined, neither sleeping nor making love, we didn't seem to be bodies anymore nor even energies; we were the primordial earth itself.

I finally understood what Bhagwan meant when he talked about a valley orgasm. The whole act of making love to Kuteer was like a timeless, prolonged orgasm. Purring and trembling, I'd melt like butter in the sun as our bodies danced on the bed in a spontaneous rhythm of surfaces and textures that made all my previous acts of lovemaking feel like a child's crude attempt at imitation.

Kuteer nurtured me and cherished me; he was like a womb to me. For the first time in my life, I felt truly loved. There was no way in the world the Mad Italian could compete with that.

"Kuteer can only give you love! I can destroy you!" he pronounced grandly as he tried to lure me back with promises and threats that sounded so ludicrous I could hardly believe I'd ever fallen for them. "Are you such a coward that you'd rather be loved than transformed?" he sneered. "Okay, you win. I won't be with other women if it's that important to you!" It wasn't anymore.

"You know what Deeksha ask me today?" Kuteer mumbled one evening as we walked towards the front gate on our way to the off-ashram

room that Deeksha had gotten for him and paid for; something she did for many of her workers.

"What?" Several sannyasins in long, flowing robes were rollerskating in Buddha Hall as we passed by, a fad that began when someone brought Teertha a pair of skates: a druid on wheels.

"She ask me how come I let Satya interfere with my work."

"Me, interfere? What did you say?"

"I laugh at her, what you think, *amoré?*," hugging me affectionately. "She say Satya make Kuteer not so surrendered anymore. Can you believe? She wants I should work late every night, cook fancy dinners for her and Sheela. Kuteer should stay around till midnight in case Deeksha wants to tell me something for tomorrow," motioning for a rickshaw. "Like I'm her slave."

"Did you used to stay late at night?"

"Before I meet you?" he asked quizzically, holding me tightly as we nestled into the back of the rickshaw and headed off down the road. "Sure t'ing. I got nothing better to do anyway. But now," touching my face gently, laughing, "I'd rather be with you than surrender, *amoré.*"

I felt as if I was in love with the whole world because of Kuteer. Having an energy darshan didn't feel any different from being in his arms. I felt whole and complete; fulfilled.

When Bhagwan said in a lecture one day that he was going to become less and less accessible on a physical plane as time went on, his presence was no longer needed, everyone at the ashram except me seemed devastated by the announcement. He hadn't been looking well for awhile, tiring easily; lectures and darshans had become briefer than they'd ever been. It was as if he were preparing us for his death. Not even the possibility of him "leaving the body" bothered me, though. No matter what came next, everything was happening the way it should. Meanwhile, I was flying. Soaring.

*W*hat'sa matter, *amoré*," Kuteer asked one night with concern as I grimaced taking off my robe.

"My neck feels funny," I complained. "Something seems a little...."

"You take care, *bella*. Come. I massage you."

"Something must have happened when Shiva cracked my neck."

"It doesn't feel better tomorrow, you write Bhagwan, heh? This isn't good."

Within days, I was visiting an orthopedic surgeon in town, wearing a neck collar, having physiotherapy done on my neck in the ashram medical center and taking pain killers that the ashram doctors prescribed for me. Nothing seemed to help appreciably.

I sat at my desk on the balcony above Bhagwan's room typing, Kavi and Sampurna were typing at desks on either side of me. My head was pounding; my shoulders, back, and neck aching; my stomach doing an amoebic-induced jig. I had my period, my legs were killing me, and, with it all, I was blissfully happy. If I felt this wonderful when I felt terrible, I wondered how good I'd feel if I actually felt good!

As the days went on, I began to feel guilty about how little work I was doing. Between physiotherapy sessions that didn't seem to help much, the increasingly-debilitating pain in my neck and the fatigue I had from all the muscle relaxants I was taking, I wasn't doing much writing. It was too easy to space out all day and do nothing. I decided I needed a schedule of some sort to discipline myself: part-time work in the kitchen perhaps, or some editing work when I was too tired to be creative.

"Another job is out of the question," Vidya commented when I went to see her in the frenetic main office where she worked these days.

"Sheela's asked Bhagwan a dozen times if she could give you something else to do. You know that, Sats," grinning. Sheela's hostility to my writing was hardly a secret. "Bhagwan wants you to write undisturbed. If you want a schedule though, I'll give you one. I think it's a good idea."

Turning away from me abruptly, Vidya suddenly began to bark out orders like a drill sergeant ("Take that artwork into Sheela, Premda! Now! Not in five minutes! Where were you, Laila? Sheela's been looking for you! Get in there!") and then was back with me again. "Bhagwan's enlightened," she said somberly, "you're not, so I'm not gonna make you write three books a month like him; I'll let you off easy. One book a month starting now means I'll expect to see...."

"One book a *month*, Vidya?! I couldn't possibly...."

"You wanted a schedule," she snapped irritably. "I'm giving you one. Don't argue with me!" This was my giddy friend Vidya talking!? "Start working directly on a typewriter," she continued. "You're wasting your time writing everything first in longhand. I ain't no writer and I can type four pages an hour. You should be able to do better."

"But...."

"No buts or excuses, Satya. If Bhagwan can—okay, I'm coming!" and she hurried off to the front office to see Sheela.

The woman was out of her mind, I thought irritably as I left the office. There was no way in the world I could write a book a month. Bhagwan had a staff of twenty people editing every phrase he spoke, each word of his was gone over dozens of times by someone else. What had I gotten myself into?

I wrote furiously for days and then decided that Vidya's insane schedule was better off ignored. She didn't know the first thing about writing. It was an act of love, something to savour, not a hit and run affair no matter what she said.

ঌ

As concern over Bhagwan's health reached paranoid proportions, anyone in Lao Tzu House who got sick was moved out of the house till they recovered. When I came down with a cold one day, instead of being moved to another room at the ashram as other house residents had been, I was sent to Saswad, an old castle/fortress on the outskirts of Poona that was being used as an ashram annex.

Being at the castle, with its stone walls, narrow, dark staircases, low ceilings, and cow dung floors was like something out of a childhood fantasy for me; I loved it there. Not even the bats that overran the place at

night nor the rats I heard scurrying around outside my mosquito net disturbed me; they were part of the atmosphere.

I spent my days walking over the rough, parched hills nearby, my neck collar on and a walking stick in my hand. As sure-footed as a goat, I climbed up every incline I came across, singing Hindi *bhajans* and Sufi chants at the top of my lungs till the hills reverberated with the sound of it.

High up in the hills one morning, not another human being in sight, I met two huge mountain lions face-to-face. Close enough to look into each others' eyes, we stopped and stared in silent communion and then went on our separate ways. It didn't occur to me to be frightened; it felt like a natural everyday occurrence.

The calm, centered bliss I felt when I was alone in the mountains was the same thing I felt when I was alone inside myself in the middle of the ashram's constant chaos; it was the same thing I felt in lectures or darshans or with Kuteer; but it was a hundred times more intense at the ashram. I was addicted to Bhagwan and his crazy Buddhafield, to breathing in his energy while I worked and played, slept and ate. Two weeks at Saswad were more than enough for me. My "coming home" felt like a coming home.

"It's good to see you, Satya!" Vivek greeted me amiably as I approached the Lao Tzu gate where she was sitting, my overnight bag in hand. "Is your neck better, love?"

"I don't know about better," I shrugged, sitting down beside her, "but at least it's no worse."

"Bhagsie thinks it's funny," she giggled.

"What is?"

"Your trouble with your neck. He told me you've been in such a good space lately that you could have got enlightened at any moment. He wondered what you'd do to prevent it," eyes twinkling with merriment. "He said the first time he saw you in a neck collar, he almost laughed out loud."

"Vivek! I didn't do this on purpose! The x-rays show...."

"The x-rays!" flipping her hand dismissingly. "Of course it's *physical*, Satya," laughing. "That's not the point. Oh well," patting my leg cheerfully, "he says we've all been avoiding enlightenment for lifetimes. It's probably not the first time."

It was hard for me to imagine that I was actually doing this to myself. My neck hurt badly. I had a slipped disc, degenerating vertebrae. My unconscious wouldn't go to that much trouble to make sure I remained unconscious, would it?

On the day after my thirty-ninth birthday, when our elegant resident prince (a nephew of Queen Elizabeth of England) died of a brain hemorrhage, was declared enlightened by Bhagwan and given a farewell ceremony on the Lao Tzu lawn, I danced and sang along with everyone else for hours, celebrating the occasion, the pain in my neck notwithstanding. It was the first time a friend of mine had ever gotten enlightened; it was a major ashram event.

I wondered for a moment if it was really true. It was such an ideal publicity gambit: the enlightened prince. My skepticism was short-lived, though. If I'd nearly been enlightened myself, it could happen to anyone. Of *course* he was enlightened.

Puja's assistant at the medical center approached me later that day while I was on my way to lunch. "I'm glad I ran into you, Satya," she smiled nervously. "I've been looking all over for you."

"What's happening?" I asked her absently, wondering why she looked so ill-at-ease; it wasn't like her.

"I, ah, that is, Bhagwan just saw a video of this morning's celebration," she stammered.

"And?"—curious now.

"Of you in your neck collar," she mumbled. "Dancing. If you people don't know how to take care of yourselves," she said after an awkward pause, "he said we'll have to take care of you. You're to be admitted to the ward tomorrow."

"I'm to.... *what?*"

"You don't have to come till after the discourse. Bring your things. You'll be staying awhile."

"Are you sure you mean me?" I asked, bewildered. Despite the pain in my neck, I felt wonderful.

She was sure, she insisted; it was definitely me. So dubiously and reluctantly the next day, with nothing more wrong with me than a slipped disc, I admitted myself to the medical center. If that was what Bhagwan wanted.... I supposed I should feel grateful. With thousands of other disciples around, he still worried about me.

ॐ

After a week in bed, I was considerably worse. The archaic traction mechanism that was being used on me (a leather harness that looked like it belonged on a horse and that only one of the medical staff ever learned to adjust properly) caused more pain than it alleviated. It wasn't just my neck and shoulders that hurt now; pain was shooting down my

arms. But no, I was informed adamantly when I asked, I couldn't stop the traction. It was doing me good even if I didn't realize it. "Surrender, Satya. We're taking care of you," I was told repeatedly as the staff dished out more pain killers to counterbalance my steadily-increasing pain.

Kuteer came by to see me every day, bringing me flowers and gifts. He'd stand by my window and talk to me—only patients and staff were allowed inside the ward—until the nurses shooed him away. The patients needed to be in isolation, the theory went. We needed all our energy for healing.

Before long, I was in permanent traction, the heavy leather harness kept on me for twenty-four hours a day while I was fed huge amounts of valium, morphine, and quaaludes (which I've since learned are hallucinogens and have no known therapeutic value). When I wasn't bombed out of my mind on drugs, I was obviously worried about what was happening to me. I could hardly move by now; every bone in my body ached. I didn't understand, moreover, why I'd been put into a ward with hepatitis patients when there was another ward filled with people who had back problems.

In one of my rare lucid moments, I asked my doctor why all the noncontagious patients weren't separated from the contagious ones and was visited later that day by Puja who demanded to know, an icy smile on her face, who I thought I was to be giving orders. I was no one special around here. They'd been managing perfectly well without me. I wrote a note to Laxmi (who was at the ashram at the moment), snuck it out the window to Kuteer, and was finally moved into the noncontagious ward: a minor victory.

I became progressively worse after that. After several weeks, my weight was down to seventy-nine pounds. I couldn't eat, couldn't move my bowels, couldn't walk. I was a physical wreck. But blissed out on enough drugs by this time to kill a horse.

"*Amoré*, how you are?" Kuteer would whisper at the window, looking worried.

"Kuteer," so weak by now I could hardly speak. As he pressed his hand against the screen window, I'd try to touch him, but I couldn't do it. I'd lost the ability to move my arms.

Lying in traction all day long, listening endlessly to Bhagwan's discourses on a borrowed Walkman, I felt utterly at peace, tears of joy streaming down my face. Day after day, I watched myself drift slowly and blissfully towards death. It was beautiful. I didn't care if I was dying. I didn't question my medical treatment anymore. As long as I got my pills....

After I'd been in the medical center for a month, Sheela came by one morning to visit me.

"How you doing, Satsie?" she asked, squeezing my hand affectionately. "I've been wanting to see you for weeks, but you know how it is." I'd heard her voice out in the corridor often, but no matter. It was nice of her to come at all.

"I spoke to your parents in Florida last night," she went on abruptly. "I talked to Bhagwan. You're leaving for America tomorrow."

"I, what?" I mouthed, perplexed. Leaving the ashram? Why would I want to do that?

"I lost my husband in India eight months ago," Sheela plunged on determinedly, absently stroking my forehead as I wondered groggily why she'd said "my husband" instead of "Chinmaya"; she sounded like she was repeating a rehearsed speech. "I have no intention of letting my best friend die here, too," she added earnestly, and in my delirious, drug-induced state, her words touched me. Even if she'd hardly spoken to me in two years, she still thought of me as her best friend.

"I don't know if I want...," I whispered weakly.

"It's better this way, Sats," she interrupted. "Your parents'll take good care of you; they're glad you're coming," and I suddenly thought: why not? Maybe it was important for my family to see me again before I died.

"Can I go to darshan tonight?" I managed to croak hoarsely. "I'll need help, but...."

"I'll ask and let you know, Sats."

Nodding, I wondered vaguely whom she was asking. She was the one who decided who went to darshan these days.

A few hours later, the crocodile-smiling Puja was at my bedside. "I have a message for you from Bhagwan," she said with a broad reptilian smile that even in my drugged euphoria I found unnerving. "He said to tell you that there's no need to see him in the body ever again," still smiling. "No darshan."

I was shocked. Even casual visitors to the ashram went to see Bhagwan before they left. I was hardly a casual visitor. While the nurses in the ward fluttered around my bed telling me how happy I should feel—my connection to Bhagwan was obviously so deep that I didn't need his physical proximity anymore—it felt like a rejection. If Bhagwan was trying to tell me that it was time to drop my attachment to him ("In the end, even the Master has to be dropped"), I wasn't interested. I wanted to see him, to cling to him, more than I wanted my own enlightenment.

It never occurred to me that Puja's message may not have come from

Bhagwan, or that my earlier message to admit myself to the medical center may have been a fabrication. That I was apparently poisoned and/or deliberately overdrugged was the furthest thing from my mind. When my doctor at the medical center told Puja that he thought I had toxic poisoning, he was taken off my case and the doctor who replaced him told that I was crazy: he should humor me, medicate me, knock me out; I was being "difficult."

It was years before I knew that, though. I took everything that happened at face value. The only ulterior motives I looked for were spiritual. I reconciled myself to leaving India. Everything was happening the way it should. It always did.

ᎭᎠ

As I lay in the back seat of Laxmi's Mercedes the next evening, my body supported by a profusion of pillows so the movement of the car would cause as little pain as possible, the car left the medical center and drove to Lao Tzu gate where a group of friends were waiting to say goodbye to me.

As we reached the gate, Kuteer opened the door beside me so I could see the radiant faces of all my friends as they sang and danced around the car, celebrating my departure. It felt as if I'd died and they were dancing around my funeral pyre. In my heavily sedated state, I half-wondered if I had.

My eyes flickered closed, everything disappearing, even the singing, as I faded off into a private, blissful world, tears streaming down my face. Filled suddenly with an overwhelming rush of gratitude towards Bhagwan, I longed to bow down and touch his feet in thanks; I imagined myself doing it.

"Are you ready, love?" Gayatri (a sunny blond ma from California who was accompanying me on the plane) asked; I could hardly travel alone in my condition. "If you're ready, we can leave."

As Kuteer got in gingerly beside me, cushioning me in his arms—he was going as far as the airport in Bombay with us—I took a long last look at the joyous faces of my friends as they crowded around the car waving at me, smiling, blowing kisses. I felt so loved, so blessed. As the car drove off, slowly making its way to the front gate, I heard my name called out by scores of people along the way. "Satya!" "Sats!" "We love you, Sats!"

The car picked up speed as we drove away from the ashram. Away from everything I'd known and loved for years. Back to everything I'd left behind: my family.

It was February, 1981. I was going to America to die.

III

The Separation

Florida / New York
(1981)

The author's son Billy in Scarsdale (1981).

The author's mother and two daughters in Chappaqua, N.Y. Center: Patti; extreme right: Nancy.

*T*he wayward child returneth. In a wheelchair of course, but at least it wasn't a coffin. I wondered if my parents were glad to see me.

"Well, she's certainly not dying," my father whispered furtively to my mother as Gayatri pushed my wheelchair through the Fort Lauderdale airport. We'd gone through customs and immigration in New York, a traumaless re-entry into the States; first class passengers on their deathbeds were ushered through like royalty. "I don't know what kind of crap Sheela was pulling. If you ask me, the only thing that's wrong with her is she's a goddamn junkie!"

"Quiet, dear! She'll hear you!"

"Wait till you see the schedule of drugs they've been pumping into her. No wonder she looks the way she does. The first thing we do is get her off this crap; I don't care what it takes."

As Gayatri sat beside me on my bed that night, I begged her not to leave for California the next day. "Don't leave me alone with these people!" I whimpered pitifully as she held me in her arms. I'd only known her for a day and a half and I already felt closer to her than I did to my parents. She was a sannyasin, a kindred soul; they felt like strangers. "Can't you postpone your flight till...."

"I can't, sweetie, you know that. My boyfriend's waiting for me. Your parents'll take good care of you. They're lovely people."

Lovely, I thought bitterly as my father cut down my medicine to the bare minimum the moment Gayatri left. I cried agonizingly, the pain in my body was excruciating, but he wouldn't give in.

My mother stood at the door of my room crying, begging my father

to increase my medication. "You have to give her something, dear! I can't bear to see her like this! She's in pain!"

"Pain never killed anyone," he muttered gruffly. "Drugs do." Hard. Heartless. The bastard. He was glad to see me suffering, I knew he was; he was enjoying it. He'd always wanted me to be under his control; to suffer, squirm, beg him to help me. Why had Sheela sent me here? She didn't know what my parents were like. If only I hadn't listened to her. If I'd said no, I won't go; I refuse.

"She'll have to learn to live with a little pain like the rest of us," my father insisted, pulling my mother away and closing the door, leaving me alone to weep and cry and writhe on the bed, my body suffering from more than physical pain.

What was I doing in Florida with these cold, unfeeling people, I wondered deliriously. I longed to be back at the medical center where the staff were saints, where they gave me all the drugs I wanted, more than I asked for. Who cared if I'd been dying? What difference did it make? It was blissful. This was hell.

I cried, shook, and trembled for days as I went through drug withdrawals, my mother sneaking in to see me, helpless to help me. My father came in, tears in his eyes. "How you doing, baby?" he asked as if he cared. If he loved me so much, why didn't he give me my pills?

"Please, Daddy," whimpering. "I'm in pain. I need...." He let me go through hell. He probably saved my life.

After days of agony that seemed unending, I was finally well enough to get out of bed, well enough to begin eating. I sat at the kitchen table, my plate on top of a cardboard box and two telephone books so I could rest my elbow on the glass tabletop and guide my food into my mouth. I dropped more than I got in. My mother kept wanting to feed me; my father wouldn't let her.

"She's got to do it herself," he said. "It's the only way she'll get her strength back. We're not going to have a cripple on our hands for the rest of our lives. We don't need it.

"Eat your chicken, Jill," he ordered. "You can go back to being a saint when you're better. Not even Borg Warner over there in India expects you to be a vegetarian when you look like you just got out of a concentration camp. Believe me. I checked it out with Borgie. Telepathically."

I managed a weak smile. We were friends again.

"Why'd the ashram send you back, baby?" my father asked a few days later as we sat in the sun by the pool. My mother had gone to the airport to pick up Patti and Billy who were coming to Florida for their spring vacation. "The doctors knew all your neck needed was six months of rest. If you're not well enough to work like a horse, the ashram's got

no use for you—is that it? Is that why your pal Sheela sent you out to pasture like an old work horse?"

As I loyally defended Sheela and the ashram, I couldn't help wondering if my father was right. *Would* they send someone away because they couldn't work? Would Bhagwan let them (Sheela? who?) do that? Was it possible?

I refused to accept it. Sheela only wanted what was best for me. I was her friend; she loved me. "Maybe she thought it would be nice for me to visit you and Mom, see your new place, have a little vacation." I didn't want to think about it.

Patti told me recently that my behavior was bizarre the whole time she was in Florida. Spaced out, my eyes glazed over, I rambled on endlessly about childhood traumas and insecurities, crying for no apparent reason. "I don't think you even knew who I was half the time, Mommy. You were so weird. Talkng about how happy you were and looking pathetic."

What I remember most was how highstrung, exuberant, and beautiful Patti was, and how angry she was at me. "The minute you got sick you crawled back home to Grandma and Papa to be taken care of," she accused me that first day and on every subsequent day of her vacation. "You don't give a shit about your family—I've been having a goddamn nervous breakdown ever since I got back from Brazil, and where were you, 'Mother'?!—but as soon as you need us...."

"I didn't know you were having a nervous breakdown, Pats. Did she really, Mom? Dad? Billy? Why didn't anyone write me?"

"*Why?*" screaming, enraged. "You'd only have sent us one of those revolting blue aerograms filled with the same bullshit you wrote every week about how much you loved us and missed us and why didn't we come visit you. Do you have any idea how much I hated those creepy blue envelopes? It was like getting mail from a dead person. We didn't even read them half the time. I don't know why you bothered."

"If I'd known you...."

"Bullshit! Nancy asked you to come home last year and you didn't. But the minute you need help, you expect your family to be there for you. What did you ever do to deserve it? Huh, Mommy?"

On and on she went. Me too weak to fight back, to say: listen, this wasn't my choice. I don't *want* to be here. I'd have rather died at Bhagwan's feet. Dimly knowing that would be cruel, unforgivable. That nothing I could say would take away her anger.

Till finally Billy would intervene. "Stop picking on Mommy. All of you," looking at my parents as well. My father's sarcasm and my

mother's subtle condemnations hadn't escaped his notice. "You're all ganging up on her. It's not fair."

Shortly after Patti and Billy went back to New York, I got a letter from the ashram. There was nothing wrong with my body, it said. My medical problem was a figment of my imagination. I was, in a word, crazy. There were no facilities for mentally disturbed people at the ashram. It wouldn't be possible for me to come back.

I couldn't believe what I was reading. How could Vidya, who'd signed the letter, say I was crazy? What was going on?

My father was outraged. "Nothing wrong with your body?" he sneered. "What kind of crap are they trying to pull? They did x-rays, mylograms. The doctors there are no fools. They know damn well it wasn't psychosomatic. Whose toes did you step on, baby? Sheela's? Why doesn't she want you there anymore? Does she want your boyfriend?"

"Daddy! Sheela would never...."

"You know what your friend did? Called and told us you were dying. 'Do you love your daughter?' That's how she started the conversation! If we loved you, we'd let her ship you off to us so we could take care of you. She wanted to get rid of you awfully badly, baby. How come?"

I wrote an abject, snivelling letter back to the ashram apologizing for whatever I'd done. I didn't even know what I was apologizing for; I didn't remember acting crazy. All I remembered was the beautiful space I'd been in when I was in the medical center. But if Vidya said.... With all the drugs I'd apparently been taking, anything was possible.

When the second letter from the ashram arrived, my father was livid. I could only come back, it said, if I sent the ashram affidavits from my father and every other doctor I saw in the States guaranteeing that I wouldn't get sick again.

"Do you think for one minute any doctor in the world would give you a letter like that?" my father fumed. "They'd open themselves up for a lawsuit. They're telling you you can't come back, baby, don't you see that? What's Sheela got against you?"

He was beautiful in the end though, writing a carefully-worded letter to the ashram for me and composing a suitably obscure one for my orthopedic surgeon to sign. "They're trying to cover their asses so they don't get sued for the condition you were in when you got here. If you want to go back to those jokers, don't worry. I'll get you back there."

I'd never realized before how much my father loved me. I might be misguided, a fool—he'd never approved of me leaving my children; my life was a rejection of everything he believed in—but if I wanted to go back to the ashram, he'd help me get there.

I had no idea why they were making it so hard for me to return, but I assumed it was coming from Bhagwan. I needed to drop my attachment to him. If I couldn't do it on my own, the ashram would "create a situation" for it to happen.

I didn't care what was best for me, though. I was going back. Nothing in the world would stop me.

ða

"Have you heard?" Premda's voice asked me anxiously over the phone one day. She and Deva were in the States while she recuperated from a hurt back that she'd gotten tripping over a piece of loose flagstone at the ashram. We were all living in New York, the two of them with Deva's family, me with a sannyasin couple I knew. I'd come up north as soon as I was strong enough to be on my own so I could be near my kids.

"Heard what?"

"Bhagwan's going into silence," she wept. "Permanently. The 'ultimate phase of his work.' There's a celebration at Chidvilas tonight. 'To share the good news.' Tell everyone," her voice quivering. "We'll see you there."

Over a hundred people were at the New Jersey meditation center that night. Sheela had set up Chidvilas a year ago as a book distribution center; a handful of sannyasins lived there. A nearby eighteenth-century stone castle had recently been purchased and was presumably being turned into a therapy center for ashram-sponsored workshops.

Every time I visited Chidvilas, the center leader tried to pressure me into moving there or a least working there a few days a week. I refused. It was the first time I'd ever said no to the organization around Bhagwan. I wasn't going to let myself get hooked into the work and have Sheela decide I was indispensable in the States. Bhagwan was in India, Kuteer was. I was going back.

I was surprised to see so many people at Chidvilas that night. There were more sannyasins in the New York area now than there'd been in North America when I took sannyas. A few, like me, were ashramites who were in the States because they weren't well, all of us eagerly waiting to return to India.

As I sat on the floor watching a video of the Enlightenment Day celebration at the ashram a few weeks earlier, tears ran down my face. It was the first celebration I'd missed in six years. Bhagwan had stopped speaking since then, he wasn't well, and silent meditations known as *satsangs* had been held every morning in his absence. Teertha was to give

energy darshans and initiate people into sannyas from now on. Bhagwan was gradually absenting himself from the community. I wondered if he'd disappear completely before I returned.

The following week, several ashramites who were on their way back to Poona got letters from the ashram telling them not to come. The ashram was moving north; the move would be too hard for them; they'd be contacted when it was time for them to return.

Terrified that we were going to receive similar letters, paranoid, and neurotic, Premda and I met daily, feeding each other's panic and supporting it.

"At least you've got Deva with you," I'd tell her. "If Kuteer were here...."

"He'd be panicking, too. They have to let you go back as long as he's there, don't they?"

I wasn't so sure. I cared whether I was with my lover. I doubted whether Sheela (or Bhagwan) did.

Without telling the ashram I was on my way back—I didn't want to give them a chance to say I shouldn't come—I booked a return ticket to India for the end of May, convinced I'd be healthy enough by then to go back.

When Patti asked me to delay my departure for a week so I could go to her high school graduation, I knew in my gut that I'd never return to India. It wasn't a week's delay that we were talking about. On some obscure, esoteric level, it was forever. There was no way I could say no to Patti though, choosing my family over Bhagwan for the first time in eight years. After spending three months with my children, their needs and reality had become part of my reality again. "Of course I'll stay," I told Patti, praying that my premonition was unfounded, paranoia building up in me like a disease.

Two days before I was finally ready to leave for India, I cabled Laxmi to let her know I was coming. I could hardly arrive at the ashram unexpectedly and hope to have a room waiting for me. If I wasn't allowed inside the front gate—the worse scenario I could envision—I'd camp out at Kuteer's; I'd manage till they finally took pity on me.

I went into hiding at my friend Mary's house in Westport, telling my kids not to let anyone know where I was. My anxiety verged on insanity: Premda and Deva had just gotten a letter from the ashram telling them not to come back.

"Did you hear, Mom?" Billy asked when I answered Mary's phone the morning I was supposed to leave, his voice breathless with excitement.

"Hear what?"

"About Bhagwan! He's in America!"

"Don't be ridiculous, Billy!"

"I'm not kidding, Mom. Peter's dad told me." Bhagwan wasn't totally unknown in suburbia anymore. "It's a big joke. It's the first time anyone ever heard of New Jersey being holy. Get it, Mom? New Jersey of all places!"

Hanging up the phone and calling Chidvilas, my heart pounding with fear, I suddenly wondered if this was why Deeksha and a crew of her ashram handymen had arrived a few weeks ago, ostensibly to convert the castle into a meditation retreat center. My attempts to reach Deeksha by phone had been singularly unsuccessful.

"It's Satya Bharti," I acknowledged nervously when an unfamiliar female voice answered the Chidvilas phone. "I was calling to find out.... I just heard the most ludicrous...."

"Satya! We've been trying to locate you for two days!"

"Yes, well I...."

"There's a telex here for you from Arup." Dammit, I thought dismally, I shouldn't have called! "You're not to go back to India." *No! Please!* "Call Sheela at the castle on Wednesday. She'll tell you what to do."

"Is Bhagwan...?" hopefully. Was that why? "I just heard a rumor that he's here. Is...?"

"Ridiculous!" the woman laughed. "He'd never come to America. You know that, Satya. He's said it a hundred times."

"But...."

"Call Sheela on Wednesday." Click.

When I finally managed to get through to Kuteer in Poona, he was no more helpful than the woman at Chidvilas.

"T'ings here is a little strange, *amoré*," he said above the phone's static; I could barely make out what he was saying. "There was a fire at Saswad. Someone set. And another fire at the book warehouse in Bombay. Arson. Many bad t'ings."

"Is Bhagwan still there?"

"Where else he be, *bella*?"

"I don't know. I just heard...," crying. "They told me not to come back. I don't know what to do. What if...?"

"Not to worry, *amoré*. Trust. You call Sheela, heh? I go now. T'ings is busy here. Take care. I love you." Click.

I was more confused than ever now. People like Kuteer who knew that Bhagwan was gone had been warned not to talk about it. Most sannyasins didn't even know he'd left. Sheela had made an announcement shortly after Bhagwan stopped talking that all the gossiping and

speculation at the ashram needed to stop. It was disruptive; Bhagwan could be hurt by it. They needed to trust more. People were suddenly afraid to talk about what they knew or suspected; it was the beginning of a community-wide conspiracy of silence that continued with dire consequences for five years. Kuteer couldn't tell me anything. Someone might hear him.

The next day, the media confirmed what no sannyasin had been willing to admit. Bhagwan was at the castle in New Jersey. He'd come to America for health reasons. No one could see him.

<center>❧</center>

"This is Satya Bharti. I was told to call Sheela."

"Hold on, hon," the voice on the other end of the phone said. "I'll try and find her."

Sheela's husband came to the phone. A middle-aged businessman who'd been my New York publishing liaison, Jay had married Sheela a month ago. It made sense suddenly. With a new American husband, she'd be able to keep her residence permit "green card."

"Sheela asked me to speak to you, Satya. She wanted...."

"I'd rather talk to her personally, Jay," I cut in nervously. I hardly knew the man. How could I appeal to him as friend to friend?

"I'm afraid that won't be possible," he demurred. "Sheela's very busy these days." I should get a job for a few months, he mumbled. When the time was right, I'd become part of the community again.

All my feeble protests were in vain. My offer to do anything at the castle—cook, clean, whatever was needed—fell on deaf ears. The pace of the work at the castle (eighteen hours a day, more sometimes) would be too much for me. No, I couldn't go back to Poona. I'd only get sick again.

"Earn some money," Jay commented dryly. "We need all we can get." Click. Don't call us, we'll call you.

Every time I phoned Sheela after that—she'd intercede with Bhagwan for me if she had to; she'd been too good a friend for too long to refuse—I was told she wasn't available. The clues were obvious. I was never going to be allowed to see Bhagwan again.

The forty-eight hours of hell I went through seem incredible to me now. It was as bad in its own way as the agony of drug withdrawal. Addicted to being with Bhagwan, my banishment felt like a death sentence.

I lay on the floor of a sannyasin friend's apartment and listened to

satsang tape after tape, sobbing and sobbing, feeling abandoned and desperate, wondering where I'd go, what I'd do, how I'd survive. I couldn't continue to impose on friends indefinitely, constantly dependent on others for everything I needed. I had no survival skills. It would take me months to get a job; there was no work outside the publishing field I felt capable of doing; I wasn't even a good typist.

Shocked by my appalling sense of helplessness, I wept inconsolably for two days and nights. How could I have let myself become so dependent on Bhagwan and the ashram that I couldn't survive without them? My fear and paranoia over the last two months I suddenly saw as the disease it undoubtedly was. I'd tried to manipulate the world into being the way I wanted it to be, hoping against hope. I want what I want. Let me come home.

It was hopeless. Sheela would never let me come back.

When I finally accepted the inevitable—I'd never see Bhagwan again, never see Kuteer, never again be in the community of my Master—the darkness suddenly lifted. What was, was. There was nothing I could do about it. Now what?

I put on another satsang tape—it might be the closest I'd ever get to being with Bhagwan again—and lay down on the floor exhausted. Enough was enough, I thought finally, closing my eyes and tuning into my own energy. A feeling of peace suddenly filled my body; waves of bliss flooded me. How could I have forgotten my "waves" all this time? I wondered. They'd always been there, waiting for me. All I needed was to remember them.

What an incredible Master Bhagwan was! It didn't matter if I ever saw him again. What he'd given me was embedded inside me; there was no way I could lose it. I didn't need him anymore.

ꙮ

As huge numbers of sannyasins were left stranded in Poona (some working as prostitutes to get the money to leave India, some doing drug deals, others begging friends, strangers and their estranged families for plane fare), Sheela looked for, and found, land "somewhere in the States" to build a large, city-sized ashram. Seven and a half million dollars was needed to purchase the land, and I was phoned unexpectedly by Sheela's chief fundraiser one day and asked to help raise it.

Swept up in the excitement of Bhagwan setting up shop in America— my kids would finally get a chance to meet him, the rest of my family and friends would; the miracle of what he'd given to me could be given to untold thousands of others—I began visiting Rajneesh centers all over

eastern America and Canada with Kavi, who'd recently arrived from India.

As Kavi and I travelled from city to city raising hundreds of thousands of dollars for the new commune, I was in an incredible space inside myself; I felt like I'd suddenly woken up after years of dreamy unconsciousness. My "waves" were constantly with me whether I was alone or talking to people in groups or in the private counselling sessions that both old and new sannyasins kept asking me for. Everything happened effortlessly; I never felt as if I were "doing" anything. The words that came out of my mouth amazed me. I wished I had half the wisdom of my speech.

The idea of Bhagwan staying in America permanently seemed to have touched the heart of every sannyasin Kavi and I met. "Speak from the heart" was the only instruction we'd been given; it was weeks before we even knew that the new commune was in Oregon. "Whatever you feel to say will be what needs to be said."

I did most of the talking, Kavi most of the organizing work. Sitting on the floor in front of a group of people, I'd close my eyes, hold on to my *mala*, and tell the Bhagwan-inside-my-head that if he wanted this to happen he'd have to do it, I didn't know how; then I'd open up my eyes, open myself up, and let the words pour through me.

At our second fundraising event at the New York meditation center, I talked for a half hour about surrender and trust, using everything that happened for our growth, treating ourselves and everyone else as Buddhas; then I got down to the nitty gritty of Bhagwan's "vision in America" and how we could help it to happen.

"The main need right now is financial," Kavi added. "If people started living communally they could save money and send it to the castle. Get a job if you don't have one, even if it means cutting your hair. Wear straight clothes and use your nonsannyasin name if necessary. Everyone needs to clean up their act. Stay away from drugs or anything else illegal; it's a bad reflection on Bhagwan. We can't afford it if he's going to stay in America. It's all a game anyway. The whole world is our playground."

"Where's Laxmi?" someone asked as people had been doing everywhere we went.

"At the castle." A murmur of excitement greeted my words. Information about Laxmi and her whereabouts had been conspicuously unavailable since Bhagwan's arrival. If she was in America, it meant he was staying; it wasn't just a wishful dream. "We've set up an amplifier by the phone so she can talk to you," I said as people cheered and

catcalled. To most sannyasins, Laxmi meant Bhagwan. If they couldn't see him, she was the next best thing.

While Kavi continued to field people's questions, I phoned Chidvilas, having prearranged for Laxmi to be there when I called. I hadn't spoken to her since she arrived. The castle was presumably off-limits to anyone who didn't work there or at Chidvilas, or so Kavi and I were told.

"Laxmi ma!" I squealed with delight when she picked up the phone.

"It's the sparrow!" she chirped back happily. "We recognized the squeal."

"It's so good to talk to you, Laxmi! How are you?"

"The body, fine. Everything else, different."

"There are hundreds of people here who want to talk...."

"Laxmi has nothing to say, ma. This isn't the role now."

"Everyone wants...," not hearing her.

She interrupted me. "Sheela's in charge now," she explained in a dull, tired voice. "We signed over the power of attorney to her. Everything's been taken away from Laxmi."

"But...."

"Even to talk to old friends, Laxmi needs permission now. Deeksha I have to ask for everything; Sheela; all of Sheela's people. No need for anyone to talk to Laxmi, ma. This is America!" She gave a gay laugh, forced; I was totally confused. "Sheela's beloved country! Laxmi's finished. The times...."

"Satya?" Deeksha's heavy Italian accent cut in; she'd taken the phone from Laxmi. "It's you, Satya? How you, *bella*?"

"Deeksha! What's going on? Why can't...?"

"It's better no one talks to Laxmi right now, *bella*. She's in a little negative space. Eh, beautiful?"

I didn't understand. Laxmi in a negative space? She was practically enlightened as far as I was concerned, above negative spaces and hurt feelings. What difference did it make if Sheela had taken over her job? It was all a game anyway.

"How's Bhagwan?" I asked, trying to ignore the queasy fluttering in my stomach, refusing to feel it. "It must be beautiful there with him." Rumor had it that he walked around the castle constantly, people saw him all the time.

"It's not what you think, *bella*, believe me. Be thankful you are where you are; I envy you. One of these days...."

Deaf to the disillusionment in Deeksha's voice, I assumed she was trying to comfort me for not being with Bhagwan, reassure me that I wasn't missing anything. Even Laxmi's obvious bitterness I rationalized away.

Everything was in a period of transition now; she'd soon find a role to play in the new scheme of things.

"Laxmi wasn't well enough to talk," I announced as I hung up the phone. No one seemed to care. It was enough that she was in the States. "But she sends her love. Her heart's with us."

By the end of the evening when Prabhu came by to pick up the money we'd collected to take to Chidvilas, we had a staggering amount of checks and pledges to give him. Scores of people had decided to mortgage their homes, take out bank loans, sell their cars or ask their families for money. For $10,000 they could buy a house at the new commune, we'd been instructed to tell them. There was no guarantee of a delivery date, but "it would happen."

"Kavi'll have the bookkeeping finished in a minute," I told Prabhu, who looked more like an ex-marine now than a sannyasin with his short hair, clean-shaven face, and western clothes. "Is Bhagwan up to any new mischief these days?"

"He's getting his driver's license!" Prabhu grinned. It was the most outrageous thing he could have told me. All Bhagwan had ever done in the eight-plus years I'd known him was lecture, read books, and listen to corny Indian movie music. "I went for a ride with him and Vivek the other day. He drives like a maniac! Everything's changing so fast, Sats." It certainly was. Prabhu, a relative newcomer, was one of the chosen few at the castle, while Kavi and I weren't even allowed to visit. Amazing!

"There's no hierarchy anymore," he went on, "everyone's equal. It's great! The only weird thing is," lowering his voice suddenly as he looked around nervously to make sure no one was listening, "how we can't use the phone or talk to people on the outside. I haven't even spoken to my parents yet. It's been four years since I've seen them."

"How are Deva and Premda doing?" They'd moved to the castle the week Bhagwan arrived, promising to call me regularly. I hadn't heard a word from them since.

"Deva's already in Oregon, the lucky bugger." It was the first time I'd heard where the new commune was.

"How 'bout Premie?"

Prabhu shrugged noncommittally. "Sheela says it's too hard for ma's out there. The guys'll have to exercise their wrist muscles for awhile," laughing raucously, then blushing. "They'll be sending some ma's out soon. Hell, we'll all be going before long. Sheela says it's beautiful out there. God's country."

A week later, Kavi and I were "hit" by Sheela's secretary for suggesting that sannyasins live communally, clean up their acts, and work out

their family karma and money karma. Since the recommendations we'd made soon became standard policy, it obviously wasn't that we'd said anything wrong, only that we'd done it on our own initiative. Sheela was making all the decisions by now, a pattern that continued to a bizarre degree at the ranch. It was so contrary to Bhagwan's insistence on individual responsibility that I assumed it was a product of her insecurity. As soon as she grew confident in what she was doing, I told myself, things would ease up, underestimating the seductiveness of dictatorship.

While Kavi cried and apologized for what the two of us had "done," devastated by the hit, I was more amused than anything else. No matter how hard I tried not to over-step my boundaries, I still managed to threaten Sheela's authority. I was hopeless.

"Maybe it's time for me to stop fundraising for awhile," I told her secretary. "I'd love to start writing again. Would you ask Bhagwan if it's okay?" wondering if my query would be delivered to him directly; Sheela was away at the moment. If it were up to her, I knew, I'd be discouraged from writing.

Grove Press had asked me a couple of weeks ago to do a TV tour, hoping no doubt to cash in on the media's interest in Bhagwan since he'd arrived in the States. Despite the extensive publicity efforts that Sheela's crew were making, I was told in no uncertain terms not to do it. "We don't want people to associate Bhagwan with therapy and meditation when we're starting a farming commune. It wouldn't be helpful. If we could take your books off the market, we would." It wasn't long before they did.

The message that I got back the next day from Sheela's secretary sounded like it came from Bhagwan: "Either one will be good," he'd said. "Whatever you do is my work."

A sannyasin who was going away for the summer lent me his Manhattan apartment so I could be near my kids. Nancy and I spent a lot of time together; she'd turned out to be more my daughter in many ways than her father's. I saw Patti and Billy less often. Patti seemed less forgiving of me than the other two, while Billy was busy all the time with friends, sports, a rock band he was in, and a halfhearted attempt to earn some money.

When I wasn't with my kids or working on a novel I'd started, I spent most of my time in bed, staring at the fan rotating above my head, blissed out. As soon as I stopped functioning in a given role: mother, friend, writer, sannyasin; there wasn't any "I" anymore; I didn't exist. I'd disappear, dissolving into nothing and everything till I was the fan and the furniture, the sky and the pigeons, as much as I was my body, thoughts, or emotions.

A week before Bhagwan left for the new commune in Oregon, I finally went to the castle to see him.

⠀⠀⠀⠀⠀⠀⠀⠀⠀⠀⠀⠀⠀⠀⠀⠀✿

"I was wondering when you'd show up!" Nirdosh squealed delightedly when she saw me, throwing her arms around me exuberantly. "Quick, Satya! Sit down! He's coming!" pulling me on to the grass beside her as a group of musicians began playing and Bhagwan glided gracefully down the porch stairs of the castle, *namastéing* everyone, a broad grin on his face and one of the knitted hats that was soon to become his trademark on his head.

There were about eighty people on the castle lawn that morning, most of them Chidvilas/castle residents; the rest, like me, visitors who'd come for the brief morning satsang: a quick glimpse of Bhagwan as he walked to his car. Nirdosh and I were the only sannyasins in long Poona robes, everyone else was in jeans. Even with the castle nominally closed to the public, the "holy Poona image" had obviously changed.

I wondered if Bhagwan's presence would have any effect on me anymore. I didn't feel particularly excited to see him; it had just seemed like an appropriate thing to do on my nine-year sannyas anniversary. I'd hardly expected them to agree when I'd called to ask if I could come.

Bhagwan stopped for a long moment in front of where I was sitting, looked down at me intently, smiling, then walked to his car and drove away with Vivek and someone I'd never seen before. As everyone jumped up to leave, Nirdosh giving me a quick hug and inviting me to her room before she rushed off to work, I sat in a comatose heap on the grass, more stoned than I ever remembered being; I could barely move. Bhagwan could still do it to me, unquestionably. He was a magician. A rascal. (A hypnotist, my father would have said.)

Later that day, Homa (the young American woman who was in charge of the castle in Sheela's absence) invited me to move to the ranch in Oregon. "If you want to go," she said indifferently, "you can. It's up to you. You're invited."

If Sheela were around, I was sure I wouldn't be. I assumed it was Bhagwan who'd decided to invite me, perhaps at Vivek's urging; she'd been delighted to see me when I met her briefly in the hall outside Nirdosh's room. With the exception of a few Lao Tzu residents who'd come to the States with Bhagwan, there were few "old sannyasins" at the castle. Sheela had only invited the people she wanted. "Lao Tzu House

snobs," mediums, and therapists (all favorites of Bhagwan's in the past) were conspicuously absent.

"Well?" Homa inquired sharply. She'd been less than cordial in extending the invitation. "I don't have all day, Satya." I was obviously expected to make up my mind then and there. Either I wanted to go to the ranch, or I didn't. It was as simple as that. "Hurry up and decide. I have a lot to do today."

I didn't know what to say. Every sannyasin I knew except me seemed hell-bent on being invited to the ranch. I wondered if I was only being asked to go because I didn't care anymore. Buddha called desire the root cause of all suffering. Anything one wanted from Bhagwan, by definition one couldn't have.

"Sure," I sighed finally, wishing I could be more enthusiastic about it. If Bhagwan wanted me at the ranch, how could I not go? I owed him my life.

After procrastinating for weeks, reluctant to give up the easy access I had to my kids, I finally moved to the castle to wait for more housing to become available at the ranch. By this time, Bhagwan, Vivek, Nirdosh, and almost everyone else I knew at Chidvilas besides Premda had already left for Oregon.

Despite the fact that the castle was half-empty by now, Homa and her underlings managed to find enough make-work for the rest of us to do to keep us busy from early morning till late at night. While there were no restrictions about leaving the castle grounds, there was little free time to do it. If I wanted to phone my kids, I had to wake up before six in the morning to use the office phone, or I'd walk to a pay phone in town at ten o'clock at night after I finished work. I didn't really mind, though. Wherever I was, and whatever was happening, was fine with me. Even the ugly power plays that the castle matriarchs continually pulled I was sure had something to teach everyone. How could it be otherwise in the community of an enlightened Master?

Chaitanya stopped by one afternoon with some things he'd brought back from Poona for the new commune. I was thrilled to see him, while he was somewhat less than thrilled by the reception he'd received. He could only stay for five minutes, he'd been told firmly. No, he wasn't allowed inside the castle. I didn't understand. After ten years as Bhagwan's meditation master, he was suddenly being treated like a pariah. I wondered what kind of object lesson it was supposed to be for him. Surely it was that.

Chaitanya was on his way to the Geetam center in California, he told me mournfully. Vidya had authorized it in Poona. "I'm supposed to con-

sider myself lucky," he laughed bitterly. "Most ashramites weren't even given a place to go. Sheela doesn't want any therapists at the ranch. They'll run groups at Geetam; I'll lead meditations; it'll be just like the ashram," snorting derisively. "Except for one little thing. No Bhagwan.

"So you're here now, huh, Satsie-pots? It pays being Sheela's old buddy these days, I guess."

I could have told him a thing or two, but it didn't seem like a good idea. It was obvious even then that one didn't say anything against Sheela. Even to old friends when no one else was around.

"Psst, Sats!" Premda whispered to me furtively through the window of the laundry room several days later while I was busy folding clothes. She'd been in an acute state of paranoia for weeks, ever since she'd been told that she was too negative to go to the ranch; she'd be an upsetting influence there. She was afraid to talk to anyone, frightened that anything she said could be construed as negative. She was sure she'd never be allowed at the ranch, that "they'd" keep her away from Deva forever.

"Can you come talk for a minute?" she sniffed miserably, her eyes puffy and swollen. "I'll meet you in the meditation room."

When I reached the meditation room above the garage, Premda was curled up on the floor crying. "Homa said I can't go to the ranch," she whimpered. "The goddamn bitch! My invitation's been cancelled. She says I'm still negative; I haven't learned a thing. I don't know what she's talking about, Sats. I swear to god I don't. I've been trying so hard."

"Maybe it's just until...."

"I have to leave here tomorrow," she sobbed. "Go back to my family. Mom died while I was in India. My brothers are all priests, my sisters nuns. Where in god's name am I supposed to go?"

Deva's sister picked up Premda early the next day. It was two years before I saw her again. The castle community was like a feudal kingdom filled with constant intrigue and subtle cruelties, but I ignored it all, blithely washing and ironing thirty people's clothes every day, determined not to get thrown off my center by what was happening around me. It would be different in Oregon, I told myself. Bhagwan was there.

After six weeks, Homa finally informed me that I could leave for the ranch in two days. "On one condition," she said coldly. "That you drop your guru-trip. We only need one guru. Bhagwan.

"You know very well what I'm talking about, Satya!" she spat out angrily when I looked at her in astonishment "It's up to you. You're on a three-month probation. We don't need any more gurus out there."

I still don't know why I decided to go to the ranch, giving up what was flowering inside me to crawl back into the womb of my Master.

Maybe I was afraid I'd fall asleep out in the world, fall into the trap of complacency, if there was no one around to push my buttons. Even strangers seemed to treat me with deference these days as if I knew something. I knew I didn't, I thought I didn't; maybe I did and was afraid to accept it.

Maybe I just didn't know what else to do with myself. How to function in the world: earn money, build a life for myself that was separate from the sannyasin community I'd lived in for so many years. I had no street-smarts. I'd led a cloistered life for too long.

I flew to Chicago to visit Nancy and Patti who were both studying at Northwestern. Then I flew to Oregon and to Rancho Rajneesh: cowboy country. It was another world altogether. Stranger than strange. Beautiful and terrifying.

IV

The Dream and the Deception

Oregon
(1981 - 1985)

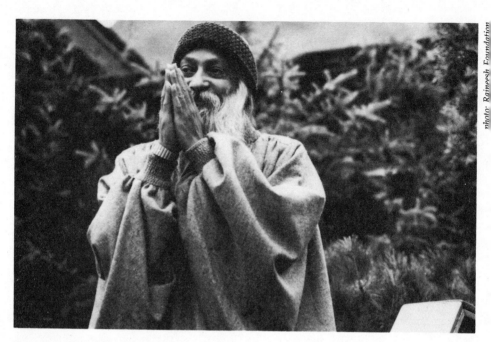

Rajneesh in his "trademark" hat at the Rajneesh ranch in Oregon (1984).

The author with her future husband Kirti at the Rajneesh ranch in Oregon (1984).

Sheela (Rajneesh's "personal secretary") with the author's parents at the Rajneesh ranch (1983).

*R*ancho Rajneesh. The name sounded like something out of Disneyland. The reality was anything but phantasmagorical, though. Harsh, desolate land with steep overgrazed hills and an occasional straggly juniper, it was hard to imagine what Sheela had seen in the place besides its awesome size (64 square miles) and its unquestionable isolation.

I never even liked cowboy movies, I thought dismally to myself as I rode over endless miles of barren hills and sagebrush in a manure-smelling pickup truck that I'd waited till after midnight for in a sleazy cafe in Madras, the nearest bus stop to the ranch, a three-hour drive away. I must have been out of my mind to come to this god-forsaken country!

Even the sannyasin who picked me up looked like a cowboy in his ten-gallon hat, cowboy boots, and Levis. His hair was so short I could hardly see it under his hat. The only thing familiar about the way he looked was the colors he wore: rust and burgundy. The scenario had obviously changed. Last time around we were pseudo-Indians; this time we were cowboys. Click, change. I wondered what in hell's name I was doing there.

It took almost a half hour to drive from the entrance of the property to the ranch area where a lonely sentry stood guard inside a small ramshackle hut. Nearby were two wood-framed houses, some run-down stables and barns, and the first trees I'd seen on the property besides weedy junipers. My hand clutching onto my *mala* for support, I willed myself to like the place, surrender. Bhagwan was here. Everything would be all right.

"Sheela's house is over there," the swami driving the truck said, pointing to the left, past my line of vision. "Most of us are still roughing

it in tents," he laughed good-naturedly; the mid-October air was bitterly cold, the wind howling, "but we'll all be in trailers soon. Everything's happening so fast," beaming with pride. "You'll love it here. Hard work. Plenty of laughs. Good food. And the best night's sleep you can imagine."

As to the latter, he was right. Put into a room in Laxmi's trailer, I fell immediately into a deep, exhausted sleep—it was 4:30 in the morning; I'd been travelling for twenty-one hours—and woke up feeling totally refreshed, the sunlight streaming in through my window. It was awesomely quiet. There wasn't a sound inside the trailer or outside it.

I unpacked, showered, dressed, and nosed around a bit. The trailer was a tacky marvel of plastic and synthetics, motel modern with dark plywood walls and flat durable carpet. Basic. Not even a Van Gogh print or picture of Bhagwan on the walls. The livingroom had been converted into a sixth bedroom; each bedroom had two mattresses on the floor; only one had any furniture. The door to Laxmi's room was closed; no sound was coming from inside it.

To be put into Laxmi's trailer instead of a tent felt like the utmost in luxury to me. Someone seemed to be looking out for me. I wondered if it was Bhagwan or Sheela, though it turned out to be an attempt to humor the disenchanted Laxmi by putting some of her old friends in her house. I suspect now that her room was bugged—the way things turned out, it would be surprising if it wasn't—but it was years before that occurred to me.

As I walked slowly in the direction of the ranch area, the stark landscape that had felt so unwelcoming the night before looked incredibly beautiful to me. I could feel my whole being fall in tune with the hills' solitary majesty. Breathing in deeply, smelling the wild sagebrush, I suddenly felt at home, at peace, excited to be here. I wanted to sing, celebrate. Welcome back to the Buddhafield! I wouldn't be caught dead wearing cowboy boots, though. I had my limitations. One could go just so far on the path to God.

A dump truck passed by, the swami at the wheel waving to me. A sannyasin dump truck driver! It was inconceivable!

"Sats!" someone in the distance called out suddenly from the roof of an enormous green building that a red-garbed construction crew was erecting. Scrambling down a succession of ladders, then galloping over the rocky field to where I was, Deva threw his arms around me exuberantly, twirling me in the air. "Welcome! Welcome! It's Satya Bharti!" he yelled to his co-workers, a half dozen of whom waved back wildly, calling out greetings.

"Did you speak to Premda before you left?" he asked expectantly, looking somber suddenly, his mood changing, when I shook my head.

"There wasn't any way I could call her from the castle."

"Bitches," he nodded angrily. "It's so beautiful here, Sats. Totally different from the castle. I've never been happier in my life. I just wish to god Premie was here."

When I asked if he'd tried talking to Sheela about it, he laughed derisively.

"Getting in to see her's like getting in to see the Pope. She's surrounded by...." He took off his glasses, rubbing his eyes wearily. "There's a lot of weird stuff going on here, Sats, a lot of power tripping. You won't recognize Vidsie when you see her: a class 'A' bitch. But if you let the ladies do their number and get on with your own life, it's paradise. The camaraderie. The sharing. Who else but Bhagsie could make us pioneers in the middle of 1981 in the middle of America? It's stupendous! I feel high all the time. If only Premie would get the hell here. They can't keep her away forever." I wondered. I had a feeling he did, too.

"Coming!" he yelled finally when he was called for the dozenth time. "I gotta run. We're on a ball-breaking schedule to get this building up. Some zoning trip we're trying to beat. I'll catch you at dinner. Welcome again. You'll love it here!"

Entering the ranch area a few minutes later, it was obvious that the dilapidated shacks along the dusty dirt road were being used for a multitude of purposes; the place was humming with activity. Since the ranch was zoned for farm use, a situation Sheela apparently hadn't considered when purchasing it, all the buildings were ostensibly being used for "farm-related activities," the first of an infinite series of masquerades that fooled no one and kept the ranch embroiled in constant litigation. Meanwhile, furniture was being constructed on the street; cars and trucks repaired in and around the stables; people scurried along the road carrying piles of papers, buckets of water, planks of wood, and metal pipes. Sannyasins from Poona greeted me with hugs that were brief but warm; everyone seemed to be in a rush to get back to work.

Seeing Laila halfway down the road, thirty pounds heavier than she'd been in Poona but unmistakably her, I ran over to her excitedly. We'd become close over the last few years: confidants and therapists to each other when we needed it.

"Hey, Sats," she commented blandly as I approached, barely glancing up as she fumbled with a piece of paper on her clipboard. I stood beside her while she read it, feeling like a fool. She certainly didn't seem very happy to see me.

"You got in last night, huh?" she said finally, still not looking at me.

"I heard you were coming," her voice hard, strident; I could hardly believe it was her.

She glanced up suddenly. "I'm glad you're here," she whispered, giving me a quick smile before her voice turned harsh again, her smile disappearing. "We start work at 7:30 every morning," she said flatly. "You're two hours late."

"I didn't get in until...."

"No one's interested in excuses around here, Satya. Work starts when it starts. This isn't the place for anyone who's looking for an excuse to be lazy."

I was dumbfounded. I hadn't even known when work started. How could I?

"Come on," she said suddenly, putting her arm around me, friendly and distant at the same time. "You can work in the kitchen today. I'll find something else for you to do tomorrow."

Laila put me to work scrubbing the floor and then turned to leave. "One last thing," she said with an awkward laugh. "No more bliss attacks. I was told to tell you that specifically. We don't have time for that kind of bullshit around here. Got that, Sats?" and before I could answer—was she kidding? Laila was even more prone to bliss attacks than I was—she was gone.

As I squatted on the porch outside the kitchen later that day, gossiping happily with several other women as we cleaned mud off the floor for the umpteenth time (the ranch hadn't been known as "The Big Muddy" for years without reason), I was suddenly paged to Sheela's trailer. Butterflies in my stomach, wondering what was coming next, I hurried off. I hadn't seen Sheela since I left India. I wasn't looking forward to it.

She couldn't have been lovelier to me, though. After greeting me warmly, she lay back in bed (she'd been sick for days) and held my hand while she talked to dozens of people who sat on the floor beside her bed. Listening to the various conversations that went on, it was obvious that nothing happened at the ranch without Sheela's say-so and approval. She was brutally honest and outspoken with everyone; open, even wise sometimes. As she joked with everyone, including me, I found all my resentment and suspicion towards her dropping. How could I have misjudged her so, I wondered, libeling her in my mind, assigning motives to her out of my own paranoia and insecurity?

Teertha, who was visiting from Geetam for a few days, knelt before Sheela in an attitude of supplication. With his long hair and beard neatly trimmed and his red robes replaced by a burgundy jogging suit, Bhagwan's presumed successor looked decidedly ordinary. After being

away from Bhagwan for several months, he seemed to have lost most of his radiance and clarity, as if he'd only been a reflection of Bhagwan. I wondered suddenly how much of the beauty I'd seen in people at the ashram in Poona was false, borrowed; if Bhagwan had created a world of clones, mimics, shadows of the real thing; if the diaspora that followed his departure from India was an attempt to show us how far we were from our own truths.

As soon as everyone left, Sheela gulped down a handful of pills that Puja brought her, lay back on her bed, and shut her eyes, looking exhausted, dark raccoon smudges framing her eyes. As I stroked her forehead, my heart filled with love for her, I thought about the awesome responsibility she'd taken upon herself: building a city-ashram in the middle of nowhere, forty-five minutes away from the nearest town (the sleepy, half-deserted hamlet of Antelope; population: 38). There was one telephone line at the ranch, little water or electricity, few roads. It was an exercise in futility. I didn't envy her.

"There's something I wanted to tell you, Satsie," she said finally, sitting up in bed. I thought she was going to apologize to me for what had happened in India: my "sickness" and forced departure. I was a fool.

"Everyone's glad you're here," she smiled. "Bhagwan. Me. Everyone. But you can't stay if you're sick. I wanted you to know that. We don't allow anyone to be sick here. No matter who they are. Not so much as a cold. Do you understand?"

I forced a smile, close-mouthed, a meager attempt; it was the best I could do.

"Okay, Satsie? As long as we understand each other." And winking at me, grinning, she slumped back on the pillow again and closed her eyes.

Within seconds, she was sound asleep, snoring. I tiptoed out of the room. Totally and utterly confused.

&

Lying on an empty mattress in the dormitory above the kitchen, I tried futilely to catch a few minutes sleep before I had to be back at work in the ashram laundry. Our lunch breaks were barely long enough to get our food, wolf it down, and go for a short walk, take a quick nap or have a brief conversation with someone you'd never see if you didn't meet them at mealtimes. The ranch was so spread out that it could be weeks before you ran into anyone you didn't work with. I'd only seen Deva five times in the month I'd been at the ranch; I never saw Vivek, Nirdosh, or anyone who lived in Bhagwan's trailer; but then I rarely went to meals.

The outdoor eating area, noisy and overcrowded at lunchtime, turned into a meat-market at night. Even old Poona ashramites, gentle would-be holy men in India, had turned into boisterous, rowdy beer-drinkers, constantly horny and on the make. I felt like a bitch in heat the minute I walked over to the food line: sniffed at, looked over, every casual remark a prelude to sex. It was hardly surprising when the only entertainment available after a long day's work was a fast fuck with someone you scarcely knew.

There were four times as many men at the ranch as women; it was easy to be popular. At the castle in New Jersey, where the proportion of men to women had been even greater in the beginning, the women were instructed to share their favors and the men not to be possessive: to share their lovers with their friends. Sexual frustration and jealousy would only lead to problems. There was too much work to do; there wasn't time for it.

Sheela had been promising the swamis more women for months. Some were waiting for mail-order brides: sannyasin girlfriends who had been invited to come to the ranch at their request, to share their bed and board, working full-time, asking for nothing but the privilege of being there. But in the meantime the atmosphere was raunchy and promiscuous. Content to wait for Kuteer, whose letters from Italy talked about his efforts to raise money for a ticket, get a visa—he'd arrange to marry someone for his immigration green card when he got to the States ("Sheela will take care," he'd written. They'd become good friends after I left India)—I was too tired at night to think about sex anyway. All I ever wanted to do after an exhausting twelve-hour work day was go to sleep.

I'd never slept so soundly before, passing out as soon as my head hit the pillow, then waking up in the dark the next morning, eager to get to the laundry and begin work. The pace of the work was a daily challenge, an exhilarating adrenaline high. Washing greasy, mud-caked clothing for 200 mostly outdoor workers every day in the cramped quarters of what had once been a chicken coop was like running a marathon race blindfolded on a conveyor belt that moved backwards.

We made a game of it. Laurel and Hardy at the laundromat. Four dizzy dames: awarding prizes to the men with the nicest laundry of the day; deciding which men we were attracted to, and which not, on the basis of their laundry; flirting outrageously with swamis who knew enough not to take us seriously; laughing and gossiping constantly about our love lives or lack of them as we worked, played, and attempted to do the impossible.

"None of the boys will fuck me!" three-year-old Jyoti was sobbing

desolately now to her mother as they lay on a mattress several feet away from where I was trying to sleep. Her mother tried vainly to quiet her down, dozens of people were resting, but Jyoti was inconsolable. "I don't care!" she cried petulantly. "It's not fair! Just because I wear diapers they won't fuck me. They said I'm a baby!"

"If you stop wetting your pants at night, you won't have to wear diapers anymore," her mother explained patiently as I buried my head under a pillow, wondering how I'd get through the rest of the day if I didn't get some sleep.

Up half the night before with Laxmi, I was more exhausted today than usual. She'd left a note on my bed asking me to come to her room "for a little chit-chat" when I got home last night. I couldn't not go. She was alone all day, bored; her only diversion was when someone came to see her.

As much as I loved Laxmi, I hated visiting her at night. I was having enough trouble trusting Sheela as it was without listening to Laxmi talk about how conniving and power-hungry she was, how she'd clawed her way to the top, leaving everyone who was a threat to her in her wake (me included?). Dozens of people who'd been close to Bhagwan over the years had dropped sannyas when Sheela took over; something strange must have been going on at the end in Poona.

"You know why Deeksha left?" Laxmi had muttered discontentedly last night. To everyone's amazement, Sheela's second-in-command had left the ranch shortly before I arrived. "Sheela treated her like dirt. Scum. Telling everyone she was nothing anymore, nobody; they shouldn't listen to her. Putting her in the laundry room. Laxmi, too, she put into the laundry."

Maligning the best job I ever had! "What's so bad about...?"

"For the sparrow it's just a job. For Laxmi it was a deliberate attempt to degrade. Not even the servants Laxmi used to give the underpants to. Not even when Laxmi was a child. These unconscious women here! Sheela knows! They leave blood on the underpants and sheets. And white stains from when the boyfriend comes. And Laxmi has to wash! Sheela knows what this means to an Indian woman. The Indians won't come, mark Laxmi's words. They know the kind of person Sheela is."

"Do you ever get to see Bhagwan alone?" I asked curiously, trying to change the subject. Presumably in isolation these days, most of us only catching glimpses of him when he drove through the ranch in one of his Rolls Royces, I'd heard that he occasionally saw people besides Sheela and Vivek, speaking to various ranch residents from time to time to discuss the projects they were working on: farming, construction, public relations, legal issues. Rumor had it that he sometimes saw new residents

when they first arrived; a handful of sannyasins on garbage and construction crews sported expensive pieces of gaudy jewelry that he'd apparently given them when they saw him.

"There's no way for Laxmi to see Him," she complained. "No way to even write. Sheela sees all the letters. How to know if she even gives? She censors everything into Him." It was exactly what people had said about her for years. "The answers you think come from Him?" laughing scornfully. "Laxmi doubts!" Like it or not, she'd taught Sheela everything she knew.

It was almost one o'clock by the time Jyoti's mother shook my shoulder gently to wake me up; I could have slept all afternoon. Climbing over wall-to-wall mattresses, I scrambled quickly down the attic stairs, thankful for the hundredth time for the luxury of living in Laxmi's trailer. While no one at the ranch slept in tents anymore, there was never enough room for everyone in the trailers no matter how fast new ones were purchased and installed; people were cramped like sardines into every indoor space available. Deva and five other men lived on the aptly-named Cat Piss Porch, their beds literally touching one another's. Other people were crowded into equally unappetizing surroundings. Anyone who didn't like it was welcome to leave, but few chose to. Sharing hardships, roughing it, was half the fun. We were the new pioneers. Personally, I was glad for a quiet place to escape to.

"Vidsie wants to see you," one my co-workers in the laundry said as I walked in the door. She was stuffing work clothes into one of our small, antiquated washing machines. Mountains of clean clothes and bedsheets were piled on the counter, ready to be folded. A basket of laundry from Jesus Grove (where Sheela and her next-in-commands lived) sat on one of the dryers waiting to be handwashed in buckets of warm water that we carted over from the office trailer across the road. "Maybe Kuteer's coming," she smiled hopefully.

I grunted, not sharing her optimism, and headed for the trailer where Vidya held court every afternoon. Nine times out of ten, I knew, seeing her meant a dressing down: a hit. Worse than that sometimes. People who "weren't adapting to the lifestyle" were being asked to leave constantly; thousands of sannyasins around the world were eagerly waiting to take their place.

I wondered what I was going to get hit for. A paragon of enthusiasm, I never complained about anything or criticized Sheela or anyone else. Always in a good mood, exhausted or not, I was the perfect slave, yes-m'am-ing everything. The fact was, I loved it at the ranch. There was nowhere else I wanted to be.

"I'll be with you in a minute," Vidya commented offhandedly as I entered her trailer, glancing at me briefly before she turned back to what she was reading. She was lying on the floor, leaning against a pillow. It was how she conducted most of her business from the first days of the ranch to the end. While weak backs had been barely tolerated in Poona and were even less likely to be sympathized with at the ranch, Vidya was an obvious exception. Solicitous subordinates clucked over her like mother hens when they were around, while Puja presumably supplied her with generous doses of pain killers the way she allegedly supplied Sheela and the other Jesus Grove ladies with them. By the end of the ranch, so many of the women in the hierarchy were reputed to be using copious amounts of drugs that it led one to wonder who was in control of whom, and why.

As Vidya lay on the floor, her body looking thinner than ever, her beak-like face pinched and strained, I had no way of knowing how hard a time she was having at the ranch. Her attitude towards me was as harsh as it was impersonal. It was as if she hardly knew me.

"You just don't get it, do you, Satya?" she said finally, looking up at me with distaste. "You think Sheela's just some old friend of yours, don't you? Let me clue you in on something, lady; she ain't. She's Bhagwan's personal secretary! Her *position* is why you have to do the laundry in a special way for her...."

So *that's* what it's all about, I realized suddenly. The ranch was incredible! I'd told someone who worked in Jesus Grove yesterday that I didn't think we should do their laundry for them. Their good percale sheets trailed on the muddy floor when we ironed them. Sheela's expensive designer clothes were bound to get stained sooner or later, scorched, ruined. Maybe they should install a washer and dryer in Jesus Grove, I'd suggested. The suggestion had obviously been taken as a criticism; the criticism reported to the higher-ups. I tried to explain.

"I only meant...."

"...Why she has diamond rings and gold watches, silk clothes and a fancy car. *She's Bhagwan's representative!* Will you get that into your thick skull once and for all!

"I feel sorry for you, Satya. You'll go on being nothing around here as long as you don't get it that things are different now. Wise up. You don't want to go on missing forever, do you?"

I wondered vaguely what she thought I was missing. I didn't want to be part of Sheela's power elite in any way, quite the contrary. Vidya's hostility towards me upset me, though. So did the fact that an old friend of mine had obviously "reported" me. No matter how exemplary my be-

havior was, my life at the ranch was insecure, unstable; I could be asked to leave at any moment.

As I walked pensively back to the laundry hut, disturbed, Deva came rushing out of Jesus Grove looking upset. "Wait up, Sats!" he called, hurrying down the path to meet me. "I'm getting out of here!" he grumbled angrily when he'd caught up with me; he was trembling with rage. "Fucking goddamn bitches!"

"What happened?" assuming it was something to do with Premda. He'd been asking repeatedly when she could come, never receiving a definitive answer.

"If I don't want to be away from Premie I can leave, they told me. She's not welcome here, now or ever."

"You're kidding!? Why?"

"Know what those broads had the *chutzpah* to tell me? To find a girlfriend. There are so many beautiful women here. I should divorce Premie and marry some foreign ma so she can get a green card. I've been busting my ass studying for the Oregon Medical Boards; I know they want me to stay; they need doctors. But not enough to let me 'dictate' to them. That's what they called it! Can you believe it?"

His eyes were flooded with tears, his face flushed with fury and outrage: a forty-five-year-old psychiatrist who'd given up everything he had to "find himself."

"If I leave, I'll never be allowed to see Bhagwan again. That's the way they laid it out to me. I have to choose between my wife and my Master. Bhagwan doesn't have the foggiest idea what's happening around here, I know he doesn't. And there's not a way in hell for anyone to tell him.

"Keep a low profile, Sats, that's all I can say," smiling shakily as he wiped his tears. "It's beautiful at the bottom here. It's the power-hungry bitches on top who'll destroy this place, not the Oregon rednecks."

Yes, I wanted to leave with Deva. No, I didn't want to. I had nowhere to go. Kuteer was coming. Bhagwan was here. The power games would change; they were bound to.

There was a lesson somewhere in all of this for Premda, I convinced myself. For Deva. A lesson for me in Vidya's hit whether it was justified or not. There was something I had to see, get. The ranch, with all its abuses of power, was no different from the rest of the world except for one thing: Bhagwan was here; we were all sannyasins. Even the women running the place were. We were building a Buddhafield in the heart of America. Everything that happened had something to teach me.

I spent the next four years justifying everything I didn't like about Rancho Rajneesh, the Rajneesh Commune, and the soon-to-be-incorporated city of Rajneeshpuram. Or at least trying to. Day by day, it got harder to do.

❧

By the time Vidya hit me again three months later, I was working in the kitchen. Everyone at the ranch worked twelve or more hours a day, seven days a week—all but the office staff, department heads, and ranch administrators—at exhaustive physical labor.

Women were as apt to work in the fields and on construction sites, driving backhoes and bulldozers, as they were to work in office or service jobs; the only sexist roles were administrative ones: the majority of coordinators were women. While there were as many Ph.D.'s in the community as at a fair-sized university, most ranch residents having at least a college or technical degree, the administrative staff by and large was an exception. The name of the game was surrender, as it had always been around Bhagwan, and, with varying degrees of struggle, we all learned to surrender to the decisions of untrained, unskilled coordinators whose incompetence led to unnecessarily long hours of work and nothing ever being done as well as it could be. We were accomplishing so much so fast, it didn't seem to matter. If anyone didn't like the way things were being done, they were free to leave.

"Vidya wants to see you," the kitchen coordinator told me one afternoon after answering the squawk-box that served as the major communication link between one ranch department and another until phone lines were installed and motorolas appeared on the scene. I was sitting and chopping onions with a dozen other people in the new ranch kitchen. The lovely Paravati, who'd recently arrived from India, was sitting beside me. She looked at me questioningly and then spoke in rapid-fire Hindi to the other Indians at the table who all glanced over at me sympathetically, clicking their tongues.

Contrary to Laxmi's prediction, many of Bhagwan's Indian sannyasins were as eager to be with him in America as they had been in Poona. Those who were hoping to stay were divorcing their husbands and wives and looking for Americans to marry with the help of the ranch immigration department's matchmakers. Every ranch resident who wasn't an American was either married to one or arranging to be. Paravati (who balked at marrying a swami half her age) left before the year was over. The ranch wasn't her idea of heaven in any case, nor Sheela her idea of someone she wanted to surrender to.

"Good luck," she mouthed as I got up to leave, her knife clacking away rhythmically on her chopping board. The kitchen was filled with the sound of people gossiping and laughing, rock music playing, the potwashers spraying each other with water, gaffawing and shrieking, and with the tempting smell of mushrooms and onions sautéing and sauces simmering. The new cafeteria was a wonderful place to work, a

cloistered, private world. Besides the vague rumors I heard at the chopping table, I had no idea what was happening anywhere else on the ranch. My world consisted of cutting vegetables, washing lettuce, and sweeping the floor. I had no responsibilities or cares. It was perfect for me.

Kuteer ignored me as I walked past the twelve-burner stove where he was adding spices to the tofu stroganoff we were having for dinner that night. He'd arrived at the ranch two weeks ago. After fourteen months of waiting eagerly to be together, we'd taken one look at each other and known there was nothing between us anymore. Our one obligatory night together was a disaster.

It wasn't long before Kuteer moved into Jesus Grove, becoming one of the few non-gay men in Sheela's entourage. Over the next few years, he set up bugging equipment all over the ranch for her, spied on Bhagwan for her, and eventually became the head of a para-military group of ranch-trained guerillas that few people knew anything about until after the ranch closed down. We had nothing in common anymore. It was hard to believe we ever had.

Hopping on one of the yellow school buses that had recently been purchased from a neighboring community for a hastily inaugurated mass-transit system, I rode down to Zarathustra, the so-called farm storage building where Vidya's new office was. The bottom of the metal warehouse building was filled from floor to ceiling with Bhagwan's books, the top floor jam-packed with desks, all of them occupied. The area was buzzing with intensity; I got a headache just walking through it. It was a gift to be working in the kitchen.

Vidya shared an office these days with the computer department and the immigration staff. When I walked inside, she was lying on the floor surrounded by a circle of people. I sat down between a clinical psychologist from California who was working as a mechanic and a German actress who was working with the chickens and listened as Vidya joked and laughed with some people and derided others till they were snivelling and crying, apologizing for whatever they'd done and begging to be allowed to stay if she'd told them to leave: they hadn't learned the first thing about surrender; this wasn't the place for them.

"You can come back when you're ready to melt into the community," she told a big, burly civil engineer who sat in front of her weeping. "Ready to say yes." He'd donated a sizable amount of money to the ranch before he came, I knew. I'd convinced him to do it. When he asked for part of the money back—be needed it to live on if he was leaving—Vidya sneered that his asking for it proved how unsurrendered he was. "Speak to Savita," she snapped: the head accountant. "I don't know nothin' about no money you gave. It ain't my business. Next?"

As harsh and unloving as Vidya was with some people, there was a grain of truth in much of what she said. One minute I was disgusted by her and the next minute filled with respect as she zoomed in on someone as if she could see to the very core of them.

She turned to me abruptly. "You're on a guru-trip, lady!" she barked. "You were warned about that before you got here!"

I looked at her in bewilderment. It was the last thing in the world I'd expected.

"If you want to stay, you better drop it. This is the last warning I'm giving you. I'm moving you into the office so I can keep my eye on you. Report to the Hakim Sanai department immediately!" turning purposefully to someone else, leaving me feeling as shaken and bruised as if I'd just been assaulted by a cadre of stormtroopers.

For days afterwards, I mulled over what Vidya had told me, trying to see what truth there was in it. Was I so unaware of how I related to people that I didn't even know when I was playing guru? It was true that people in the kitchen often talked to me about their problems—all we ever did was gossip— but it was always friend to friend, not guru to disciple, therapist to client.

I didn't know about the "Shit Lists" at the time, of course—actual lists that were found after Sheela left the ranch—actually labelled "Shit Lists". Didn't know that I was one of the people to be singled out over the years, hit constantly for things I never did, my every action reported to the higher-ups, someone never to be trusted.

I finally blamed Vidya's hit on the kitchen coordinator who'd been acting strangely towards me recently because she assumed I'd usurped her role in some way. Apparently she felt hurt when people confided their problems to me rather than her. It was the only explanation I could think of for Vidya's hit. Years later, the woman apologized to me for how she'd treated me. She'd been under instructions to do it.

We all sound insane, I know. Even in the ranch's first year there were more glimpses of ugliness than an intelligent person should have been willing to put up with. The handwriting was on the wall of every illegal building we erected and written into every letter of protest we sent off to local politicians accusing our adversaries of religious discrimination and bigotry. The us- and-them mentality that Sheela emphasized in mandatory general meetings and did her best to create by abrasive public behavior fostered an atmosphere where it was easy to suspend critical judgement. Whatever our Bhagwan-appointed leaders did was necessary, imperative. The community was struggling for its right to exist. In a battle against opponents who wanted us out of the state, the country—who saw us as red devils, Christ killers, communists, and menaces to the "American way of life,"—the community's frequent skirting of the law

and its dictatorial internal policies seemed justified in many ways despite a queasy feeling of distaste that never left me.

Everything had a meaning. It had to. We were living in a Buddhafield, building a utopia, growing, changing, learning things about ourselves that we'd never seen before. For those of us who had been with Bhagwan in India, the commune in Oregon, like the ashram in Poona, was a mystery school. Trusting Bhagwan, we "pointed the finger at ourselves" whenever we disagreed with anything, looking at our own motivations and conditionings and finally saying yes to whatever Sheela and her coordinators said. To surrender to Sheela was to surrender to Bhagwan. Who knew what kind of mischief he had up his sleeve, or why?

For the newcomers who had never been around Bhagwan before (and an exceedingly large proportion of ranch residents were new sannyasins), the lure was the social experiment that was taking place: the reclamation of badly damaged farmland as a new city/commune developed on sound ecological principles; and the visible proof that people from all over the world could live together in cooperation and harmony, a large, closely-knit extended family. Except for Sheela and her Jesus Grove cohorts, it was a virtually classless society. The garbage collector had as much status as the doctor (and sometimes was a doctor). The toilet cleaner was as respected as the lawyer. Someone who was a coordinator one day might become low-man-on-the-totem-pole the next day. Anyone could become a coordinator at any moment; even I was for a while. Only the position of a handful of Sheela's deputies never changed.

The community had 100% employment and no crime. Medical care and dentistry was free. Housing. Clothing. Transportation. Haircuts. Legal advice. Our laundry was done for us; our living spaces cleaned; abundant, free, gourmet-quality vegetarian food served three times a day. If one didn't look too closely, the ranch was a utopia. Every visitor who came felt it; our joy was infectious. Despite long hours of work and occasional unwarranted hits, we were all having a ball. Playing at what we were doing. Never taking it seriously no matter how hard or long we worked at it. Living moment to moment. Knowing that life was a game, a *leela*, a play.

If anyone was on a power trip, that was their game, their play; they were welcome to it. We laughed about it instead of being disturbed by it and didn't even notice as Sheela and her gang's lust for power slowly grew stronger, fear seeping insidiously into every aspect of our lives. We shut our eyes to what we didn't like, turned off the alarm clock, and went back to sleep. The dream we had of living in a near-perfect world was beautiful.

*W*e weren't supposed to hitch rides anymore; the buses were supposed to run often enough to get us to work and meals on time; but we all did it anyway. It was the only way to eat in the morning and still get to work at seven unless you woke up early enough to get into the bathroom before everyone else did. I'd been living in a trailer near the cafeteria for months, but it was still a rush in the morning. After working till midnight every night (a seventeen-hour work day with time off for meals and Bhagwan's by-now ritualized lunchtime drive-bys), I needed every second of sleep I could get.

As I scrambled into the back of a van one morning with a dozen other people and sat down opposite a tall, bearded Englishman with a long ponytail (one of the ranch mechanics, I didn't know his name), I had a sudden uncontrollable urge to brush my foot against his out-stretched leg, to touch him in some way. Too embarrassed by my feelings to look at him, out of the corner of my eye I could see him staring at me with disconcerting absorption. When he got out of the van at his stop, he gave me a warm smile. I thought he was the most gorgeous man I'd ever seen.

I saw Kirti everywhere I went after that. He never said a word to me, just looked at me with a steady, unwavering gaze, seducing me with his silence. At lunchtime, sprawled out in front of the cafeteria, elegant even in a greasy monkeysuit, he'd joke and laugh with the other mechanics, never taking his eyes off me. I thought his attentions were my imagination. I knew they weren't. I waited for him to approach me, talk to me, make the first move.

When we finally spoke to each other one night, words poured out of us both in a torrential flood: this is who I am; I want you to know every

minute detail about me. We spent the night together. It felt like the most natural thing in the world to do.

The minute Kirti touched me, I knew we'd always be together. He said he knew it when he saw me in the van that day. He'd held off talking to me (he was in another relationship at the time), knowing that we'd get together eventually; it was inevitable.

I felt as if I'd been waiting for Kirti my whole life. I sometimes wondered how I'd managed to be happy for so long without him. The energy between us was extraordinary. So was sex and the way our minds danced together and our beings melted into each other. We played together like kids, laughing and talking incessantly; we couldn't stop touching each other. For the first time, I understood why I was at the ranch. If other people loved it because Bhagwan was here, I loved it because Kirti was.

Kirti had quit his engineering job in Vancouver and was about to move to Poona permanently when Bhagwan came to the States. He and his ex-wife were amongst the first people invited to the ranch. Auto mechanics were desperately needed and someone in the personnel department misunderstood what a mechanical designer was. Thrilled to join the community, Kirti bluffed his way through auto mechanics, repairing cars outside in zero-degree weather all winter long, his tools sticking to his hands, his eyeballs freezing, until he was an expert at it.

Kirti donated his car and all his savings to the commune when he arrived and, a few months later, somewhat less willingly, donated his motorbike as well. Bhagwan didn't want them around, Sheela told everyone with bikes; they were dangerous. Her use of Bhagwan's name to enforce something that Kirti was sure he knew nothing about saddened him but didn't surprise him. No starry-eyed idealist, he didn't expect things to be perfect in the Buddhafield. None of us did. Things would change.

ミ�

"There's a message for you, Sats," my coordinator said one afternoon as I stood at the wall-length, hundred-drawer filing cabinet in the office "pulling cards" for Sheela and Vidya, my back killing me from bending over, my neck aching. The commune maintained meticulous records of every sannyasin in the world, past and present, a coded history of each person's life in mysterious hieroglyphics that I didn't understand, and wasn't supposed to, even as I updated the files day after day. Since Bhagwan had given many people the same name over the years, it wasn't always clear if it was the right person's card that was being pulled or updated. The endless complications this resulted in were pre-

sumably offset by the confusion it created for the press and legal authorities as the years went on. "Which 'Ma Satya Bharti' did you mean?" one could reasonably ask. "There are twelve. And five 'Ma Sat*yam* Bhartis'; eight 'Satya Bha*ratis*'; three 'Satyabhartis,' one word. Not to mention all the swamis with similar names." It allowed us to be hopelessly vague, to change identities, disappear.

"I have to go to the medical center," I announced as I read the note my coordinator handed me; I'd been expecting it. A woman Kirti had slept with before we met had had a positive VD test. He'd been put on antibiotics; I was about to be. Every case of VD that showed up meant that every sexual contact (and every contact of every contact down the line for months) had to be tested. It kept the commune relatively free of venereal disease despite the frequent changing of sexual partners.

"You better give me those," the woman beside me said, nodding at the stack of letters to Bhagwan that I was pulling cards for. Sheela answered all the mail, Bhagwan only seeing the letters she wanted him to see. "The medical center's mobbed," the woman said. "If you and your sweetie are going to Antelope tonight, you better take your things with you. The taxi shuttle won't wait."

Guarding the Antelope office at night once a week was the closest thing Kirti and I had to leisure time together. We had nothing to do all night except answer the phone and call my kids. With only one telephone line at the ranch, it was the only chance I had to talk to them. Had I not been on the Antelope rooster, I'd have been even less accessible than I was in India.

Kirti and I got to Antelope that afternoon before the office staff was ready to leave so we strolled idly over to the town's only store for a milkshake and French fries. The roads were empty as usual, but it didn't take much imagination to feel eyes peering out at us suspiciously from inside the small homes and trailers we passed. To most local townspeople, sannyasins were the enemy, tension between the old and new residents of the town intensifying considerably since a recent town election that attracted nationwide media coverage: "Cult Takes Over Town of Antelope!"

In all fairness, it was hardly an accurate description. Most of the homes in the tiny, nondescript town had been on the market for years. Since current zoning laws allowed only six people to legally live on, and farm, the 64-square miles of ranch land—there were already over 400 people there, with plans underway for an additional 10,000—several houses in Antelope had recently been purchased for sannyasins to live in, in a partial attempt to explain away the large numbers of people who

were clearly visible at the ranch. We were hardly a welcome presence in the community with the remaining original residents.

As Kirti and I ordered our shakes and fries, two truckers who were in the store looked at us with distaste, barely lowering their voices as they talked to the proprietor about us. It wasn't long before the commune bought the store, renamed it "Zorba the Buddha," stocked it with health food, imported chocolate and Bhagwan's books, and began serving veggie-burgers and quiche to visitors who stopped by enroute to the ranch. If the local people wanted to buy bread or cornflakes, they had to drive to the next town (twenty miles away) to do it. We were at war.

"They really hate us, don't they?" I murmured uncomfortably to Kirti as we walked back to the office, munching on our fries.

"Do you blame them?" he responded grimly. "I wouldn't be surprised if the accusations of harassment they've made about us are true. Sannyasins ringing their doorbells day and night, taking photos of them constantly. Who knows what's going on around here anyway?"

I nodded. It was a disquieting thought. Sheela was fond of calling sannyasins the new niggers, discriminated against at every turn, but to the mostly-retired Antelope residents, we were hardly the underdogs. We had unlimited financial resources: donations poured in continually from all over the world. We were big business: urban intellectuals from the east. Worse: foreigners. Money, muscle, all the lawyers we wanted, a multi-national cult. Only a few of the townspeople found the change stimulating.

"We've been getting threatening phone calls at night," one of the office ma's told us a few minutes later. A hot dinner from the ranch was waiting for us in the kitchen. There was no way I could eat it after ravenously devouring an order of fries. "If anything happens that you can't handle," she said, "call the ranch and we'll send down some reinforcements. We sent a few carloads of swamis down on Saturday night. Some of the local rowdies came by waving shotguns. I don't think you'll have any trouble tonight, though; it's mid-week. See you guys in the morning. Have fun."

While Kirti handled the incoming phone calls, I tried to reach Nancy, who'd called the ranch during the week and left a message for me to call her. I had no way of getting back to her until my night in Antelope. I was always just within reach of my family and just out of grasp.

When there was no answer in Nancy's apartment, I tried Patti's number and spoke to her roommate. She wouldn't be in till after midnight. Could I call back again tomorrow? No, I couldn't, actually. When I tried reaching Billy, he wasn't home either. I finally gave up and phoned my parents.

"Jillie-girl!"

"Hi, Dad."

"Long time no hear, kiddo! How's Borg Warner these days? See much of the old rascal lately?"

"Not really. He's...."

"We saw Sheela the peeler on TV last night. You're really shaking them up in Antelope, aren't you, baby? Looks like you're raising some stink out there, huh?"

"I heard Sheela was on TV. What'd she say? I haven't seen the video yet."

"What's with your pal anyway? She comes across on TV like...."

"Satya, darling!" My mother picked up the other extension. I motioned to Kirti to listen in on one of the office phones so he could hear about Sheela's interview. "We were hoping you'd call. I've tried to get you a dozen times. The line's always busy."

"I wouldn't be able to talk anyway, Mom. I'm nowhere near a phone. Dad said you saw Sheela on TV. How was she?"

They both began talking excitedly. They knew Sheela. They knew how charming she could be when she wanted to be. Why did she insist on making a fool of herself every time she was on TV? She sounded like a moron. Bitter. Aggressive. I looked at Kirti, then closed my eyes, sighing. Sheela was an embarrassment to three-quarters of the people at the ranch. The rest thought she was wonderful.

"Why does someone as shrewd as Borgie let that girl speak for him?" my father asked incredulously. "There are plenty of smart people in that cult of yours. Anyone would be better than Sheela."

"Your father's right, dear. I can't tell you how many times I have to defend you all because of Sheela. A well-brought-up girl like her! She should be ashamed of herself."

I know, I wanted to say. If you're upset by it, can you imagine how I feel? But I defended Sheela instead, looking for justifications, excuses. The local people were being hostile. "Of course they are," my father interjected reasonably. "The way Sheela carries on, can you blame them?"

"Bhagwan has her in the role she's in purposely," I went on blithely; it's what I told myself constantly. "He wants all the publicity he can get. If it weren't for Sheela, no one would have even heard of the ranch. We're building a utopia out of nothing here. Bhagwan wants everyone to know about it. Sheela's antics have gotten us more publicity than all the money in the world."

"But what about those poor people in Antelope, dear?"

"There's no one *in* Antelope, Mom! It's a ghost town. Most of the

homes we bought were for sale for years. They were lucky to get a buyer for them. There are more sannyasins living here now than anyone else. We only ran for city council because the other councilmen vowed to kick us out of town. They have "Better Dead Than Red" stickers on their cars. This is Ku Klux Klan country. The press distorted the whole thing. They wouldn't have had a story otherwise."

"But if the ranch is as big as you say...."

"We *have* to be in Antelope. The ranch is zoned for farm use. All our business stuff, book, and tape sales, happens out of here."

"But to call those old people fascists, bigots. Who does Sheela think she is?"

It was only the beginning, of course. Sheela's public aggressiveness got progressively worse every day. As I tried to defend her to my family, I sometimes managed to convince myself of what I was saying. Kirti couldn't believe that Sheela and I had once been friends. I could hardly believe it myself.

The next night, a video of Sheela's recent TV interviews was shown in Rajneesh Mandir (the recently-built meditation/lecture hall that was officially touted by the press office as "the largest greenhouse in the world"). Kirti went without me. I was working late in another panic blitz to get some obscure work project finished. Now that I was with Kirti, I resented all the late-night work that Vidya's irrational urgencies necessitated. I wanted to spend my evenings with him, not doing some ridiculous job that I couldn't see the point of anyway. Surrendered or not, though, I did it. I had no choice.

"Sheela came across worse than your parents said," Kirti whispered as I slipped into bed beside him at 1:30 that night, exhausted; I'd practically fallen asleep at my typewriter. "They were being kind, believe me," he murmured, tenderly caressing my body till we were making love again as we'd miraculously been doing every night no matter how late I worked, trying to keep our voices down so we wouldn't wake Kirti's (or my) roommate or our fourteen other housemates and their lovers.

The next night, after four hours' sleep, I had to work late again. And the next night, and the next; it went on for two weeks. As exhausted as I was, I determined not to get sick again.

Anyone at the ranch who got sick either had to go into the home care ward or continue working; no one was allowed to stay in their trailer. A few months earlier, when half the ranch residents, including me, came down with the flu, the home care trailer was packed, six of us sleeping in double-decker beds in an 8' x 10' room, all of us with raging fevers and brutal headaches.

On my second day in bed, one of Sheela's cronies came thundering

into the trailer, slamming doors and talking so loudly my head felt like it was about to break. She visited every room in the ward, a group of other Jesus Grove ma's huddling in the doorway behind her. There was hardly any space for her to stand in the room I was in, it was filled with so many moaning, half-comatose bodies.

"Sickness is negativity!" the woman announced in her booming Australian voice. A quiet, unobtrusive ma in Poona, I couldn't understand what had gotten into her suddenly; I felt like throwing something at her. "You guys only picked up this bug because you were in a negative space," she said. "It's your resistance coming out. You don't see me with the flu, do you? Or Sheela. Vidsie." I wished she'd shut up for godssakes! Didn't she know we were sick?

"Who's ready to drop their negativity?" she went on fiercely, looking at us each challengingly. I closed my eyes determinedly. If she forced me to say anything, I'd tell her what a goddamn bitch she was; my head was pounding. "Which of you guys are ready to get out of bed right this minute and go back to work?" she asked. "We've got too much to do for you to cop out by getting sick. Sheela's counting on you."

Worse than the callous inhumanity of Sheela's crony was how many people, half-dead with fever, dressed themselves clumsily and went back to work.

"Nothin' but negativity," the bulldozer operator in the bed above me muttered as he struggled to put on his socks. "No fuckin' way I'm negative. The ma's right. They need me," and with a 103 degree temperature, he went back to work. The miracle is that he didn't kill himself. He left the ranch several months later apologetically; he couldn't handle the pace. Sorry, ma. Maybe when I get a bit of my strength back. He never returned.

When Sheela and her Australian sidekick came down with the flu a few days later, a quick, bitter flash of "Ha! I'm glad they got it!" ran through my mind as I sat at my desk trying to work, still weak from having gotten out of bed too soon. Then, of course, I felt guilty for my lack of compassion. Their power trips were their trips; I didn't have to stoop to their level. I was never going into home care again if I could help it, though. Once was enough.

Ironically, it was Kirti who ended up getting sick. Exhausted from long hours of hard physical labor, hardly able to hold up his head, he finally went to the medical center where he was told he had mononucleosis and would have to be in isolation for weeks, months perhaps.

I snuck in to see him in home care every day, missing either my lunch or dinner to do it; it was the only free time I had. I probably

wouldn't have been allowed in if the doctor in residence thought Kirti really had "mono," but he didn't.

The longer Kirti stayed in home care, the worse he got. At one point he suddenly became so ill he had to be injected with copious amounts of morphine; he felt like he was about to die. He suspects now that he was poisoned.

After Sheela and her crew left the ranch, scores of people were convinced that they'd been poisoned over the years, either in home care or before they were admitted to it. All the staff doctors could say in retrospect was that they didn't know. They'd often seen strange symptoms in patients that they couldn't account for, but they'd never suspected poisoning. Why would they?

Perhaps it was hoped that Kirti's relationship with me would end if we didn't see each other for awhile. I wasn't someone to be trusted. If he was my lover, he couldn't be trusted either. When his co-workers in the garage became the nucleus of an elite cadre that roamed the hills and roads on secret missions day and night in pickup trucks, conversing with each other in code over the omnipresent motorolas they all carried, Kirti wondered why he wasn't asked to join them. As it turned out, he's lucky he wasn't.

&

On the first day of the ten-day-long First Annual World Celebration, 7,000 people gathered in Rajneesh Mandir for satsang. Outside of two small satsang celebrations for ranch residents, it was Bhagwan's first public appearance since India.

Everyone in the commune had been working extra-hour shifts for weeks to set up thousands of tents and install bathroom and shower trailers, an outdoor eating area, and medical facilities where every festival visitor was meticulously checked for crabs and lice; Sheela's fetish for cleanliness verged on paranoia.

Most of the people in Rajneesh Mandir that first morning were dressed in "the colors." By the end of the festival, I imagined, the rest would be, too.

Teertha and Sangit had both been invited to the festival to initiate people into sannyas. When Sangit arrived from Europe without the entourage he'd gathered around him since leaving India, Sheela confiscated his *mala* and kicked him out. He was on an ego trip, the office staff was told. Unlike other Poona therapists, he'd never sent the commune any of the money he made running groups. He'd also refused to buy festival admissions for his entourage; he'd come alone. He was unsurrendered,

unworthy; a miser. I assumed it was Bhagwan who invited him and Sheela who kicked him out. It didn't occur to me until years later that Bhagwan might have orchestrated both sides of the drama himself.

Sangit wasn't the only old Poona ashramite who was refused admission to the festival and had his *mala* taken away. Various sannyasins who'd been critical of Sheela were excommunicated, labeled "the late" Swami or Ma So-and-so. "This could happen to you!" seemed to be the message. It was hard not to see that.

"You think you'll be okay?" I asked Kirti as we sat down on the floor of Rajneesh Mandir for the first morning's satsang. "Why don't I spread out my shawl so you can lay down?" After a month in bed (he'd just been released from home care the night before), Kirti's clothes hung pitifully from his emaciated body.

"Don't bother," he said, laughing when I spread out my shawl anyway. He took my hand and held it; I adored him.

All around us, meanwhile, people in bright fire colors were dancing and swaying to live music. It was just like a celebration day in Poona, but I felt none of the anticipatory excitement that I'd always felt at the ashram. The crowd seemed more like party-goers than meditators. I wished I were back in bed with Kirti. It wasn't until I closed my eyes and tuned into his energy that pulsating waves of bliss throbbed through me like a caress.

As the music built up to a frenzy, Bhagwan arrived in his long, white, bulletproof Rolls Royce, dressed like an ostentatious monarch. I preferred him in plain white.

Namastéing everyone, smiling, he sat down gracefully in his chair on the raised dais, flanked by two hired armed guards in khaki army fatigues. The Oregon National Guard had been put on twenty-four-hour alert for the festival period by nervous state officials, but it was local hoodlums that the commune itself was worried about. It was the first time the ranch grounds had ever been open to anyone (besides a handful of sannyasins) who was willing to pay the price of admission.

"*Buddham sharanam gacchami,*" 7,000 people in Rajneesh Mandir chanted in unison, bowing our heads to the floor. "I go to the feet of the commune of the Awakened One," a voice intoned over the PA system. Before long, the *gacchamis* (as we took to calling the traditional Buddhist prayer) became an institutionalized part of ranch life, each work day ritually beginning and ending with it.

"*Sangham sharanam gacchami,*" we continued, touching our heads to the ground as Bhagwan sat serenely in his chair, eyes closed.

Disturbed by the armed guards in the hall, I tried to convince myself they'd be a deterrent to potential troublemakers; we needed them. Hired

thugs with guns gave me the chills, though. Why had Bhagwan come to the gun-toting wild west of all places?!

I felt little attunement to either him or the audience during the music-filled, hour-long satsang that morning. I didn't know what was wrong with me. I didn't even go to Bhagwan's drive-bys anymore. I felt more blissed-out when I was alone, or with Kirti.

"I have to run," I murmured as the satsang ended and Sheela drove Bhagwan and Vivek back to the Lao Tzu compound. Masses of people had rushed outside the hall to *namasté* Bhagwan as he left. I felt no inclination to join them.

Kissing Kirti goodbye, I rushed off to the festival guest center where I was handing out mail to people whose correspondents assumed that letters and bank drafts addressed to any strange Indian name that approximated their sannyas name would get to them. It was, obviously, a fiasco; one of many during the festival. By the time I finally got to the dining area for lunch, the tent that had been set up for ranch residents and people from the various residential ashrams throughout the world was almost empty; it was nearly drive-by time.

"My god, Satya!" an old friend from Poona shrieked excitedly when she saw me piling tabouli, cheese, and strawberries on my plate. "I thought you were dead!" she laughed, hugging me in the old Poona way we didn't have time for at the ranch. "We had a celebration for you when you left India! How long have you been here?"

"Nine months, I guess. Since...."

"Satsie-pots!" Chaitanya threw his arms around me exuberantly, crushing me against his bony chest.

"Hi, baby," I grinned, my Dutch friend wandering off as Chaitanya carried my tray to a nearby table.

"Eat," he said. "We'll talk on the way to line-up. There are enough people here to circle the ranch; drive-by'll take hours today.

"You have no idea how lucky you are to see Bhagsie every day," he added mournfully as he popped a strawberry into his mouth, his eyes misty with longing. "Just to know he's here." I didn't have the heart to tell him how rarely I went to drive-bys anymore.

As I wolfed down my meal and we hurried to the drive-by line-up, Chaitanya asked me curiously about a number of old friends of ours who were at the ranch. There was little I could tell him. The ones who were part of Sheela's elite ignored me. Those like Vivek and Nirdosh who lived in Bhagwan's house I rarely saw. It wasn't until after the festival that large numbers of Poona-people were finally invited to the ranch (and substantially later that Chaitanya and the other Geetam resi-

dents came: they were making too much money for the commune running therapy groups at Geetam).

"Laxmi left a few months ago," I told Chaitanya. "You knew that, didn't you? It was weeks before I even knew she was gone. Arup's living in Jesus Grove with Sheela and her entourage, but she doesn't seem to have any power these days; I'm surprised she's even there. And Shiva, god!" Bhagwan's ex-bodyguard (and Sheela's ex-lover) had been out of favor ever since he arrived in the States with Bhagwan, creeping around the ranch like he had a black cloud over his head all the time. It was pathetic.

"He's driving the 'shit truck' now," I mumbled as we squeezed into the line-up. As far as the eye could see, there were red/pink/purple/orange/ magenta-robed people lining the road: talking, singing, dancing. "Pumping excrement and sewage," I explained. "No one's special here," conveniently forgetting about Sheela and her hierarchy, somehow.

When I mentioned that Krishna had left the ranch voluntarily, Chaitanya stared at me in shocked disbelief. Why would anyone leave the Garden of Eden, his pained look seemed to ask. Laxmi was one thing: her negativity to Sheela had been highly publicized by now. But Krishna?

"This place isn't for everyone, Chai," I whispered in a hushed voice; what I was saying was sheer heresy. "It can be gruelling here sometimes," thinking about the way Vidya continually pushed me in the office, piling work on me, waiting for me to crack. "There's no time to meditate or just *be*. There's a lot of weird stuff going on," I said, but he couldn't hear me. He longed to be here. Nothing I could say would change that.

It suddenly occurred to me why the ranch administration made it so hard for people to come. How could ranch residents complain about long working hours, overcrowded housing, or anything else when thousands of people were begging to take our place?

"How come Kavi didn't come to the festival?" I asked Chaitanya curiously, everyone else from Geetam had, but there was no time for him to answer me; people were shushing us to keep quiet as Bhagwan's latest Rolls Royce moved towards us at a snail's pace. People were crying and carrying on like they were having orgasms as he approached. The Mad Italian, who was visiting with his German girlfriend, suddenly rushed towards the car, camera in hand. As the armed guards tried to stop him, Bhagwan motioned him forward, greeting him with a big smile. His knees buckled underneath him, he fell to the ground, the article he was writing for *Playboy* forgotten. I didn't think it was the brutal heat, somehow.

As the car drove slowly past, I wished I felt moved by Bhagwan's presence the way everyone around me seemed to. Facts are facts. I didn't.

ъ.

A few months later, several swamis from the heavy equipment department were asked to leave the ranch after their coordinator overheard them questioning some decisions that had been made. Negativity breeds negativity, Sheela told us at a public meeting afterwards. The warning was clear: don't question anything.

Shiva left soon afterwards, writing magazine articles and impassioned letters to sannyasins denouncing Bhagwan and Sheela. Some of his accusations were so bizarre (amongst them, that Bhagwan was a drug addict who pissed in the halls of his house) that whatever credibility he might have had was easily dismissed as the bitter rantings of a defrocked priest.

In an open letter from Sheela that soon appeared in *The Rajneesh Times*, we were all advised to close our hearts, minds, and homes to Laxmi, Deeksha, Shiva, Sangit, and other disgruntled "late" sannyasins. Because their egos were no longer being fed by Bhagwan, the letter said, they wanted to destroy him and the community. This was how "the mind" worked; it was to be expected. We were to ignore them, pity them. Bhagwan had only compassion for them, of course—someday they'd be back, he said; he'd welcome them with open arms—but in the meantime: get thee behind me, Satan. The letter seemed singularly lacking in compassion.

"It's just the way Sheela is," Kirti commented dryly when I showed him an early copy of the newsletter with Sheela's letter in it. We were lying on a mattress in the tiny room above the garage after lunch; three people were lying in a tangle of bodies on the mattress opposite us; two other hunched-over figures in greasy coveralls were leaning against the side wall engrossed in *Time* magazine and Louis L'Amour. A flimsy blanket covered us as Kirti fumbled with the buttons on my shirt, my hand inside his shirt. After six months together, we still couldn't keep our hands off each other. "Everything that comes out of that woman's mind is coarse and crass," he said. "What do you expect?"

"Bhagwan's coming!" someone suddenly hollered from outside the building. Half the people in the room jumped up, grabbed their boots, and thundered down the stairs. Kirti and I remained where we were, engrossed in each other.

We weren't the only ones who didn't go to drive-by anymore. At a

recent public meeting Sheela had made an announcement that everyone was to "look ecstatic" during drive-by or not bother going. "Why should Bhagwan have to look at your miserable faces?" she'd asked. "He doesn't need that. He wants to see how happy everyone is." Rumor had it that he'd asked her earlier that day why someone at drive-by looked despondent. Her response was to ordain ecstasy as if we were all extras in a Coke commercial. People were pissed off. They stayed away.

It was barely a month later that four old Poona friends of Sheela's and mine left the ranch in the middle of the night, sneaking out like thieves. Three of them had worked under Puja at the medical center in Poona, refusing to work under her at the ranch. I couldn't help wondering if it was significant.

Distraught by the obvious dissatisfaction of people she considered friends, Sheela begged Bhagwan to relieve her of her duties. She'd obviously failed as an administrator, she told him; she wanted to retire. As she repeated the story at a community-wide meeting, my heart danced with joy. Sheela was resigning!

"Bhagwan said he needs me," she said, her voice quivering with emotion—dammit!—as Vivek came up to the microphone and put her arms around Sheela, tears in both of their eyes.

"I want you all to know," Vivek whispered softly in what was the first and last public speech I ever heard her make, "that I think Sheela's doing a wonderful job. Bhagwan's happy with her. If we can't all work together without conflicts, he said he'll leave." Die, she meant obviously: "leave his body." "He's only here for us. We have to work together in harmony. *Please!* I can't tell you how important it is. I want you all to know that I support Sheela totally."

Seeing the two women who were presumably closest to Bhagwan suddenly embracing each other after years of hostility, tears pouring down both their faces, touched me immeasurably; I began to cry. As Kirti held me in his arms, Sheela asked everyone if we wanted her to continue in her job. Catcalls of affirmation and thunderous applause that neither Kirti nor I joined were the enthusiastic response to her insecure (manipulative?) query. For the umpteenth time since I'd gotten to the ranch, I willed myself to trust Sheela. If Vivek did, how could I not? Surrender, Satya, I told myself; it's time. It wasn't easy.

ॐ

At weekly staff meetings that I attended irregularly in Jesus Grove along with representatives from every other ranch department, I sat for hours listening to Sheela dictate ranch policy in the guise of democratic

decision-making, mock and humiliate people in the guise of conviviality, and air her personal problems.

Sheela delighted in portraying herself as winsome and vulnerable, tough and resilient; everyone's buddy. "Who, me?" she'd say, grinning. "I'm just another nigger here," then launch into a mock-jovial tirade against her husband. "Did I tell you guys what Jay did last week?" she'd snort derisively. "It's not enough that he's married to the goddamn pope...." She'd recently begun calling herself, only half-facetiously, I suspected, "the pope of the religion of Rajneeshism." "...He's got to fuck around with some pretty Mexican mama, too. Who invited her here anyway, Vidsie? What are you guys laughing about?" turning to a newly humbled former Poona-ite. "I know what you're up to, too. There are no secrets around here," everyone but me howling with laughter, loving Sheela and her weekly true-confession sessions that only I seemed to loathe.

She was equally as obnoxious and self-indulgent at compulsory ranch-wide general meetings.

"I wish she'd shut up already!" Kirti would groan disgustedly as she paraded her coy little-girl cuteness, liberally sprinkled with expletives, before the mostly-appreciative audience. A few other disgruntled misfits, most of them old Poona-ites, were scattered here and there around the hall, looking annoyed and bored. At least Kirti and I had each other to complain to. "It's 10:30 for chrissakes! She may be able to sleep till noon, but I can't!"

꿔

Yet when Billy told me over the phone one night that he didn't think I was happy at the ranch ("You sound a little, I don't know, not so enthusiastic anymore, Mom. You didn't even defend Sheela and Bhagwan when I criticized them. I get the feeling you don't want to be there anymore. What do you think?"), I denied it vehemently. Billy was wrong. It was only his projection. I loved it at the ranch.

"Why don't you come visit me sometime?" I mumbled into one of the outdoor pay phones that had been installed shortly before the festival. I wondered uneasily what Billy had sensed about me; he was one of the most intuitive people I knew. "You'll see how wrong you are," threatened by what he'd said. "It's beautiful here."

By and large, it was, too. Everyone who visited the newly incorporated city of Rajneeshpuram (a major tourist attraction these days) saw it. Despite any occasional discontent ranch residents might have, we all looked radiantly happy, laughing and singing as we worked in offices

and on construction crews, in skilled trades and domestic services; doing the impossible, having a good time: life was a game.

Hundreds of us drove to Portland one day to protest "INS discrimination": the Immigration and Naturalization Service had refused Bhagwan's request for a visa extension. We staged counter-demonstrations in another Oregon city when an evangelist and his congregation began holding daily protest rallies against "the anti-Christ": Bhagwan. When the I.N.S. raided the ranch looking for illegal aliens, hundreds of people including Kirti were forced to go into hiding for the day; Sheela had been forewarned of the raid. It was all a game. When the employees of a Portland restaurant were suspected of being "Rajneeshees" because they wore red uniforms, the place nearly went bankrupt, business only picking up after their uniforms were changed. More games.

Sheela made slanderous remarks during a TV interview about the sex lives of some of "our Antelope enemies," immersing the commune in several bitter million dollar libel suits and countersuits. Responding to criticism of Bhagwan's steadily-increasing collection of Rolls Royces, she announced on "The Merv Griffin Show" that she intended to buy him one for every day of the year: "Why not? He deserves them," a typical spontaneous Sheela-remark that, like others, soon became a reality. The game became more outlandish every day.

After a year and a half of trying to get a visa, Ravjiv finally arrived at the ranch. I'd asked several times if I could divorce him—a dubious marriage seemed irrelevant in India but not in the States: how could I tell my family? how could I not tell them?—but divorce was out of the question. He'd helped me to stay in India. How could I refuse to do the same for him? Play the game, Satya. Surrender.

Ravjiv moved in next door to where Kirti and I now had a small room to ourselves, taking the place of a college professor with a penchant for prepubescent girls who often shared his bed with him at night; innocently, I liked to think. Ranch kids were notoriously precocious sexually, teenage girls hopping into bed regularly with men old enough to be their fathers, often at their own initiative. Scores of ranch swamis would have been considered child molesters out in the world. Appalled on one level, it was prevalent enough to seem acceptable on another. If their parents didn't object—at least someone was paying attention to the kids they were ignoring—how could I?

ò•

Dear Mom (Billy wrote),
I've been feeling a lot of fear and anger in your letters to me

recently, your reaching out. Asking me if I still love you and long for you the way you do for me.

Tears streamed down my face as I sat in the office at lunch time reading Billy's letter, afraid of what it was going to say. It was the first time he'd ever written me.

It isn't a simple topic. What I've been seeing lately is that 16-year-old Billy doesn't starve for or wait for 39-year-old Satya in Antelope, but there's an infant still inside me who starves for his mother who's 30 years old and lives in Riverdale. Is it the same for you? Probably, I think. It's time to move on.

I think about you obviously. Our relationship was the most powerful thing I've ever experienced. When you left, part of me refused to grow up, waiting for your return, hoping, praying. I fed myself on that pain; I put you inside me. I never lost you that way. It's time for me to let go of the you of those years, let go of the pain, and face what I couldn't face when I was younger. I need to grow up.

I hope you're happy, Mom. I'm happy sometimes, sad sometimes. I sometimes feel like there's a light at the end of all this shit, but it's so hard reaching. I don't know if Scarsdale's the right place for me, or if where you are is the right place for you. I have my doubts.

You're a good woman, Mom. I love you,

 Billy

PS: I'm not so strong as I sometimes come across. I still cry a lot.
 It's okay.

Billy, Billy, I wept inconsolably. I wouldn't have hurt you for the world. I knew I was doing it. I did it anyway. Sobbing and sobbing. Pleading for his forgiveness, pained by his forgiveness. He was so good. I was so bad. Forgive me, Billy.

"Satsie!" Kirti's voice rang out in the empty office. "What's wrong, baby?" pulling me on to his lap, holding me and stroking me as I went on sobbing; I couldn't stop. I'm so sorry, Billy.

As I cried myself to sleep that night and every night for weeks afterwards, Kirti held me in his arms, loving me.

When I flew to Illinois a few months later for a dance performance of Nancy's, my first trip away from the ranch, Billy was there, too. Letters and phone conversations had hardly been the right avenue for an adequate response to his heartrending epistle, but face to face we couldn't seem to talk about it. He was as distant as he was loving, only staying in Evanston for a day; he'd made weekend plans with some friends at home. "I love you," he said, kissing me goodbye; cool, superficial; how could I blame him?

"People sometimes get negative when they leave," Vidya had warned me when she reluctantly gave me permission to visit my kids for four days, no more. "See that it doesn't happen to you, Satya. You're doing well here. Don't ruin it."

And remarkably enough, as much as I loved being with my kids, and as many qualms as I had about the commune, when I arrived at the Portland airport at 2:30 in the morning and saw a ranch swami waiting for me ("You're back in the Buddhafield now," he smiled at my surprised greeting, taking my suitcase. "Everything will be taken care of for you!"), I felt like I'd come home. Compared to the rest of the world's tensions, neuroses, noise, dirt, violence, and hysteria, Rajneeshpuram was paradise.

Not even the bomb that Kirti hit me with thirty-six hours later changed that.

*I*t has nothing to do with my love for you," Kirti said softly. "Can you understand that?"

I nodded, dry-eyed, amazed at my calm acceptance of what he'd told me. It was as if I'd been waiting to hear it ever since I met him. The worst scenario I could imagine was happening, but instead of feeling devastated by it, I felt as if Kirti's desire to be with other women—to move out of our room and "move with his energy"—was an adventure we were both embarking on. Could I give him his freedom and go on loving him? Was it possible?

"Bhagwan's coming," I whispered, the two of us lumbering down the hill we'd been sitting on, holding hands. The sun was shining in a glorious affirmation of life, the stark hills breathed the beauty of solitude, and the love of my life wanted what I always knew he'd need someday: to sow his oats, spread his seed, roll in the hay with the scores of women who wanted to be with him. He'd always been in relationships; he needed to play; it had nothing to do with me. We'd still be together some nights, most nights maybe. I knew it wouldn't be enough. I was terrified suddenly.

It was two weeks before Kirti finally moved into a room with someone else who'd just "taken space" from his lover. Eros was in the air as the commune got ready for the Second Annual World Celebration. Hundreds of sannyasins from Rajneesh centers abroad had arrived to help with pre-festival preparations, many them hoping to "merge with the community" by taking lovers who were a part of it. Half the couples I knew were breaking up. The office was filled with women who were going through the same thing I was.

There were plenty of men I could have dated if I'd been interested,

but I wasn't. The only reason for anyone to be alone at the ranch was if they wanted to be. Everyone was a potential sexual partner: there was no such thing as confirmed monogamy or homosexuality (or heterosexuality for that matter). We all had common interests and the same lifestyle; everyone had been checked and cleared for sexually-transmitted diseases; the ranch was better than a dating service. Distracting myself with someone else didn't seem to be the point, though. I'd done that too many times in the past; it was an old pattern.

On the nights when I wasn't with Kirti though, I went through hell, hating every woman he was with; always aware of who it was, obsessed with knowing it.

Ravjiv, who'd moved into my tiny "couple's room" when Kirti moved out, was as miserable as I was. The two of us would lie on mattresses that were twelve inches apart and cry all night long about the end of our respective relationships. We never comforted each other or talked to each other, each of us lost in our own private pain.

During the ten days of the festival, I felt closer to Bhagwan than I had in two years. I'd sit in satsang with 12,000 other people, close my eyes, and tune into my "waves," scarcely noticing the armed sannyasin guards who stood near Bhagwan and around Rajneesh Mandir, their presence less disconcerting than last year's hired mercenaries. Dressed in "the colors," they blended into the crowd.

The highlight of my days was when Kirti stopped by the mail tent tc see me, bringing me pieces of driftwood or a heart-shaped rock he'd found. Then at night, serving drinks in the beer garden, I'd see him with other women; he didn't seem to care particularly who it was. "Breathe!" I'd command myself, wishing I was a drinker; I could have used a bit of oblivion.

As Nirdosh stood beside me one night pouring endless glasses of beer (the Lao Tzu women, normally exempt from overtime work, were helping out in the bars and restaurants that had opened for the festival), she asked if I'd been doing any writing lately.

"Not really," handing out drinks and collecting coupons for them. My anguished love poetry to Kirti hardly counted.

"I wish you'd write about the ranch so I could understand it," she said, putting her arm around me as my eyes searched Kirti out, my heart sinking when I saw him with someone. "I don't get it, I swear to god," Nirdosh said. "What do you think Sheela and Bhagwan are up to anyway? You think it has any spiritual significance?"

"I guess so," shrugging; as confused as she was. "If I ever write about it, maybe I'll figure out what it is. Offhand, I haven't the foggiest idea."

I thought about our conversation a few months later when Nirdosh

and her lover left the ranch in the middle of the night. She'd been a sannyasin for thirteen years, living in Bhagwan's house, cooking and cleaning for him; one of the people considered to be closest to him. No one knew why she left. She hadn't even told Vivek she was going. The shock of her departure filled the commune with vague feelings of uneasiness for days till we all forgot about it; we had other things to occupy ourselves with.

Nirdosh's lover, the engineer nominally in charge of all ranch construction, had apparently been asking too many questions about secret building projects that were underway, questioning too many decisions, so Sheela demoted him, handing over his job to Laila. Disturbed, he went to Jesus Grove to discuss it, was graciously given a cup a tea and told that he was run-down, overworked; he needed a rest. He suddenly felt extraordinarily tired, he admitted, and was driven to home care without having a chance to tell anyone where he was. He slept for days, swearing finally that he felt better, he was ready to resume work under Laila, to surrender.

Convinced that he'd been drugged, he phoned a relative who lived in Portland from one of the new pay phones and arranged to be picked up late that night on the outskirts of the ranch property. Nirdosh joined him. Within days, the phones were tapped and security guards posted along the road into the ranch. Ranch security intensified, and quietly and subtly unauthorized departures became impossible.

ह

"Can you stop by the office and pick up a letter today?" I asked Kavi over the interoffice phone one afternoon.

"Is that you, Satya?"

"Yes. I...."

"Can you send it over with the rest of the mail, love? I have to get some sleep. I didn't finish work till 2:30 last night."

"It's not the kind of letter that.... You know how easily mail gets lost around here, Kavi. It's from a lawyer. I...."

"Okay, okay. I'll be over later." Slam.

If Kavi had any idea of what was really going on, she'd have been even angrier than she was. All letters that looked important were pulled out of the regular mail delivery service every day and the recipients asked to pick them up in the office where we'd offhandedly inquire about the contents in the most charming way possible "in case" it was something the commune should know about. If anyone was reluctant to tell us, the assumption was that they had something to hide and Sheela

or Vidya would be informed. While no one's mail was actually opened, as far as I know, envelopes were held up to the light regularly and read; nothing went by the eyes of the coordinator unnoticed. Even when the small part of the ranch that was incorporated as the city of Rajneeshpuram got its own government post office, both incoming and outgoing mail continued to be scrutinized.

Nothing we had at the ranch was private. The cleaners went through our personal possessions periodically, ostensibly to straighten out our drawers and shelves. Everything we owned was subject to other people's questioning, suspicious eyes. It was a fact of ranch life, as accepted as it was disturbing.

As I sat reading the incoming postcards that people had received that day, another part of my job, my coordinator hung up the phone on her desk and informed me that my parents had finally arrived; I'd been expecting them for hours. "Take all the time you want," she offered breezily. "Don't worry about coming back. Hurry up! Go! We'll clean up after you. Have fun."

Of all weeks for my parents to come, I thought dismally as I hurried off to meet them at the reception area, tears welling up in my eyes. Kirti had finally gotten so tired of my constant jealous inquiries, my insane obsession with grilling him about who he went out with and what they did, that we'd had a fight. He'd closed himself off from me totally ever since, looking the other way whenever he saw me. I was suffering, miserable, whenever I wasn't too busy not to be.

My parents thought I looked wonderful. I hid my pain well.

"Satya, darling!" "Jillie-girl!"

"Mom! Dad!" embracing them as much as they'd let me, shocked at how much they'd aged in the two years since I'd seen them.

"This is quite a set-up you've got here, kid," my father remarked caustically as he told me that he and my mother (and their rented car) had just been searched for drugs. Sheela had instituted "voluntary" drug searches recently, a reaction, I suspected, to all the rumors about drug deals in Poona. Rajneeshpuram prided itself on being the only drug-free community in the world. "I could've brought in any kind of crap I wanted in a prescription bottle and they wouldn't have even looked at it. The next thing you know, you'll have sniffing dogs here." A few months later, we did.

My mother, meanwhile, trying to diffuse any tension that existed, talked enthusiastically about the new Krishnamurti dam. "Why as soon as I saw that lake I said to your father no *wonder* they brought this property! Didn't I, dear? It's breathtaking! To drive through all that barren land from Antelope.... You're right about that town, dear. It's hard to be-

lieve the press was making so much fuss about it. A handful of trailers! Then driving through that dismal landscape and suddenly seeing your magnificent lake! It takes one's breath away! And to top it all off, this lovely lady here"—pointing to a grey-haired "Twinkie" tour guide—"tells me you just built the lake. It's phenomenal! She's been telling us about all the amazing things you've built here: roads, stores, restaurants, houses. We'll be able to visit your room, won't we?" I nodded. Ravjiv had moved out temporarily in anticipation of it.

When my parents reached the A-frame hotel unit where they were staying as guests of the commune (made out of recycled tent platforms from the festival), they marvelled at how cleverly made everything was. Simple. Utilitarian without being austere. As tacky, plastic, and serviceable as any motel room in the world.

The ranch tour they took the next day impressed them even more. The way everything from sewerage to oil waste was recycled. The emus that protected our chickens from predators. The cows that we got our milk from. The fields of worthless land that we'd cleared by hand, rock after rock, fertilizing and irrigating it till the ranch was virtually self-sufficient for its present population. The overgrazed farmland that had been considered barely adequate for a family of four when Sheela bought the ranch now fed over 2,500 people. A state-wide conservation group nonetheless was diligently trying to destroy the community by claiming we were using farmland to build a city. It was a battle that even to my skeptical mind reeked of religious prejudice.

After eating lunch in the ranch cafeteria ("Did you ever see such an array of food, dear?" "They certainly don't stint on you, kid!"), my parents went to drive-by with me, my father snapping pictures of Bhagwan in a new magenta Rolls Royce while my mother shyly *namastée*d. All around us, people were dancing and singing, laughing, crying, hugging one another: the usual drive-by scene.

When my parents asked me to invite Sheela and Jay to dinner that night at one of the new ranch restaurants, I was flabbergasted. I hadn't spoken to Sheela since the day I arrived. "I'll invite her," I equivocated, "but I don't know...she's very busy."

Feeling like a fool, I phoned Jesus Grove from my office and conveyed my parents' invitation. An hour later, one of Sheela's assistants phoned back to tell me that Sheela couldn't wait to see my parents. She'd meet us after she finished with Bhagwan that evening.

Dinner that night was like a TV sitcom, everyone conning everyone else, not even knowing they were doing it. When Sheela arrived with

Jay, she greeted my parents like their long-lost daughter and me and Chaitanya (who'd joined us) like her best friends.

"I'm gonna retire and be a bartender," she told my parents enthusiastically, discussing her latest pet project: a gambling casino that was scheduled to open in the fall. "Did Satsie ever tell you what a terrific drink I make? The best! Me and Chai are gonna deal blackjack; someone else can run this place. It's time I had a chance to have some fun like the rest of these guys. You're having fun, right, Satsie?" squeezing my hand, laughing. "I'm tired of being the only one who does any work around here."

"Tell me something, Sheela the peeler," my father interrupted dryly. "Anyone want another drink?" He ordered another round, then turned back to Sheela with feigned innocence and asked her why I was working in the office instead of writing. "Journalists are doing articles on this place all the time and they don't know half of what's going on around here. The kid's damn good and she's marketable. Why don't you use her?"

"Daddy!" I could have brained him! He'd been after me all day about how funny it was that all my old friends were running things and I was a nobody. Didn't I think it was a little peculiar?

"I like it this way," I'd told him. "Honestly."

"But to not even be allowed to write!"

"It's not a question of 'allowed.' It's...."

"Don't give me that crap, kid. Even with you giving cult headquarters the rights to your books—stupidest damn thing I ever heard: books out in a half dozen languages and you don't see a penny of the money. My genius daughter! You're lucky you got rich parents. And with all that, Sheela's still got something against you writing. Don't tell me she doesn't; I'm not stupid." My doing nondescript work had long since lost its charm for him.

"We'd *love* Satsie to write for us," Sheela beamed, not missing a beat, "but she gets so neurotic when she writes. Doesn't she, Chai? We want her to be happy here," smiling broadly as my parents gave each other tight-lipped looks, eyebrows raised.

The next night, while my parents were supposed to be staying at the new Rajneesh Hotel in Portland, a bomb exploded on the guest floor, seriously wounding the man who was later charged with setting it off and causing extensive fire and water damages throughout the building. The bomb became the excuse for further intensifying the security at the ranch and in commune-run businesses in Portland, the new "security temple" soon becoming one of the largest departments in the commune. The two men arrested for the bombing had been at the ranch a few days earlier,

giving rise to speculation that they'd planned to set the bomb off there. More disturbing was other speculation (whispered, joked about, and partially believed) that it was the ranch administration itself that had hired the men to do the bombing. After all, wasn't that what had happened in India at the book warehouse, Saswad, the ashram medical center? It was the first time I'd heard rumors about sannyasin complicity in the acts of violence that Sheela had used, along with Bhagwan's health, to justify his move to America. In the Alice-in-Wonderland reality of life around Bhagwan these days, it made sense.

ða

By the time Kirti was ready to give up casual romps in bed with women he didn't care about, I was blissfully happy without him, high on my own essence in a way I hadn't had time to be since I'd been at the ranch. I'd finally gotten the job change that for months I'd been asking Vidya for and was working in one of the laundry trailers and writing every free moment I had. I looked forward to spending my lunch time writing as much as I'd always looked forward to being with Kirti; writing was my beloved. Every night I fell asleep enveloped by waves of bliss. During the day my "waves" accompanied me everywhere I went: as I walked past the silent, majestic hills to and from work, folded laundry and gossiped with my co-workers.

When I didn't need Kirti anymore, we finally got back together again. We'd spend our nights making love, waves of bliss rushing through me, our lovemaking so deep suddenly that it wasn't "just sex" anymore; it was meditation, God; mind-blowing. Everything that had happened between us (from our meeting to our separation to our getting back together again) seemed like a repetition of a multitude of other realities. Our relationship became stronger than it had ever been. Blissfully happy alone, I was infinitely more so with Kirti.

ða

After a healing month in the laundry trailer of a quiet, secluded housing site in the hills, I was transferred to the tiny laundry room behind the main restaurant where I was doing what had previously been a job for three people. We were in the midst of another "crunch" as Rajneeshpuram's city status, and our right to issue building permits, was being contested in court. In an attempt to complete the construction of scores of new buildings before the courts denied our right to do it, we were all working sixteen or more hours a day, our only breaks a short

lunch period that I usually spent writing. My only company all day long was people who stopped by to use the bathroom and gossip. While I ironed and folded tablecloths and uniforms, I listened to their problems, offering advice when necessary. It was the first time in years that I didn't feel as if I were being watched constantly. I could talk freely, say anything I wanted; no one would accuse me of being on a guru-trip.

"Bathroom empty, Sats?" an ex-math-professor-now-taxidriver who was one of my "regulars" asked one afternoon as he squeezed past me at the ironing board. "They're killing me out there. I gotta talk to you when I get outta the can. You got a minute?"

My neurotic friend was hardly out of the bathroom before he began complaining. "You know what they got me doing now?" he grumbled irritably in frenetic Brooklyn-ese. "Swing shift till 10:30 every night! Then I get back to my room last night and that bitch of a wife of mine"—an Indian ma who later became one of Bhagwan's chief administrators; he'd married her so she could get her residence permit green card—"is playing some crappy Indian movie music you could puke from. When I ask her to turn it down, you know what the bitch does? Laughs! So fucking high and holy just because Bhagwan stops in front of her every day during drive-by. If he thinks she's such hot shit, he should try living with her! Then she tells me my energy's fucked up, I should find someone to sleep with. Go to some ma's place so she can have the room to herself. The Indians have *chutzpah*, huh? I don't know why I have to live with that bitch. What a farce!"

As the ex-professor raced off to do his next taxi run, I switched on a Bhagwan tape, transferred the wash, and started two more loads. Hundreds of brie-stained napkins and tablecloths were waiting to be hand-scrubbed, there were baskets of clothes and linen to iron; it would be ten o'clock before I was through tonight.

When Bhagwan heard several weeks later that people were having accidents and collapsing from exhaustion, he told Sheela he didn't want any more crunches to happen. His people weren't slaves, he said. We were here to meditate and enjoy ourselves. After a day of ranch-wide euphoria, Sheela decided that what he'd meant was that our normal work hours (twelve to thirteen hours a day) should be increased substantially so crunches weren't needed. Enraged at her distortion of everything Bhagwan said, I ranted and raved to Kirti about it for twenty minutes, then shrugged indifferently, accepting it. My rebellions seemed to pass through me as quickly as the Bombay trots these days. I took it as a sign of spiritual growth, not apathetic resignation. What was, was.

Later that day, between loads of laundry, I sat in the restaurant gar-

den with Frances Fitzgerald, a Pulitzer Prize-winning journalist who'd asked to meet me. It wasn't until Frances had insisted that she wasn't leaving the ranch till she talked to me that a meeting between us had finally been arranged.

"I can't believe you've never been interviewed before," she told me as she ordered iced tea for us both and a sandwich for herself. I was starving; I'd had too much work to do to stop for lunch if I was meeting her; but I didn't know if she was treating. I had barely enough money for iced tea if she wasn't. "Any journalist who's done his homework has read your books," she said. "Reporters must ask to meet you all the time; you're an obvious person to talk to. I find it curious, I must say," smiling pleasantly. I liked her.

As she reached into her shoulder bag for a notebook and pen, I wondered idly why I'd never thought about what she was saying before. I supposed I hadn't let myself. Two years ago, when the head of the press office asked me if I'd work with her, I told her to ask Sheela about it, knowing Sheela wouldn't let me do it. I'd never heard a word about it again.

I suddenly thought about the TV tour I hadn't been allowed to go on; about all my manuscripts from India being "lost at sea"; about the one unpublished manuscript that my Poona roommate (now a "late" sannyasin) had managed to retrieve and send to me in New York, borrowed by the editor of *Rajneesh* magazine a year ago, ostensibly to excerpt, then promptly "lost"; about the commune publishing coordinator who'd furtively told me that all the Rajneesh centers had been instructed not to buy my books, the publishers not to reprint them. "When we're selling 10,000 Bhagwan books a week," she'd mumbled apologetically, "Sheela says we can have your books on the market, not till then." She'd quietly left the ranch shortly afterwards, eventually testifying for the American authorities in its case against Bhagwan.

"I think what you're doing here is marvelous," Frances told me enthusiastically as our order arrived. "I'm not clear how it fits in with what was happening in Poona, though. Do you ever have time to meditate? You all seem to be putting in awfully long hours working. 'Worshipping' I gather you call it. I don't get this religion business, frankly. After everything Bhagwan's said against organized 'religion' there's suddenly a 'religion of Rajneeshism'; you all 'worship' in 'temples.' How do you justify it?"

She was bound to ask, and I was just as bound to find an answer that evaded the issue. Since the American legal system didn't recognize unaffiliated "men of God," Sheela had set up a mock religion to allow Bhagwan to remain in the States as a religious teacher. Once set up, un-

fortunately, the "religion" began to be taken seriously, even sannyasins soon forgetting the pragmatic tongue-in-cheek con it had started out as.

"I'd prefer the words 'meditation' or 'play' myself," I laughed in response to Frances' question. "Calling our work 'worship' means the commune doesn't have to pay us for it: it's a religious practice. No one here pays income tax. It works out well for all us old '60's radicals. Not having to support the military-industrial complex with our taxes, etcetera." Frances laughed.

"Someone said the other day that he wouldn't do what he was doing here for all the money in the world, but he does it gladly for no reward other than the sharing of the moment. If we weren't having fun, do you think we'd work this hard?" I didn't mention all the physical casualties, of course, the back injuries that people would have for the rest of their lives because they'd been pushed too hard. Sometimes I wondered if Bhagwan was behind even Sheela's distortions, if the crunches were a spiritual technique of awareness under pressure: the kind of thing George Gurdjieff did with his disciples. Other times, the work felt like a sadistic experiment to see how far people could be pushed before they collapsed.

"You certainly all look like you're having fun!" Frances acknowledged, smiling. "Have your kids come yet?" My books had told her more about me than a ten-hour conversation would have.

As we said goodbye a half-hour later, Frances asked me what every newcomer to the ranch, festival visitor, and member of my family continued to ask: was I writing anything? And, for once, even if I was skipping meals and sleep to do it, I didn't have to give her a hundred dubious reasons why I wasn't.

By the time I had half a manuscript finished, I was ready to let my editor at Grove Press know that I was writing again. I'd spoken to Lisa periodically over the years whenever Vidya wanted me to ask her for a favor. She always asked me pointedly if I was writing, greeting my blithe explanations of why I wasn't (things to do, other priorities) with stoney disapproval. I was a writer, she'd insist emphatically; I should be writing. What did I think I was doing at the ranch anyway? Grove would gladly publish whatever I sent them.

If the commune was offered a lucrative enough contract for a book, I told myself naively, maybe Sheela would let me work on it part-time. I didn't know how to contact Lisa about it, though. I could hardly phone her. Sheela had mentioned so often in public meetings that the telephones weren't tapped that I was sure they were. Writing to Lisa or anyone else at Grove was out of the question: it was exactly the kind of

thing the mail was routinely scrutinized for. I'd be called into Vidya's office to see her, told I was being manipulative, on an ego trip, asked to leave. I wasn't even allowed to use one of the ranch typewriters at night to type up what I'd written so far, I'd been told. My only option was to talk to Sheela.

"Now isn't the time," she told me dispassionately as we sat in the dining room at Jesus Grove with a half-dozen sannyasin lawyers who'd just been talking to her about an exposé of the commune that had been written by a disenchanted ex-sannyasin and published in a prestigious Oregon magazine. The woman had taken sannyas after reading one of my books, I knew; she'd been a fawning admirer of mine for the few months she'd been at the ranch. I couldn't help wondering if Sheela had purposely scheduled her appointment with me to coincide with the lawyers' discussion: to show me the kind of people my books brought to Bhagwan, how dangerous I was to the cause.

"Things are too unsettled right now," Sheela said. "There are too many things we can't talk about," winking at me as if we were co-conspirators. I suppose in a way we were. Just living at the ranch was an act of complicity. "It's not for me to decide, though. I'll ask Bhagsie about it and get back to you. Don't do any more writing till then, okay? Things can get into the wrong hands." Spies in the community were one of her favorite themes. "You never know how people will twist what you write and use it out of context."

I was so busy at the new job I started two days later that it was weeks before I thought about writing again. When I went to look for my notebook, I couldn't find it. I asked everyone in my trailer and at work if they'd seen it. No one had. It was gone.

*S*atya, it's Kirti!" Blondie suddenly shrieked excitedly.
I looked up from the engine compartment of the truck I was servicing and called out to him ecstatically as he drove past the gas station, nearly spilling 30W oil on my monkeysuit. I had all the women who worked with me well-trained; they got as excited as I did when Kirti drove by.

As Blondie went back to checking the lights on Prabhu's jimmy, I went back to pouring oil into a pathetic Dodge pickup that took two quarts every day, feeling like Lauren Bacall in a 1940's movie: earthy and self-sufficient; nobody's fool. Some days I played Spanky from *Our Gang*, some days Loretta Young; the gas station was pure Hollywood to me. I loved climbing into engine compartments, hoisting myself up on the bumpers of school buses at night, a flashlight under my chin (we had no overhead lights) and a screwdriver in my hand so I could check the brake fluid, a pint-sized macho gas jockey who didn't even have a driver's license.

"Okay," I said as I lowered the Dodge hood, getting a kick out every gesture I made. Blondie, meanwhile, looking sexy in a burgundy monkeysuit and rhinestone belt, was hugging Prabhu goodbye. She was the hugger, I was the therapist; we made a good team.

"Yum," she squealed deliciously as Prabhu drove off finally, mumbling into his motorola. "Su's boys" (an elite goon squad comprised largely of Kirti's co-workers in the heavy equipment "temple") communicated to each other constantly in code over their omnipresent motorolas: "Tarzan to Laughing Bull. Can you get a 10-2 on that 12-12 at Diamond Lil's before Eggbeater heads out?" as enamored of intrigue as if they were kids playing cops and robbers. No one ever questioned Su's boys' right to do anything they wanted to do. They operated on their

own authority, or seemed to, playing at guerilla warfare when the rest of us didn't even know there was a war going on.

"My type definitely," Blondie sighed, then shook her head, laughing. "Would you look at you, Satya! Where's your belt? I can't leave you alone for a minute! Let me fix your hair," giving me a quick hug before she carefully piled my straggly locks back into the Gibson girl bun she'd decided was "me." Looking glamourous was important when you worked in a gas station, Blondie insisted, putting lipstick and eye make-up on me at seven A.M. every morning after *gacchamis*.

"Gorgeous, bubbsky," she said finally. We'd taken to wearing sexy lingerie under our monkeysuits recently. "Is what's-his-name with the motorola with anyone by the way?"

"I don't think so. He was with Kavi for awhile, the ma in the kitchen with the frizzy hair. Know who I mean? An ex-medium."

"Can't place her," Blondie commented as one of the "Hollywood crowd" drove into the gas station in the glittering gold Rolls Royce that Bhagwan had just given her.

As a steady stream of cars and trucks pulled into the station all morning, Blondie and I alternated between servicing them, hugging the drivers (Blondie), or listening to their problems (me). The gas station was like a drive-in therapy clinic sometimes.

A pretty American woman who later became the security temple "Mom" drove in, bursting into tears as she shut off her engine. Vidya had just told her that she was unsurrendered, worthless, she sobbed; she hadn't learned a thing in all the years she'd been with Bhagwan. She accepted Vidya's analysis totally, without questioning it. It was the first step in the making of a "Mom" (though we didn't know that, then). I talked to her; Blondie hugged her. When she left, she was smiling.

Sheela had begun calling herself "Mom" a few months ago. Before long, all the coordinators were called "Mom" (or occasionally "Dad"), the whole commune masquerading as one big happy family. We were surrounded by "Moms" everywhere: mother images; psychological blackmail. If the majority of sannyasins had been bad kids once, rebels, most were reformed brats by now, eager to please their Mom/Moms/Sheela's whole crew of matriarchs. Truck drivers, doctors, and engineers wagged their tails pathetically, trying to please Sheela, the "big Moms" who worked directly under her, and the Moms of their respective temples. It was enough to make a person sick.

Any woman could become a Mom at any moment. Housewives dictated to lawyers. Administrators dictated medical treatment. I was the Mom of the gas station. Su (a cockney Englishwoman with two kids) was the big Mom I worked under. In addition to running the garage

temple (which included the gas station), the investment corporation that owned the ranch property (and that Jay had run until he and Sheela separated), and a half dozen other departments, Su had her own underground security squad and co-ran a secret para-military guerrilla force with my ex-lover Kuteer. The big Moms were busy ladies.

Shortly before lunch, a "Peace Force sister" (i.e., Rajneeshpuram cop) drove into the gas station looking upset. While Blondie serviced her car, I asked her gently what was happening; the fact that I barely knew her seemed irrelevant. Her father was dying, she blurted out suddenly, bursting into tears. I talked to her for a long time, telling her about my own near-death experiences: how ecstatic it was to be "out of the body," that death was nothing to be afraid of.

"I thought this was just a gas station!" she murmured gratefully as she laughed and cried in my arms, thanking me.

Nothing at the ranch was "just" anything. That's what made the place so special. The intimate encounters. Someone always there when you needed them. The grotesque abuses of power that Sheela and many of the Moms committed seemed inconsequential in many ways. If the Poona ashram had given us wings, the ranch seemed to be grounding us, giving us roots deep into the bowels of the earth where the mud and excrement lay. While Sheela's crew wallowed around in the mud like sows on a hot day, the rest of us were spreading our wings, soaring. Sometimes.

"Did you hear about the meeting tonight?" Kirti asked when he came by an hour later to bring me a sandwich that he'd snuck out of the cafeteria for me. I was on lunch duty at the gas station.

"On a late work night, Kirti! I'm shocked!"

He laughed good-naturedly. God only knew why everyone in the garage temple was expected to work late three nights a week when there was nothing to do at night in either the gas station or the garage. We all walked around the mammoth garage building aimlessly for hours, looking for make-work to do. After several nights of it, Kirti and I had finally decided it was ridiculous and began sneaking out together in the truck he used for work (and kept at night for occasional emergencies) when no one was looking, hoping we weren't missed. I'd have never had the courage to sneak away without Kirti, I knew. I was too afraid of authority these days, terrified without knowing what I was terrified of, as eager to please as an inmate in a concentration camp. Fear mingling with the adrenaline excitement of being "bad," I let Kirti talk me into what felt like courageous acts of daring, a thousand excuses prepared in advance in case anyone saw us. The fact that we'd both already worked for thirteen hours that day never occurred to me; I felt guilty. The Moms

were as skillful at evoking guilt, and exploiting it, as Jewish mamas; the ranch was built on guilt. With Kirti's encouragement, I was willing to live with mine.

As people lined up in front of the gas station for drive-by, Kirti and I sauntered over to the road in our matching monkeysuits, the Mutt and Jeff of the garage, giddily amusing ourselves as we waited to see Bhagwan. We could hardly avoid going to drive-by when I was on lunch duty.

"See those hills over there?" Kirti asked me casually.

"Uhuh," my leg resting on his arm, Harpo Marx-ish.

"They're yours. All the hills as far as you can see."

"Wow!" throwing my arms around him exuberantly. "You mean it?"

"Nothing's too good for my baby."

"I gave you the sun yesterday, didn't I?" He uhuh-ed as Vidya and Su drove slowly by in a jimmy, their grim faces scrutinizing the crowd and scanning the hills. "Anyone own those clouds over there?" I asked a crowd of somber-faced Rajneesh University therapy group participants who were standing nearby. They looked at me like I was nuts. "They must be the ones I ordered for you," I told Kirti. "They're all yours except for those two over there. I'm saving them for Billy when he gets here. He'll love them."

Two of Su's boys were walking up and down the line meanwhile, asking people to fill in the gaps as Prabhu strolled nonchalantly behind everyone, making sure nothing suspicious was lying around. Su and her boys lived in a different world from the rest of us. Constantly on guard. Watching everything, suspicious of everything.

When Bhagwan finally drove by in one of his gaudily-painted $150,000 Rolls Royces that sparkled like a circus clowns' rattletrap (a different one every day: stars stencilled on one, clouds on another, a rainbow of colors on a third; expensive jokes that ranch sannyasins assumed were an attempt to press people's buttons and succeeded; he had more than fifty Rolls Royces by now), I tried to feel something more than amusement at the grotesque paint job on his latest car. All I felt, pressing my lips together so no one would see me giggling, was Kirti affectionately fondling my ass. My favorite part of drive-by was hugging him afterwards. A legitimate bliss attack. Heaven.

ॐ

At the general meeting that night in Rajneesh Mandir, Sheela announced solemnly that Bhagwan had just told her that two-thirds of the world would die of AIDS, a disease that few of us had ever heard of be-

fore. It was early spring 1984. We had little access to the media at the ranch. As a hushed silence fell over the hall, Sheela told us about a Dutch swami who had been at the last July festival and had just died of AIDS, possibly bringing the disease into the community.

Bhagwan had given Sheela numerous AIDS-prevention suggestions that she was to pass on to the rest of us. Gay and bisexual men in the commune had apparently been told a year ago to use condoms. Now everyone had to. Anyone who objected was welcome to leave. We couldn't afford to let Bhagwan's work be wiped out by our negligence; we had no option. If we followed his advice diligently, we'd become the first AIDS-free city in the world.

"The first choice he gave us," Sheela announced, "is to be celibate. If you can't do that, be monogamous. And if you can't do that—I know you guys!—wear condoms and rubber gloves. Anyone who hasn't been monogamous for two years"—soon changed to seven—"has to wear them. Oral sex is out. Anal sex. Do people really do that? Yich!"

Bhagwan's doctor spoke to us briefly about AIDS, then Puja demonstrated how rubber gloves were to be used, someone mouth-tromboning torchy blues music while she did it. "It can be very sexy," she said. "It'll add a new dimension to your lives." The laughter that greeted her words was more nervous than authentic.

"I have a feeling it's just the beginning," I whispered dismally to Kirti as mouth-to-mouth kissing was discouraged and the possibility of sweat-transmission discussed. It was hard to believe that Sheela wasn't playing games with us, exaggerating at the very least; I'd never even heard of AIDS before. Sheela had never liked sex very much. More to the point, perhaps, was the way jealousy interfered with our work. Or was it Bhagwan who was playing games this time, making sex so unappealing that we'd all decide to become celibate? Had sexual license only been a prelude to celibacy all along? I wondered how long it would be before we were forbidden to even sleep with our lovers.

"How about masturbation?" someone suddenly called out earnestly. "Do we have to wear gloves to jerk off?"

People laughed self-consciously. "Just make sure you don't get cum on anything," one of the ranch doctors responded solemnly.

"That brings up another point," Sheela said. There was more tittering in the hall. She looked around bewildered till Puja whispered something quickly in her ear. She giggled and then went on: "Contaminated-waste bins will be in every bathroom for used condoms and gloves," she announced. "Laila, make sure all the cleaners wear gloves, especially in the bathrooms.

"There are people cleaning up after you guys in your homes and at

work, so don't leave anything contaminated around; it's not fair to the cleaners. There'll be condoms and gloves in every trailer and townhouse by tomorrow night. We've bought out the entire Oregon supply." Raucous laughter. "Ticklers and fancy stuff'll be available in the boutique by the end of the week. Any questions?"

As the days went by, and sex classes were held in every department, it became clear that there was an objective reality behind the AIDS warnings. Jokes about the possibility of a sex patrol starting became widespread: people arrested for kissing, sexual partners reporting one another for infringements of the rules. The jokes were an indication of our fears.

When a friend of mine spent the night with someone who refused to wear a condom, she felt that she had no other option than to report him to the medical center. He was one of Su's boys; nothing seemed to happen as a result of it. A handful of other recalcitrant sannyasins, however, were asked to leave. In the ranch's first year, a single swami gave gonorrhea to forty women before the source of the infection was discovered. V.D. was finally eradicated by testing every new resident before they entered the communal sexual pool. AIDS was a different story, though. It could lay dormant for years. There were no cures. It was fatal.

According to the weekly AIDS report that appeared in *The Rajneesh Times* ("Positive Journalism Straight From The Source"), any breach of the rules created a potential life-and-death threat for someone and, by extension, for the commune. While the years have proven this to be true in many ways, at the time it felt like one more way to control people. Kirti and I had been monogomous for over nine months. What we did in bed with each other didn't seem to be anyone else's business as long as we remained that way. Long after we stopped using condoms though, we still acted out the charade of it: depositing unused condoms and gloves into the contaminated bin every night. We couldn't afford not to; anyone could be an informer. Our housemates, the cleaners, even friends.

When Billy came to the ranch for a three-day visit, he spent half a day at the medical center where he was checked for crabs and lice, given a talk on AIDS and how to use condoms and gloves (accompanied by a song: "Wear a condom every night, la-di-da!"), then told he couldn't have sex at the ranch anyway: he wouldn't be around long enough to be cleared for V.D. I thought the whole thing was ridiculous (he was only staying for three days!), but he loved it, amused and complimented: he'd just turned eighteen.

"I really like it here, Mom," he told me with a big grin on the first evening of his visit. He'd been afraid to visit me for years. I was part of a cult. How could he be sure he wasn't going to be brainwashed? Now

suddenly he was talking about coming back again one summer for a month or so to "experience the work trip."

"The only thing I don't get," he commented quizzically as Kirti and I drove him to the guest A-frame where he was staying, "is what Bhagsie has to do with anything here. All he seems to do is drive by in his car once a day like he's some kind of weird tourist attraction. The farm's great, though. An Indian guy I met today said I could work there for a few hours tomorrow. You don't mind, do you?"

On the last evening of his visit, Billy and I went out to eat alone together for the first time at one of the ranch restaurants. "I know I haven't been totally open to you while I've been here, Mom," he said, taking my hand lightly in his after we'd finished eating. I could feel my stomach suddenly tense up anxiously as he spoke. It had been such a light, carefree visit so far. I wanted it to stay that way. "I've been afraid to let my guard down," he murmured softly. "Is there any reason why I should? I'm ready to deal with the trips we have to work out together if you are, Mom."

I wasn't prepared for Billy's words; I couldn't handle them. I began to cry. I still wasn't ready to face what I'd done to him by leaving. The pain I'd caused him, his sisters, myself. All the years I'd missed of watching him grow up, mothering him. He was leaving the next morning, I rationalized to myself like a coward. Twelve years of pain couldn't be resolved in a few hours. As the years went by, he'd understand. I didn't know how few years we still had left together.

"I love you so much, Billy," was all I could manage to say to him through my tears. He was everything I'd ever wanted him to be: as loving and compassionate as he was sensitive and kind.

"If you're not ready, it can wait, Mom," tears in his eyes, too. "I've been waiting a long time. I can wait a little longer." Sobbing, I reached out to hug him, the two of us holding on to each other for dear life, oblivious to everyone else in the restaurant.

"Do you still want to be my baby?" I sobbed; it was what I knew I still wanted. Hurt, he pulled away from me abruptly, feeling belittled by my words, he told me years later; not knowing how much I still longed for my baby, mourned for him; wanting to hold him in my arms, cradle him as I'd once done, cling to him.

When Billy checked out of the visitors' center the next morning, it was obvious that he was glad to leave. He hugged me good-by without really hugging me; distant and aloof, afraid to trust me. Scarcely a day went by when I didn't help someone at the ranch deal with their pain, but I still couldn't let myself look at my own anguish, or Billy's; afraid of drowning in a wound that was so deep I might never come out of it.

If the ashram in Poona was ostensibly a place to confront all the dark shadows of one's soul, the ranch wasn't. It was a place to live on the surface, hide: "rise above the pain, transcend it: the watcher on the hill" is how I thought of it at the time. It was a different phase of Bhagwan's work. Only ordained bliss attacks, no anguishing; we were above it.

As Billy drove off waving, tears in his eyes, I broke down finally; I couldn't control myself anymore. I'm crying now as I'm writing this. Billy may have forgiven me, but I didn't forgive myself. I don't know if I ever will. How can I now that he's dead? I know he wants me to.

He'd seen Bhagwan finally. It was what I'd dreamt about for so long. But I still longed for the little boy I'd loved and left; I missed him unbearably. Even when Billy and I were together in the few years before he died, I went on missing the little boy I'd left behind. And miss, now, the extraordinary young man he became. Wishing I'd known him better and had never left.

*W*hat do you mean we can't sleep together?" Kirti muttered increduously as we walked to the new cafeteria near the gas station for lunch one afternoon. We'd been living together again for several months now, Kirti having finally threatened to leave the ranch when the administration refused for the dozenth time to give us our own room. His skill as a heavy-equipment mechanic was in great demand. They couldn't afford to lose him.

"We can't touch each other till we've both been checked for conjunctivitis," I said, an outbreak of itchy eyes having recently been discovered in the community. Bhagwan might have been exposed to it, we'd been told with all the wailing and gnashing of teeth as if the world was coming to an end. Three-quarters of the Lao Tzu House staff had been found to have early signs of conjunctivitis and put into home care. Everyone in the commune was being tested now.

"That's ridiculous!" Kirti scoffed, deliberately putting his arm around me. "It's not the fucking black plague for godssakes! It's conjunctivitis!"

It took our whole lunch hour to get inside the cafeteria. The kitchen staff, wearing surgical gloves, were spraying everyone's hands with alcohol, passing out plates and utensils, and dishing out food. Drive-by was cancelled and rules set up at work ("Wear rubber gloves when you touch anything! Don't touch anything that anyone else has touched!") that were as bizarre as they were impractical.

As each department was tested for conjunctivitis, half the ranch population was put into isolation where they were told they'd have to stay for up to three weeks. Work virtually stopped everywhere except in the kitchens and medical facilities. Three days later, everyone was suddenly released and sent back to work.

The whole incident was outlandish to say the least. With preparations underway for the Third Annual World Celebration, it was obvious that the commune couldn't get along with half its staff in home care, but why the travesty was set up in the first place remained a mystery. Spraying our hands with alcohol before meals and in the bathroom, spraying toilets and telephones, had been a ritualized practice ever since the AIDS scare began. Kissing had been all but prohibited since then. The conjunctivitis fiasco seemed to be another attempt to move us in the same direction.

A year and a half later, when Sheela and Puja were convicted of numerous poisoning attempts both within the community and outside it, more disturbing explanations came to mind. Would poison have some day been added to the alcohol bottles that we all diligently sprayed ourselves with before eating? Could large numbers of people have suddenly disappeared from the community one day without anyone worrying about it? Or was it simply that Sheela had wanted to empty Lao Tzu House so she could install bugging devices in Bhagwan's rooms and needed a justification to do it? All of the above, perhaps.

ða

On the first day of the festival, along with numerous people from different departments, I was suddenly transferred to the main office of the new "currency card" program. The computer-operated, pre-payment, credit-card system had been hastily inaugurated a few weeks before the festival in an effort to bring huge sums of money to the ranch as quickly as possible. Virtually overnight, sannyasins in Europe, Asia, and elsewhere had collectively deposited millions of dollars into the system through the various Rajneesh centers abroad, money that the depositors could use for purchases, food, and accommodations when they got to the ranch. Since many people had similar sannyas names, endless complications were created as hundreds of duplicate accounts were inadvertently opened. From after satsang in the morning till midnight every day, there were long lines outside the currency card office as people tried to find out where their money had gone, and why.

Along with several other women in the office, I worked till three o'clock every morning and then got up at 6:30 for satsang, taking vitamin B shots daily to keep me going. When I finally managed to crawl into bed beside Kirti for a few hours, I was more revved up than I was exhausted. I could hardly sleep, my mind preoccupied with trying to work out all the computer bugs in a system that was still months away from being adequately operational. Sheela had wanted money fast—

now!—she couldn't wait for the computer programmers to be ready. Meanwhile, people who had come to the festival from thousands of miles away were spending hours standing on line outside the office. While most of them were remarkably good-natured about it—they made new friends on line, met new lovers, gossiped with people they hadn't seen in years—I felt guilty about the situation. It was gruelingly hot outside. They should have been off swimming in our two barely-used lakes.

"I don't think I have all this money in my account," an Italian swami I'd called into the office acknowledged sheepishly to me one afternoon shortly before drive-by, "but all the time I'm hoping you lovely ma's won't discover it so I can do the hypnotherapy group." When the handsome young swami discovered that the $2,000 he'd deposited into the currency card system in Geneva had miraculously turned into $50,000 by the time he got to the ranch, he went on a spending spree: buying expensive clothes and meals in the various boutiques and restaurants, drinking and gambling in the new casino, moving from a tent to the luxurious new hotel that had just opened. "The miracles that happen in the Buddhafield of our Master, I think to myself," he grinned cheerfully. "Flowers showering down on this poor Italian swami!" The stout, heavily- made-up American ma beside him, his namesake and the holder of a duplicate currency card account number, looked at him benignly, charmed.

"You were planning on doing hypnotherapy?" she asked in a squeaky little girl's voice; she was sixty if she was a day. "I've been deciding between that and The Buddhafield Experience," a three-month work program that cost several thousand dollars.

The young Italian shrugged his shoulders, smiling agreeably. "To do hypnotherapy now is impossible. No money is there."

"Ridiculous!" the woman scoffed, taking his arm and holding it protectively as she told me to transfer $5,000 of her money into his new account. "It's fate we met," she insisted. She wouldn't dream of depriving him of doing the group; maybe they'd do it together. What else did Bhagwan teach but nonpossessiveness, sharing, love? I wondered how long it would be before Sheela discovered the woman and her money.

"Are you on drive-by duty today?" I asked Sampurna as the two new friends left the otherwise closed-for-drive-by office ten minutes later. Sampurna, one of the last Lao Tzu residents and mediums to finally be allowed at the ranch, had been here for a little over a year. Until a few days ago she'd been a forklift driver.

"I thought you were," she laughed. "I was trying to avoid the heat a little longer. Why don't you go." Drive-by music was already drifting

into the office window: bongos, guitars, flutes, bells, noisemakers. "I don't mind staying, honestly."

As I slipped into the line-up a moment later, a swami from the Geneva center hugged me impulsively. "Did you hear the news?" he beamed. "I'm on Bhagwan's new list of enlightened people! What a day! First I win a Rolls Royce in the car raffle, then this!"

To some sannyasins, the lists of "enlightened people" Bhagwan had recently begun issuing were a joke. To others, including some of the people on the lists, they were an outrage. "If this is all enlightenment is," one newly-proclaimed Buddha commented dryly, dropping sannyas, "we've all been conned. It's a crock of shit."

A few of the most unlikely people were on Bhagwan's initial list. The mournful, neurotic mother of a former Poona medium; the professor with a fondness for prepubescent girls; Sheela's rascal of a father. Teertha (still assumed to be Bhagwan's obvious successor) wasn't on the list. Nor was I, though rumor had it for days that I was: there was both a "Satya" and a "Bharti" on the list. Neither Sheela nor Vivek were on any of Bhagwan's lists, while several "late" sannyasins like Shiva and Sangit were.

In establishing a second hierarchy-of-sorts in opposition to Sheela's crew, Bhagwan seemed to be reminding us that we were a spiritual community. Anyone could become enlightened at any moment, the lists seemed to imply. If I thought I was, I would be; nothing would bother me anymore. If I thought someone else was enlightened, I'd stop judging them. The lists felt like an awareness exercise, a technique, nothing more. I didn't take them very seriously.

"How will you get the car back to Geneva?" I asked the fledgling Buddha beside me as we waited in line for Bhagwan.

"It's staying here," he winked, grinning. "I'm donating it back to the commune. I didn't even have to buy a raffle ticket to win it!" he whispered in my ear, giggling, as I smiled back at him wanly, appalled. Sheela was too much! I wondered how much money she'd raised with her phony raffle, how many more cons she'd pull before she was caught.

As Bhagwan's car moved slowly towards us, surrounded by an entourage of sannyasin bodyguards carrying Uzi machine guns, waves of impassioned frenzy moved like ripples along the line. Su and Savita (the Englishwoman who oversaw all financial operations at the ranch, including the currency card office, and seemed to be Sheela's second-in-command these days) walked on either side of the car with Smith-and Wessons in holsters around their waists while Sheela, similarly armed, stood beside a second Rolls that was standing in front of the office. As shocked as I'd been to see Sheela and Savita with guns on the first

morning of satsang, I was already used to it by now. I assumed the guns were needed. Threats against Bhagwan's life had apparently increased.

Bhagwan got out of his car in front of the office, as resplendent as a fourteenth-century monarch in a velvet gold-encrusted robe and hat, diamond bracelets sparkling on his wrists, and raised his arms exaltantly, spurring the crowd on to greater and greater enthusiasm. A warning had been issued to sannyasins all over the world that the festival might be the last time they'd ever see Bhagwan; he was ready to "leave the body" at any moment (news that had quadrupled the disappointingly-small pre-festival registration to over 15,000); but he looked radiant, playing to the grandstands, dazzling his "lovers."

To my jaundiced, cynical eyes, the emperor looked naked. I'd never have been attracted to him if he'd portrayed himself like this when I first met him: the rich man's guru, the avatar of the affluent and amoral, the hedonist's messiah. If the ashram in Poona had been a spiritual Club Med, the ranch was more like Stalag 17, but Bhagwan clearly had his nets out to attract the moneyed and the influential. Even one of Danny's business associates was a sannyasin now. It wasn't my scene anymore no matter how much I told myself that Bhagwan knew what he was doing; I had no right to judge him.

As Sheela held a white umbrella over Bhagwan's head to protect him from the sun, he walked slowly over to the second Rolls Royce, everyone dancing and singing ecstatically. I made a half-hearted effort to join in, clapping my hands and bobbing my head in time to the music. The mood of celebration was infectious. Despite myself, a big grin spread over my face, what had been feigned became authentic; I would have heil-Hitler-ed if I'd been around, many Jews did. Why did I think of it in those terms, I wondered. I owed Bhagwan everything.

Sheela's father, meanwhile, looking like a traditional Indian sannyasin, was dancing exuberantly in front of Bhagwan like a madman of God. Bhagwan stopped to watch him for a moment, clapping his hands, laughing, then got into his car and drove off, chuckling.

As everyone moved to the other side of the road to wait in the hot sun for forty minutes for Bhagwan's return—every day people fainted; still, they waited—I thought about Sheela's recent hairbrained scheme to resolve Bhagwan's immigration problem by claiming that her parents had adopted him as a child. The scams she tried to pull never ceased to amaze me.

"As my parents' adopted son," she'd proclaimed at a general meeting, defiantly waving in front of the video cameras what were purported to be signed adoption papers dated forty-five years ago, "he has every right to be in America. My parents are naturalized citizens. It's perfectly legal.

There's nothing the fucking government can do. Bhagwan has to be allowed to stay!"

The audience, incredulous a moment ago, greeted her last words with exuberant applause. Most sannyasins loved Sheela's audacious attempts to rip off the system: yes, you *can* fight City Hall. Kirti and I were disgusted.

Bhagwan had talked often about living with his grandparents as a child. At his birth, an astrologer had predicted that he'd either die before the age of seven or become a Buddha. In an effort to defy his fate (presumably, death), he'd lived with his mother's parents until he was seven. It was, in fact, Sheela now claimed, her father whom he'd lived with. Unbeknownst to her until now, Bhagwan was her adopted brother.

When he was finally granted permanent resident status in America a few weeks later as a religious teacher, Bhagwan's alleged adoption was quickly forgotten. As embarrassingly childish a ploy as it had seemed at the time, for all I know it may have been true. Hindu men without sons often adopt an heir so they'll have someone to pray for them when they die; Sheela's father had no children at the time. Bhagwan had mentioned once in a private talk that he'd lived with her father as a child; their fathers had been close friends. Anything's possible.

ॐ

By the time the festival ended, I'd been made the "Mom" of the currency card office. "All you have to do is make sure that everyone gets enough rest and the work happens," Savita told me as she put me in charge. "There's nothing to it."

It took weeks for us to unravel the grotesque confusions left over from the festival period. "How come you took $25,000 out of this account and put it into that account?" I'd ask someone earnestly. We'd all been too busy at the time to keep written records of what we did for the auditors. We hadn't even known they were needed. None of us was an accountant.

"It just seemed like the thing to do," was the usual, unconcerned response I got. "Don't worry, Sats, you'll think of something. That's why a writer's running this place, not an accountant. The creative approach to banking."

By the end of the month, when my parents and sister came to visit, most of the chaos was finally under control and half the people working with me had been sent back to their original departments. Two weeks later, my younger brother came with his son and girlfriend; and in late August, Nancy and Patti finally visited.

৯

There wasn't a nongay male between the ages of fifteen and fifty who didn't notice the girls as they explored the ranch grounds, dressed in vivid blues and greens, dancing and singing, oblivious to the stir of interest they were creating.

"They're gorgeous!" Sampurna told me as I waited for them to pick me up at the office one morning. "Nancy's the spitting image of you, and Patti's as luscious as a ripe melon. They feel just like sannyasins!"—an intended compliment that the girls heard from everyone, and hated.

"Just because a person has a little life in them," Patti grumbled irritably, "everyone thinks they're *really* a sannyasin. As if you people have a monopoly on happiness. It's so fucking chauvinistic I can't believe it."

What Nancy and Patti liked about the ranch was the closeness they felt between people, the playfulness and lightness that pervaded everything, and the fact that people changed jobs frequently enough not to get bored. What they didn't like was Bhagwan's disconcerting omnipresence (glossy 3' x 6' playing cards with his smiling face on them hung on the walls of the gambling casino; every store, office, hotel room and restaurant had his picture in it; every gift item in the boutique was imprinted with his face or the Rajneesh Commune logo; the closed circuit TVs in the hotel rooms showed only videos of his discourses; not even the complimentary boxes of condoms and rubbers in the hotel bathrooms escaped imprinting); the endless hours of work that everyone did; the fact that we all wore the same colors ("Don't you get a headache from all this red?!"); the unrelentingly middleclass atmosphere of the town center with its shopping mall vibe and expensive touristy shops ("Where are all the streetpeople anyway? What kind of city is this?!"); and the absence of any kind of creative arts, theater, movies, or non-Bhagwan books.

It was only through the girls' eyes that I realized how strange it was that all we ever did was work, eat, sleep, and make love occasionally. Few people other than guests and group participants at the university went to the disco or gambling casino at night; most of us were too tired to be bothered. I'd been too busy before to notice how rigidly prescribed our lives were.

As we headed towards Krishnamurti Lake one afternoon after driveby—it was my third time swimming in three years; Savita had told me to take all the time I needed to be with my kids—Sheela drove by in her Mercedes, stopped the car, and called out the window to Nancy and Patti. Savita was sitting beside her, smiling; Vidya and Su were in the back seat: the unholy quartet of dowager duchesses who ran every de-

partment at the ranch. "How do you kids like it here?" Sheela grinned. "It's great, isn't it?"

"It's okay," Patti shrugged noncommittally, uncommunicative for once; Nancy adding that it was pretty nice, she guessed; both of them taking an instant dislike to Sheela whom they'd never met before.

"Why don't you stay for a couple of months?" she beamed as the other women smiled encouragingly at the girls as if to say: so these are Satya's beautiful daughters, owning them with their eyes. "Your mother would love it, wouldn't you, Satsie? We'd all love for you to stay. As our guests. I'll arrange it."

The fact that the girls had no intention of staying for more than three days seemed to be immaterial to Sheela as she extended her abrupt invitation. After years of making it difficult for people to move to the ranch, a concerted effort was being made to encourage Americans of voting age to become residents. The usual monetary considerations (by the commune's second year, most new residents were paying for the privilege of working thirteen hours a day and sleeping three to a room) were suspended for anyone eligible to vote; the upcoming federal and local elections in November were presumably crucial to the community. Few sannyasins had availed themselves of the opportunity. I had no doubt that Sheela's invitation was motivated by the girls' ages.

That night they received a note from the ranch personnel department (a cadre of women who were the hierarchy's link to the rest of the commune) asking them to stop by the office the next day. They went reluctantly—deciding why not, finally—but the more the "Ramakrishna ladies" tried to push them into staying, the more resistant they became. Patti, who'd toyed vaguely with the idea of coming back again some day, put her guard up defensively: leery and distrustful.

She telephoned from Portland several hours after she and Nancy left to tell me that she was sure she'd been drugged at the ranch. "I didn't even realize how dizzy I've been till I left. Are you aware of what they're doing there, Mommy?"

"That's ridiculous, Patti! You couldn't have been drugged! You're imagining things!"

I'm not so sure anymore.

23

I 've got ten minutes for you," Savita said breezily, grabbing a towel and motioning to me to follow her into the bathroom. "Did you make up that list of large accounts I asked you for, love?" she inquired as she stepped into the shower, steam quickly filling the room.

"I have it here," I answered, sitting down on the closed toilet seat with my stack of papers and questions for her. I assumed the list she wanted would be used to request donations from wealthy sannyasins; the ranch was continually in debt. "Have you found anyone to replace Sampurna yet?" I asked hopefully.

"Tell her to forget it, love. We need her. Is Dipo worshipping regularly? I heard he was in Portland yesterday."

"He was in, in the morning," I responded uneasily, wondering whether it was Savita who didn't trust Sheela's new lover (a middle-aged, gay businessman from Switzerland) or Sheela who didn't.

"I want you to tell me when he doesn't show up, love," Savita commented as she shut off the water and reached for her towel. "He's no different from anyone else here."

As I sat on her bedroom floor a few minutes later watching her select a skirt from her ample wardrobe (the Jesus Grove women had closets full of expensive clothes; I had a few utilitarian hand-me-downs. Savita had a private phone, a private room; the hierarchy led different lives from the rest of us), I told Savita that I'd been thinking about why it took so long for funds from abroad to reach the ranch. "Someone's obviously making money on it," I postulated. "I don't see why we're still using The National Bank of...."

"Don't waste your time on something that's none of your business, ma!" Savita interrupted sharply. "You have enough to do!"

"I just thought...."

"Well, don't think! Your job is to handle the office. You don't have to do my work for me."

"Sorry," bewildered by her testy reaction. Dignified and sedate, Savita was usually a model of calm deliberation, kind and considerate where the other big Moms were demanding and imperious. "I didn't mean...," wondering if it was the bank that was making the money on foreign exchange, some sannyasin who worked with the bank, or a Rajneesh corporation. I never questioned that it might be Savita herself. I trusted her implicitly.

As the phone rang and she turned to pick it up, I busied myself with my papers, pretending not to listen to her conversation. "How many people do you have so far?" she asked guardedly. "You won't be the first busload in, then. How are the other recruiters doing? Encourage them, love. We want enough homeless people to fill the buses. See you in a few days, swami."

"Homeless people?" I couldn't resist asking as she hung up the phone, knowing I shouldn't be so nosey; it was none of my business. Savita nodded brusquely. "What do you mean 'homeless people'?"

"People without homes, obviously," she snapped curtly. "The first busload will be here in two days. Did you find out who can do cash in the casino Thursday nights? It doesn't have to be an American."

à

Within three weeks, there were more than twice as many streetpeople in the crime-free, pathologically-health-conscious community of Rajneeshpuram as there were sannyasins.

"We had some money left over from the last festival," Sheela told a stunned audience in Rajneesh Mandir the night after I first heard about what came to be known as the Share-A-Home program, "so we thought: why not share it with people who don't have anything? We opened up our home to Americans and no one came. Why not open up our home to the homeless instead? Give them good food, medical treatment. We have so much here. It's time to share it."

"If we have so goddamn much," Sampurna grumbled under her breath to Kirti and me as the three of us sat on the floor in the back of the auditorium, "I don't see why I still have three goddamn people living in my room!"

Kirti laughed, looking around anxiously to make sure no one heard Sampurna. Remarks like hers had an ominous way of reaching the higher-ups.

"Since when has Sheela become a humanitarian?" she snorted, but it was obvious that the November election was the reason for it. Some of the candidates running were sympathetic to the community, others had vowed to destroy it. Every vote counted; the more the merrier.

ʾ▰

Since no initial screening of the recruits had been done, the majority of people who came on the Share-A-Home program were society's casualties: alcoholics and drug addicts, shell-shocked Vietnam vets, ex-cons and petty thieves, the psychopathic and the criminally insane. There were people who were hiding out from the police, escapees from mental institutions and undercover reporters and government agents. A quarter of the recruits were agent provocateurs of some sort, Sheela eventually claimed, blaming them for the many incidents of violence that occurred in the first few weeks of the program.

Initially, most of us saw little of our new "guests." After lengthy orientation sessions where their knives, guns, razor blades, chains, steel pipes, and drugs were confiscated, their clothes taken away and washed, new clothes issued to them, and their bodies and heads de-liced, they were put into A-frames in isolated housing sites that had been emptied for their use, crews working day and night to install additional housing for the hundreds of new people who were arriving daily by the busload.

It was weeks before any of the "friends," as they were euphemistically called (a term that nauseated me: I referred to them instead as "Share-A-Homers"), were allowed out of what was virtually an open-air prison. Even then, their emergence into the community was individual and gradual. Sannyasin housing sites, the main cafeteria, and scores of other locations were off-limits to them, grey plastic wristbands identifying them as Share-A-Homers the way special mala beads and other wristbands identified the rest of the community.

According to the endless rumors we heard, trouble started as soon as the first busload of newcomers arrived. Fights broke out constantly, the Share-A-Home housing sites turning into battle fields where gang wars, extortion, theft, and intimidation were barely controllable. The Share-A-Home Moms (a group of Sheela's trusted subordinates) were threatened repeatedly and occasionally attacked. Toothbrush handles were melted and molded into lethal weapons. Nails, forks, rocks, and planks of wood became deadly tools.

The worst troublemakers were escorted off the ranch in droves several times a day by Su's boys, whose numbers and authority expanded rapidly as more new people arrived.

Once it became obvious that less than half of the 4,300 recruits would stay (many having left voluntarily shortly after they arrived), the newcomers were no longer promised return bus tickets home. Meanwhile, hundreds of early recruits who'd left had sold their bus tickets and were stranded on the Portland streets.

"What do you people think you're doing?" my mother asked me angrily over the phone after the media's first sensationalist reports of the program. "Taking these poor people from their homes...."

"They had no homes, Mom!" automatically defending what I found indefensible. "That's the point. Now they do."

"From their hometowns, then. Carting them thousands of miles away for some illegal voting scam. Do you think for one minute...?"

"We're feeding them, Mom," talking to myself as much as to her. "Clothing and housing them." Facts were facts. What difference did it make what Sheela's motives were? The only way we'd win the upcoming election in November, someone in Jesus Grove had apparently remarked facetiously, was if we invited every homeless person in the country to the ranch. The next day, we did. Tongue-in-cheek remarks had a habit of becoming a reality around Sheela. "Giving them good medical care, dental care; putting them on detox programs. Most of them have never had it so good." Why did the whole thing seem so ugly to me, then? "They love it here."

The media played up the story for all it was worth, reporters and camera crews flocking to the ranch in unprecedented numbers. Oregonians, meanwhile, convinced that a bloodbath was inevitable, were terrified that we were building an armed camp for ourselves, arming outlaws and ex-marines to fight our battles for us. If we couldn't take over the state the way we'd taken over Antelope (now "the city of Rajneesh") through stuffing the ballot boxes in the next election, we'd do it through premeditated acts of violence. At the very least, there'd be another Jonestown-style massacre.

While the Justice Department set up rumor control centers in the state to allay people's fears, secret meetings (according to Sheela) were held by representatives of the National Guard, the INS, IRS, FBI, state police, and other government agencies to discuss how to handle the situation.

Sheela had spies everywhere, and she saw spies everywhere. Her paranoia and the paranoia she induced in the community was magnified a hundredfold. "They" were out to get us, to destroy everything we'd done. Constant vigilance was needed, gossiping discouraged; anyone might turn out to be a spy. Ranch security increased substantially and Su's boys and armed sannyasin guards were soon visible wherever the Share-A-Home people were.

"This country's so fucking bigoted," Sheela said at a general meeting one night, TV video crews filming every word and gesture, "that it deserves to be taken over!" The audience in Rajneesh Mandir exploded with applause, sannyasins and *friends* united in their indignation against the authorities who wanted the streetpeople back on the streets, the homeless to remain homeless.

"They think we invited you here for your votes," she went on as innocently as if the idea had never occurred to her before. Voter registration tables, meanwhile, had been set up in all the Share-A-Home housing sites since the program began. "I never thought about it before. It's a good idea. I think you should all register to vote. How 'bout it?"

While people cheered and catcalled, Sheela asked how many of the newcomers had never voted before (most hadn't) and why. One by one they came up to the microphone to talk about it, the press zealously taping every word. The Share-A-Home program was back-to-the-grassroots radicalism, the ultimate in social welfare.

"This is our home now!" a black man in army fatigues and a khaki beret shouted, fist raised defiantly above his head. "And we're gonna protect it! With our bodies and our lives if we have to!" Applause, oh, applause. "And with our votes!"

Meanwhile, a crew of trusted swamis (including Kirti) were checking the Share-A-Home houses for weapons, drugs, and proof of who was an informer. As fast as weapons were confiscated, new weapons were made. Scores of *friends* were hoarding and black-marketing the free packs of cigarettes that were given out every day. Free-beer tickets were being accumulated. Clothes, readily supplied to anyone who needed them, were being stolen and squirreled away.

The abuses of our "generosity" were used as an excuse to invade people's living quarters. Few of the men involved in the searches had any compunction about it. A man's home wasn't his castle at the ranch; there was no such thing as freedom from unlawful search-and-seizure for any of us. All our rooms were open to the scrutiny of cleaners and Moms, our personal things gone through periodically under the guise of straightening out our closets; we took invasions of privacy for granted.

*

It wasn't long before half the commune was begging to work with the Share-A-Home program in one way or other. Kirti, Sampurna and I seemed to be the only people who weren't enthusiastic about it or about the "vibrant," "exciting" changes that were happening in the community. Realistic or not, I'd preferred living in a cloistered, protective atmosphere

where I wasn't propositioned at eight o'clock every morning by alcohol-reeking strangers on the street, where I didn't have to listen to crude, licentious remarks, witness fights, or worry about my things being stolen. Few of the *friends* had chosen to work, an option the rest of us didn't have; they had nothing to do all day but make nuisances of themselves. It felt as if the whole community could explode in violence at any moment.

One afternoon, as I was helping one of the *friends* open up a currency card account with the $400 in loose change that she'd carted into the office in two tattered brown shopping bags (other *friends* opened up accounts with their social security payments, others with forged checks, most of them running up enormous bills that they had no way of paying), a rock suddenly came hurtling through the window, shattering the glass. Two Peace Force brothers rushed inside, emptying the office except for me; someone had to stay behind to guard the money.

While I watched from the back window, a burly black man stormed down the road to Jesus Grove, shouting that he was going to kill Sheela. No one tried to stop him, Su's boys and several Peace Force brothers standing off at a respectful distance. As Sheela emerged from Jesus Grove and confronted the man, he grabbed her around the neck and began choking her, screaming abuses, while Puja approached him from behind and stuck a hypodermic needle in his arm. He collapsed onto the ground in a heap.

I saw what was happening. I made no judgement about it. I didn't know what else could have been done under the circumstances. I had no idea at the time that tranquilizers were being routinely added to the *friends'* nightly beer supply, but I don't know how upset I'd have been if I'd known.

"Why doesn't Sheela just admit she made a mistake and give these guys bus tickets out of here?" I complained morosely to Kirti when we were alone in our room that night. "It feels like an inner city ghetto here for chrissakes!"

"She'll never back down," he whispered furtively; we couldn't afford to let anyone in the house hear us. "She's too fucking tight to buy these poor buggers bus tickets home. Wait'll the election's over. They'll disappear so fast they won't know what hit them!"

"It's like living in a prisoner of war camp!" I grumbled, disillusioned and disgruntled; I didn't know if I was one of the guards or one of the prisoners anymore. I hated the constant anticipation of mayhem, the tension that never abated, the vicious fights I pretended I didn't see.

Over the next couple of weeks, Sheela held endless meetings with the Share-A-Homers and increasingly frequent general meetings with the

whole community where she alternated between assuring the *friends* that she was their Mom—she'd defend them to the death—and lambasting them for their behavior.

"We've offered you everything," she'd say as the newcomers listened sullenly, segregated in small clusters from the sannyasins in the lecture hall by mutual inclination, the atmosphere hostile and tense, "and you can't drop your old habits." Su's boys stood guard conspicuously throughout the auditorium meanwhile, scanning the crowd for potential trouble, while the *friends* watched us and we watched them, two desperate species of people, each suspicious of the other.

"We had to close down the disco," Sheela went on contentiously. "Women were afraid of being mauled or raped. In this community! We never had that kind of vibe here before. Don't make me impose law and order on you guys! I don't want to have to do it!

"I'm ashamed to walk down the street in my own city! I've never been ashamed before. There's litter on the streets. We never had that. Drunkenness and fighting. Loitering and obscene remarks. If you like living in the street, you're welcome to leave, but don't turn my home into a gutter! Take showers. Brush your teeth. Some of you smell disgusting. I don't have to put up with that.

"Stealing. Let's talk about it. I want to know who stole that Walkman in Walt Whitman two days ago. Don't be afraid to tell me. No one's gonna punish you. I want to know *right now* who stole that Walkman or anything else since they've been here."

And like an Alcoholics Anonymous meeting, or an old-fashioned Baptist revival, the mood in the hall changing abruptly, everyone relaxing, people sauntered up to the microphone to confess, touchingly or tediously; the meetings went on for hours. While their homes were surreptitiously searched for contraband again, the *friends* talked on and on about why they stole or didn't steal something ("Even though it was right there, Mom! I could'a took it just like that! You ask me, it's that honkey dude over in D-10 what done it!"), delighted with the captive audience in front of them, defending, accusing, parading, and posturing like it was Ted Mack's Amateur Hour and they were being rated on their sincerity.

The community had changed inalterably and I, for one, didn't like it.

*Y*ou?!" I pointed at Sampurna in surprise. "You, too, Kavi?"

"Join the gang," Sampurna laughed grimly as I glanced around the Jesus Grove waiting room, amazed to see so many old Poona faces there. Sampurna was back driving a forklift these days while I was working in the main accounting office, demoted to mindless peon again. I'd asked too many questions, protected and supported my staff too much; I wasn't good "Mom material" after all. "Don't tell me you're here to see Vidya, too?"

When I nodded, everyone laughed, all of us wondering what we were about to get hit for. What else could being paged by Vidya mean?

Ten minutes later, we were told that we were about to become the new Moms (and Dads) of the Share-A-Home program; the original Moms were burnt out. Our day-and-night life from now on was to be with the *friends* constantly: to eat with them, befriend them, break up their fights, and watch everything they did.

"You have no idea how horrific it's been," the Magpie Queen told us when Vidya failed to show up for our meeting. We all looked at each other warily. The one common crime we'd managed to discern amongst us was that none of us had been very happy about the program.

"Most of the troublemakers have already gone," she went on. "The job'll be a breeze from now on. There are less than 2,000 people left"— the program had been going on for five weeks. "We'll show you the ropes for a couple of days; then you'll be on your own."

It was obvious to us all that Bhagwan had selected us for our new jobs. Sheela and Vidya would have never trusted us, we knew. We were

all ranch renegades in one way or another; some, like me, more subtly than others.

"We're probably the only people here he trusts!" Kavi whispered to Sampurna and me as the three of us trailed behind everyone else walking to the "Mom's trailer," our main base of operation. We were all bubbling with excitement. It was one thing to deplore an unruly subculture and another to try and change things. "God knows what he's heard about the program! After two years of doing shit-work I can't believe I'm a Mom suddenly! Amazing!"

As we reached the Walt Whitman housing site, a scattering of *friends* in somber ranch-issue blues and greens shouted to the Magpie Queen ("I gotta talk to you, Mom!" "Can you see me now, Mom?"), some of them boisterous and lighthearted, others sullen and morose. She ignored them all. Office hours didn't begin for another hour.

"You've got to be straight with these guys," she said as she unlocked the door of the dismal one-room Mom's trailer. The room was lined with desks on one side and straight-backed chairs on the other. The walls and carpet were brown. The only decoration was a poster of Bhagwan. There was a subtle smell of urine in the air.

"Don't play therapist with them," she continued, relocking the door behind her, "and don't believe anything they tell you. They lie through their teeth. Once they see you have a bleeding heart, they'll manipulate you. They're so full of shit you won't believe it. Don't treat them like they're normal people. They're not. They're the lowest of the low. Animals." Sampurna, Kavi, and I were smoldering with rage by this time. So much for "giving people back their dignity" as Sheela called it!

"They'll be honey-sweet to you one minute," the Magpie Queen elaborated; sugar wouldn't have melted in her mouth, "and the second your back is turned they'll be beating someone up. You've got to be tough. It's the only thing they respect. Satya, you take care of clothing requests today. Sampurna, you'll handle...."

That evening, I was sent to Hassid cafeteria (the Share-A-Home dining room) to help Vidya, Su, and her Gestapo crew make one of their periodic purges. The place was a zoo: wild, throbbing with life, intimidating. Hundreds of people were talking and shouting at the same time. Minor skirmishes were happening in a half dozen places at once: ear-piercing arguments, rowdy fights, rambunctious roughhousing. People were throwing food from table to table. The tension was so palatable I could taste it.

While I waited self-consciously for Vidya and Su to show up, wondering what I was doing there, wishing I weren't, my heart pounding with fear, the only people I recognized were Su's boys and some of Kirti's co-

workers who took turns eating in Hassid "to create a moderating pres-
ence" there. The majority of the faces in the cafeteria were black; only a
few were women. A few ranch ma's drifted in with their Share-A-Home
lovers as work hours ended. A few *friends* wore red clothes and malas:
recent sannyasins.

"Good, you're here," Vidya commented dispassionately when she and
Su arrived an hour late, flanked by several of Su's boys. As we stood in
front of the beer line, bundled up in our heavy winter coats, Su's boys
tensely surveying the scene, the two big Moms conferred intently with
one other in hushed tones, ignoring me. Suddenly Vidya tapped me on
the shoulder. "See that kid in the red coveralls?" she said, tilting her
head toward a black youth at a corner table. I nodded. "Tell him it's
time to leave the ranch; this isn't the place for him. There's no need for
him to finish his dinner. A couple of our guys'll drive him back to his
A-frame to get his things."

I was flabbergasted. "I've never laid eyes on him before in my life,
Vidya! How can I...?"

"I don't care how you do it," she snapped tersely, "just do it! I don't
need any of your bullshit sentimentality, Satya. I've had enough of their
crap. They all know why they're being asked to leave. You don't have to
tell them."

"Two of my boys'll be behind you in case there's trouble," Su added,
smiling encouragingly.

Sighing (if I didn't do it, someone else undoubtedly would), I
squeezed my way over to the youth's table, introduced myself, and
started talking, wondering how to bring up the subject of him leaving.
He was a lovely kid. Vidya obviously had him mixed up with someone.
I went back to talk to her.

"I'm sure you made a mistake about him, Vidya. He's...."

"I'm not asking for your opinion, ma! Just drop your bleeding heart
and do what I tell you!"

And sick to my stomach, hating myself, I did what she said, trying to
be as gentle as possible about it: "Maybe you'd be happier somewhere
else. It's freezing here in winter. Were you promised a bus ticket home?"
annoying Vidya to no end by my procrastination.

Some of the men that Vidya pointed out to me that night left quietly.
Others threw their food trays on the floor, screaming that they wouldn't
leave, no fucking bitch could make them, till Su's boys carted them off
bodily, kicking and struggling.

I felt like an executioner. It was brutal, uncaring, and unloving. No
trial, no jury; no explanation even of why they were being asked to

leave. I cried myself to sleep that night in Kirti's arms. It wouldn't be the last time I did. Callous inhumanity was the keynote of the program.

Two days later, Vidya and Su held a meeting in Jesus Grove for the fifty or so Moms, guards, cleaners, taxi drivers, and medical personnel who worked with the Share-A-Home program.

"If you see something that you don't like and you don't speak up," Su said, "you're copping out. You have to take responsibility for what you're doing; we can't do everything. We're bound to make mistakes. We need all the feedback we can get from you. Don't make us your mamas. That's not what we're here for."

"Don't put all that responsibility on me!" Vidya huffed indignantly. "I'm not gonna take it. This ain't my project; it wasn't my bright idea. We're all in this thing together. If something doesn't feel right, open up your mouth and say it!"

Did they really mean it, I wondered, a flicker of hope rising up in me. Something must have gone wrong that they'd been hit for; maybe things would change. By the next day though, it was business as usual. Follow orders. Don't ask questions. Do what I tell you.

Day after day, the new Moms (and Dads) disappeared into other departments till I was one of the few new Moms still left in the program. I have no idea why I stayed as long as I did. They probably couldn't get rid of us all. While I gave out clothing requisitions slips and work assignments to the *friends* who were working, counselled people, and chastised them for minor infractions, the original Moms (who worked directly under Vidya and Su) dealt with anything that wasn't routine. Arguing constantly with what I didn't approve of, getting hit for it constantly, my opinions ridiculed and ignored, I was their reluctant lackey.

ॐ

"Can you talk to me when you finish with him, Mom?" a Puerto Rican man in red clothes and a mala asked one afternoon as a flamboyant 6'5" black transvestite got up from my desk and stormed majestically out of the trailer, and Clarence sat down in front of me. The Moms at the desks on either side of me, meanwhile, were lecturing various Share-A-Homers to start working, stop fighting, start taking showers, stop taking other people's things, start behaving, stop lying. Prabhu stood beside the door, letting people in one at a time. Another one of Su's boys sat guard at the far end of the trailer. Several others milled around outside. There had been threats of a rumble in one of the housing sites last night.

"This be three days I wait for the big-tooth lady Mom what tell me to come," the Puerto Rican complained with a fawning smile. "I gonna be

in big trouble at work. The truck farm Mom, she no gonna believe I been here all this time." Once a *friend* took sannyas, he was expected to work as diligently as anyone else.

"I'm sure she'll be here soon," I muttered apologetically as I turned to the trim, dapper little man in front of me, one of my favorite Share-A-Homers. Clarence looked elegant, as usual, as if he'd just stepped out of an L.A. bistro, a red scarf flung casually around his neck, a rhinestone stud in his ear. "Have you been creating trouble again?" I asked him solemnly, trying not to smile.

"Who me?" he responded innocently as there was a sudden loud commotion outside, people shouting and yelling. No one paid the slightest attention to it. "Who's been telling you those nasty lies?"

I shook my head, sighing. "What am I going to do with you, Clarence?" trying to look stern; I was supposed to be disciplining him.

As I called out to a dishevelled-looking white kid to join us, two men in the trailer suddenly began to fight. Another started screaming abusive expletives as two others rabbit-punched each other ferociously till they burst out laughing.

I was so used to the *friends'* constant fighting by now that it didn't bother me anymore. Scarcely a day went by when I didn't have to insinuate myself into the middle of a raging brawl and pull the combatants apart bodily, risking life and limb to do it. When I wasn't playing therapist or hatchetman, I played scolding mama, babysitter, and referee to the men's endless battles.

"Come here, Mark!" Raising my voice above the din in the trailer, I motioned to him impatiently. "Come and join us!"

Mark finally lumbered over to my desk, scowling and muttering as he sat down beside Clarence, whom he'd accused of making sexual advances to him in the shower trailer.

"Me, proposition *him*?" Clarence protested indignantly when I brought up the subject: a black, balding Sarah Bernhardt. "He's not my type, darling! I like my boys clean!" and a second later, fists flying, the two of them were battling it out, Prabhu dragging them outside to cool off as Joe the Killer, a cantankerous old wino in his seventies, stumbled into the trailer reeking of piss, his clothes caked with mud; he'd been rolling around in the rain again.

"I didn't kill that old woman!" Joe announced in a booming voice as the noise outside grew louder: indistinguishable shouts; cars screeching past the trailer. "I'm a good boy. You can ask anyone in the Bronx; they all know me. Ask 'em if they know Joe. I never killed no old lady. It was a frame-up."

"It's okay, Joe." Walking over to him cautiously, I put my hand ten-

tatively on his arm. I could never be sure how he'd react to my touch; he didn't like women. "I know you'd never do a thing like that. Can you find someone to give Joe a shower?" I asked the guard at the door. "They'll put some nice, dry clothes on you, okay, Joe? You don't want to catch cold, do you?" Half the old-timers defecated in their pants every day. Joe wasn't so bad.

"Now, ma?" the nervous young Puerto Rican asked again. "It's my turn next!" "Me next, Mom!" "I been here before any of them, little Mom!"

One of Su's boys suddenly rushed into the trailer, picked up the phone, and began frantically dialing as Prabhu stuck his head inside the door, ear to his motorola, and motioned to the two Moms beside me. They jumped up from their desks and ran out, hollering to me to go on seeing people; there was nothing wrong.

As the shouting outside grew more impassioned, some of the *friends* got up anxiously to leave, the receptionist blocking their path and sending them back to their seats. The Puerto Rican pushed his way outside, agitated and jittery, everyone else obeying.

Five minutes later, Su charged into the trailer. "Which of you guys is George Washington Jones?" she demanded. "Which one of you's George?" Silence. "Is George Washington Jones here?"

"I don't think...." "No, Mama." "Ain't seen him in days, Mom."

"Satya?"

"He's not here, Su."

Glaring at me like it was my fault—she paraded up and down the room peering into people's faces; she had one of the *friends'* photo-personnel cards in her hand—then stomped out of the trailer, slamming the door behind her. Everything was suddenly ominously quiet outside.

The next day, George Washington Jones' personnel card had a red slash across it: "Left." I never found out what he did. Half of what went on in the program was a mystery to me even though I was supposedly one of the Moms. Midnight roundups happened continually, *friends* escorted off the ranch property by the busload. It was days before I even knew people were gone.

A spy system (that I eventually learned ran through the sannyasin community as well) was as obvious in the Share-A-Home program as it was disturbing and accounted for many of the forced departures. Living quarters were searched regularly. *Friends* were encouraged to report their companions for misconduct and "negativity"; Moms were encouraged to wheedle information at every possible opportunity; rumors and half-truths were accepted as fact. At group therapy sessions that the *friends*

were strongly urged to attend, confessions were prodded out of people and then used against them. People disappeared without warning.

I understood for the first time what the "good people" in Nazi Germany must have felt like. Impotent rage. Silent compliance. When there's nothing you can do about Gestapo tactics, you pretend they're not happening.

ॐ

By the time the Magpie Queen finally showed up later that day, the receptionist and I were the only people left in the trailer.

"Where's Dennis?" she demanded sharply. "The Puerto Rican with the dirty pictures? Why aren't any of my people here?"

"Satya dealt with them," the receptionist murmured apologetically. Sometimes the Magpie Queen didn't show up for days. "Her people" had been getting progressively more volatile. We didn't want any trouble.

She looked at me disgustedly. "Who the hell do you think you are?" she spat out angrily. "You've got some nerve! I asked those men to see *me*, not you. Wait till Vidsie hears about this!" picking up the phone and dialing it.

"I just told them...."

"I don't care what you said! You have no business interfering in something you don't know the first thing about!"

Two days ago, she'd gotten angry at me for asking someone to wait for her. How dare I treat another human being that way! It was demeaning to make people wait for hours. "You can handle things perfectly well on your own, Satya; you're not helpless. Try to be a little more loving, ma," all sweetness and smiles suddenly, her voice oozing with compassion. "Open up your heart, love. There's someone beautiful inside, I know there is." I felt like slugging her sometimes.

ॐ

"I could have been finished two hours ago if it wasn't for that bitch!" I grumbled irritably to Kirti as I crawled into bed beside him seven hours later. Everything I did had to be reported to the Magpie Queen every day; after-dinner conferences with her were normal. She'd recently broken up with her lover. She liked working till all hours of the night.

"What happened?" Kirti muttered sleepily, putting his arms around me.

"She spent the whole night ignoring me!" I sobbed self-pityingly, giv-

ing in to my frustration finally. "Giving me one dumb-ass thing after another to do every time I asked her if we could just get our goddamn work done!"

"Don't cry, baby. It's okay."

"Then when we finally got to work, all she did was bitch about my notes. 'I don't want to see anything crossed out. Have some pride in what you're doing, ma.' They're my fucking notes to myself for chrissakes! I hate her, Kirti," whimpering. "I hate her! Why's a bitch like her a Mom anyway?"

"Talk to Su about it, baby. You don't have to put up with that crap."

"It won't do any good. She's Su's best friend. I'll just end up in the kitchen the way Kavi and Sampurna did."

If I'd ever deluded myself into thinking that we had any recourse from our coordinators' insulting, demeaning behavior, the Share-A-Home program made it clear to me that we didn't. Orders were to be followed without question; democracy was an illusion; there were no courts of last resort. The hierarchy's attitude towards the *friends* was a reflection of their attitude towards everyone else. We were all expendable. Shut up or ship out.

"I can't leave the Share-A-Homers at that bitch's mercy," I sobbed. "You have no idea what she's like. Dangling them on a string like they're puppets. Smiling while she shafts them. The only thing worse than working with her is watching the way she treats the Share-A-Homers. At least if I'm there...."

Dealing with criminals, addicts, the insane, and the senile was the easy part of my job. "Surrendering" to the Magpie Queen and the buttons she pushed in me was the hard part. Humiliated constantly ("I told you...." "How dare you...?" "How could you...?" "I don't care if it takes all night for me to get here, I expect you to wait!"), my only outlet was to complain endlessly to poor Kirti about it. He listened patiently. He had no answers. There was no way to change what was happening.

ﻩ

"Hey, little Mom, what'chu hear 'bout that dude what got killed two nights ago?" Leroy asked one morning, sitting down opposite me at my desk. "Robbo down there, the big boy sittin' in that last chair," pointing to a truly gargantuan black man who was suspected of pimping among the *friends* with the few women still left in the program, "he say the dude was beat up by some ranchers, but I heard you people OD'd him and got rid of him."

Leroy sat in front of me, a big grin on his face, sweating profusely as

if he was afraid he'd said too much. I didn't know what he was talking about.

"Come on, Leroy, that's nonsense. I would have heard about it if anyone died."

"Then what happened to that dude? Where he be? None of us seen him in days."

"People are leaving all the time, you know that. Maybe he just didn't have time to say goodbye. Were you good friends?"

"I didn't even know the dude. I just heard what I heard."

I spent the rest of the day reassuring the *friends* that no one had been killed. We'd never do a thing like that; it was impossible. My belief in what I was saying made me an effective spokesperson. I was the good guy, the innocent; my innocence used to calm people down and to justify what was unjustifiable.

When I heard the next day that a man suspected of having been at the ranch was found dead outside a pub in a neighboring town—the commune was considered responsible for bringing every homeless person in Oregon into the state—I assumed his death was the reason for the rumors that had been going around. He'd presumably left the commune awhile ago, voluntarily or otherwise; he wasn't anyone I knew. I didn't see how we could be held accountable for what happened to someone after they left.

Then I remembered the fight I'd had with the Magpie Queen a week ago when I heard that the *friends'* ranch-issue winter coats were confiscated when they left.

"No one's sent away without a coat," she assured me. "They don't need expensive down jackets; they'd only pawn them. We always give them something else warm to wear. We're not ogres."

Did we send people out into the cold without adequate clothing, I suddenly wondered again. Had the man frozen to death? Was it our fault morally if not in fact?

When Sheela left the ranch ten months later, I finally learned what had actually happened. The dead man had apparently been on a detox program at the medical center, taking maintenance drugs to help him go through drug withdrawals. He OD'ed one night, presumably after taking more than his allotted share of tranquilized beer; the blackmarket sale of beer tickets amongst the friends was rampant. Terrified that his death would give the police an excuse to raid the ranch and arrest someone, "the body" was carted to a nearby town and dumped in the snow outside a pub.

Few of us had any idea of the staggering depths of inhumanity that

we'd sunk to as a community. The evidence was there, but we refused to see it.

ઢ

Ed sat in front of me, toothless and benign, emphysema coughs punctuating his conversation as the Magpie Queen burst into the Mom's trailer, her face flushed with excitement.

"Bhagwan's talking again!" she announced ecstatically. "He's talking everyone! Lectures are starting again!"

Oblivious to the earthshattering impact of the news, Ed continued his ardent plea for a new roommate.

"I walk into my A-frame," cough, cough, "and he's talking to his underpants," cough. "Yesterday," cough, "it was his shoes. 'Shoes,'" cough, "he's saying," cough, cough, "'where you gonna take me today?'" coughing and sputtering while I listened to the Magpie Queen explain that Bhagwan would be speaking to a small group of people in Lao Tzu House every night, she didn't know who, and videos of his talks shown to the rest of us the following evening before dinner.

"Some of you will have to be worshipping at that hour, of course." Ed was still talking, coughing; unstoppable. "But we'll try to arrange for everyone to go to the videos at least every other night. Bhagwan's talking again! I can't believe it!" She looked so radiant suddenly that I almost forgot how much I loathed her.

Bhagwan's lectures were like a shot of adrenaline for everyone at first, a boost of energy. Despite the disharmony at the ranch since the Share-A-Home program started, it was still Bhagwan's community; he was part of everything that happened here. His words would bring us back to our spiritual roots, remind us of what we were here for, make everything all right again.

"I put words into Jesus' mouth because I wanted to appeal to Christians," he said one night. It was my turn to go to the video. On alternate nights I was on guard duty in Hassid Cafeteria or one of the Share-A-Home housing sites. Some of the *friends* went to the videos every night, some didn't. "I put words into Buddha's mouth that he would have been totally against. Now that I have my own people, I don't need to speak on other religious Masters anymore. I'm ready to speak my own truths."

Night after night, Bhagwan derided Buddha, Christ, and all the enlightened Masters he'd honored in the past, offending both sannyasins and *friends* alike; outraging people.

As the weeks went on, I found myself curiously indifferent to his words. I'd heard too many of his lectures over the years and struggled

with too many of his contradictions. On the rare occasions when I didn't fall asleep watching the videos, they bored me.

≥a.

"I got some dude to show you, ma!" a *friend* in red coveralls and a burgundy jacket said one afternoon, pulling me by the arm and pushing his way through the crowd of residents and visitors who were dancing their way down the street behind Bhagwan's car as he drove slowly through the ranch. "No tellin' what that boy gonna do," pointing incriminatingly at Dennis, a blond-haired, shell-shocked Vietnam vet who was one of the most gentle, harmless Share-A-Homers around. Dennis was constantly being pointed out to me at drive-by time as potentially dangerous, an obvious weirdo. "He lookin' mighty strange to me, little Mom."

Paranoia about Bhagwan's safety had intensified considerably since he began speaking again. Every afternoon his Rolls Royce was surrounded by a somber, humorless garrison of armed sannyasins guards. Armed cars proceeded and followed his car. A helicopter circled overhead. Every sannyasin who either was, or ever had been, in the Share-A-Home program or the security temple remained constantly alert to the possibility of danger. It was hard to believe that anyone could harm Bhagwan under the chilling circumstances.

When Dennis was forcibly escorted off the ranch several days later after masturbating in the cafeteria, a beatific expression on his face as ejaculate spurted all over him, it was the beginning of the end of my tolerance of ranch policy. If we couldn't even handle an emotional four-year-old's innocent testing of what he could and couldn't do, the Share-A-Home program wasn't worth much. We could have provided a safe haven for people like Dennis who had no other options, but we kicked them out instead, knowing they'd end up in insane asylums, jail, murdered perhaps.

Every day, more and more of my favorite Share-A-Homers left. When the Oregon Election Board made it clear that none of the newcomers were going to be allowed to vote, Sheela decided not to fight it. If they couldn't vote, no one in the community would. There weren't enough *friends* left at the ranch by this time for it to make an appreciable difference in the election outcome anyway.

Pressure was suddenly stepped up to convince any of the *friends* who weren't working full time that they should leave; the party was over. "Tell them it's time to go," the Magpie Queen instructed me. "They've

had a nice vacation. It's been nice having them. They've worn out their welcome."

When the *friends* were first recruited, they were promised that they wouldn't have to work. Most hadn't had jobs in years; some had never had one. They'd all been urged to work continually ("Try it! You might like it!"), but as long as they'd kept a low profile, they'd managed to escape the periodic purges that went on. It wouldn't be so easy anymore. Non-workers' days were clearly numbered; we didn't need them anymore.

"I ain't got nothin' against helpin' you people out," I'd be told when I suggested work assignments to the non-working *friends*. "You all been good to me. I ain't saying different. Train me on one of them bulldozers you got and I'll do me a day's work. What you got inside for me? It's too cold for a southern boy at the truck farm. I ain't used to it." The tedious, back-breaking work that sannyasins did willingly, the *friends* found demeaning.

Meanwhile, Sheela resumed her public meetings, challenging the Share-A-Homers and pitting them against one another in charges and counter-charges of negativity, theft, and subversive attitudes.

"There was a disturbance in the cafeteria yesterday. Who wants to tell me about it? Don't tell me you're all cowards," she'd sneer when no one came up to the microphone to talk. "We don't need any cowards here. Either open up your mouths or get out!"

Whenever someone finally spoke up, Sheela mocked everything they said, kicking them out if they tried to defend themselves, Su's boys bodily escorting them (and anyone else that Sheela pointed out) on to the buses that were waiting to drive them to a nearby town. A general atmosphere of watch-out-or-you'll-be-next-buddy was created. Things were getting uglier and uglier. I was getting more and more appalled by it.

By the end of November, when there were only a few hundred *friends* left at the ranch, most of them sannyasins or harmless old coots, my "bleeding heart" wasn't needed anymore. And abruptly, without warning, I was transferred out of the program.

I 'll get it!" I shouted, reaching for the telephone and spraying it with alcohol. "Who did you say this is, love? I can't hear you." The medical center trailer was mobbed this morning. There was a flu going around.

While I made an appointment for the ma on the phone and answered three other lines that were ringing simultaneously, a taxi shuttle driver came in carrying two large cardboard boxes. "I want to make sure these get to Satya Bharti," he insisted stubbornly when I motioned to him to put them down; they were the folders I'd ordered for the new filing system I was working thirteen hours a day to set up.

When I finally had time to explain that I was Satya Bharti, the driver burst out laughing. "The writer?" I nodded, answering another call. "You're the receptionist here?" Nodding again, I wondered at his incredulity; he was obviously a newcomer to the ranch. "It's perfect!" he howled with laughter, the attention of everyone in the room focussed on him now. "Where else but in this *mishuggana* place would a successful writer be an office flunky? If this doesn't take the cake!" chuckling and waving enthusiastically as he left. "You're terrific, ma!" blowing kisses at me.

Later that day, a psychiatrist who worked with the Share-A-Home program came into the tea room where I was organizing the next day's work. (The staff doctors and nurses took turns helping me from 6:00 to 7:30 every morning.) The psychiatrist's main job these days was writing grant proposals for medical facilities that he knew would never be built and research projects that he knew would never be undertaken: i.e., one more scam to raise money.

"Can you go over these cards with me?" he asked, holding out a

stack of medical records with photos of the *friends* on them. "I can't get the time of day from the Magpie Queen. I don't even know which of my patients are still here. They're all on heavy medication; they should be seeing me regularly. Any information I can get from you would be great." Harvard psychiatrist or not, he was at the mercy of the Moms like everyone else: a nobody; his expertise not worth as much as a good mechanic's.

Twenty minutes later, the Dutch physician who was my co-reception-ist in the medical trailer peered his head inside the door. "I was wonder-ing where you were, Satya," giving the psychiatrist such a condemnatory look that he hastily turned over the index cards he'd been showing me like they were dirty pictures. "Handle the desk for me, will you? I have to take a leak."

The psychiatrist was paged into the office of the big Mom who ran the medical center under Puja. He shouldn't be talking to me about the *friends*, he was told sternly. I had nothing to do with the program any-more; it was none of my business. She trusted he understood?

I didn't know whether the hit was aimed at him or me; he apparently got hit often. Two days later, fed up with it finally, he and his girlfriend quietly left the ranch.

≥●

At our staff pre-evening-*gacchami* meeting a week later, the medical center Mom warned us that if anyone came to drive-by late from now on they'd run the risk of being shot. We should all be aware of the con-sequences, both professionally and personally.

"The risk of *what?*" people queried after a moment of stunned silence, disbelief, and horror on everyone's faces. "What do you mean 'shot'?" "Bang-bang-you're-dead? *That* kind of 'shot'?"

"Shot," she said flatly. "Threats against Bhagwan's life have increased. The guards will deal with any movement in the vicinity of the drive-by area by shooting on sight and asking questions later. If you can't be at line-up early, don't come; you may get killed. Okay, who's doing *gacchami* reminders tonight?"

I could already see the handwriting on the wall. Someone would be killed. A tragic accident would be claimed. We were being set up for it.

Sheela had done everything she could for years to inflame public sen-timent against us. She'd paint Oregon red with our blood, she'd pro-claimed recently. Sannyasins would defend the community with our lives if we had to, defend to the death any possibility of Bhagwan being de-ported. What I'd dismissed as childish, empty rhetoric, an attempt to

260 • The Promise of Paradise

bully the authorities, suddenly seemed ominous. I wondered if Bhagwan had any idea of what was going on.

Strangest of all, perhaps, is that I never thought about leaving. The sannyasin world was the only reality I knew anymore; my life was what it was. Despite what was going on around me, I was happy. The silent hills filled me with peace. I was more in love with Kirti every day. As long as I didn't dwell on the things that disturbed me, I was content. I'd have been happy in prison if Kirti were there.

ða

When I was transferred to the kitchen a week later, it was clearly a punishment. Over the last two years, the kitchen had metamorphosized into a slave-labor camp for the recalcitrant; it had little of the lightheartedness it once had.

That the medical center Mom had been looking for an excuse to send me there seemed obvious as soon as it happened. She'd announced at an evening staff meeting that we all had to share in the responsibility of running the department. Naively, I'd taken her at her word, making a benign suggestion to her the following morning that she immediately snapped at. Who the hell did I think I was? "You were sent here to do a job, Satya. Do it!"

That night, Puja made a rare appearance at our staff meeting, turning to me abruptly in the middle of a policy discussion, smiling her crocodile smile, and telling me to report to the kitchen the next morning. I was horrified.

Made into a cook and put on long, odd-hour shifts, I had even less time to be with Kirti than when I was with the Share-A-Home program. He was transferred to the airplane mechanic's crew the week I moved to the kitchen, our schedules rarely overlapping. Either I'd crawl into bed at three A.M. and he'd have to leave by 4:30, or I'd start at four A.M. and he'd work till three. He'd come home exhausted. I'd leave exhausted.

We weren't the only couple at the ranch who never saw each other anymore. Sampurna's lover worked in the law office. She was lucky if she saw him before midnight. Blondie's new lover drove a bulldozer all night long, building a new road for Bhagwan. The commune seemed to be operating on imperatives and unreasonable commandments from above more than ever recently, no coordinator ever saying no to Sheela's demands no matter how irrational they were. They'd push their workers into the ground instead. (For fifteen days, Kirti worked a twenty-hour day, taking catnaps on the job whenever he couldn't keep his eyes open.) It was the only way to remain a Mom.

"I can't even remember the last time I shtupped my cookie," Blondie would complained dismally to me on the rare occasions when we ran into each other. "I swear to god, these goddamn Moms do it on purpose. Even the ones who have lovers don't seem to give a damn if they ever see them!"

Work was clearly the beloved for many of the Moms; their relationships seemed far less important to them than their never-ending "worship." The only way lovers had time to be together was if they worked together, but couples rarely did. More and more, casual sex or celibacy was becoming a pattern for people. The severing of deep personal relationships has always been a classic way of fostering dependence on a group and its leaders. In the absence of family and loved ones, the group becomes the only support system a person has.

While some couples left the ranch because they wanted time to be together, Kirti and I had been around for so long that we took our ludicrous work hours for granted, assuming they'd change eventually. After several months, they did. I moved into kitchen office work, went off shifts, and finally had time to be with Kirti again and talk to my kids, whom I'd scarcely spoken to since my stint with the Share-A-Home program.

The only thing I still didn't have time for was sleep. I was perpetually exhausted. Only the intensity of my work and the hyperactive energy in the kitchen kept me awake sometimes. At night I'd fall into a dead sleep, feeling as if I could sleep forever. The pace was gruelling. The pressures on me exorbitant. Morning always came hours before I was ready for it.

ও

"I've gotta see the Dragon Lady," Sampurna stage-whispered to me one afternoon as she hurried past the cafeteria table where I was working. "They must want some more of my money," grimacing. I wished her luck, knowing how much she loathed her monthly visits to the "RHT" office. After two years at the ranch, she was still on the Rajneesh Humanities Trust program, paying for the privilege of working long hours and sleeping three to a room.

Hardly a day went by when someone on the RHT program didn't ask me for money. Despite Sheela's frequent admonishments against it, university participants and visitors were preyed on continually for loans that would never be paid back. Most RHT people eventually ran out of money. If they couldn't beg or borrow it from someone, they were either asked to leave or invited to become commune members. There was no

way of knowing which it would be, no guarantees. If no one's life at the ranch was secure, it was particularly true for the RHT people.

While the cafeteria tables were being washed and the floors mopped, loud rock music playing over the PA system, I sat with my head buried in a recipe book, calculating how much food I needed to order for a hundred trays of lasagne, and wondering if it would be enough to serve 2000-some-odd residents. I wasn't even sure how many people there were at the ranch—it was top secret—but if we ran out of food it would be my head. If we made too much, it was almost as bad.

Mama Fraulein, the kitchen Mom, called to me from where she was sitting with the big Mom she worked under. "We can't have mushroom and barley soup tomorrow," she said. "Mom doesn't want it. Change it to cream of broccoli. You can use the broccoli we ordered for the *au gratin* and change the *gratin* to enchiladas."

I nodded, knowing we wouldn't have half of what we needed, then rushed to the phone to order broccoli from the warehouse so it could be prepped that night in the three cafeterias. After telling the cooks, chopping Moms, and stock people at each location about the change ("Mom's whim" would cause a spiraling of complications all week), I returned to my seat. Convalescing sannyasins and *friends* from every ranch department were sitting at long cafeteria tables now, gossiping as they made cookies. The thirty-person chopping team was merrily chopping away; the cooks were assembling trays of food; humongous bowls of salad and buckets of dressing were being made, bread sliced and twenty-pound pails of tofu cut; while the main cooking went on in the kitchen itself and meals were sent to home care and dozen of temples where people were working through dinner. Meanwhile, Mama Fraulein, two buddies of hers, and the big Mom were whispering and giggling together like conspirators, their raucous outbursts of laughter a startling counterpoint to everything else that was happening.

As one of the dishwashers ran into the cafeteria screaming hysterically, Mama Fraulein jumped up quickly to confront her and calm her down. The kitchen was like a lunatic asylum these days, people crying and catharting constantly. Someone else was freaking out in the far corner of the room. A retarded teenage boy scratched his crotch absentmindedly, staring blankly into space.

By and large the kitchen staff were either *friends*, newcomers to the ranch, or oldtimers like me who'd been sent to be provoked, pushed, and overworked. All us "bad guys" knew who each other were, an underground contingent of the discontent. We were hard nuts to crack, yes-yes-ing everything, catching each others' eyes whenever we were blamed

for something we didn't do, "surrendering" on the surface, rebelling underneath.

"Let's move Bharka here, Suvan there, and send Anando to Hassid," the big Mom was saying as she and her small coterie sat eating pastry samples from the bakery (part of their "worship" presumably!) and I tried to figure out how many corn tortillas we'd need for enchiladas and how fast we could get them from Portland. "If he thinks it's hard here, let's see how he likes it at Hassid!" peals of laughter greeting her words. "Then we can move what's-her-name with the rhinestone glasses here. She's getting awfully chummy with that negro Share-A-Homer who washes pots." Another outburst of laughter.

When Sampurna got back from the RHT office, she collapsed into a chair beside me. "Watching those RHT bitches operate makes me want to puke," she grumbled. "They give me any of their shit and I'll leave. You wouldn't believe how they treat people! Smiling while they wheedle information and money out of them. It's disgusting. I gotta run," getting up again. She went to Bhagwan's lectures in Lao Tzu every evening. "See you in the morning."

The only thing I envied about Sampurna sitting on the floor in a freezing cold room listening to Bhagwan talk was the fact that she got to leave work early. I didn't think I could sit still for two hours anymore. When I was finally invited to attend one of Bhagwan's lectures, I spent the whole evening wishing it were over. The magic was gone, but I didn't blame Bhagwan; I blamed myself. I was unsurrendered, a lousy disciple; not even a disciple anymore.

Even Sam had a fine old time banging on her tambourine at drive-bys. I didn't even bother going to them. My attachment to Bhagwan was gone.

৯

"Reminders" were almost over by the time I finally sat down on the kitchen floor for *gacchamis* that night. "Remember," the bakery Dad was saying, "your work is your connection to Bhagwan. The more energy you put into worshipping, the closer you'll feel to him."

Bullshit, I muttered irritably to myself. As if anyone could tell me what my connection to Bhagwan (or lack of it) was! I'd loved *gacchamis* when we first started doing them—it was the only meditative part of the day—but they'd degenerated into little more than brainwashing sessions by now; I hated them.

As I waited for Kirti to show up for dinner, I read a newspaper article that was posted on the bulletin board. A firearms demonstration had

apparently taken place at the ranch a few days ago in front of police and state officials. I was shocked. I had no idea there was a rifle range at the ranch, or that scores of sannyasins had been trained in the use of fire-arms. A photo of the commune's cache of weapons (thirty rifles, sixteen submachine guns, twenty-four pistols; only a small portion of what was eventually discovered when Sheela left) was published in *The Oregonian.* A second picture showed several ma's and swamis dressed in quasi-mil-itary garb demonstrating their weaponry skills; while a third photo, the most unnerving of all, pictured the group piously doing *gacchamis* on the rifle range as if they were samurai warrior monks: Zen and the art of archery. I had a sudden, chilling vision of a holy war: the Ayatollah's supporters killing and dying for their fanaticism; brutal carnage, insane self-sacrifice.

Outsiders seemed to know more about what was going on at the ranch than we did. Guns had apparently been purchased through the mail and in stores throughout Oregon and California, Sheela's trusted co-horts periodically making off-ranch trips incognito (i.e., not dressed in "the colors") to do it. When gun registration laws made the authorities aware of some of the community's purchase of firearms, they expressed their concern about guns in the hands of untrained people. The demon-stration was presumably an attempt to assure them that sannyasins were well trained in the use of firearms. On another level it seemed to be a warning. We're armed. We know how to use our arms. Beware.

The whole thing terrified me. Oregonians had become increasingly paranoid about the "Rajneesh issue" ever since the Share-A-Home pro-gram began, gun sales in the state increasing by an alarming 90%. Sev-eral public officials claimed that they'd been poisoned when they visited the community; one outlandish accusation after another had been made against us recently. It was as if the battlelines were being drawn. If it came to bloodshed, the ranch was hardly worth it.

It was little wonder to me anymore that most Oregonians were hostile to the community. While a handful of university professors were im-pressed by Bhagwan's words and by the ecological feats we'd accom-plished, we had few other sympathizers in the state. Playing power politics with an erratic mixture of sophistication and stubborn naivete, Sheela tried to manipulate the legislative and judicial systems so she could do whatever she wanted, blaming religious bigotry when the com-mune didn't win every legal battle.

When we were denied a permit for the Fourth Annual World Celebra-tion, sannyasin lawyers took the issue to court. We'd have the festival anyway, permit or not; it was the principle of the thing. Fined over a million dollars for electrical violations in some of the housing units that

were hastily built for the Share-A-Home program, the commune went to court to challenge the unprecedented severity of the penalty. When bills were introduced into the state legislature that were clearly directed against the community, we were harangued over the PA system at every meal to write letters of protest objecting to the "obvious religious discrimination."

The state stopped funding the public schools in Rajneeshpuram and the city of Rajneesh. We went to court. The trucks we depended on for food and fuel were suddenly prohibited "for safety reasons" from using the public access roads into the ranch. We ignored the injunction while we went to court to protest.

"Red phobia" had clearly become epidemic in Oregon. When a fire broke out in the local county planning office, sannyasin involvement was suspected. Unnamed sannyasins were accused of the salmonella poisoning of a salad bar in a nearby town. Sheela had a "bad habit" of poisoning people, she admitted later at her trial.

Despite the callous displays of inhumanity at the ranch, I was sure the accusations of poisoning were unfounded. Sheela was nuts, but she wasn't crazy. Even if I didn't get weak-kneed when I saw Bhagwan anymore, he was still an enlightened Master. He'd never let anything malevolent happen.

&

When Bhagwan's video talk was cancelled one night with the dubious claim that it had been damaged, I was convinced that it had been deliberately destroyed. Sampurna hadn't been at the lecture that evening and those who had been were warned not to talk about it. They didn't want to "misinterpret Bhagwan's words," they all claimed like parrots when asked. Bhagwan had apparently said that night (we learned months later) that, before he died, he'd destroy the concentration camp Sheela had created. It was hardly a promise she could afford to have made public.

A week later, she tried to stop Bhagwan from lecturing altogether. "The work" wasn't getting done, she announced at a general meeting. The ranch couldn't continue to operate that way. Either Bhagwan could go on speaking to a small group every night and we'd see the videos in a few months, or he could stop talking altogether. "It's up to you guys," she said. "We'll vote on it. It's not fair to the kitchen people to have to serve dinner at ten o'clock every night. We have to think of them."

I'd already been told to have dinner ready by seven o'clock the fol-

lowing evening. "Who does Sheela think she's bullshitting?" I grumbled to Kirti. "There's no work backlog anywhere!"

"Why can't we see the videos at lunchtime?" someone shouted. "After dinner." "Take turns going every other night." It was the first time I'd ever heard rumblings of rebellion at the ranch.

Sheela wheedled and cajoled, offering limpid excuses for every suggestion, but it was unthinkable to anyone that Bhagwan should stop talking if he wanted to talk, unthinkable not be allowed to hear him. People were yelling and shouting: outraged.

Maybe this was the way it was supposed to happen, I thought elatedly. People revolting as Sheela tried to stand between them and their Master, sheep becoming lions; her power stripped from her by a sudden mass refusal to surrender.

She threw up her hands finally, laughing. "I give up!" she said. "We'll go on showing the videos!"

"We love you, Sheela!" "Love you, Mom!"

"At ten o'clock every night. Gacchamis everyone!"

"Why so late?" I whispered to Kirti.

"So no one will come. She's counting on it."

He was right, of course. So was she. Every night less people showed up for the videos. Bhagwan went on lecturing, but only a handful of old faithfuls ever heard him.

≈

"Can we go over the...?"

"Not now, Satya!" Mama Fraulein barked irritably. "Can't you see I'm busy?" She was sitting alone at an empty cafeteria table behind me not doing anything.

She walked into the kitchen, came back an hour later, and called to me to join her. We were halfway through making up the first day's menu for the following week when she jumped up again. "Where are we now?" she asked fifteen minutes later, then called to the kitchen-kid's Mom and spent twenty minutes talking to her.

"Okay, so with tomato soup on Monday," she told me finally, "we'll have mock crab salad. And for dinner...."

"We're having mock crab the day before."

"Then make it.... Svarga!" calling out to one of the *friends*.

I sat with her for three hours while she ignored me. Every time I got up to check on what the cooks were doing—if anything went wrong with dinner, I was the one who'd be hit for it—she told me to wait,

she'd be right with me. It would be another endless late night again to-night!

We'd hardly made it through Wednesday's lunch menu when Mama Fraulein disappeared into the kitchen again. "Stop what you're doing, everyone," she announced over the PA system. "We're having a meeting! Hurry up! Kids, too!"

Sighing, I got up and joined Sampurna who was waiting for me. "I don't know how you can put up with the way that woman treats you!" she fumed as I handed her a letter I'd gotten at lunchtime from a friend in the press office. "Doesn't it even piss you off for chrissakes?"

"Read the letter," I murmured noncommittally. I was so battered and bruised by Mama Fraulein all day long that I didn't even notice it any-more. We'd been friends once. I had no idea why we weren't now. Nothing I did seemed to be right as far as she was concerned. It didn't really bother me, though. It was her problem, not mine. No matter how badly people like her and the Magpie Queen treated me, there seemed to be a strong core of self-acceptance inside me that no amount of insults eroded. Mama Fraulein was welcome not to like me if she didn't want to. It had nothing to do with me.

It wasn't until I heard about the "Shit Lists" after Sheela left the ranch that Mama Fraulein's hostility towards me made sense. I wasn't the only person in the kitchen she'd been told to push, provoke, and keep tabs on for the Jesus Grove Moms: a daily record of my conversations and ac-tions.

"What I want to talk to you about," the big Mom of the kitchen was saying now in a rare public appearance as 200 of us sat on the floor be-tween 250-gallon caldrons of steaming sweet-and-sour sauce, 50-gallon pots of rice, and hundreds of pounds of sliced vegetables waiting to be stir-fried in giant woks, "is something Mom spoke to us about in Jesus Grove last night." (*Mom* clearly being Sheela; we were expected to know that.) "I wanted to pass the message on to you directly," she beamed. "Myself.

"It's about hoarding," she went on breathlessly. She looked exactly like a clone of the woman she'd replaced in the kitchen two years ago, I couldn't help thinking. "All of us hoard things," she said. "Even me!"

"Even her!" Sampurna giggled covertly. "Imagine!"

"When I looked inside my closet last night," the big Mom continued earnestly, "I was shocked. I had fifty sweaters and thirty-nine pairs of shoes! Can you believe it?" I couldn't, frankly. I had three hand-me-down sweaters, a secondhand pair of sneakers, and a pair of boots. I considered myself lucky to have them.

"Hoarding's ugly," she went on. "I want you all to go home after din-

ner tonight." There was no pretense anymore that anyone went to the videos. "Go through your closets and get rid of everything you don't absolutely need."

"How many shoes and sweaters do you think she decided she 'absolutely needs'?" Sampurna whispered.

"All any of you need to own is two sets of clothes; anything else is hoarding. Leave your extra things outside your rooms tonight. They'll be picked up in the morning and recycled. That's all I wanted to say except one thing: the food's been great recently! You guys are terrific!"

Everyone applauded. Wasn't she terrific? Sampurna was amused. I was disgusted. The chutzpah of those women to tell us to get rid of our few paltry possessions! A week later, our closets were gone through again by the cleaners and stripped of extra "surplus." By the time we were told we could trade-in three articles of clothing for someone else's discards, I had nothing left to trade.

As Sampurna and I wandered back to our "desks," she asked me if I were going to send Bhagwan the letter I'd just shown her. "The man's right, you know," she said, frowning.

"I know. I never thought about it like that before, though," tucking the letter from a visiting Japanese professor into my back pocket, out of sight. The man had flown halfway around the world to meet me (he used one of my books in his sociology classes) and he hadn't been allowed to. If he hadn't asked an old friend of mine in the press office to hand-deliver his letter to me when he left, I probably wouldn't have gotten it.

"Rajneeshpuram's beautiful," the letter said. "I'm glad I got to see Bhagwan finally. The fact that I couldn't meet you though, even more than the guns and the security people on every street corner, shows me the extreme fascism and totalitarianism of the political regime in the commune. I was saddened to see it."

The envelope of the letter was addressed to me, and the letter itself to both Bhagwan and me. I forwarded it to him, doubting he'd ever see it.

*S*atya-ma-ji? Kirti? You are there? I can come in? Ravjiv here."

It was early evening. Kirti and I were sitting on our futon reading spy thrillers. "How you doing, Ravjiv?" I asked as he opened the door and sat down familiarly on the floor beside us. Our room, I knew, looked exactly like his room and every other room in the house, our only furniture our commune-owned futon. We all spent so little time at home it hardly mattered. It was the third townhouse that Ravjiv and I (and our lovers) had moved to in almost as many months. Having husbands and wives live in the same place made it easy to change rooms quickly if the immigration authorities raided the ranch. I'd asked again if I could divorce Ravjiv—Kirti had been told to marry an American; Ravjiv could marry his American lover—but the answer was still no. Kirti would have to marry someone else, he was told. He refused.

As Ravjiv explained the reason for his uncustomary visit, Kirti and I glanced at each other uneasily. Sheela's "sources" had informed her that Bhagwan was going to be arrested before the next festival and a grand jury investigation begun. She and other community leaders had filed suits against the U.S. Secretary of State, the immigration department, and various state and county officials in response. Ranch paralegals were interviewing everyone who might be called before the grand jury meanwhile, playing devil's advocate: throwing questions at us that we might be asked, showing us how we'd get caught in well-laid traps, perjuring ourselves, if we didn't have our stories straight.

Having lived in Bhagwan's house for many years, openly cohabiting with someone other than my husband, I was apparently one of the people most likely to be called up before the grand jury. One of my books had been used by the authorities in their investigation of Bhagwan's im-

migration case. There was no way I could deny the fact that I'd lived with Chaitanya; I'd written about it. The government would presumably threaten me with imprisonment for my marriage-of-convenience unless I agreed to cooperate with them.

As I loyally tried to protect Bhagwan and Laxmi in the mock cross-examination one of the paralegals put me through, I got myself into deeper and deeper evasions of truth that were easily proven to be lies, "perjuring" myself and becoming progressively more vulnerable to the inevitable we'll-make-a-deal-with-you offers that I gathered would be given in exchange for immunity from prosecution. If my dubious marriage had seemed inconsequential in India, it was the government's pawn ticket on my soul now.

"We have to get to know each other better," Ravjiv was telling me earnestly now; he'd just had his first mock interview. "To prove this is a real marriage, more time will be needed. I'm knowing of course about Nancy, Patti, and Billy." We'd brushed up on our backgrounds when he applied for his green card two years ago. I'd forgotten most of what he'd told me. "And about Danny. Your whole family. And you're knowing about my family, isn't it?" I nodded vaguely as he continued talking. "It's the sex things we don't know," he added lightly. "The intimate details. What the likes are. The grand jury has the right to ask. We need to know."

As Ravjiv got up, presumably to leave, I wondered if he was about to suggest that we have sex together, gallantly asking Kirti's permission. No licentiousness intended; it was strictly business. To my astonishment, he began undressing. Did he propose to do it now, with Kirti watching?!

Stark naked, Ravjiv stood in front of Kirti and me totally unselfconsciously. "This is the body," he began professorially. "Arms," lifting his long, bony arms out to the side. "Torso. Hips," giving us a brief anatomical lesson as if he were a slave and we were potential buyers. It was obvious that he hoped a quick show-and-tell would suffice.

"This is the genitals," he continued matter-of-factly, picking up his flaccid penis and holding it out like an offering. "You will notice how, in repose—" Kirti and I were struggling not to laugh. "—the penis veers slightly to the left. When it's engorged—" Jesus Christ, I thought suddenly, giddy and alarmed at the same time, he's not going to jerk off in front of us, is he?! "—this remains true. You may want to tell them how much you like this if it comes up." Was he joking?!

"There's a small mole on the side of the penis head," Ravjiv went on solemnly, pointing it out, then turned around and bent over like he was about to fart in our faces. My stomach ached from not laughing. "And

another mole is there, you can see it clearly, it's a sizable one, an inch or two from the anus on the right side."

His demonstration finally completed, Ravjiv silently began to dress. I wondered if he was about to ask me to reciprocate, but he didn't. "Some other night we can talk more" was all he said. "It's better to be prepared. I know these government people."

As Ravjiv closed the door quietly behind himself, Kirti and I collapsed on our futon, convulsed with laughter, trying not to let him hear us. "If that wasn't the most bizarre...," picturing similar scenes taking place all over the ranch. Ravjiv was too much. The whole commune was too much. Half the things that happened were absurd, half disturbing; everything high camp: a tragi-comic farce.

ॐ

The next few months flew by in a flash of escalating outrage and discontent. An elderly ex-sannyasin who'd lived at the Poona ashram for several years won a $2.2 million lawsuit against the Rajneesh Foundation for reimbursement of the money she'd "lent" the ashram once, numerous ex-sannyasins testifying against both Bhagwan and the community during the court proceedings.

The city of Rajneeshpuram was declared unconstitutional on grounds of nonseparation between church and state. Our lawyers prepared for a lengthy legal battle. It would be hard to prove the claim wasn't true when Sheela ran everything from the newspaper to the legal and medical corporations even though she ostensibly had nothing to do with them.

An Oregon woman who'd never visited the ranch issued a class action suit against the commune on charges of widespread child abuse. The ranch teenagers went to court to defend us. The community's condoning of mutually-agreed-upon sex between people regardless of age didn't seem to be anyone else's business. Rape was unheard of at the ranch. Violence against women and children nonexistent. The commune may have had it's own evils, but it didn't suffer from the evils of the outside world; it was a benign, safe universe in comparison.

Sheela, meanwhile, was voted one of the ten most influential women in the world in Germany. Traveling extensively, she visited every country where there were Rajneesh centers, outraging the press, public, and many sannyasins by her behavior. Her dictatorial control over the centers—determining from afar who could live where and who did what—was in direct contrast to what had always been Bhagwan's policy of autonomy.

As sannyasins were blithely shifted from center to center and country

to country, scores of ranch residents were sent to centers abroad. Touted as a great honor, to many it felt like a punishment as couples were separated with no regard for personal preferences. While people could ostensibly refuse to go, few did. The consequences of being "unsurrendered" were never pleasant.

As the amalgamation of the centers reached ludicrous extremes, I was asked to send weekly menus and recipes to the centers abroad. If we had chili rellenos on Tuesday at the ranch, they were supposed to serve it that day at the Tokyo center. The attempt at uniformity sickened me. We were turning into a tightly-controlled, mass-market franchise operation, a rinky-dink, multi-national kingdom without boundaries.

Everywhere Sheela went, she created chaos and animosity, leaving in her wake a flurry of charges of illegal financial practices. In Australia (where she made worldwide news with a picture of herself "giving the finger" to a local journalist, a smile on her face and a photo of Bhagwan prominently displayed on the table beside her), she and a cohort were accused of drugging the stockholders of a corporation they were trying to take over "on behalf" of a group of local sannyasins who had a financial interest in the company. When Mom came to town, all hell broke loose.

The more outrageous Sheela's behavior was, the more publicity she received. While Kirti and I grew more disgusted with her every day, many ranch residents (ex-radicals and rebels all) seemed proud of her antics, choosing to see her clumsy defiance of the law as a brave gesture: the third-world yokel making fools of the sophisticated. The Sheela-cult of adoration that had grown to absurd proportions over the years made a mockery of what had once been a Bhagwan-centered infatuation. If the first was as foolhardy as the second, I hadn't noticed. I'd been infatuated, too.

As I made up the food order for the July festival months in advance, not knowing whether to expect 10,000 visitors or 100,000, I had the distinct feeling that it would be our last festival. Few new people were coming to the ranch these days. Sheela was rarely around; no one seemed to be in charge anymore. Many of the Moms and big Moms had been sent abroad. While legal battles overwhelmed the community and threatened to destroy it, we all went on working ungodly hours seven days a week, but nothing substantial was happening. It was clearly time for Bhagwan to do something: change the scenario, reshuffle the deck, let a new game begin.

ह

"The security temple?!" I couldn't believe what the Dragon Lady was telling me. I'd expected to be transferred to the law office as half the people in the commune had been in the last few weeks, not this. I didn't approve of the security system—systems really: four overlapping groups of official and unofficial guardians of the faithful. I didn't see the need for it.

The Dragon Lady's toothy smile denied any possibility of refusal. "We need people we can trust," she said. "Half the security staff has been sent to the legal department. Have your uniform on when you report for worship in the morning," turning resolutely to a teary-eyed Swiss ma who was sitting beside me, deaf to my incoherent sputterings of protest.

After a wearying night of "examining my resistance" (was I being put into the security temple because I disapproved of it so much? was there something it had to teach me?), I dutifully reported to work early the next day in a burgundy/pink quasi-military uniform, my long hair tucked inside one of the burgundy East German officer's hats that Sheela had purchased in bulk on her last trip abroad.

After a torturous morning of tennis-referee-like movements as I tried to read the license plate numbers of the cars that whizzed along the public access road leading to the ranch, reporting the information to the security guards in either direction, my neck was killing me. I went back to see the Dragon Lady.

"I don't think your problem has anything to do with your body," she said. "I understand you don't want to do security."

"I don't." I'd scarcely bothered to disguise the fact from anyone. "But that has nothing to do with why I'm here. My neck hasn't hurt so much since I left India."

"Security needs people like you," she insisted with a determined, unwavering smile, reciting a dozen reasons why I should feel honored. I listened to her stoically, gritting myself against the onslaught of her persuasion. I'd watched her in action while I was waiting: manipulating people, talking them into doing what they didn't want to do, not giving up till she succeeded.

"It's your duty," she told me finally as I sat calmly toying with the locket on my mala. "I'll speak to the doctors and work out how...." I didn't say anything. It was her will against mine. "There are new threats against the community every day," she went on, ever-more impassioned. "People are trying to destroy this place!" Nodding and smiling blandly, my silence was more than she could bear. "Do you want the commune to be destroyed?!" she shouted finally, her face palsied with emotion.

"I don't care, frankly," as calm as she was agitated.

"Don't care?! You mean to tell me...?" her voice screeching.

"And I don't imagine Bhagwan does either," knowing I was right the minute I said it. "If the ranch closes down, the birds will still sing, the flowers will still...."

"Ingrate! Traitor! After everything..."

"It's just a game," calm, cool, collected. Saying no to "the work," I realized for the first time with startling clarity, was saying yes to myself. "Whether the ranch continues or not is irrelevant."

Tremoring with rage, the Dragon Lady ran off to confer with her superior, then, seething, ordered me to return to work.

I knew as I left her office that I was going to be asked to leave the ranch. I didn't care suddenly. I wasn't going to creep and crawl around this place anymore. It wasn't what Bhagwan wanted. If being excommunicated was the price I had to pay to stand up to these bureaucratic bitches, so be it.

ஃ

It wasn't until after Sheela left the ranch that I realized why I wasn't asked to leave. The next day I was transferred back into the kitchen, waiting to be given my walking papers any day, not caring if it happened.

When I was made into the kitchen-kids' Mom, it felt like the punishment I'd been waiting for. Supervising a crew of six- to twelve-year olds who were supposed to work nine hours a day over the summer was the hardest job I ever had. The kids wanted to roughhouse and play. I was supposed to make sure they worked. I spent my days chasing them and breaking up their fights: they were as scheming and cruel with one another as the Moms (and Dads) most of them aspired to be.

The kids in my crew, many of them sannyasins since birth, had been brought up to be outspoken and rebellious. That I was insulted and mocked, yelled at and ignored, kicked, scratched, and lied to continually was less difficult for me to handle than my disillusionment over their upbringing and the kinds of people they were becoming.

While the ranch teenagers I'd worked with over the years (in what was euphemistically called, and often legitimately was, work-study programs) were bright, delightful kids with few adolescent hang-ups, innocent even in their precocity, the kitchen kids seemed like caricatures of what was worst in the community. With Sheela and her cohorts as their primary role models, it wasn't surprising that they relied on power and cunning to get what they wanted. Most of them lived in loosely-supervised kids' housing, not with their parents. They looked to each other for

security, a Mafia-style protection racket of young, red-robed bullies extorting candy and favors regularly from the younger kids.

Every two weeks I asked the ranch personnel department if I could write part-time. My requests were as ignored as if I'd never made them.

ॐ

"Kirti, look! Isn't that Lazie?" Jumping up impulsively from the floor, I ran over to where a group of swamis (and one ma) were sitting, isolated from everyone else, in the middle of the crowded lecture hall. It was the first morning of the Fourth Annual World Celebration, and the first time in four years that Bhagwan was going to be lecturing publicly. 12,000 people had come for the festival; we'd counted on at least twice that number. Festival pre-registration had been scant until it was announced that Bhagwan would be speaking. Last year's lure was the announcement that his death might occur at any moment. We were running out of plausible hype.

As I called to Lazarus from the edge of his isolated group, hesitating to go any closer, hating myself for my hesitation as I threw him a kiss instead of throwing my arms around him, he waved back weakly, his face lighting up with pleasure. "Svadesh! David! I wondered what happened to all you guys! My god, how are you all doing?"

As streams of people filtered into Rajneesh Mandir, music played and festival excitement filled the air, the men muttered gratefully how glad they were to be at the lecture; how good they were all doing. Only Lazarus looked really sick.

I remembered wondering months ago where he'd disappeared to. I couldn't imagine him leaving the ranch; he was one of the most surrendered people I'd ever met. Then we heard rumors of an isolated AIDS colony that had been set up for a handful of gays and bi-sexuals who'd tested H.I.V. positive. When the festival ended, the rest of the community was supposed to be tested for AIDS. Meanwhile, facilities for several thousand AIDS patients were being set up in newly-installed army barracks in the city of Rajneesh (formerly Antelope), something everyone in the community knew about even though it was never openly discussed.

"Lazie looks terrible," I whispered sadly to Kirti as I sat down beside him a few minutes later. The helicopter was hovering outside the hall by now, the music building to a peak. At any moment Bhagwan would arrive. Video lights were glaring as outside press crews, as well as the ranch video department, filmed the lecture and festivities.

As Bhagwan entered, resplendent in a gilded robe and his trademark hat, the audience went wild. He was back with us again: physically pres-

ent, lecturing. If there'd ever been any doubt that this was his commune, he was in charge of everything that happened here, his presence this morning refuted it. Guards with Uzi machine guns stood on either side of the raised dais, a familiar sight around Bhagwan these days. It wasn't my idea of holy.

His lecture that morning was anti-climactic to say the least. He made up for it the next day with a disquietening story about Laxmi's ordeals over the last few years with the American authorities: bribes she'd been offered, promises, threats; beatings she'd had; her continued loyalty to Bhagwan and her refusal to cooperate with the government's determination to slander Sheela.

"Laxmi's back!" he announced happily. "Sitting in the second row!" The audience applauded, an American phenomenon; in India, everyone would have shivered in silent ecstasy. I couldn't help wondering if it was Sheela or Bhagwan who'd been responsible for keeping her away all these years.

"Bhagwan told you to go back to India," I remembered hearing Savita aloofly tell Laxmi over the phone last year. "I told you that before, ma. Nothing's changed. You're welcome to apply for the RHT program like anyone else, but there's no guarantee you'll be accepted."

Appalled by Savita's uncordial tone as much as by her words, I'd convinced myself that she was following Bhagwan's orders; there was no other explanation for it. He wanted Laxmi to drop her attachment to him so enlightenment could "happen." Or was it Sheela's message she was conveying? I had no way of knowing.

"When Sheela leaves the country," Bhagwan was saying now, "when Savita leaves, Vidya, all my people, and they try to come back, this has happened many times, they're taken into a dirty room at customs and made to take their clothes off, fingers forced into their vaginas on the pretext that drugs are being searched for. And you call this country a democracy?"

Filled with fire one day, Bhagwan's lectures were tedious beyond description the next. He spent half his time talking about Indian politics, anticipating perhaps his return to India. Some days he felt like "my" Bhagwan again. Most days, not.

ॐ

Timed to coincide with the festival, *The Oregonian* published a series of in-depth articles on the Rajneesh story, the result of a ten month investigation that we'd been hearing portentous warnings about for months. Reporters had visited the ranch several times, two of them try-

ing to interview me at last year's festival. Savita had instructed me in no uncertain terms not to talk to them; they were cunning, deceitful people. "They'll trick you into saying things you don't mean, love. Don't give them the time of day. Leave it to the Moms who've been trained in these things."

What surprised me the most about the articles was how little any of it was news to me. It read like scandalous, muckraking journalism, yet most of the facts it presented were things I knew without always knowing I knew them. Bhagwan's reputation in India as a sex guru, hypnotist, and charlatan. The "inside story" of Sheela's rise to power and Laxmi's dethronement. Accusations of illegal financial practices stemming back to the early Poona days. Sheela's brother's financial involvement with the movement. Dope dealing allegations, unethical coercion for donations; guns, sex, violence, and political intrigue both within and outside the community. Sheela's control over every aspect of people's lives and her domination of every presumably privately run Rajneesh corporation. The Share-A-Home program's ulterior motives and results. Nothing but the facts, and the story was as sordid as a TV melodrama. It made the Rajneesh movement look as unsavory and disreputable as the public suspected.

When Ravjiv disappeared suddenly, I assumed it was because of *The Oregonian* articles. He and an Indian woman who'd been Sheela's assistant in Poona were wanted by the Indian government on currency smuggling charges. The woman was sent to a Rajneesh center abroad and Ravjiv went into hiding.

ৎ

When Nancy came to visit with a friend several weeks later, Bhagwan was still lecturing daily as he continued to do till the ranch closed. I kept wanting to tell her how much better his lectures had been in India, but she didn't seem particularly judgemental, agreeing with much of what he said even if she didn't find it very stimulating or original. Neither she nor her friend seemed bothered by the security measures during lectures and drive-bys. There were armed guards in mid-Manhattan stores afterall. Guns were a fact of life in America.

Nancy's only overt criticism of the ranch was the way she thought the Share-A-Homers were treated. "No one even talks to them!" she complained testily at lunch one day, going out of her way to sit near a few wizened old men who invariably ate together, rarely interacting with anyone else. "Say hello to them, Mommy!" she hissed. "You invited them here! You can't just ignore them!"

"Hi," I tried gamely, none of the men responding. "How you doing?" lightly touching the sleeve of the *friend* beside me. He gave me a dull-eyed look, grunted, then went back to his meal.

"Say something, Mommy!" but the most I could get from any of the men was a blank stare. While the younger remaining Share-A-Homers had all become an integral part of the community by now, the oldtimers never would be. They worked in the fields and kitchens, they had a roof over their heads and all the food they wanted, their meager needs were taken care of, but they were still a community within a community. Old winos who'd vagabonded it for decades, they stuck out like field slaves in the massa's mansion.

Two days after Nancy left, Bhagwan began a ludicrous pre- and post-lecture routine that I was glad she'd missed. Entering the meditation hall every morning, he danced an awkward, old-man's dance in time to live music; then after the discourse he was joined on stage by Vivek and several other women in a musical Ziegfield Follies extravaganza that had little grace or charm to it, Bhagwan shuffling along clumsily in the center of a chorus line of women who had no idea what they were supposed to do but were clearly delighted at the privilege of having been selected to do it. If Bhagwan's mediums in Poona had looked like temple goddesses as they danced in front of him at darshan in their long, flowing burgundy robes, his *gopis* now looked like fools in their tight jeans and blouses, video lights emphasizing their awkwardness the way flashing strobe lights in a dark auditorium never did.

The whole act embarrassed me: Bhagwan cavorting around on stage like an aging vaudevillian who'd lost his touch, his smile a bit too radiant, his maladroit movements too clumsy for comfort. He was trying too hard. It was pathetic. I felt sorry for him.

❧

Sampurna was sure at the time that we were being drugged during the lectures. "I swear to god, Sats," she said—we were both back in the kitchen again after festival jobs elsewhere—"the closer I sit to Bhagwan, the more zonked out I get. It's as bad as energy darshans used to be. Even Mama Fraulein's as giddy and lightheaded as if she's drunk lately. Something's going on, mark my words."

We were warned that the discourses would have to stop. "The work" wasn't happening; people were all but comatose after the lectures. As a compromise, everyone began attending the discourses on alternate days, and the "stoned feeling" suddenly stopped.

Meanwhile, Bhagwan's lectures became more outrageous every day. If

he was out to provoke people, he succeeded. One morning he suddenly began talking about his sex life: how he'd had more lovers than any man alive. If we loved him, he asked, why wouldn't we want him to enjoy sex as much as we did?

His claim that he'd never been celibate astonished me. As far as I'd known, he'd led the life of an ascetic in Bombay and Poona. I wondered if he was talking about the distant past or the present, if "making love" meant something different to him than it did to the rest of us. Despite Vivek's comment to me years ago that Bhagwan was a virgin, had she been his lover once? Were any of the Lao Tzu ladies? I couldn't help listening to his boasts of sexual prowess with skepticism. He sounded like an old man bragging about his youth, ancient history magnified by time.

It wasn't until Kirti and I became involved in our own tantric experiences with each other that I was able to look at Bhagwan's use of sexual energy in a new way. If Bhagwan was having sex with other women when I was around, why not with me? I was certainly as attractive as the other women he allegedly had sex with (though admittedly, perhaps, not his type: "We Indians like more fat on our women!") and was certainly as sexual a being. I didn't think of him as being sexual himself, though. I could never imagine him having a penis under his robe. Perhaps he didn't respond to me sexually because I didn't respond to him that way. My intense reactions to his energy bypassed my genitals. Not everyone's presumably did. Even Chaitanya, who was totally heterosexual in every other way, told me once that he'd make love to Bhagwan gladly if he could. Yet the explosions of energy that I experienced in Bhagwan's presence and during meditations were clearly orgasms. They may have bypassed my "sex center," but they were powerfully sexual experiences.

Bhagwan's comments about his sexuality seemed like little more than bravada to me at the time, an attempt to shock. He was playing with us, I told myself, and with the worldwide press that was avidly videoing his talks. In a taped interview for "Good Morning, America," he spoke about what he called *orghees*. "There are no *orghees* at the ranch," he said, "but not because I prohibit them. It's up to the people. If they feel like having *orghees*, so far so good. I give my people total freedom."

We could make love to anyone we wanted, but we couldn't live where we wanted, work at the jobs we wanted, eat what we wanted, or even be sick when we were sick. It was a strange freedom.

ॐ

I continued to ask regularly if I could write part-time. My requests

continued to be ignored. Finally one afternoon when I was particularly insistent, the Dragon Lady promised me a definitive answer the next day.

I can only assume that she didn't see me working on a food order in the main office later that evening when she asked her "Mom" what they were going to do with me; she couldn't go on ignoring me forever.

"Satya Bharti!" her supervisor squealed. The two of them were huddled together on a sofa twenty feet away from where I was sitting with my back to them. "My god, what are we going to tell the illustrious Satya Bharti!" giggling and laughing as my name was repeated over and over again in giddy whispers that I could only understand enough of to know the answer to my question.

Bitches! I thought grimly as I got up hastily to leave, the two women glancing up at me guiltily as I walked past them, wondering no doubt how much I'd heard of their conversation.

The next morning, the Dragon Lady told me that it wouldn't be possible for me to do any writing at the moment. I asked her why, playing it as innocently as she was, watching her face twitch and contort as she patiently explained to me that with Bhagwan speaking now there was no need for me to write anything. "You don't want to be in competition with him, Satya, do you?"

"Me, compete with Bhagwan? That's ridic...."

"I mean," she stammered, "he's saying everything so beautifully now, isn't he?" He certainly was, I agreed. What did that have to do with me writing? "As long as he's saying everything there is to say, why would you want to write anything?" laughing nervously. "You do see what I mean, don't you?"

"Is there any objection to me writing in my free time?" I persisted with a calm smile, waiting to hear how she'd get out of it.

She rushed off to consult with her supervisor, then explained to me uneasily that it wouldn't be possible for me to write in my free time either. "You can do what you want obviously," she added quickly. "Who am I to tell anyone what they can or can't do in their free time? But I don't think it's a good idea, ma. I wouldn't advise it."

The next day, a friend of mine who worked as an office cleaner furtively handed me a crumpled note she'd found in the wastepaper basket. "Tell Satya Bharti she can't even write a cookbook!"

*M*eetings in every ranch department the next day confirmed the latest rumor. The commune treasurer and her lover (a psychiatrist and frequent commune spokesperson) had left the ranch unexpectedly in the middle of the night. Official word had it that they'd stolen a car, thousands of dollars, and priceless works of donated art.

"The whole thing makes me sick to my stomach," the big Mom of the kitchen decried sanctimoniously at an impromptu staff meeting. One of Sheela's "Mexican Mafioso" by now, she was apparently spending her days poisoning people in bizarre espionage attempts that none of us knew anything about at the time. "We can't call ourselves a crime-free community anymore," she continued piously. "I feel absolutely sick about it. It's a reflection on us all."

According to the unofficial story, whispered from mouth to mouth for days amongst the renegades, the commune treasurer had objected to some of the ranch's recent financial activities and had been replaced in her job by the Mexican Mafioso. Her lover, meanwhile, was reportedly scheduled to take charge of the new AIDS colony when it opened and would be in virtual quarantine when he did. The only way she'd be able to see him was if she worked with him in the isolated community. They were clearly being pushed into untenable positions.

They left a note in their Jesus Grove room ("Like footsteps disappearing in the sands....") that sounded like a pledge of silence, a promise. The only reason they'd been able to leave was because they had access to a car. They went away often on commune business; the guards hadn't questioned it when they left. Heads would roll no doubt. Ranch security would be tightened even more.

With the exception of Savita, the couple were the only people in the hierarchy I'd trusted. All I could think of now, enviously, was that they were free.

❧

"I'm here for my AIDS test," I told the receptionist at the medical annex where a group of swamis and ma's were nervously telling AIDS jokes to each other. Kirti had been working in the audio department since the festival, sitting at Bhagwan's feet several times a week to tape his by-now nightly press conferences, so the two of us were amongst the first group of people to be tested.

As I waited to be assigned a number to "ensure anonymity," I was suddenly frightened. If Sheela wanted to remove someone from the community and silence them, AIDS was a perfect way to do it. Anyone could be told they had AIDS and put into quarantine. Retesting would be pointless; the ranch medical facilities were the only ones available. The way things had been going at the ranch recently, the scenario seemed plausible.

"If I'm told I have AIDS, will you leave with me?" I asked Kirti anxiously that night. I was being paranoid, he said; I couldn't have AIDS. If they said either of us did, we'd leave.

We'd have no way of knowing if they were lying, though. What if they weren't? Where would we go? How would we live? We'd been told over and over again that AIDS was epidemic out in the world; no place was safe. Only the commune was prepared to take care of people with AIDS lovingly and compassionately. Where better to die than in the community of an enlightened Master?

As soon as we were told our tests were negative, my paranoia abruptly vanished; and when Kirti asked me several weeks later if I ever thought about leaving, I answered, "No," instinctively without even thinking about it. "Do you?"

"Sometimes," he murmured as he massaged my stiff shoulders. I'd been in perpetual pain for days from working long hours on the kitchen dock. It was the closest I'd come to a job change. "I sometimes think I've been here long enough," he said as the sound of a Richard Pryor comedy drifted into our bedroom, hopefully burying our words; someone in our townhouse had just bought a VCR "Maybe it's time to move on."

"I'm ready to go whenever you are, Kirts!" I burst out excitedly, surprised at how happy the idea made me. "Let's leave now! Tomorrow!" my heart dancing with joy. How remarkable it was that I'd never seriously contemplated it before. We could leave!

"Not so fast," Kirti laughed as I threw my arms around him exuberantly. "I just said I'm thinking about it. When the time is right...."

"Oh, Kirts!" I'd never leave without him. I knew that much about myself by now.

"We'll go before it gets cold," he promised. "I don't want to leave them stranded with the new road." He was back doing heavy equipment mechanics again. "They've got no one else. It'll be another month at the most. I'm not spending another winter here."

&

The strains of a Mozart concerto filled the post office. Where else but in Rajneeshpuram, I thought contentedly as I handed out mail to people, would the local version of muzak be Mozart, Rachmaninoff, and Pink Floyd? Where else would bulldozer drivers read Heidigger while they waited on their machines, laundresses discuss Carl Sagan and Monty Python in the same breath, and construction workers with Ph.D.'s debate Buddhist theory? Despite what I didn't like about the ranch, I still found the place fascinating.

"I've been looking for you all afternoon," the press office Mom said exasperatedly when I picked up the phone a moment later. I'd been working in the post office for a few hours a week recently, still asking constantly for a job change out of the kitchen. "Have you been in contact with Frances Fitzgerald?" she asked sharply, the journalist who'd interviewed me two years ago.

"No, I...."

"She's here. She won't leave till she sees you. Are you sure you haven't been writing to her?"

"No, I...."

"Was she a writer friend of yours from before sannyas? Is that it?"

"I just met her when...."

"Never mind," sighing. "Meet her at the hotel in an hour."

&

If my first interview with Frances was an eye-opener, the second one was a shocker.

"I couldn't help noticing how much the ranch has changed," she said as we sat on the terrace of the hotel where I was soon to become a chambermaid, a step up in desirability from my job on the kitchen dock. "There are a lot more security people around. More places I can't visit...."

I'm leaving, I wanted to tell her anxiously. You have no idea how ugly things have gotten here recently. Longer and longer hours of work when there's nothing to do. Incompetents put in charge till everything's in a state of chaos. People living in fear. There was no way I could say anything to her, though. If she innocently repeated what I said to anyone, I'd be in danger.

I thought of it instinctively as danger, not even knowing what I was afraid of. I wasn't the only one who was filled with vague twinges of terror that I couldn't rationalize away these days. The commune was buzzing with furtive whispers of discontent and confusion mingled with fear.

I answered Frances' questions guardedly, not knowing how much I could get away with telling her. Was there any way to warn her of what was happening without risking my own safety? Could I ask for her help (in what? I didn't even know), avoiding any mention of myself except for a veiled allusion about not wanting to spend the rest of my life at the ranch. "I understand why people have left," I admitted cautiously. "It's not everyone's idea of utopia."

It was at the end of our talk that the shocker came.

"I've asked twenty people here the same questions," Frances commented, "and except for you and one of the therapists, every single person has given me the exact same answer to every single question."

"They, what?" I felt as if the wind had suddenly been knocked out of me. What was she implying? Brainwashing? Zombied, programed behavior? Was it possible?

"Eighteen people, from the hierarchy to ordinary commune members like you, and I heard the exact same words as if they were answering by rote. I found it a bit disturbing, I must say."

Help me get out of here! I wanted to scream, panicking, as I suddenly thought about what a friend of mine had told me last week, sneaking out to talk to me from the medical center where she was living while she underwent radiation treatment for breast cancer.

An entire wing of the medical trailer had been emptied out recently except for her, and Vidya put into a room across the hall that only Puja was allowed to enter. While Vidya was ostensibly being treated for anorexia, heaping trays of food were left outside her door three times a day and clearly consumed. It seemed obvious that she was being kept in involuntary isolation the way various people in the hierarchy who'd rebelled over the years had been. They all seemed to come back to the fold as loyal to Sheela and the cause as they'd been before they rebelled.

After Vidya left the ranch with Sheela a month later, we heard rumors that she'd been "uncooperative" for awhile, upset by her (now ex-)

husband Bodhi's exile to one of the centers abroad and by Sheela's comment that he was still being "difficult": something would have to be done with him.

The ominous possibilities of what that "something" might be became apparent after Sheela's departure and we learned about the various poisoning attempts that had been made in recent months. Vials of AIDS-contaminated blood were discovered in Puja's secret laboratory. Long before Vidya developed her dubious anorexia, people in the AIDS colony were allegedly being experimented with, something Vidya might well have been aware of.

Two weeks after Sheela left the ranch, my friend with breast cancer died of the same complications of the liver that Lazarus (who'd presumably had AIDS) had died of a week earlier. It gave one pause to think.

Most of this is hindsight, though. Sitting with Frances that afternoon, I told myself that I was being ridiculous. Vidya's enforced isolation had nothing to do with me. I didn't need anyone's help. Kirti and I could leave any time we wanted.

"Let's go!" I begged him that night. "It's getting too ugly here. Please!" But the road that was being built wasn't finished yet; they still needed him. He didn't share my paranoia. In two more weeks he could leave with a clear conscience.

As things turned out, we were lucky we waited. I'd never have been allowed to leave. I knew too much. I had access to the media and a big mouth. At the New Jersey castle years ago when Bhagwan first arrived in American and Deeksha was still second-in-command, a Mafia-style hit list had been made up of people to be "taken care of" if they ever left the fold. Perhaps, like others, I'd have been invited to Jesus Grove to discuss the matter if I tried to leave, offered a cup of tea, gotten sick, been put into the medical center where Kirti wouldn't be allowed to see me, patients having been forbidden to have visitors for years.

Or maybe I wasn't that important; no one would have cared if I left. It wasn't until a year later that I even knew about the "hit lists" that Deeksha claimed to have witnessed Sheela and Bhagwan drawing up. But I knew I was afraid.

&

When Nancy phoned and told me that she'd decided to go to graduate school in Portland or Seattle ("I'll be right near you, Mom! We can visit each other!"), I panicked. She was moving west because of her boyfriend, not me, but I was sure my being in Oregon was a factor; I had

to tell her I was leaving. I didn't know how to do it, though. The phones were obviously tapped. I was terrified that even my letters to my children might be steamed open.

I talked to Nancy in such cryptic terms that day that she thought I was crazy. I couldn't help it. There were people around who could hear me. If anyone knew Kirti and I were leaving, it could be dangerous. We hadn't even told our closest friends.

"Don't tell anyone," I cautioned Nancy before she hung up, wondering how much, if anything, she'd understood. I didn't want my mother to phone and innocently ask why I was leaving.

While Nancy was convinced that I was totally out of touch with reality, she didn't say anything to my parents, and when I spoke to them a week later from the Rajneesh Hotel in Portland (where I'd suddenly been sent to work), they told me they were on their way to Oregon to see me.

"It might not be a good idea right now," I told them uneasily, wishing I could talk to them from a phone booth somewhere else, but for "safety reasons" no one was allowed to leave the hotel unaccompanied anymore; hostility towards sannyasins in Portland was presumably acute these days. There was no way I could explain to anyone why I wanted to call my parents from a pay phone in town; no one could be trusted.

Every reason I gave my parents about why they shouldn't visit sounded feeble even to my own ears. They'd already booked their flight, they said. I could hear the switchboard operator talking on another line, meanwhile. Anyone could be listening in to our conversation. "Call and tell Nancy you're coming," I said finally. "Maybe she'll join you." It was all I could think of to say.

When I got back to the ranch three days later, Kirti and I decided to leave immediately. I could be sent back to Portland at any moment for two weeks at a stretch; it wasn't worth it. Working in the kitchen was even worse. It was a madhouse with constant panics and capricious last-minute changes that had people running around like chickens with their heads cut off, clucking and bitching. That meals happened at all was a miracle.

The road could be finished without Kirti. Enough was enough.

ॐ

"Sheela asked me again and again during these last four years," Bhagwan said two days later in what was to be my last discourse. Kirti and I were planning on leaving that night in his truck, me hiding on the floor as he nonchalantly pretended to be answering a service call on one of the back roads. "'Bhagwan,' she said, 'help me so I never deceive you,

never betray you.' And finally she did. And the reason she did is worth understanding."

While the audience in Rajneesh Mandir gasped in shocked disbelief, Bhagwan told us that Sheela and "her gang" (Vidya, Su, Puja, Savita, the Moms of several "temples" I'd been in, the mayor of Rajneeshpuram, Sheela's Mexican Mafioso, her houseboy, and hairdresser: i.e., the head of every corporation in the city/ranch/commune) had suddenly left the country: fled. Sheela had ceased to be important once he'd started speaking again, he said. Her ego hadn't been fulfilled anymore. She preferred being at the communes abroad where she could still control things, refusing even to see Bhagwan when she was at the ranch.

As he went on to talk about the crimes Sheela and her gang had allegedly committed—attempted murder, embezzlement, bugging people's living quarters (including Bhagwan's), sabotaging the vehicles of Oregon politicians, attempting to poison the water supply in a nearby town, the salmonella poisoning of a restaurant salad bar in the same town, a fire that had caused $65,000 worth of damage in the local planning board's office—most people found that they weren't really surprised. It was as if they'd known it all along without knowing they knew it.

There was an overwhelming feeling of relief in the community. Dancing in the streets. Ding dong, the witch is dead! Long live Bhagwan! People were ecstatic.

Then hours later they felt ripped off, as if they'd been brutalized for so long that they only realized it after it stopped.

Maybe things would change now, I thought hopefully. Even if Kirti and I were still leaving, there was no reason to rush away. We could stay a few weeks, take our time, check out what was happening.

Two weeks later, it seemed obvious that only the faces had changed. People were still being manipulated and allowing themselves to be. Fear was as rampant as ever. The more I learned, the more confused I was. And the more frightened.

V

Plots and Counterplots

Oregon
(September 1985)

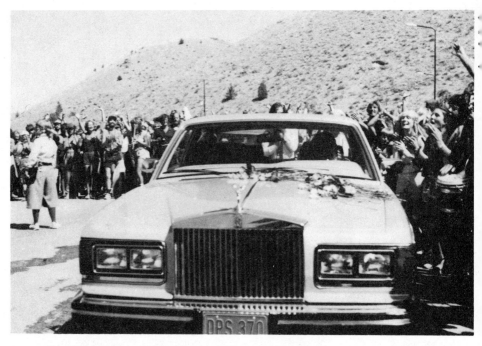

One of Rajneesh's many Rolls Royces during "drive-by" at the Rajneesh ranch (1984).

The Rajneesh ranch in Oregon, circa 1982-1984. Despite numerous stop-work orders by Oregon government officials, the ranch was perpetually in a state of growth. New office buildings, stores, and houses were being erected continually.

*T*rouble in Guru Gulch!" the Oregon newspapers called it. When all was said and done, the wild west was still the wild west. Dirty politics. High falutin' ambitions. Only the tough guys win. For four and a half years, Sheela was the undisputed dowager duchess of a minor duchy in the backwaters of America, an imperial ruler appointed by the god of her choice. It was a perfect set-up for her: the world according to Sheela.

The point was, how much did Bhagwan know about what she was doing and how much didn't he know? How many of her shenanigans had he condoned, and how many had he instigated? While she'd clearly censored all information that reached him, it was a scenario he'd presumably set up himself; he'd obviously wanted it that way.

At first, most sannyasins were inclined to believe that Bhagwan had been duped along with everyone else. Until Sheela left, he had no idea what she was up to. She was the wrong-doer; he an innocent victim. Unlikely or not, it was a comforting version of the past.

Sheela had apparently been talking to her closest colleagues for months about starting a new commune in Europe, warning them to be prepared to leave at any moment.

"Why didn't you go with her?" I asked Kuteer a few days after "the gang" left in what was virtually my first conversation with my ex-lover in the three-and-a-half years that he'd worked closely with Sheela.

We were sitting on the sundeck of Jesus Grove, now called "Sanai Grove." One of the first things Bhagwan did when Sheela left was to rename things. The city of Rajneesh was suddenly "Antelope" again. "Let it be as it was," Bhagwan announced. "We have no quarrel with these poor

people." Like a multitude of other "misunderstandings," both legal and ethical, it was all Sheela's doing.

"When I t'ink Bhagwan is coming to the new commune, I'm ready to go," Kuteer told me as the "Hollywood crowd" (who'd replaced Sheela and her crew) conferred with reporters, sannyasins, and each other on the sundeck. I felt like I was at a garden party in Beverly Hills, the Hollywood crowd as sophisticated and articulate as Sheela's crew of housewives and houseboys had been vulgar and abrasive, soft laughter replacing the hardy guffaws of the past.

"She have a meeting the night before she go," Kuteer went on. "Everyone should come with her: America's finished. Somet'ing feels a little funny, you know, *amoré*? Like's she's escaping. Kuteer wants no part of it."

He'd been with Sheela earlier that night when she eavesdropped (via the bugging equipment in Bhagwan's room) on a conversation he was having with Savita. If Sheela was happier when he wasn't speaking, Savita was to tell her, maybe she'd prefer it if he was dead. It could be arranged. She was less interested in his work than she was in being a celebrity.

"When she hear the message," Kuteer said, "she go crazy, yelling and t'rowing t'ings. I never seen not'ing like it before."

In addition to assisting Su coordinate the activities of a secret paramilitary guerrilla force at the ranch, Kuteer had worked for some time under the tutelage of an English electronics expert, installing bugging equipment in a wide variety of ranch locations. Sheela had apparently justified the bugging of Bhagwan's house and the twenty-four-hour-a-day monitoring of his room by claiming that Vivek was insanely jealous of Bhagwan and was plotting to kill him; he had to be protected. Whether he was being protected or incarcerated depended upon whose script one was reading. Numerous townhouses had also been bugged. I suspected that mine was. It housed a curious assortment of people, most of us old sannyasins.

As Sheela boarded a plane at the Rajneeshpuram airport, Kuteer told me, enroute to Europe where Dipo (her new husband: the gay Swiss businessman who'd worked with me in the currency card office) was waiting for her, she waved gaily to Chaitanya, hollering: "Say good-bye to Satsie for me!" It was her first acknowledgment of me in years.

Several days later, the woman who'd been in charge of the medical center under Puja (one of Sheela's Mexican Mafioso) returned to the ranch, turning state's witness and providing the FBI with much of their information about poisoning attempts. The mayor of Rajneeshpuram left Sheela's group in Germany shortly afterwards and went into hiding,

eventually testifying before the FBI on racketeering charges, allegedly in exchange for immunity and a change of identity, including plastic surgery.

Sheela's second husband, Jay, meanwhile, flew to Nepal on Bhagwan's advice in order to contest the quickie divorce Sheela had gotten from him there, obtained with forged consent forms. He returned to the ranch visibly shaken, convinced that an attempt had been made on his life. He'd caught glimpses of Su (who once owned a hotel in Nepal) lurking in the shadows everywhere he went.

ﾟ•

While Bhagwan continued to talk in morning lectures and evening press conferences about Sheela's psychosexual reasons for leaving him ("I never make love to my secretary," he pronounced somberly, claiming that she'd been upset when he talked about his sexuality. She didn't like men, he said, surrounding herself with gay men, even marrying one. She'd only loved Bhagwan because she'd thought of him as asexual), Sheela made her own counter claims to the German press, accusing Bhagwan of greed and avarice, and of masterminding everything she'd done.

They battled it out in the media like a couple in divorce court, levying bitter charges against each other. ("He used the drug Ecstasy to control people!" "The only ecstasy I give is not a drug!" "She escaped with $43 million, deliberately building up a commune debt of over $55 million!" "He demanded more cars, more jewels, threatening to 'leave his body' if I didn't buy them!") till the whole thing sounded like *I, Claudius* in orange, a story spiced with political intrigue and intricate plots of duplicity and revenge.

As new revelations came to light, it was a chronicle of the impossible that defied credibility. Luxurious underground escape chambers were discovered beneath Jesus Grove; army and CIA handbooks on guerilla tactics, poisoning, and brainwashing; a staggering number of bugging devices; an arsenal of 300 firearms; explosives, books on how to make bombs and the materials to make them; and Puja's secret laboratory with live viruses, white mice, and AIDS-contaminated blood.

The number of people whom Bhagwan announced in his morning discourses had been poisoned was astounding, people both outside the community and within it, including Vivek, Bhagwan's doctor, and his dentist, the only people besides Sheela who saw him regularly. Sheela plotted, poisoned, and schemed to maintain power, he said, calling it an

addiction that was "more uncontrollable than any drug addiction." But, in the end, he forgave her.

"If she comes back," he said, "I'll welcome her with open arms. She can do some therapy, some groups, clean herself out. We can reprogram her. Help her to become a simple human being."

Within Sheela's frame of reference, it was probably the most derogatory thing he could have said.

ಎ

"They were trying to destroy the ranch before they left," Sampurna informed me confidently at lunch several days after the gang's departure. "Ordering us to make revolting food that had nothing to do with what we'd bought or prepped. The kitchen was always chaotic. It was deliberately off-the-wall at the end."

While Sampurna was trying to bring a semblance of order back to the kitchen, I was working as a maid at the hotel, playing hookey more often than I worked. As FBI agents, police officials, and reporters swarmed the ranch, I interviewed everyone who'd talk to me, trying to piece the whole sordid story together; I assumed I'd write about it some day.

When I arrived at the hotel after lunch one afternoon (drive-bys had been cancelled indefinitely), a group of cleaners were sitting on the floor of the laundry room exchanging gossip, information, and insights. More gossiping went on these days than anything else; work happened when it happened. It was as if we'd all been let out of our cages for the first time in years, free to say anything we wanted. Every day people remembered more, heard more; things clicked into place.

"They actually put poison on their hands," the wife of Puja's ex-lover was saying as I walked in, talking about the Mexican Mafioso. Most of the hotel cleaners were on the "Shit Lists" that had just been found: a telephone operator who'd heard things she shouldn't have heard, a doctor who'd inquired too persistently about chemical health hazards, a radical-feminist who was considered "difficult." "...and shook hands with people on the street, hoping to make them sick so they wouldn't be able to vote the next day. Housewives playing war games!"

"Eight salads at the last mini-festival were poisoned. They were supposed to be for some of the Lao Tzu people, but the picnic boxes got mixed up. They went crazy trying to find them. We finally had to open up 2,500 boxes and dump out all the salads!"

Everyone had their own story to tell. One of the security dogs had been killed a few months ago after he'd discovered buried explosives.

Bhagwan's dairy cows had just been tested and found to be poisoned. Over the last year, the gang's bizarre crimes had escalated past the point of absurdity.

Used cars were bought under false names, used for "secret missions" throughout the state, then abandoned. Sannyasins infiltrated Oregon public interest groups, inciting hostility against us in order to justify our virulent counter-attacks against them. A pilot ex-lover of Sheela's was ordered to crash a plane filled with explosives into the county courthouse, then parachute to safety. When he refused, he was sent to a center abroad; it was a favorite way of getting rid of people.

So was AIDS. On retesting, most of the people in the AIDS colony were found not to have AIDS afterall. They'd apparently known things Sheela didn't trust them to know. Once they were in isolation, their health began deteriorating. With hindsight, it seemed obvious that they'd been poisoned or drugged.

"They're dredging Patanjali Lake for explosives and toxins," someone commented. "The fish are suddenly dying. God knows what they dumped down there before they left."

I suddenly remembered the strange behavior of Savita's lover in the last days before the gang left. Security people had seen him driving around at all hours of the night in his pickup truck. Kirti watched him bulldozing, covering, and compacting 300 feet of new road in the middle of nowhere one morning when everyone on the road crew was supposed to be at discourse. He'd obviously been disconcerted to see Kirti. What had seemed merely odd at the time seemed menacing in retrospect.

"Savita's the one who amazes me," I said. I couldn't get over her involvement in the whole fiasco. "I'm sure she had no idea what was going on. She probably thought the money was...."

"You must be kidding!" a Swiss ma snorted derisively. "I was cleaning in Jesus Grove the day they left. Everyone but Savita was in tears. That woman doesn't have an ounce of feelings in her!"

"It's just her cool, English...."

"Bullshit! You should have seen her. She's a cold, hard bitch. She pulled the coup of the decade, embezzling millions of dollars; half the money's in her name, you know—she just wanted to leave. Sheela doesn't have the brains of a flea. Savita was behind everything."

Months later it was rumored over the sannyasin grapevine that Savita had been a Mafia accountant before she took sannyas, that she'd left the gang in Germany after Sheela's arrest and disappeared with all the money. A year later, Vidya and Su were still looking for her.

"You wouldn't believe how ugly it was in Jesus Grove that day," the Swiss ma continued passionately. "While Puja emptied out every medi-

cine cabinet in the place—those women were hooked on drugs, I swear; I've never seen so much pill-popping in my life—the rest of them packed everything that wasn't bolted down. Clothes. Silverwear. Jewelry. Tea bags and cereal for chrissakes! It was disgusting!"

"I heard Puja took suitcases full of drugs."

"And Sheela suitcases of bone china, Baccarat crystal, and gold bricks." Most of the gold jewelry that people had donated over the years had apparently been melted down into bullion. It accounted for the astounding number of sannyasin jewelers at the ranch, something I'd never understood before.

As we all got up reluctantly to begin work, I thought about the strange conversation I'd had with Sheela's brother the day after she left. After being conspicuously absent for years, Bipen had been at the ranch since the last festival, few people realizing who the new Indian bicycle messenger was, making him privy no doubt to things he might not have seen (or heard) otherwise.

Bipen had offered me a lift in his car that day. He was leaving in a few hours, he said; his parents, sister, and brother-in-law (Bhagwan's official biographer) following soon afterwards. His ten-year-old niece meanwhile had left with Sheela, who'd legally adopted her several years earlier, an arrangement her sannyasin parents had begrudgingly accepted. If Bhagwan wanted it, how could they object? While the original intent of the adoption was allegedly to qualify Sheela for a larger claim against Chinmaya's life insurance policy, her niece was soon treated as her heir apparent, Sheela posing publicly over the years as a mother, widow, and housewife: the epitome of the middle-American experience.

"I've been lookin' all over for you, Satya," Bipen remarked grimly as I opened the door of his Mercedes and got in. "I'm gettin' outta here. Bhagwan can go to hell for all I care."

Stopping his car along the side of the road, he insisted on telling me Sheela's side of the story, presumably in case I was going to write about it. "Bhagwan was makin' the ranch bankrupt with his demands," he grumbled. "More cars. More jewels. Sheela split 'cause she couldn't take it anymore."

According to the Hollywood crowd of course, it was Sheela who'd wanted to accumulate Rolls Royces; Bhagwan had over ninety by now. His diamond watches and bracelets, he'd made a point of emphasizing in a lecture, were nothing but paste and glass, custom-made for him by his jewelers. Yet the man protesteth too much for my comfort. I wondered where the diamond originals were, convinced that they existed.

As Bipen brashly tried to justify his sister's actions to me, I thought about Bhagwan as the ascetic he'd once seemed to be and the pampered

leader he'd portrayed himself as in America, a caricature of people's attitudes about cult leaders. I thought about how convenient it was for him that the Hollywood crowd, with their wealth and political connections (peripheral ranch residents up until now who'd paid dearly for the privilege of staying at the ranch and rarely working; a class unto themselves), were suddenly managing his affairs and about Sheela's excessive shopping sprees, her passion for conspicuous consumption. (For months afterwards, secret warehouses of her extravagant purchases were still being discovered.) No matter how one looked at it, money seemed to be at the crux of her departure.

"Sheela didn't get nothin' outta this operation," Bipen complained. "I been tellin' her for years she should take care of herself. I could see the way this thing was going. I had to give her the watch off my wrist—I'm not even wearin' a watch, right?—just so she could get outta here. He'll milk you people for all you got, then get rid of you, mark my words."

He started up the engine of his Mercedes and drove me to the hotel. "I guess I won't be seein' you anymore, Sats," reaching out to shake my hand. "I'd get outta here fast if I were you. The shit's gonna hit the fan. You don't need that."

Vidya commented to a friend of mine before she left that she didn't care enough about Bhagwan anymore to go to jail for him. I had no idea what was coming next, or who'd been in control of whom, but I was determined to find out. Was Bhagwan responsible for what he called "the concentration camp that Sheela and her fascist gang created" or had he merely refused to see it? Was he about to be arrested? Were we all going to be rounded up as witnesses, conspirators, accessories to crimes against ourselves?

When the shit hit the fan, I had a feeling we'd all stink.

≈

"It's not so much that I feel sorry for you, Mom," Billy told me over the phone when I finally reached him at Wesleyan, where he'd just started his freshman year. News of the ranch was a page-one media event; I didn't want my family to worry about me. "I'm more disappointed than anything else. I expected more from Bhagwan. I always figured your leaving us was worthwhile no matter how painful it was; I was proud of what you were doing. Trying to live more humanely than other people. That you'd show the world how...and it was just another con, Mom," his voice quivering with emotion. My kids were the real losers, not me. "A joke."

Nothing Nancy had heard so far surprised her. "I told you Sheela was

an asshole the first time I saw her on TV," she said. While Patti hoped I hated Sheela as much as she did, that I'd stop defending her finally.

No matter what Sheela had done though, I couldn't bring myself to hate her. When she was around, I'd found her obnoxious and impossible. Now that she was gone, all I could remember was the vulnerable child-woman she'd been when I knew her: a bratty, difficult substitute-child I'd once loved. Even after I pieced together the story of my medical misadventures in India (according to Deeksha, who'd been in a position to know at the time, I'd been poisoned and deliberately over-medicated; according to my first doctor, I'd had all the symptoms of toxic poisoning; while the doctor who replaced him was told that I was crazy: he should keep me doped up, quiet; it was the only way to handle me), I still didn't blame Sheela for what happened. Puja, yes. Sheela, no. It was a year before Deeksha told me that even Bhagwan had been involved. "Sheela wanted to get rid of you, *bella*. Rajneesh agreed. He didn't need you anymore. He wanted Norman Mailer to write about him, not you. They only kept you in Oregon to keep you quiet."

When half the sannyasins at the ashram came down with severe dysentery shortly after I left India, Sheela warned the medical staff that if they couldn't keep people healthy, the ashram would have to move to America. My first doctor, again suspecting toxic poisoning, insisted that the ashram water supply be tested for contaminates. He was told to mind his own business—everything that needed to be looked into was being taken care of—and soon became deathly ill himself with what was diagnosed as hepatitis. Laboratory tests that he surreptitiously conducted while he was a patient in the medical ward confirmed his conviction that the water was contaminated and he refused to eat or drink anything that his girlfriend didn't bring him from outside the ashram. Within days he was completely better while all around him people continued to be sick.

The doctor's stubborn persistence didn't earn him any brownie points. When he tried to immigrate to America years later so he could move to the ranch, his mail was allegedly tampered with by CIA agents whom he learned had been "warned about him" by Vidya. On a brief visit to the ranch during one of the festivals, he told someone in the commune hierarchy what Vidya was doing. It was a figment of his imagination, he was assured. If he ever wanted to become a ranch resident, he'd better forget it. The next day, Vidya was made head of the ranch immigration department.

While records obtained under the U.S. Freedom of Information Act indicate that Vidya was, in fact, a government informer (and presumably Sheela's mysterious source of inside information), her ultimate loyalty seemed to have been with the commune. While the majority of ranch

marriages were unquestionably marriages of convenience, the handful of marriages that the I.N.S. chose to investigate for immigration fraud were bonafide relationships, lending plausibility to the commune's contention that the couples were being discriminated against on religious grounds. Some people found it impossible to get green cards, others had no problem. I have no doubt that it was because of Vidya's intervention. Being a double agent had sounded like fun to her once. She'd evidently decided to try it. That Sheela knew what she was doing is obvious. The question is: did Bhagwan? And what does it mean if he did, or didn't?

It was after discourse one morning, while I was talking to the doctor who'd taken over from my first doctor in Poona, that it became patently clear to me how instrumental a role the ashram and ranch medical centers had played in the use of drugs to control and manipulate people. When Puja and Sheela had insisted that my medical problems in India were psychosomatic, the doctor had accepted it without question. "It seemed like as reasonable an explanation as anything else," he said. "You were so much sicker than you should have been. Puja and Sheela ran the medical center, not the doctors."

At the ranch, the two women were sent daily lists of everyone who visited the medical center. They decided who was sick and who wasn't, Puja and her (nonmedical) underlings diagnosing patients without even seeing them and prescribing treatment. I'd heard harrowing stories over the last few days about people who'd been forced to work with dangerously high fevers, their coordinators pushing them harder than ever when they finally crawled back to their jobs half-comatose.

While the doctor and I were talking, people kept approaching us to ask about mysterious illnesses that they'd had a month ago, a year ago, three years ago. They'd invariably gotten sick when they began questioning things at work and, released from home care finally, were invariably given new jobs. They wondered now if they'd been poisoned.

All the doctor could say was that it hadn't occurred to any of the medical staff to look at the possibility of poisoning when they saw patients with unusual symptoms. Overworked and understaffed, they'd treated people symptomatically, accepting their coordinators' assurance that the person was creating his/her own problem. He/she was in a negative space: mind over matter.

The most chilling thing the doctor told me that morning wasn't about the medical center, though; it was about his ex-lover, the big Mom of the kitchen when I worked there and one of the Mexican Mafioso. "We used to laugh about her being a clone of 'P's,'" he sighed mournfully: the first kitchen Mom. "The closer she worked with her, the more she looked, sounded, and acted like her. By the time she took over her job, she was

dressing exactly like her and wearing her hair the same way. She didn't think it was a joke anymore; it was who she was. I always thought it was beautiful that she was so surrendered, a real *bhakti*. And she ended up poisoning people...."

A clone, my god, it was true, I thought with horror, remembering all the ma's in the hierarchy who'd begun to look like clones of Sheela over the last few months: butch haircuts, leather jackets, tough vibes: the new woman. The Australian ma who was later arrested with Sheela was a carbon copy of her in every way. The Magpie Queen was a homely imitation of Su; Vidya's protege a better-looking version of her; Savita's two proteges as genteel and English as she was.

When the doctor's lover became one of Sheela's trusted cohorts, she and the doctor broke up; Sheela didn't trust doctors. She played a pivotal role in both the breaking up and initiating of many of the relationships around her. Vidya's protege was encouraged so persistently to be with the mayor, Chaitanya told me bitterly two-and-a-half years after the fact, that she broke up with Chaitanya. "It was Sheela's idea!" he claimed. "She pushed him on her!"

The big Moms were as apt to interfere in people's love affairs as Sheela was. Prabhu was told over and over again by Vidya and Su that Kavi was crazy; his "negativity" came from her; if he wanted to stay at the ranch he had to prove himself. He broke up with Kavi and became one of Su's boys, incriminating himself day after day by illegal acts that he eventually had to answer to the FBI for.

If someone's lover wasn't trusted, they couldn't be. Guilt by association. You'll be known by the friends you keep. It would have been easier if they'd pinned a scarlet letter to our chests, tattooed stars of David on our arms, or marked our foreheads with the sign of Cain. Lepers, untouchables, the people on the "Shit Lists" contaminated those who befriended us in all innocence, and the number of names on the "Shit Lists" grew.

ह्व

"The Vatican should be taken over as a home for dying AIDS patients!" Bhagwan commented drolly, the small Sanai Grove audience of sannyasins and journalists exploding with laughter as he took on Mother Theresa and the Pope, calling AIDS the most religious disease in the world, brought about by celibate Catholic priests and Christian morality.

Bhagwan seemed more appealing to me tonight than he had in years: playful and outrageous; enjoying being with "his people" again. (Half the audience were old Poona ashramites; the rest journalists and the Hol-

lywood crowd.) I'd been invited to one of his nightly Sanai Grove press conferences for the first time; an effort was being made to make up to all the people on the "Shit Lists" for how we'd been treated.

He hadn't handled himself so well on the subject of AIDS at a public press conference in Rajneesh Mandir a few days after Sheela left. It was the first time I'd ever seen him caught off guard. A San Francisco journalist had asked him about the proposed AIDS colony in Antelope that there had been widespread rumors about for months. Bhagwan denied that he'd ever intended it to happen. He'd told Sheela to drop the idea the minute he heard about it, he said.

"What about the big announcement you've been saying you were going to make?" the journalist persisted doggedly as Bhagwan stammered and lied, sounding ridiculous. I could hardly believe what I was hearing. He was fallible!

His lectures these days were bonafide "lectures" as he castigated us for not working the way we'd done under Sheela ("It means you need her. Freedom doesn't mean license. I can call her back any time. It's your choice.") and scolded us for our behavior towards the bureaucrats in the hierarchy who were still around.

"These people are here because they revolted against Sheela," he said. Bullshit, I thought jaundicely. They were here because she didn't invite them to go with her; they weren't important enough. "You should respect them. They've done more than you have. A community of loving people should know how to forgive."

I had nothing against forgiveness, but I didn't see why the Dragon Lady and the Magpie Queen were still in positions of power. As loyal to the new regime as they'd been to Sheela, smiling now instead of snide, they defended their pasts by quoting Eichmann ("I was only following orders"), all of them justifying what they'd done in the same way, word for word, still automatons.

Not that the rest of us were any better. We'd all been cowards when Sheela was around, compromising ourselves for Bhagwan when he'd never asked us to. Then when the "revolution" was handed over to us on a silver platter, we strutted around as if we'd done something courageous: we (the revolutionaries) who threw them (the tyrants) out when we'd never done anything at all, never put our collective feet down and said, damn it all, this is no way to run a utopia. We'd copped out from the very beginning, refusing to see what we didn't want to see, to take a stand; risk.

By making fall guys of Sheela and her gang, we were abdicating responsibility for our own complicity of silence. Yet to reward the bureaucrats by keeping them in positions of power felt irresponsible to me.

Forgiveness may have been the spiritual thing to do, but it was in applying spiritual principles to a political context that we'd turned our home into a prison. On a societal level, surrender and unquestioning obedience led to fascism, totalitarianism, and a loss of civil liberties. Artists, musicians, writers, doctors, lawyers, and therapists had all plied their trades under Sheela's directives or not at all. We'd taken it for granted—it was just the way it was—rarely questioning it. I was ready to forgive but not forget, no matter what Bhagwan said.

His talk tonight was delightful, though. He was "my" Bhagwan again: naughty and incisive; seducing everyone in the room including the journalists. It wasn't until he stood up to leave, dancing with the woman who'd been interviewing him, ranch musicians playing sentimental Russian melodies in the background, that something soured for me. What had felt light and frivolous before suddenly seemed forced. Or was it only me who felt that way?

As Bhagwan glided out the door *namasté*-ing, Vivek and his new secretary beside him, he turned to a giddy, rotund American heiress and gazed at her intently until she began shrieking and babbling, her body shaking and contorting as everyone in the room except me laughed uproariously; it was apparently a post-press-conference ritual by now. "Every time he stops his car in front of her at drive-by and she starts shaking," Sampurna had commented caustically to me once, "I think: there goes another million dollars!"

Whatever Bhagwan was up to, he'd lost me. I was disgusted.

I appreciate it, Arup, I really do, but I'm leaving," I said as I sat with Sheela's old nemesis in Sanai Grove after the press conference that night. Part of the new ranch administration now after years of being shunted into one lower level management job after another, feeling as if she'd failed Bhagwan somehow, Arup had been eager to compare notes with me. We'd both been pushed out by Sheela, she told me. It was time for us to resume the reins of responsibility again. Any job I wanted in the new regime I could have; it was there for the asking.

"Whatever you feel you have to do, Sats," she said with a smile when I refused her offer, no condemnation in her voice; the days of psychological manipulation were over. "When are you leaving? There's an incredible book to write here. I think you know that."

A few days ago, someone in the Hollywood crowd had tried to lure me into staying as well. If I wanted to write, she told me, I could do it under the auspices of the community. I'd be given a place to work, time to write, all the help I needed. No assurance of artistic freedom would have any value if I wrote on the ranch's time though, I knew; my manuscript would belong to the commune. Once again, in the name of surrender, I'd have to sacrifice my truth for Bhagwan's, molding my reality to fit someone else's dream. Nothing in the world could compel me to do that anymore. I was finished with the whole "Bhagwan scene." Enough.

❧

As I left Sanai Grove a few minutes later, I ran into three of the

women who'd been big Moms under Sheela. Two of them had been banished from the ranch and sent to communes abroad after they'd balked at some of Sheela's commands. The third had left with the gang, then returned. All of them were spending their days with the FBI and their evenings in painful reflection. Everywhere they went they had to confront people they'd hurt and manipulated, demeaned and used. It couldn't have been easy for them. They looked shattered and miserable. My heart aching for them, I stopped to say hello and goodbye, telling them I was leaving.

"Why?" the ex-Mom of the medical center asked me curiously. "Everything's changing now."

When I mentioned that I wanted to write, she nodded, tears in her eyes. "I took sannyas after reading one of your books," she murmured softly, "and I forgot that you were a writer. I forgot you were even human," weeping. "That you had feelings. I'm so sorry, Satya."

As I put my arms around her, hugging her, she apologized to me for the way she'd treated me when I worked under her; she'd been instructed to do it. The other women joined in the apologies. They'd all been told how to deal with me; they'd only done what they'd been told.

As the four of us stood outside Sanai Grove crying, all the pain I'd pushed aside for years suddenly rushed to the surface. I'd been treated like a pariah at the ranch, ignored by all my old friends, hit and humiliated, never allowing myself to realize how much it hurt. "It would have been so nice if one of you had just said hello to me once in awhile," I stammered. They'd all been friends once, Laila a close friend.

"You were lucky you were on the 'Shit Lists'!" she snapped defensively. "You have no idea what it was like for us. We were told who to like and who not to like, who to push around. Brainwashed constantly. Harassed twenty-four hours a day. It was no picnic, believe me!"

The making of a big Mom, as Laila explained it to me the next day, was a sophisticated step-by-step process of brainwashing and co-option. After being intimidated, brow-beaten, denigrated, and mocked over and over again by Sheela and Vidya; told they were unsurrendered, full of ego, they hadn't learned anything from Bhagwan; the future big Moms eventually learned that they could avoid getting hit by saying yes to everything they were told to do. Authority, privilege, power, and respect followed. They were given cars, expensive clothes, and a room of their own in Jesus Grove where they could eat whatever they wanted, whenever they wanted (a unique indulgence when the alternative was an overcrowded cafeteria with 2,000 noisy, rowdy people).

The big Moms formed a clique apart from the rest of the community. Privy to too many things that couldn't be discussed openly, friendship

with anyone other than the other big Moms was impossible. They ate together, spent most of their days and nights together, repeating to Sheela and one another every casual conversation they had and everything they overheard or observed.

They had no private lives. Sheela called them into her room at all hours of the night while she held court in bed, surrounded by a crowd of supplicants and admirers. Half the time she forgot why she paged them, ignoring them; it was enough that they'd come.

On the other hand, being a big Mom meant that you were close to the source of power, an insider, aware of what was going on beneath what appeared to be going on. Most important of all, it meant being close to Bhagwan. The big Moms had a direct connection to him that no one else had, Sheela assured them. Any problems that they had they could bring to her and she'd bring to him.

It wasn't until Laila wrote to Bhagwan about her disaffection with the ranch, telling him she wanted to leave, that she realized her treasured avenue into him was a sham. Sheela refused to bring him her letter ("He doesn't need to hear this crap!"), throwing it in her face. There was nothing she could do about it. Sheela was the supreme authority, the pope; the only one who spoke to God.

That Laila couldn't be allowed to leave was obvious; she knew too much. She was trapped. She didn't trust anyone; there was no one she could talk to. She was finally sent to one of the communes abroad, neutralized the way I'd been in my own way and Arup in hers, made impotent and voiceless.

ॐ

Two days later, when I tried to talk to Laila again, she refused to speak to me. Already facing numerous criminal changes, she didn't want to say anything that could incriminate her legally, she explained lamely.

She wasn't the only person who wouldn't talk to me suddenly. The word had apparently gone out that I was writing an exposé of the community; I wasn't to be trusted.

A final attempt was made to lure me back into the fold and I was invited one morning to open Bhagwan's car door before the lecture, a unique honor. As he emerged from his car, *namasté*-ing the few of us beside him—it was the closest I'd been to him since the castle—he gazed into my eyes and smiled. I smiled back: unmoved, unzapped; indifferent.

"Some mouse has written," he announced that morning, "that he doesn't like guns in the meditation hall. There have been many threats against my life. That's why they're here. If we get rid of them, I'll have

no protection. But if that's what you want...." We could vote on it, he said. Whoever loved him, wanted to protect him, and thought the guns should remain should raise their hand.

I was sure Bhagwan was playing games with us; no one wanted the guns anymore; but to my astonishment every hand in the hall except mine seemed to be raised. I couldn't believe it. He was manipulating us, he wasn't even being very subtle about it. Didn't anyone see what he was doing?

"It looks like everyone," he chuckled finally. "Who's this mouse who's afraid of guns? Raise your hand! Stand up! Let everyone see who this poor mouse is!"

And rationalizing my timidity, justifying myself to myself (I hadn't written the letter afterall. I was making myself conspicuous enough as it was by interviewing people. I didn't need to raise my hand; it would be presumptuous), I copped out for the umpteenth time, letting myself be manipulated as much as everyone else was, not courageous enough to stand up and say, no, I don't like guns; it's bullshit, sacrilege, an invitation to violence; shrouding myself in silence, anonymity, excuses: I was leaving soon anyway. What business was it of mine what happened?

My cowardice made me an accomplice to everything I loathed. I accused myself and found myself guilty.

ও

While I spent my days trying to interview anyone who'd still talk to me ("You're not going to write about this, are you?" everyone asked as if they'd suddenly remembered I was a writer; no one had thought about it for years), meetings took place all over the ranch where people were encouraged to express their anger towards Sheela and her gang. The university therapists meanwhile offered free counselling sessions to anyone who wanted them, the personnel department was disbanded and the role of Moms eliminated, coordinators becoming simple coordinators again.

Despite the proliferation of cathartic talk sessions though, the commune was suddenly filled with paranoia again. Friends warned me that I was making myself too visible, my life was in danger. Illusions were gone, trust gone; it was time to leave.

ও

Sampurna took me out for a farewell lunch at the restaurant where Kavi was now waitressing. Looking elegant in a long burgundy waitress

uniform, Kavi suddenly knelt down beside my chair and began frenetically pouring out her ranch history to me in a nervous rush of words, a familiar story of humiliation and abuse. By the time she'd served our omelettes and Buddha-blend coffee, Sampurna had added her own tales of intrigue: poisoned birthday cakes, drugged beer, Mama Fraulein's daily record of my activities. Everything both of them said sounded plausible. It fit in with everything else I'd heard over the last two weeks.

While Sampurna went to pay the bill, I walked over to Kavi to say goodbye, knowing that I wouldn't be seeing her again. As I leaned over to hug her, she pulled away from me anxiously, glancing nervously over her shoulder.

"I don't think we should be seen together," she muttered under her breath, barely looking at me. "Kuteer saw me talking to you before. I'm scared."

She began walking to the front of the restaurant with me with a deliberate, exaggerated nonchalance, her mala clicking against the buckle on her belt. "He's supposed to be cooking and he's still wearing a motorola!" she whispered feverishly. "He's still at Sanai Grove half the time. He may think Prabhu told *me* something and I told *you*, and.... Will you just *go* for godssakes, Satya! Leave!"

I'd never seen such sheer terror in anyone before in my life. Kavi was panic-stricken, trembling, her face ashen. She scurried away from me and began frantically bussing dishes at a nearby table, her back to me.

≈

"We're leaving tomorrow," I told Kirti when I got him alone at the garage twenty minutes later. Three days from now wasn't soon enough. Tomorrow wasn't soon enough for that matter, but it was the best we could do.

Kavi's paranoia had gotten to me the way a dozen friends' warnings hadn't. "Avoid the restaurant!" I'd been cautioned. "Be careful of what you eat!" I was crazy not to have listened. Scores of people had been poisoned in the restaurant in the past; not even the FBI would eat there these days. I shouldn't have gone out to eat, shouldn't have told anyone I was leaving; I was a fool. If I got sick, I'd end up in the medical center where anything could happen to me. I wasn't so sure all the "bad guys" had left yet.

Kirti didn't ask what was happening; I didn't explain, but he agreed immediately. He'd surreptitiously add our names to the bus list for tomorrow. With any luck, no one would notice. He no longer had nightly

access to a vehicle; sneaking out on our own was impossible. The commune bus was the only way off the ranch property.

"We're leaving in a few days," I lied impassively to an Indian ma in the bustling Zarathustra office a half hour later. While anyone who wanted to leave these days was presumably free to do it, there were certain procedures that had to be followed; we couldn't leave without telling anyone in the administration that we were going. "I'm not sure exactly when, though," I added cautiously. "Kirti's very busy now."

"You'll both have to sign commune resignation forms," the woman responded indifferently, handing me a mimeographed sheet of paper as a hundred separate conversations in the open-plan office all but drowned out her words. "Tell Kirti to come see me."

As I glanced quickly at the form she gave me (a sworn pledge that I'd never reveal anything I'd learned at the ranch), I knew I couldn't sign it. I'd signed dozens of release forms over the years, coerced into doing it whenever I objected; I didn't even know half of what I'd signed away by now. It had never seemed to matter before.

As the Indian ma got up from her desk to talk to someone, I slipped the release form into my pocket and hurried out of the office, hoping she was too busy with other things to be concerned about me. When Kirti and I saw her outside the cafeteria that night after dinner, we panicked, scurrying off quickly in the opposite direction before she saw us, both of us giggling like school kids as we ran down the path to our townhouse, high on cops-and-robbers adrenaline and paranoia.

ઢ

Our paranoia didn't seem so funny later that night when there was a sudden, loud banging on our bedroom door. Startled awake, we popped up in bed like jack-in-the-boxes, clinging to each other, terrified. I half-expected the door to suddenly fling open and some old friend of ours to be standing there with an Uzi machine gun in his hands, ready to fire, firing.

The door opened slowly. Kirti's heart was pounding as loudly as mine; we were both trembling. "Who is it?" he asked, his tone convincingly decisive.

"I just wanted to let you know," a woman's voice answered softly; I couldn't tell who it was, "that your bus is leaving an hour early tomorrow. I didn't want you to miss it."

"Thanks, we know," Kirti said as the door slowly closed.

"My god, Kirti, do you know I thought for a minute?" I whispered, feeling like a fool, only to learn that the same bizarre scenario had been

running through his mind as well. No doubt our paranoia was ludicrous, excessive, we were both out of our minds—we'd heard too many rumors about secret assassination squads that had been in training at the ranch—but if it seemed even remotely plausible that someone could walk into our room and kill us, if we believed that for even one second, thank god we were leaving; the sooner the better.

ዼ

As we drove to the ranch reception area in a borrowed pickup truck at six o'clock the next morning, I was still nervous. I knew I wouldn't feel safe till we were off the ranch property, off the commune bus, out of the country altogether.

There was nothing here I'd miss, I realized sadly as we drove down the sleepy, deserted streets. Not even the silent hills. Not even Bhagwan. I should have left months ago, years ago, I thought wearily. I wondered if I'd have gotten out alive if I'd tried to. After piecing together the mosaics of the past, it didn't seem likely. Out in the world I'd have been a potential threat. At the ranch I wasn't.

Silently blessing my parents for the money they'd sent me a few months ago (without it, Kirti and I wouldn't have been able to leave), I wondered anxiously if it would be safe to cross the Canadian border in red, if government officials would be looking for sannyasins, Rajneeshees, escapees from cult headquarters, if our names were on any kind of list. Would we be stopped, questioned, held, prevented from leaving America, prevented from entering Canada...prevented from leaving the ranch for that matter?

"Did you fill out your commune resignation form?" a security temple ma asked as we went through the final checking out procedures.

"Yes," I lied calmly. "Late yesterday afternoon."

She flipped through the papers on her clipboard, looking at me questioningly as I smiled back at her with breezy bravada, shaking inside, then ticked off my name on her list. "Okay," giving me a quick, officious smile as if we were strangers. I'd known her for eight years. We both knew we'd never see each other again. "Next?"

Within minutes, Kirti and I were on the bus, on our way. In a few months, everyone would be gone from Rajneeshpuram, even Bhagwan, but we didn't know that then. So far, only the disenchanted were leaving, the no-longer starry-eyed, and the frightened.

After thirteen years with Bhagwan, I was leaving Shangri-la. Escaping from utopia.

VI

Coming Home

Vancouver / New York
(1985 - 1987)

The author and Kirti at their wedding in Vancouver, B.C. (1986).

The author with her son Billy and her daughter Nancy in New York (1986).

The author with her daughter Patti and her husband Kirti in New York (1986).

30

*I*t may have been the Third Reich all over again," Kirti commented lightly, "but we didn't lose a single Jew."

Everyone in the room burst out laughing, the tension suddenly dissipating. I smiled at Kirti gratefully; he was wonderful. I'd been doing all the talking at the meeting some Vancouver sannyasins had asked us to hold, it was presumably my forte not his, and in a single sentence he managed to put everything in perspective. Things had been bad at the ranch, but not that bad. Neither of us were sorry we'd been there.

"Bhagwan said he put Sheela in the job she was in," he went on, rationalizing and defensive the way I'd been when I was talking. After three days in Vancouver, the reality of the ranch was already fading, dreams clouding our vision again, "because she was tough enough to stand up to outside hostility. Oregonians wouldn't have liked us no matter what we did. Sheela didn't invent religious bigotry. Her behavior drew people's hostility out; it didn't create it."

I watched people's faces as Kirti talked, glad to let him take over for awhile. I didn't know most of the sannyasins in the room. Few had spent much time at the ranch; even fewer in Poona. How could we have been so blind, many of them had asked us angrily at the beginning of the meeting. Any fool could have seen that there was something ugly going on at the ranch. Why hadn't ranch residents seen it? Meanwhile, they all had their own stories to tell: what they knew or suspected; why they hadn't been allowed to stay at the ranch; whose toes they'd stepped on.

"Nineteenth-century communes in America," I interjected when Kirti ran out of steam, "Oneida, Aurora, Brook Farm, were no different from the ranch. Free love, free sex, transcendental religion, a strong authoritar-

ian leadership. The more hostile outsiders are to a group, the stronger the group identity gets and the more individual freedoms people are willing to give up. War requires sacrifice. The government creating trouble for us fed right into Sheela's hands."

"Sheela's or Bhagwan's?" "Did he know?" "How could he not know?" "Was it an object lesson?" "Bhagwan trying to trick us into enlightenment?" "Wean us from him?" "Make the nightmare so horrific that we'd 'wake up' finally?" People were upset, confused. Looking for reasons to absolve Bhagwan. How could he have let the dream become so distorted? How could any of us?

"Everything that happens around an enlightened Master when he dies, Bhagwan always said he wanted to have happen while he was alive," I continued amiably, trying to justify Bhagwan the only way I knew how, trying to convince myself. I'd left my children because of him for godsakes!

Kirti winked at me, straight-faced. As far as he was concerned, Bhagwan *wasn't* enlightened. He was just a rascal who was playing games to amuse himself; the brains behind everything.

"Before things got too bad," I added, forgetting three-quarters of what I'd learned in the last few weeks, "he stepped in. And as Kirti said...." Everyone laughed. "The hotel's lowered its rates, the university's reduced its prices; Bhagwan's talking every morning; the doors are open to everyone. Check it out for yourselves."

A week later, someone from the ranch phoned the communal house where Kirti and I were staying to tell me that he had no hard feelings against me for conducting the meeting. I wondered why he would. I hardly even knew him. "No one at the ranch holds it against you, Satya," he assured me. "You can do anything you want. No one's dictating to anyone anymore."

No? I thought bitterly as I hung up the phone. Why did he call then? Was every word I said being repeated to some amorphous "they"? Was this a goddamn cult afterall?!

Maybe we shouldn't have moved into a sannyasin house, I brooded uneasily as I sat down at the kitchen table with three other recently arrived ranch residents. Kirti and I had come to Vancouver because his family was here; we knew we'd have a place to stay. He couldn't work in America, I could write anywhere; it seemed like a viable option. Moving into a communal house had turned out to be more practical than staying with Kirti's family, but I wasn't so sure it was a good idea anymore.

"I'd have left the ranch months ago if I'd had anywhere to go," a swami who'd worked in the heavy equipment department was saying as

he leafed idly through the help-wanted ads in the paper. Kirti was the only ex-ranch-resident who'd found work so far: fixing cars with a local sannyasin. I'd sold some stock my parents had bought me and hoped to sign a book contract soon. With what Kirti was earning we'd get by if we continued to live communally.

"Have you seen the new *Rajneesh Times* yet?" someone asked as they handed me a copy of the paper. In a discourse that was quoted in last week's issue, Bhagwan had declared the end of the religion of Rajneeshism. He wasn't our guru anymore, he'd said; he wanted to be thought of as a friend, a companion along the way. People didn't have to wear red-hued clothes or malas anymore; sannyas was finished. In a typical grandiose display, Sheela's red "pope's outfit" and thousands of copies of *The Rajneesh Bible* were burnt to ashes, sannyasins singing and dancing around the funeral pyre. Now, I read, Bhagwan was "profoundly saddened" by people's reaction to the death of Rajneeshism. They'd stopped wearing malas and red clothes, buying everything the boutique had in blue and green as if they'd been waiting for an opportunity to reject him, he remarked petulantly. People put on their malas and red clothes again: docile sheep following their capricious shepherd's games and manipulations; it never stopped. I hadn't bothered to change my clothes in the first place; they were all I owned. I was still wearing my mala. After thirteen years, I couldn't imagine being without it.

As I got up to make dinner for everyone, I listened to the endless gossip that went on day and night as new sannyasins arrived in Vancouver from the ranch. "She was so doped out at the end," someone was saying about one of the Mexican Mafioso, "that she could hardly hold her head up. I saw her at the restaurant the day before they left. She was bombed out of her mind. It makes you wonder who was controlling whom."

One of the swamis in the room had done a dope run once in India. He knew Bhagwan knew about it, he swore. Another talked about a mutual friend of ours who'd been at the dock in New York when a large shipment of what were allegedly drugs arrived: bribes paid off, back-alley intrigue; it coincided with the time I'd arranged for Sheela's brother to meet Swami Dope Dealer. Another piece of the puzzle slid into place.

As other people drifted in and out of the kitchen, the talk moved on to Bhagwan's "presumed illness" in Poona, the ostensible reason for why he'd come to the States. Had he been poisoned? drugged? In retrospect it looked like he might have been. Then on to theories about the tapes which Sheela claimed in interviews to have, proof that Bhagwan was behind everything she did. As many of us knew, she'd had a wide variety of Bhagwan's discourse tapes edited over the years till they only said what she wanted them to say, while ashram/ranch videos and films had

been judiciously spliced and edited, rewriting history. It was a process many of us, including me, had been involved with in one way or another. Whatever tapes she had in her possession proved nothing.

A woman who'd lived in Bhagwan's house in Poona and had been one of his mediums talked about a private conference she'd had with him and Sheela during the first year of the ranch. Bhagwan had apparently told Sheela to make the ex-medium one of the commune's principle spokespeople. The next day she was transferred out of the press office and into the construction department.

"That woman!" the ma laughed indulgently, shaking her head, but I knew perfectly well that Bhagwan could have set up the whole scenario himself, remembering how he'd tell people one thing in darshan in Poona, then instruct Laxmi privately to arrange the opposite; she'd amused us for years with stories about his games. Pressing people's buttons, she called it: a spiritual exercise. I still wasn't ready to see it as manipulation.

Like successful rulers throughout history, Bhagwan set himself up as the good-guy and Laxmi/Sheela as the heavy. He could afford to be all-loving, all-giving, earning people's adoration and devotion—they'd die for him if necessary—as long as he had other people "to do the needful." Any atrocities that were committed were the fault of his subordinates, not him. He was blameless.

Until the Share-A-Home program slowly opened up people's eyes to what was happening, the bottom line for most ranch residents was that, despite Sheela and her gang, we were all enjoying ourselves, buoyed up by the magnitude of what we were doing: building an ecological Shangri-la in the middle of nowhere, a religious utopia. Army life may be fascistic, but people love it. One doesn't negate the other.

Sheela's passion for the impossible created a continual adrenaline high. Frustration was as short-lived as it was intense while unfair treatment became an excuse to "point the finger" at ourselves as we'd been taught to do for years: to see things we wouldn't have seen otherwise, grow, change, learn. Religions have always been good at rationalizing their abuses. Rajneeshism was no exception.

੩ਝ

As I worked diligently for weeks on a proposal for the book I planned to write, it became progressively more clear to me how estranged I was from the "real" world. It was as if I'd been living on another planet for thirteen years, or on some remote South Seas island amongst an alien race of people who had their own unique culture, vo-

cabulary, and vision of life. Sannyasins spoke a foreign language that sounded like English but wasn't: Bhagwan-ese.

I felt like a displaced refuge sometimes, as vulnerable as a snail without its shell. Everyone out in the world didn't have a Ph.D. in psychology or a five-year (minimum) involvement in the human potential movement. They didn't laugh all the time, joke, improvise comedy routines at the slightest provocation; it was a different universe. Everything was a culture shock in one way or another: going to the supermarket, the movies; walking down the street. A hundred times a day I blessed Kirti for his presence in my life, his unfailing love and belief in me.

ॐ

"Bhagwan's on TV! Hurry everyone! Quick!" The impossible had happened. Bhagwan had been arrested in North Carolina when the plane he was said to be fleeing to Bermuda on stopped there to refuel.

"I can't believe the way they're treating him!" I huffed indignantly as I watched him being led from the plane at gunpoint, handcuffs on his wrists, his legs chained together. Dozens of FBI agents surrounded the plane, guns drawn, as Bhagwan, Vivek, and another Lao Tzu ma were escorted into police cars. "You'd think he was a dangerous criminal! He's being charged with immigration fraud for godssakes! The man's never harmed a soul in his life!"

Televised interviews with Bhagwan in jail over the next few days showed a sick old man, weak and disillusioned. The sedentary life he'd led for fifteen years hadn't prepared him for the rigors of jail. He hadn't been escaping to avoid arrest, his secretary insisted; he hadn't even known where he was going. They were forced to get him out of Oregon. There was too much prejudice against him in the state. He'd never receive a fair trial there.

It wasn't long before Bhagwan was purportedly sent back to Oregon, his whereabouts remaining unknown for ten days as government officials secretly (and, apparently, illegally) shunted him from jail to jail all over America until an inmate in one of the prisons he'd been in was released and told reporters where he was.

While commune spokespeople issued press statements accusing the authorities of cruel and inhuman treatment (at one point Bhagwan was allegedly put into a jail cell with an inmate who was in isolation with a contagious disease, a blatantly illegal situation according to both American and international law), the police assured the press and public that he was being given every amenity he needed for his well-being, includ-

ing private nursing care. Pale and drawn, a gentle luminosity shone from his face during TV interviews.

Outraged at the government's underhanded treatment of Bhagwan, I felt a sudden connection to him again that surprised me. It felt as if he were being tried for his success more than for the immigration violations that he'd been formally charged with. He'd attracted wealthy, well-educated people to his movement over the years, turning them into rebels who questioned the status quo, troublemakers; he was a dangerous man. In a country where the average length of imprisonment for murder is eight years, where sex offenders serve token terms and drunk drivers who kill people get off in thirty days, Bhagwan faced a possible prison sentence of 165 years. The punishment hardly seemed to fit the crime.

On the advice of his attorneys (including several prominent non-sannyasin civil liberties lawyers), Bhagwan pleaded guilty to two felony charges: having made false statements to the authorities when he entered the country and concealing his intent to remain in the States. Upon payment of a $400,000 fine, he was deported to India where Laxmi and hundreds of sannyasins awaited him.

ॐ

While an initial attempt was made to keep the ranch going as a growth center and experiment-in-communal-living, it wasn't long before people were told they had to leave. The few remaining Share-A-Homers were given bus tickets to wherever they wanted to go while all others, penniless or not, were forced to fend for themselves as best they could. Paradise was closed for the season, the commune was hopelessly in debt, and voluminous amounts of every conceivable item under the sun from mobile homes, heavy equipment, and Rolls Royces to kitchen supplies and condoms were sold to the highest bidder. While the money left in people's currency card accounts was honored up to a point, the demand for cars in which to leave the ranch was so great that most people weren't even able to buy back the vehicles they'd donated to the commune.

Meanwhile, in Vancouver, scores of ex-ranch sannyasins got on with their day-to-day lives: doing temporary jobs to earn money; waiting for the next phase of Bhagwan's work to begin. Suddenly disinclined to talk about "all that" anymore, it was as if the abuses at the ranch had never happened. When all was said and done, Bhagwan was still their Master.

ॐ

Two months after we left Oregon, Kirti and I finally had enough money saved to visit my kids in New York. Nancy was living in Manhattan after deciding not to move out west, Patti had transferred to Barnard, and Billy was only two hours away at Wesleyan.

Before curtain call at a school play Patti was co-starring in, Kirti finally got to meet the rest of my family. When Danny and his brother refused to sit near us during the play, Nancy, Billy and their cousins were faced with the usual children-of-divorced-parents conflict of whom to be with. I couldn't help thinking how much more convenient it had been for everyone when I wasn't around. My parents had maintained a close relationship with Danny over the years because of the children. My sister's relationship with his brother (her ex-husband) was relatively amicable. I was the sore spot. Danny had never forgiven me for leaving him; his hostility had existed long before I moved to India and "abandoned" my kids. I'd given him a justifiable excuse to loathe me. He'd loathed me for years without it.

If I'd expected my family to welcome me back with open arms now that I'd left Bhagwan, I was naive. Danny could hardly disguise his contempt, my sister and her kids were distant and aloof; only my own kids seemed to grant me amnesty.

Kirti and I visited Billy at Wesleyan, where he was active in every civil libertarian cause on campus, putting himself on the line continually for what he believed; then we traipsed around New York, meeting literary agents and publishers. While everyone was interested in "the Rajneesh story," few wanted anything but an exposé: nail the bastard to the wall; pin every crime on him; he had no redeeming value. Scandal meant money; I could write my own ticket. It was more than I was ready for.

I promised Grove Press, my old publishers, a book in exchange for full artistic freedom (I should have known better!) and returned to Vancouver feeling as if I were back in business finally. Kirti and I left the communal house we'd been living in, telling few sannyasins where we were going, and moved into a basement suite in his brother's house, rejoining the straight world again. Kirti cut off his pony tail, trimmed his beard, and started working as an engineer: another game to play; while I packed away my *mala*, bought myself some non-red clothes, and filed for a divorce from Ravjiv so Kirti and I could get married. Normalcy seemed like a beautiful thing suddenly; a relief.

ဆ

As each day passed, the sannyasin world seemed more and more dis-

tant from me. The Bhagwan/Sheela gossip that I heard from time to time felt like idle chatter about childhood acquaintances whom I hadn't seen in years and had never been particularly close to.

While Bhagwan travelled all over the world trying to rebuild his floundering movement, Sheela, Puja, and an Australian accomplice were extradited to the States where they were convicted of attempted murder and various other poisonings and Sheela was accused and convicted of masterminding the largest non-governmental wiretapping operation in America's history. The women would all be eligible for parole in three years.

When no country in the world seemed to want Bhagwan—he was refused entry or deported from twenty counties—he returned to the ashram in Poona and set up shop again, lecturing for an astounding four hours a day. Meditations and therapy groups resumed, and soon there were thousands of sannyasins from all over the world in Poona again. The drama continued.

<div style="text-align:center">ʃ❦</div>

"Telephone, Satya!" Kirti's sister-in-law called downstairs one evening as I sat pounding away at my typewriter, rushing to meet the three-month deadline Grove had given me; I was working long ranch hours to do it.

"Billy!" I squealed delightedly when I heard his voice. "How are you, sweetie? I tried calling you last night. Your line was busy for hours."

"I was having one of my marathon conversations with Dad," he laughed good-naturedly. "How's the manuscript going? Anything new happening with Bhagsie? What's the old rascal up to now?"

"What are *you* up to?" I asked, but my conversations with Billy these days were more intellectual than they were personal. While Nancy and Patti gratefully shared their problems and private lives with me, Billy invariably talked about politics and how *I* was doing. By the time I'd felt capable of dealing with the issues he'd wanted to deal with at the ranch, he didn't need it anymore: "I'm finished with all that stuff, Mom." It was my loss, I knew.

"I'm reading some fantastic stuff in my poly sci class," he was telling me enthusiastically now. "It's absolutely crucial for your book. According to Weber, power always corrupts spiritual vision. The greatest visions lead to the greatest corruption because people mobilize behind them. I'll xerox some pages and send them to you."

In long sprawling letters that I barely understood—he was so much

smarter than I was—Billy tried to justify the years I'd spent with Bhagwan.

"The particulars of religion are arbitrary, Mom," he wrote. "What's important, Durkheim says, is that people are sharing the same beliefs and feelings. It's the sentiment of togetherness and oneness that brings joy. Don't you see? It wasn't Bhagwan. It was all of you together that made it special."

Signing off: "I love you," his only personal message.

Politics and social issues were Billy's passion. Whenever he was home from school, he and Danny had long, heated political discussions; he was too much like me for them to see eye-to-eye on many things. But he never said a word against his father to me, vehemently defending him if I criticized him. It was one thing for Billy to do battle with Danny over the length of his hair, the loudness of his music, cleaning his room, mowing the lawn, his politics and activism, and another thing for me to judge him. He never let either of us castigate the other.

In the years I'd been away from my kids, I'd always imagined Danny to be the perfect father. He seemed to want custody of the children so badly. If I'd been around, I was sure, they'd have become pawns in an unending battle between us, but I'd absented myself from the battlefield, refused to fight; he'd been able to raise them the way he wanted without my interference.

"They'll grow up with me and turn out to be your children!" he yelled at me bitterly over the phone shortly before I moved to India. "You sound just like your mother!" was his supreme condemnation as he mocked the kids' idealism, no matter how subtly, giving them oughts and shoulds, as critical of them as he'd once been of me. They understood. "It's just the way Daddy is," they told me, loving him while I resented him for his failings, angry that he hadn't been perfect. I should have battled it out with him thirteen years ago instead of running away, I tortured myself endlessly, questioning my decision to leave now in a way I hadn't questioned it then, finding little justification for it: guilt-ridden, regretful; condemning myself for what the kids lovingly forgave me for.

Longing to be near my children again, I thought constantly about moving back east. To Toronto if Kirti couldn't work in the States; at least it would be closer to where they were. "You want a kind of relationship with us that it's years too late for, Mommy," Patti told me. "I don't know where I'll be living six months from now. Nancy and Billy have no idea where they'll be. Don't look to us for what you want to do. It's not fair."

Yet when I talked about the possibility of moving to England (as Kirti

was frequently tempted to do) or spending some time in Asia, it sounded to Patti like another abandonment. Kirti and I finally moved to an apartment of our own instead. At least Vancouver was in North America, a phone call away. Our phone bills were astronomical.

I flew to New York every few months to see my kids, Kirti joining me sometimes; sometimes not. A few months after Kirti and I were married, I finally told my family about Ravjiv. No one cared.

*S*atya? Is that you, *bella*?"

"Deeksha!" I'd have recognized her voice anywhere.

She corrected me. She wasn't using the name "Deeksha" anymore. Her years with Bhagwan (whom she now pointedly referred to as "Rajneesh") had been a mistake. She didn't need reminders of it.

In hiding ever since she left the ranch, afraid for her life, Deeksha wanted to set the record straight in case I was writing a book, as she'd heard I was doing. Her phone call came at a propitious time. Grove Press had just been bought out by an English publishing company that didn't want to do my book. It wasn't negative enough, objective enough; I was back to square one again. Having missed my moment by now— other books about the Rajneesh story would soon be on the market—I'd decided to rewrite my manuscript completely, hopefully turning it into something more meaningful than a three-month rush job had allowed.

I realized as Deeksha talked to me that day how much I was still looking for excuses to exonerate Bhagwan and defend Sheela. The stories she related to me made it difficult to do. In three hours of impassioned conversation, she told me countless anecdotes about drugs deals, bribes, and hit lists of sannyasins who were to be "taken care of" if they ever defected.

"We can't do what he wants!" she'd protest vehemently to Sheela after their daily meetings with Bhagwan in New Jersey.

"Don't worry," Sheela would laugh back, unperturbed. "We'll claim we were brainwashed if we're caught. They won't be able to touch us. I'll have proof that he was behind everything," showing Deeksha the recording devices she hid on herself whenever she was with Bhagwan.

For all his professed love of Jewish people, Deeksha confided to me

bitterly, Bhagwan was virulently anti-Semetic. "Jews are so ugly," he'd remark after private conferences with rich Jewish sannyasins at the castle. They'd be weeping outside his door, blissed out, ecstatic, while he'd be making derogatory comments about them to Deeksha and Sheela.

"Keep her out of my sight," he'd allegedly ordered once, referring to one of the Hollywood crowd who later became a prominent part of his new regime. "I can't stand looking at her. Such ugly noses Jews have. If she wants to see me again, she'll have to bring money. Tell her to go to California and introduce me to people in Hollywood. But not too heavy with her, hmmm, Sheela? Her money will be needed."

"His adulation of Hitler was disgusting," Deeksha insisted. "He used to boast to Sheela and me that he'd succeed where Hitler failed: 'My people will not betray me like Hitler's people did.'"

"Maybe he just meant...," defending him again.

"He wants to take over the world, *bella*. You think I'm kidding? He'd swallow valiums and quaaludes by the handful, close his eyes and babble away to himself about how the world would be at his feet soon. Presidents and prime ministers would come to him. He'd be the power behind them. You're surprised, *amoré*? He used to say the same thing in India. That Tibetans would come to him; the whole of China; Europe would be at his feet: Christians, Muslims, Jews. It sounded very spiritual in his discourses, eh, *bella*? You remember? The man's a megalomaniac."

The Bhagwan whom Deeksha saw in daily intimate encounters at the end of Poona and in New Jersey was coarse, avaricious, cruel, and demanding. He wasn't the Master she'd fallen in love with. She'd witnessed him beating Vivek once, she swore. Vivek had zealously defended him when she went to her aid. I remembered that Vivek had been in a physically abusive relationship before sannyas. Was willingly accepting physical abuse part of a recognizable pattern for her? Why would Deeksha lie to me? I didn't want to believe it was the truth.

"He's an impotent dirty old man," she insisted, claiming she'd been one of many women he'd had sex with in Bombay. "A voyeur," allegedly ordering various ma's to make love to Vivek while he watched. "Ask Kavi if you don't believe me, *amoré*."

By the time I hung up the phone, my grip on what was real and what was projection was shattered. Despite my resistance to Deeksha's words, they had the unmistakable ring of authenticity. I wondered if it would ever be possible to objectively evaluate Bhagwan. Was he good or evil? In the final analysis perhaps, the only answer was whether people were better or worse off after they'd been with him. Was he immoral or merely amoral—indifferent to anything that happened as long as "his work" benefitted?

"To die because of Bhagwan," Deeksha's ex-lover had remarked lightly when she told him about the alleged hit lists, "would be a gift. Death doesn't mean the same thing to Bhagwan as it does to the rest of us. It's just another part of the journey."

If Bhagwan was enlightened, anything he did could be justified. He could have created a religion to prove what he'd always said about the hypocrisy of organized religion—a commune to prove what he'd said about all governments ultimately trespassing upon people's rights. He could have intentionally "created situations" for Deeksha and me to leave him—going out of his way to shock her, withholding his energy from me. He often said that the Master chooses the disciple and chooses when to drop him; he had himself covered on all grounds.

Was he merely playing games for his own amusement all along? According to his own accounts, he was a mischievous rascal even as a child—rebellious and constantly courting danger. As soon as he got away with something, he became more outrageous. It was like walking on thin ice; if the ice held him, he'd venture out a little further, step by step.

He may well have figured that if a poor village kid could become a college professor, if he could travel all over India lecturing to large enthusiastic crowds, why couldn't he become a guru? Most gurus were phonies. He was intelligent and perceptive; he could get away with it. He practically fell into the role: people were demanding it of him, begging to call themselves his disciples.

Reading every book on pop psychology and religion that he could get his hands on, Bhagwan developed a repertory of powerful meditation techniques that opened people up to mystical experiences. What '60's drop-outs used drugs to attain, Bhagwan created through hypnotic music, frenzied dancing, intense catharsis and finally, at the ranch, exhaustive physical activity. His most successful technique was Dynamic, to which he quickly added a final stage of celebration, turning catharsis into meditation into rapture.

People soon learned to associate their euphoric states with Bhagwan. In Poona therapy groups they were told to look at a picture of him and "surrender to it" after they'd been through a particularly heavy emotional catharsis. What I'd chosen to think of as a helpful spiritual technique could easily be seen as deliberate imprinting. We were all advised to keep photos of Bhagwan beside our bed at night so he could "work" on us in our sleep. "When you make love," he went on to say, "keep my picture nearby. I will be there with you," fostering a primal attachment to him even amongst sannyasins who'd never met him personally.

Once he arrived in the States, Bhagwan seemed to up the ante and go

one step further than he'd gone before. If he could be a guru in India where they knew all about gurus, why couldn't he be the richest man in the world in America where they knew all about wealth and power? Why stop there for that matter? He could rule the world some day. Perhaps he wasn't evil, the way the media made him out to be. He was just amusing himself, riding the wave for all it was worth.

During his years of silence and isolation in Oregon, sannyasins turned Bhagwan into an idol, an icon, a god—making him into Jesus Christ, Buddha, the Wizard of Oz—pretending he knew what was happening, that he was running the show somehow. Religious people all over the world pray to statues, pictures, and the empty void, believing their prayers are answered. We did the same thing at the ranch, believing in an absent God and an alive priesthood.

Sheela was God's messenger; his parrot, Bhagwan called her. Trusting him, we trusted her. Perhaps we shouldn't have trusted either of them. "Following in the footsteps of Jesus, Buddha or Krishna doesn't make you a Christ, a Buddha or a Krishna," he warned us. "You have to find your own path, your own way." Yet he also told us to surrender to him and accept him as our Master; everything he said he contradicted. We each believed what we wanted to believe, ignoring the rest.

Every belief system in the world preaches surrender, yea-saying; following the priests, elders, and prophets; the gospels and parables of the past; the lessons of history. Christians, Buddhists, communists and capitalists are all cult followers in their own way.

It was hard to find fault with Bhagwan's words. He talked about individuality, creativity, and freedom, while in practice something very different went on around him. Rebellion against the hypocrisy of the outside world was coupled with the requirement to conform to ashram/ranch rules. Creativity was extolled ("Every act can become a creative act. Even cleaning the floor can be an act of great creativity"), while all artistic expression was discouraged unless it was in the service of glorifying Bhagwan.

To become a Buddha, Bhagwan taught, is both the goal of evolution and every person's birthright: an animal becomes a man becomes a god. All it took was a lifetime of effort and the courage to follow a pathless path with no guarantees; to risk, take chances, catch the bull by the horn till he throws you off. All it took was to accept Bhagwan as one's Master.

In a TV documentary on hypnotism produced by the CB, Bhagwan was compared to a stage hypnotist, the Marines, Moonies and Jesuits. To change people's fundamental belief system, the film postulated, all you have to do is change their environment and put them into one that you

control. When their sense of identification is shaken, an authority figure steps in to tell them what to do, think, feel, and believe. "Surrender and I will transform you. This is my promise."

The stage hypnotist controls the situation by rejecting anyone he can't work with; total trust is a prerequisite. Marines recruits are kept in a perpetual state of physical exhaustion and harangued constantly about the imminent threat of outside enemies till they relinquish their individuality and are ready to follow orders blindly. Moonies are seduced by the love and support of a sympathetic community of peers, hooked long before they know what they're getting themselves involved in. Jesuits renounce their past and their desire for spiritual achievement as they seek to become worthy in the eyes of God by their submission to the rules and austerities of their order. Bhagwan employed all the methodologies of the others. It was a comparison that was as chilling as it was irrefutable.

It may well be that all spiritual communities are dictatorial, people voluntarily giving up their outer freedom in order to attain inner freedom, their ego for the sake of spiritual growth. In a small community, under the direct guidance of a Master, it may be a benign dictatorship; but as the community becomes more and more successful, the Master loses touch and unenlightened disciples carry out his vision and prostitute it.

Part of what was so confusing around Bhagwan of course was how beautiful so many things were. Even my parents and children were impressed by the ranch; most visitors were. That those of us who were closest to what was happening were most blind to it is hardly surprising when one thinks about the intolerable situations married couples put up with in a bad marriage—refusing to see what they don't want to see, making excuses for what they can't ignore. Sannyas was a love affair: a marriage turned sour.

To Kirti, the ranch was a seductive dream: the illusion of a Buddhafield. "It's not what you do until the messiah comes," he said. "It's what you do after he's come and gone. If I could find another dream to believe in, I'd do it in a minute."

"You can't know God unless you experience Him," William James wrote. All my life I'd longed to experience God. During my years with Bhagwan, there were moments when I felt I did. When Buddha reached nirvana, he realized that he hadn't had to leave his wife and son to do it, but he didn't know that till he left and found what he was seeking. I found glimpses of it with Bhagwan. It might have been enough for me, but I wish it had been more for my children. I'd have preferred returning to them as a Buddha.

ﻩﻩ

"You did everything wrong and you're closer to your kids than I am to mine," my friend Mary remarked pensively one day as I sat in her Manhattan office between patients; she was a therapist now. After years of not communicating, we'd renewed our friendship as effortlessly as if there'd never been a gap in it. "It doesn't seem fair somehow," talking about her problems with her own children. "Maybe it's worse when mothers are physically present, and a thousand miles away in their minds."

Leaving my children was unquestionably the theme of my life. While everyone in my family except Billy saw it as cowardice—I'd run away from my responsibilities, wanting an all-knowing father figure to tell me what to do—to feminist friends it seemed like an act of courage: I'd left my secure world for a life of uncharted possibilities. My children might have been worse off if I'd stayed, denying the yearnings of my soul as I fought a bitter unending battle against Danny that I was bound to lose. What was rationalization, what was real? Are all spiritual paths as selfish as they are self-absorbing? Is anything worth causing pain to the people you love, even Buddhahood? What if there's no alternative?

ﻩﻩ

"I don't think you should do it, Mom," Billy cautioned, putting his hand on my arm as I started to walk towards Danny and his wife-of-six-months, wanting to stop this ridiculous I'll-pretend-I-don't-see-you-if-you-pretend-you-don't-see-me nonsense. We were both parents of the same children. How could any two people have more in common than that?

"Let him be," Billy said gently. "You may be ready to be friends with Dad, but he's not ready for it. Accept him for who he is even if you don't agree with it, okay?" I nodded, shrugging. Billy hugged me, a budding Buddha if there ever was one. "Thanks, Mom," he said.

Kirti and I were in New York for a series of performances that Nancy's dance company was giving. My mother had come up from Florida for the occasion, Patti from L.A. where she was now living, and Billy from Europe where he'd spent the last few months traveling, taking a semester off from school to do it.

After the show, Billy said goodbye to Kirti and me. He wanted to spend a few hours alone with his cousin before he left for San Francisco the next day. We'd had dinner with him earlier that night and spent the

afternoon and evening with him the day before. He was visiting Vancouver in a few weeks. We'd see him again before we knew it.

"We'll have lots of time alone together this summer, Mom," he promised, his face glowing with self-confidence; he looked happier than I'd ever seen him. "I'll spend at least a week in Vancouver, maybe more," hugging me goodbye.

"Promise me you'll call the minute you get to San Francisco," I begged, wanting to cling to Billy suddenly, cradle him in my arms like he was a baby. I was more nervous about him driving cross-country in ten days to deliver a car than I had been about him bumming around Europe by himself for three months, but I'd never try to dissuade him from going the way Danny was doing. I wanted my kids to have the freedom I hadn't had when I was their age—to do what they wanted, be who they wanted; explore life, live out their fantasies and dreams; act out their rebellions while they were young enough not to have responsibilities; find someone to love the way I loved Kirti.

It wasn't my own determination to be free that I condemned myself for now. It was simply the timing that was off. I wished I'd found Bhagwan before I had kids. Yet I wouldn't have wanted not to have them for all the enlightenment of a Buddha.

If guilt was who I was, so was happiness and contentment. My years with Bhagwan had given me a capacity for joy and the sensitivity to feel it. For that, I was deeply grateful. The odyssey I'd spent most of my adult life on was over, half my life was over. I was content to live each new day as it came.

While people like Deeksha went on private crusades against Bhagwan; others blamed him for things they'd done themselves: leaving their families and professions, making him answerable for the problems of the children they'd left behind; and still others, experience-junkies, addicted to the adrenaline energy-fix of being with Bhagwan, couldn't wait to go back to Poona, I felt as if Bhagwan was irrelevant to anything in my life but my memories and regrets.

The spiritual ecstasy I'd once found with him, I had with Kirti now. Holding Kirti, touching him, our energies merging into one primordal energy, was the most intense meditation I'd ever experienced, a tantric connection that I'd never imagined was possible before. I adored Kirti, adored my children. With everything that had happened to me over the last fifteen years, the good and the bad, the promises and the disappointments, the things I'd done wrong and the gifts I'd been given, I wouldn't have traded my life for anyone's.

Until July.

VII

... to the Unthinkable

Vancouver / New York / Poona
(1987 - 1990)

The author's son Billy at his high school graduation (1984).

*T*he phone rang in the middle of the night. Heart pounding, I ran to answer it. It could only be bad news.

Danny's voice: "Jill."

Oh my god, no! "Which one of them is it, Danny?"

"Is Kirti with you?"

"He's in the bedroom. *Tell me, Danny!*"

"Get him."

"Kirti, it's Danny! Who is it, Danny? *Tell me!*"

"Is Kirti with you, Jill?" "*Yes!*" He was crouched on the floor beside me anxiously. "Tell him to put his arms around you."

"Hold me, Kirti. Tell me, Danny, for godssakes!"

"I just got a call from the San Francisco...."

"Billy! No!!! What hospital is he in? I'll fly right down. He'll be okay, won't he?"

"I'm afraid Billy's no longer with us, Jill. I'm sorry."

No, my god, no! I threw myself on the floor, sobbing. It wasn't true! I'd just spoken to him! He was on his way to Vancouver!

Kirti took the phone, trying vainly to comfort me as Danny told him had what happened. I tore the phone out of his hands, needing to hear it with my own ears. Half of what Danny said was lost to me; I couldn't hear it through my hysteria.

Billy had been walking down the street by himself early that evening when he saw a young man physically assault a young woman on the other side of the street. As he stopped to see if he could help, the man started shouting at him. Lumbering drunkenly towards Billy, hurling demeaning insults at him as Billy tried to calm him down with soothing

words, the man suddenly pulled out a knife and brutally stabbed Billy in the face and abdomen. He died moments after he reached the hospital.

As Kirti frantically booked plane tickets to New York for us, I lay on the livingroom floor crying hysterically, overwhelmed by grief. I felt as if I'd been waiting for a phone call like this ever since I became a mother. Someday I'd be forced to pay for having such wonderful kids; I didn't deserve them. When the children were sick as infants, I was always terrified they were going to die. Every time Danny and I went out at night and couldn't be reached by phone, I panicked that something terrible would happen. Each phone call I got in India or Oregon petrified me. "Are the kids okay?!" I'd gasp desperately before I even said hello. Were my parents sure they were all right? I always seemed to be waiting for the news that something was wrong, knowing God would punish me some day. No wonder I never believed in Him.

Patti called, Nancy, my sister, and parents. As soon as I hung up the phone, it rang again. I phoned Nancy, Patti, Danny, one call after another; the phone my lifeline, till Kirti finally hurried me into the bathroom—we had a seven A.M. flight to L.A. to catch to pick up Patti.

"I thought you of all people would be happy for me, Mom," I heard Billy's unmistakable voice say inside my head as I showered, tears streaming down my face. I had no idea what he meant, too anguished to marvel at the phenomenon of him talking to me; all I knew was that he was dead. I couldn't stop crying. All my years of meditation were worthless. They hadn't prepared me for this.

ɤ

If it hadn't been for my years of meditation, I don't think I'd have survived Billy's death. He wasn't "just my son"; he was one of the most gentle loving human beings in the world. He wasn't "just dead," he was killed; wasn't "just killed": gratuitously murdered. Bleeding to death on the street with only strangers around to help him.

My intrinsic disbelief in what had happened got me through the next few days, the next month. Billy was away somewhere: on vacation, travelling, at school. I'd spent years mourning his absence in my life; I should have been used to it by now. Past life experiences, near-death experiences, meditation; Kirti, Nancy, Patti, my sister and her kids; the waves inside me that centered and calmed me, all helped in their own way.

My heart went out to Danny as I watched him suffering. Whatever reproaches I'd ever had of him as a father suddenly seemed unfounded. I

could see why the kids loved him so much. Even in the midst of his despair, he was warm and loving to everyone.

As I listened mournfully for days to people sharing their memories of Billy, it was like listening to things I might have said once about Bhagwan. That Billy had had a profound affect on people's lives was obvious; I was hardly the only one he'd been a guru-of-sorts to. He was a catalyst. Things happened around him: problems disappeared; friendships were formed between the most unlikely people; love flowered. "Billy taught me what love and caring mean," was something I heard over and over again from his friends. In his total, nonjudgemental acceptance of everyone, and his unfailing concern, Billy was as remarkable as any spiritual Master...a gentle soul who always operated out of love and goodness, and he was killed for it.

֍

"I told that kid a thousand times not to stick his neck out," Danny remarked dismally, shaking his head sadly. "He had to go save the world! *Mishuggana* kid!"

Yet for all that, Danny never once accused me: "It's your fault, goddammit!" the way he'd blamed Billy's idealism on me for years. "You're just like your crazy mother!" he'd grumble every time Billy went to black power rallies to protest police brutality or organized food for the homeless in decimated areas of the Bronx. Billy lived his life according to ideals I'd only paid lip service to: "the unlimited liability of human beings for one another" (Huxley). It was my fault he was dead.

֍

"We're not going to open the casket," Danny announced solemnly when Billy's body arrived at the chapel from the airport shortly before the memorial service began. The immediate family was huddled together in the hallway outside the chapel in large grieving groups; hundreds of people had already gone inside. "It's not Billy," Danny said. " It's better for you to remember him the way he was when he was alive."

I didn't know about Billy's multiple face wounds yet, or how badly mutilated his body was; I just wanted to see him one last time to say goodbye. Danny looked at me mournfully, tears in his eyes. "You don't need to see Billy this way, Jill," he murmured. "Believe me."

I nodded, acquiescing reluctantly. I had no right to interfere with what Danny wanted; I'd given up my rights years ago, but it hurt so

much. I longed to say goodbye to Billy, to tell him one more time how much I loved him, how sorry I was for what I'd done.

With Kirti on one side of me and my sister and mother on the other, I got through the memorial service somehow. As the pallbearers carried the casket out of the chapel (in accordance with Danny's family's tradition, Billy's body was to be cremated), Patti came over to hug me.

"Are you all right, Mommy?" she whispered tenderly. "It's more than just Billy dying, isn't it?"

I nodded, crying, the pain of Billy's death magnified by my guilt and sadness at all the years I'd missed of my children's lives, all the pain I'd caused them. I felt like an outsider at my own son's funeral, a stranger; I didn't know half the people who mourned him. Newspaper articles spoke about his father ("...who brought him up after his mother left the family when he was a baby"), his stepmother, sisters and step-sisters. At a family meeting with the rabbi the night before, when everyone talked about incidents with Billy that stuck in their minds, I had nothing to say. All my memories of him were either from his early childhood or too painful to talk about.

"I feel sorry for you, Mommy," Patti said as I sunk into her arms, wanting to comfort her; letting her comfort me instead; wishing I was stronger. Billy wouldn't have wanted any of us to suffer, I knew. He'd been my champion and advocate in the family for so long. I thought he'd always be there for me. And at long last, whenever he wanted it or needed it, I'd be there for him finally, too. "You missed so much all these years, didn't you?" Patti murmured sympathetically.

There are no words that can describe the enormity of the grief and pain I felt, the utter desolation. My kids had all deserved so more than I'd given them. So much more than life gave them. Billy deserved a better life, a better death; he deserved to live.

&

Hours after the funeral, when most of the condolence callers had finally left Danny's house, Danny asked to speak to Kirti and me privately.

"I didn't say anything to the press about your cult involvement," he commented wearily when the three of us were alone together. The newspapers in California and New York had been running front-page articles on Billy for days; his murder was every urbanite's fear come true. "I just told them that you left the family to travel, make your own life. It would only be one more issue for the press to play up. It had nothing to do with Billy's death.

"A reporter from San Francisco'll be here tomorrow. I wouldn't talk to him if I were you; you don't need that *tsoris*. I know how hard this must be for you, Jill. It's good Kirti's here.

"You have a right to know why I wouldn't let the casket be open," he went on sorrowfully, telling us for the first time about how brutally Billy had been attacked. "I wish to god I hadn't seen him like that. You have a right to know." He was sobbing. I was sobbing. Tears streamed down Kirti's face.

ૐ

"*Yis g'dhal, va yis g'dhosh....*" Saying kaddish two days later at Friday night services was the most painful thing I ever had to do in my life, unbearable in its finality. Parents weren't supposed to say kaddish for their children, goddammit! Their children were supposed to say kaddish for them.

By the time the service was over, I felt as weak and vulnerable as a wounded sparrow, my heart torn from my body, nothing left inside me. Several hundred people stayed behind in the chapel afterwards for a private memorial service, family and friends sharing countless Billy stories with one another, all the incidents of a lifetime I hadn't been around for.

I spoke up finally, hesitantly. "I wanted to say something," Patti nodding encouragement at me, tears in her eyes. "I'm Billy's mother," voice quivering as I leaned forward in the pew to speak. "There are so many people here I don't know," weeping as I talked. "I missed so much of Billy's life. I just wanted to say how grateful I am to you for everything you did, Danny. How grateful I am to everyone here. You were all here for my kids when I wasn't. Thank you so much, everyone," crying so hard by now that I could hardly speak, Nancy, weeping in the pew behind me, reaching out to touch me.

ૐ

Billy's friends were all beautiful to me in the days following the funeral; everyone was. My sister, who'd resented me for years for abandoning her as well as my kids, was unfailingly loving and supportive. Danny's brother went out of his way to be kind. My niece and nephews were tender and affectionate with me for the first time in years. I wished it hadn't taken Billy's death to do it.

"Billy was very proud of you," one after another of his friends told me compassionately. "He loved you a lot. He never doubted your love for him for one minute. I wanted you to know that."

Billy knew how to love; that was the simple truth of it. Lovingness was his legacy to me and to everyone who knew him. A gift.

≥▲

Two weeks after the funeral when I got back to Vancouver, a complimentary copy of *The Rajneesh Times* (of India) was waiting in my mailbox for me. As I leafed through it absentmindedly, I felt disgusted. The newspaper was filled with the same self-indulgent garbage I'd been reading uncritically for fifteen years.

"No one can tame a wild wind or a wandering cloud," Bhagwan was quoted as saying. "Even if I'm chained, handcuffed, put into jail, my spirit will remain as free as ever. My freedom is indestructible; no power can tame me. Freedom is my being."

Bullshit, I screamed angrily inside my head, incensed at Bhagwan's pompous proclamation. He could milk "the abuses the American government put him through" all he wanted (numerous books about it were in the process of being written by loyal disciples), but he was hardly an innocent victim. While his nebulous "freedom" was indestructible, Billy was dead.

Saccharine ads from Rajneesh centers all over the world ("We love you, Bhagwan!") filled the inside pages of the newspaper along with several excerpts from Bhagwan's most recent discourses.

"A commune is a gathering of free spirits," he said as if he hadn't already tried to implement his theories about communes in Oregon with disastrous results. "A declaration of a non-ambitious life.... I don't want there to be any Mother Theresas in the world, I don't believe in the virtue of serving the poor, because I don't want there to be any poor people."

But there *were* poor people, goddammit! What Bhagwan wanted was irrelevant. Was he a fool, or did he think everyone else was?

His words in another recent discourse infuriated me even more. "Children should belong to the commune, not to the parents," he said. "Parents have done enough harm. They can't be allowed to corrupt their children anymore...."

I'd listened to his litany on the subject for years. The nuclear family was repressive, dictatorial; the best thing that could happen to children was not to live with their parents. What unmitigated bullshit it was! The love and support I'd felt from my family in the last two weeks was more real than anything I'd experienced in Oregon in five years.

My reaction to Bhagwan's words suddenly echoed what my kids' re-

actions had always been. "What Bhagwan says sounds valid, Mommy, but it's childish; it has nothing to do with reality."

Billy's death was a painful lesson in the ways of the world, a rude awakening. I couldn't believe I'd once expected Bhagwan to wake me up. He was living in a dream world himself—creating an idyllic house of mirrors that hid what was ugly without attempting to change it.

ஃ

As the weeks and months slowly passed, every book I read reminded me of Billy; every stocky Jewish/Italian/Greek youth I saw walking down the street with dark curly hair, torn jeans and a happy/sad grin on his face reminded me of him. I'd catch my breath, heart pounding, wanting to rush over to him ("I knew it was a joke, Billy!"), feeling crushed at the reality of a stranger's face, heartbroken.

Whenever I began to cry for no apparent reason, Kirti was there for me, playing therapist when I needed it: father, mother, guru, son, friend; helping my wounded soul to heal. If my kids had been the most plausible reason I could ever find for why I'd married Danny, the most reasonable explanation I could think of now for my years with Bhagwan was to meet Kirti. As loving and supportive of me as Billy had always been, he was everything I could want in a partner. My only fear was that something would happen to him, Nancy, or Patti; dreading unexpected phone calls at any time of the day or night.

"You've been through it already," Kirti would promise me over and over again, holding me in his arms. "You don't have to go through it anymore. What you were afraid of has already happened. It's done."

I wanted to believe him. I tried to believe him. Day by day the fears subsided, pushed into the background.

I cried a lot and meditated a lot, waves of bliss washing over me as soon as I closed my eyes, centering me when I felt most vulnerable. In the midst of suffering, loss, and unimaginable guilt, I felt an attunement with my inner being that I hadn't felt in a long time, a coming home. This is who I am. Guilt, sadness, and sorrow were an intrinsic part of it.

ஃ

"Mom." Billy sat on my bed in a suit and sweater, his curly dark hair shorter than it had been the last time I saw him; he looked like he was going to a wedding. He'd been "dead" for two months.

My eyes were closed, but I wasn't asleep. As Billy sat beside me telling me about his new "life," he was as real as if was alive. "I'm the

same person I've always been," he said, grinning, "except I don't have a body anymore; I can't see, hear, smell, touch or taste. I put on this body and clothes so you'd recognize me. Pretty nifty, huh, Mom?"

He was living in a different dimension of reality now, he told me. There were other dimensions beyond his, but he didn't know very much about them. As he talked, I suddenly realized why he'd expected "me of all people" to be happy for him when he died. He'd never believed in past or future lives, or in people "leaving their bodies," yet he'd accepted death gracefully when it came, unafraid of the unknown; welcoming his new freedom.

After a brief period of evaluation, he said, he'd continued to do what he'd always done without realizing it while he was alive: teaching, guiding. The rabbi in Scarsdale had called him one of the thirty-six Righteous People the Jewish religion says are in the world at any one time, while a reporter from the *San Francisco Examiner* asked scores of people if he was another Christ, a saint. Billy never blamed anyone for anything in his life. He'd probably have forgiven his own murderer. The only unforgivable thing he ever did was die.

"It's easier to help people here," he was telling me now, grinning his familiar irrepressible grin. "They don't get angry and kill you."

"Will you be born again?" I couldn't help asking hopefully.

"I don't know," casual, vague, as if it was immaterial. "Some people take new bodies right away, but I don't have that much more to work on. I may be able to do it here. If not, I'll be back."

Meanwhile, other people were having irrefutable visions of Billy as well. He was making his last connections.

ॐ

When Sheela heard about Billy's death, she wrote to me from jail (via one of the few sannyasins who knew where I was), ostensibly to offer her condolences. The American government had tried to "...destroy Bhagwan, His Teachings and His people by dismantling Rajneeshpuram, deporting Bhagwan, and imprisoning me," she added incongruously, blithely forgetting about the multitude of criminal acts that she'd confessed to committing. "The seed of Rajneeshism is flowering within me," she noted in conclusion. She'd recently declared her undying love for Bhagwan in a German magazine: she had done it all for him.

Several months later, when the Australian woman who was convicted with Sheela was released from jail and deported, she announced on Australian TV that after two years of solitary contemplation Sheela had finally attained Christ-consciousness; she was an enlightened Master in her

own right now. Rajneeshism, whether Bhagwan wanted to destroy it or not, was the religion of the future. Sheela would soon be out of jail, ready to spread the light of truth to the waiting world. It was a terrifying thought. Shortly afterwards, according to rumors from reliable sources, she was caught in *flagrante delicto* with a male inmate in the laundry room of the minimum security jail she was in and transferred to another prison. So much for enlightenment.

૨▲

As I mourned Billy's death, the movement around Bhagwan resumed its former popularity, particularly amongst Germans and Asians. Italian, Russian, and Japanese video crews filmed ashram activities in Poona while Bhagwan went on playing games with his disciples; inventing a variety of new meditation techniques and talking, talking, talking till he seemed to tire of it finally and went into partial silence again. I couldn't imagine why anyone who'd been at the ranch in Oregon would feel compelled to visit the ashram, yet thousands did—the once-disgruntled and disillusioned amongst them: "To see what it's like with the old boy these days. Check it out." People's longing to believe in something seems as endless as their capacity to believe it.

Numerous books about Bhagwan appeared on bookstore shelves, meanwhile. *Bhagwan: The God That Failed* by Hugh Milne (Shiva) sat be side *Bhagwan: The Most Godless Man Yet the Most Godly* by Bhagwan's physician. Books by other disciples with titles like *Bhagwan: Twelve Days That Shook the World,* and books by Bhagwan himself (*Jesus Crucified Again: This Time in Ronald Reagan's America*), were an indication of Bhagwan's reading of events during his sojourn in Oregon. "Arresting me, an absolutely innocent person," he was widely quoted in sannyas publications as saying, "...is the beginning of the end of American hypocrisy about democracy," making himself a bit more important than non-disciples might be inclined to do.

While Rajneesh centers in India and elsewhere offered over 250 English-language book titles by Bhagwan for sale (with translated versions available in Chinese, Danish, Dutch, French, German, Greek, Italian, Japanese, Korean, Portugese, Russian, Serbo-Croatian, Spanish, and Swedish), spiritual bookstores in major cities throughout the world continued to carry a respectable sampling of these titles as well as various "non-Rajneesh-oriented" books that were written by disciples and ex-disciples who judiciously avoided any mention of their connection to Bhagwan other than to refer cryptically to the years they'd spent in India at an unidentified ashram with an unidentified spiritual Master.

In Vancouver (and I suspect elsewhere) the bulletin boards of health food stores and restaurants, bookstores and laundromats, were plastered constantly with notices about therapy groups that were being run by local and visiting therapists whom I knew were sannyasins (past or present), though you'd never have recognized it from their write-ups. Those who were still with Bhagwan, for pragmatic reasons, didn't always want it to be known (the movement was going underground in many ways), while those who were no longer disciples had nothing to gain by the association. "...Fifteen years studying meditation in India." Indeed! Even Teertha, Bhagwan's presumed successor for years, failed to mention Bhagwan's name in his books or therapy group announcements. Having finally seen "the truth of his own enlightenment," he ran groups all over the world, teaching people to "recognize their own Buddhahood." Teertha? Who's that? He was Paul Lowe again. Sheela and Bhagwan weren't the only ones who could rewrite history.

ह

According to rumors that I heard over the sannyasin grapevine, Bhagwan wanted to return to America. A concerted legal effort was underway to clear his name so he could do it. He changed his name numerous times meanwhile; asking to be called "Buddha" at one point, he finally settled on the Japanese-sounding "Osho," which he called a nonname, anonymous: the sound of the ocean's roar. When a woman at the ashram wrote to ask me about finding an American publisher for Osho's work, I assumed that "Osho" was the new name Bhagwan had given to a German writer friend who'd been "shit-listed" at the ranch. Bhagwan had changed many people's names since his return to India, presumably to help them avoid harrassment by the Indian government. When people told me what "this one" or "that one" was doing, I never knew whom they meant.

I didn't respond to the woman's curt request for help. Her hastily-scrawled note was so impersonal—this is what we need: send it A.S.A.P.; no words of warmth or connection; no reference to Billy's death (if she'd managed to find out where Kirti and I were living, information that was hardly widespread in the sannyas community, she couldn't help but know what had happened)—that it infuriated me. We need, we want, we'll use anyone we can get. It was ugly.

ह

"Ugly" being a relative term, of course. There were uglier things hap-

pening in my life at the time: the trial of the young man who killed Billy. Turned in by his brother several days after the murder, he'd immediately confessed to the crime, claiming he'd been drunk when it happened.

With the best of intentions no doubt, Danny forbade anyone in the family to attend the trial. Enough was enough; we couldn't go on torturing ourselves forever; what was done, was done. He was having an even harder time accepting Billy's death than I was.

Despite Danny's wishes, I felt compelled to attend the trial. I'd failed Billy too many times in the past; I couldn't not be there. In the end, Nancy, Patti, and their boyfriends (as well as my sister and her kids) joined Kirti and me in what we expected to be, and was, an excruciating ordeal. Doing what I felt I had to do regardless of Danny's opinion, creating a memorial of presence for Billy, turned out to be an important step for me. On some level, I'd grown up finally; I was ready to make my own decisions about how I wanted to conduct my life. Ready to do what *I* felt was right, regardless of what anyone else (including Danny) thought.

A chillingly remorseless young man, Billy's assailant was convicted of second-degree murder. Given a fifteen-year to life sentence, he'd be eligible for parole in seven years. I couldn't help thinking about Bhagwan's possible 165-year sentence. Is it only murderers and child molesters that we let out on the street? Was I "hiding" in India (or Oregon) when they did away with justice in America? It was frightening.

ঽঌ•

I finished my new manuscript a few weeks before the trial began. Patti found a Hollywood producer for it, my agent found a new publisher. Before long I was earnestly at work on the first draft of a psychosocial erotic political absurdist novel that I didn't care whether I ever published: a cathartic outpouring of words that was therapy for me as much as anything else and may yet turn out to be a bestseller some day, who knows? I was amusing myself in the guise of "work" at a time when I desperately needed amusement. Healing myself through humor while Kirti healed me with his love.

There were weeks when I talked to Nancy and Patti on the phone dozens of times; days (when they were having work or relationship problems) when hour-long conversations twice-a-day didn't seem to be enough. Since Billy's death, we'd become closer than most mothers and daughters, old wounds remembered only for the purpose of understanding. Nancy thanked me once for always being there for her, lovingly dis-

regarding all the years I wasn't. Patti told her friends that I was her best friend; she could tell me anything. "It's funny isn't it, Mom, after all these years?" Their words were touching precious gifts to me. Perhaps I hadn't done everything wrong, afterall.

"It's time to forgive yourself, baby," Kirti would tell me patiently as we lay in each other's arms at night. "Billy didn't think you were a bad person. The girls don't. Do you think I'd love you if you were? You can't spend the rest of your life blaming yourself for the past. It's time to drop it."

And what can I say? I did, finally. The fact was, with it all, I liked the person I'd turned out to be. Even in the midst of adversity I was content within myself, filled with a deep inner joy that transcended pain and personal tragedy. I cared deeply about others. I loved, and was loved.

While writing remained my principle pursuit, I began to do some part-time counselling as well, working with both couples and individuals. Besides my insights and intuitions, love and concern, all I had to offer the people who came to see me were the myriad of therapeutic/meditative techniques I'd learned in my years with Bhagwan. It was little surprise to me how often his words came out of my mouth when I was counselling people. It was neither his ideas nor ideals that I'd ever objected to; it was the often-unscrupulous way they'd been disseminated and exploited over the years, often under what seemed to be his direct guidance.

What people looked to spiritual Masters for, it became increasingly clear to me as Kirti and I explored our own personal version of tantra together, they could find with their lovers without the potential dangers that seem to be inherent on most spiritual paths. Ecstasy, joy, peak experiences, and profound transforming insights were possible through a loving, mutually supportive exploration of the psyche and the soul, the body, mind, and being. Kirti was more than my lover. He was my guru and guide, as I was his.

"Go two by two," Jesus said. Bhagwan had said the same thing when he told Chaitanya and me to travel around North America teaching meditation. "Two by two" was the cue, though we didn't understand that then. If one truly loves, the other becomes divine as well as the mirror through which one recognizes one's own divinity.

All that was needed was surrender and trust, a total openness to the other, total receptivity: love. All the things Bhagwan had talked about, encouraged and ultimately, perhaps, betrayed. In a relationship between equals—both of whom bow down at the feet of the other with love and respect, aware of nuances and subtleties, past limitations and future possibilities—there was no question of exploitation or betrayal.

And tantric sex was astounding!

&.

After three years in jail, Sheela was finally released and deported from her "beloved country." She returned to India to see her parents, but didn't visit the ashram. How could she when she presumably had millions of dollars of the ashram's money in her possession? There was no way Bhagwan would welcome her back unless she relinquished it, and no way, I suspected, would her brother let her do that. By the time she flew to Switzerland where her third husband lived, he'd discovered that he had AIDS and had committed suicide.

Savita was said to be waiting in Europe for Sheela; Su and Vidya apparently were as well. There were plans to develop a commune there under their joint auspices, but nothing seemed to come of it. Without Bhagwan, Sheela was nothing. Without her, he was once again a Master of Masters, leading his flock to new peak experiences: sannyasins (old and new) came back from Poona glowing.

What troubled me the most was Bhagwan's continued refusal to discuss the commune in Oregon, or his own role in what happened there. It was as if it had never been. If I was still "holding on" to my disillusionment, it was my loss. The past was past. What was happening in Poona now, I was told by the various sannyasins I ran into, was beautiful, miraculous; "the work" had never been more powerful. Bhagwan, and the ashram community itself, was transforming the lives and consciousness of everyone who visited.

When Vivek committed suicide in mid-1989, dying of an overdose of drugs while she was in the middle of her first ashram therapy group, his casual response to her death made me more wary of him than ever. His only known comment on the suicide-death of a woman who'd been his loyal companion and disciple for over a decade and a half was that Vivek had always been manic-depressive, something I'd never noticed the slightest trace of myself. It was obviously an awkward situation for Bhagwan to have to deal with, but a bit more compassion on his part seemed to be in order as far as I was concerned.

"Bhagwan has no sympathy for anyone who commits suicide," I was told dismissingly by various sannyasins when I questioned his lack of response to Vivek's demise. The fact that Anando (the Australian lawyer who now ran the ashram, and whom Bhagwan later named as his messenger and medium) tried to kill herself a year before Bhagwan went to America was obviously irrelevant, and no doubt unknown to anyone but a handful of people. Deeksha had nursed Anando (who was her assistant at the time) back to health in a private ashram room; she wasn't put into

the medical center. Although she and I were hardly close friends, she'd asked me to visit her while she was recuperating. I was the only person at the ashram she trusted, she'd told me to my amazement.

Bhagwan seemed to reward Anando for her act of desperation: she became a darshan medium as soon as she recovered. Attempting suicide wasn't what he had no sympathy for, apparently. It was Vivek's success at it that he seemed to take exception to. Unlike other ashram deaths over the years, no community-wide celebration took place on the occasion of Vivek "leaving her body." Within days, it was as if it had never happened.

Ugly, ugly, ugly, I couldn't help thinking. Vivek's death disturbed me immeasurably. One more cover-up. Another smokescreen. A lame justification (manic-depression) for an unfortunate event that might have opened up lines of inquiry into what the hell Bhagwan was up to, and why. I didn't like it one bit.

<center>ॐ</center>

Kirti and I meanwhile, middle-aged hippies masquerading as yuppies (with an English sports car and a condo in the most desirable area of Vancouver), finally had the time and money to travel anywhere in the world we wanted. We chose Southeast Asia instead of India, trekking in northern Thailand and bumming around Bali instead of visiting the ashram and Bhagwan. Someday, perhaps. Or never. It didn't seem to matter.

What mattered, for me, was Kirti and my kids. Living with the undeniable evils of the "real world" without being corrupted by them. Sharing my love and joy with as many people as possible.

While Billy never "visited" me again in the same way as he did shortly after his death, we continued to communicate, our "talks" helping me to understand both his life and death. Whenever I need him, I feel his unmistakable presence; he's still there for me, encouraging me to be true to myself, to reach out to others in their need, to act out of my "higher self" whenever the choice is mine. Billy continues to be a guru-guide to me. As do Kirti, Nancy, and Patti, and everyone else I love and trust.

Perhaps this is what it means to come home.

*B*hagwan is *what*?"

It was George Quasha, my new publisher, who told me that Bhagwan had died. I was in Massachusetts visiting Nancy when he called with the news. My reaction was more a nonreaction than a response: I felt nothing. Nancy felt more than I did. George was far more curious about what had happened, and what Bhagwan's death would mean for the future of the Rajneesh movement, than I was.

"You heard, baby?" Kirti's voice sounded solicitous when he phoned from Vancouver. "You're not upset, are you?"

I was beginning to wonder if I should feel upset about *not* feeling upset. The fact was, Bhagwan had lived a rich complex life for fifty-eight years, doing what he wanted to do with what I assumed were few regrets. What was there to be upset about? There were worse ways to die than from what early news reports said was a heart attack. Worse ways to "leave the body" than in the comfort of one's own bed. Death itself held no horror for me anymore. It happened. The circumstances surrounding its happening seemed more significant to me than the fact itself.

"I think it's weird that you're not upset," Nancy remarked finally. "My god, Mommy, you gave up your whole life for Bhagwan!"

What surprised me was how mundane his death seemed. A superb manipulator of events, and the deliberate creator of a thousand myths about himself, I'd always assumed his death would be a carefully orchestrated extravaganza of martyrdom or betrayal. He'd said on more than one occasion that he was going to be killed by one of his closest disciples. Sheela came to mind, obviously. Shiva might have been a likely possibility at one time. Years before his defection, when a few of us at the ashram were collaborating on a (never-finished) detective novel, it was obvious to us all that the guru in our novel would be killed by his

bodyguard. I always expected to hear that Shiva, Sangit, and other "late sannyasins" were back at the ashram again, as close to Bhagwan as ever, threateningly close perhaps. I dreamt often that they were back, that the only old sannyasin who hadn't turned up in Poona yet was me.

There might easily have been bloodshed in Oregon for that matter. The commune, under Sheela's gun-toting guidance and Bhagwan's implicit acquiescence, was clearly being set up for it in the last year of the ranch's existence. I often wondered whether Bhagwan had entertained visions of martyring himself at the ranch, killed by army or marine forces as they helicoptered into Rajneeshpuram, expecting to be greeted by sannyasin-manned artillery.

Bhagwan had been making enemies with his iconoclastic, outrageous remarks for as long as he'd been making disciples. All things considered, it was a miracle that he'd died a natural death, a miracle that he'd failed to make his death the stuff of "60 Minutes" news coverage. He'd simply died.

ॐ

Five days after Bhagwan "left his body," I was hit by a car a block from my apartment and almost "left" mine.

As the car hit me, my first thought was: dammit, this isn't supposed to happen! My second thought: poor Kirti; he'll be miserable without me. There was no fear for myself as I flew through the air; it was, if anything, an interesting experience. So this was death. I still had my wits about me; I was conscious. My only concern was for Kirti.

I lost consciousness before I hit the street. When I regained it, there was a crowd of people crouched around me. An ambulance had been called, I was told; I should try not to move.

"I'm okay," I murmured confidently as I forced my eyes to stay open, thrilled to be alive. Smiling encouragingly at everyone, chatting away merrily in an effort to reassure them I was all right—the poor things looked so worried; my heart went out to them—I thought about how ridiculous it was for me to have imagined I was dying, equating my flight through space with the feeling of "flying off to another dimension." If I'd really been dying, Billy would have been there calling me: "Come, Mommy. Take my hand. Don't be afraid." Bhagwan would have been there, telling me it was time. I hadn't seen either of them, or sensed them; I was obviously all right.

"My husband's office number's in my wallet," I chirped amiably. "Can someone call him for me," reaching for my bag to look for the number, "and ask him to pick me up at the hospital? Tell him not to

worry. I'm fine." They'd x-ray me, tell me to take it easy for a few days, then send me home.

"You've been very seriously injured," the doctor was saying somberly as I regained consciousness again for the second time. I had no idea how long I'd been "out"; the last thing I remembered was the arrival of the ambulance. I'd been examined, x-rayed, CAT-scanned and evaluated by now; I'd missed it all. Kirti was standing beside me, holding my hand, looking like death warmed over, congealed anguish.

"Seriously hurt?" I could hardly believe it. I felt fine.

My tibia and fibula had been smashed at the knee, I was told. A bone graft would be needed to repair it. My pelvis was broken in several places. I'd be operated on the next morning.

And so it went. Set backs. Complications. Slow painful progress. Every part of my body was affected in one way or another: lungs, heart, digestive system, circulatory system. The neurological problems were the most disturbing, obviously. For days after the operation, Kirti was afraid my brain would never return to normal; I was totally incoherent. They gave me a blood transfusion finally and like Popeye, after devouring can after can of spinach, I suddenly came back to life, alert and aware again. Other neurological difficulties, post-concussion rather than post-operative, were mercifully milder and would/should disappear, I was told, within the next two years. It could have been worse.

I never worried about whether I was going to live or die. The nurses worried when they couldn't revive me after the lengthy operation. Kirti worried when I seemed to have lost my mind. As far as I was concerned, whatever happened was fine with me. If I died, I'd see Billy. If I lived, I had Kirti, Nancy, and Patti to share my life with. I was covered on all grounds. It was/is an enviable position to be in.

Finally, with two metal plates and eleven huge screws in my leg, I left the hospital and joined the ranks of the disabled, which didn't affect Kirti's love for me one iota. How could I be depressed and despondent when I had that? A wheelchair may not be much fun when it's your only way of getting aroud; a walker, when I finally graduated to one, leaves something to be desired; crutches aren't two good legs by a long shot; but within six months, I was limping along on a cane: freedom!

Everything in life has something to teach us. What I learned from the sudden abrupt change in my lifestyle was that the joy in my being transcends everything. Lying flat on my back for months on end: in pain, unable to move, sleep or do anything but excruciating physiotherapy exercises; irrepressible joy still bubbled up inside me. Despite moments of deep despair (would I ever be able to walk again? make love freely again? would the pain in my pelvis ever end?); moments of panic-

stricken helplessness; days alone, and sleepless nights beside Kirti, when all I did was cry; I was happy more than I was unhappy. Humming waves of bliss still pulsated inside me, sneaking up on me when I least expected them. In the final analysis, neither my pain nor my frustration at all the things I'd never be able to do again mattered. The things I had to share with others, I still had to share. Love. Kindness. Understanding. Joy. New circumstances meant new opportunities to learn who I am and grow towards who I may someday be. One can never fall backwards in consciousness in a spiritual sense, it seems; one can only move ahead. What a marvelous thing to know!

I was alive. I could just as easily not have been. There was more for me to do in this life, I gathered. Only time will tell what it is.

ॐ

"It has always been a great moment in the lives of disciples when the Master leaves the body," Bhagwan's voice intoned on a video that Kirti borrowed from a local sannyasin house. I was lying on the couch in the living room where I "rested" uncomfortably for sixteen hours a day, only venturing forth to hop into the bathroom on my walker or go to bed at night; Kirti was sitting in a chair beside me. I'd read over a hundred books in the two months since my accident, watched more movies and TV than I'd done in a lifetime. When I heard there was a video out on Bhagwan's "samadhi celebration" (i.e., death), I was delighted: a change of pace was just what I needed.

"It is possible," Bhagwan's voice was saying now as random shots of the ashram in Poona were shown, "because the Master knows when he is about to leave the body.... Now that he is leaving, he would like to give you his last gift. As he opens his wings to the other world, you will feel the breeze, which is incomparable, it is sheer joy—so pure that to even have a taste of it can transform your life."

The camera suddenly zoomed in on Bhagwan's distinguished looking English physician Devaraj, who was standing in front of a packed-house audience of sannyasins several hours after Bhagwan "left the body." "In death," Devaraj murmured softly into a microphone, love in his eyes, his face radiant, "he was just as you would have expected: incredible! When I started crying, he looked at me and said, 'No, no. That's not the way.'" Everyone in the audience burst out laughing, loving Bhagwan and his ways.

Bhagwan had apparently refused cardiac resuscitation earlier that day as his already weak heart grew progressively weaker, telling Devaraj, "No, let me go. Existence decides its own timing." Lying calmly in his

bed, he'd then instructed Devaraj to tell everyone that his body had become a living hell to him ever since his days in jail, where he'd been poisoned with thalium and exposed to radiation. "My crippled body is the work of the Christian fundamentalists in the U.S. Government!," he reiterated for the final time, then commented confidently that his work would expand incredibly now, beyond everyone's wildest expectation.

"I leave you my dream," he told a wealthy disciple who'd been called into the room to say goodbye, then closed his eyes, his pulse slowly disappearing. It wasn't a death one could feel sorry for, despite the tears in my eyes.

Nine months earlier, Bhagwan had announced the formation of an "inner circle" of twenty people who were to to carry on his work after his death. "If there is any truth in my work," he said, "it will survive. If not, it won't. I will remain a source of inspiration to my people when I'm gone. I want them each to grow in their own way. Qualities like love and awareness, around which no church can be created. Qualities that are nobody's monopoly like celebration, rejoicing. I want people to be the way they are, not asked to be like someone else. After I'm gone, my presence will be much greater."

"There's going to be a lot for us all to do," Devaraj prophesied as the video ended. "In some inexplicable way, it feels as if his work has just begun."

&

Within weeks of Bhagwan's death, people from all over the world were flocking to Poona in unprecedented numbers. Therapy and meditation groups of all sorts were happening at the ashram. Workshops. Counsellor-training programs. The place was buzzing.

Ashram therapists soon began moving out into the world: teaching. It was all happening the way Bhagwan had wanted it to. "I am absolutely certain that I have the right people who are going to be my books, my temples, my synagogues," he'd said. "To spread me all over the world."

Had I "missed"? Was I still "missing"? I couldn't help wondering. Kirti and I would have been welcomed back enthusiastically if we'd visited the ashram while Bhagwan was alive, I knew. If we went back now (someday: when I was mobile enough to make the trip), we'd be welcomed. After my book came out, we wouldn't be. If the book was a closing up of karmas for me in some way, it was also a declaration of independence, an act of finality.

The excitement of communal life, proselytizing fervor, the comfort implicit in dedicating one's life to "spreading the word of the Master,"

were all things I understood the attraction of; my years with Bhagwan had been rich exhilarating ones; but there was no going back. I had to stand behind my own truths now, take responsibility for whatever clarity I had to share; own up to my own insights without putting them into quotation marks beside Bhagwan's name. Grow up. It was time.

૱

"I understand everything!" Kirti announced suddenly one Friday evening several months later as the two of us sat opposite each other in bed, doing *tratak* (one-pointed staring into each other's eyes). A stick of incense was burning in the room, a candle lit on the table beside us, two long-stemmed glasses of wine beside the candle. "How could we have been so dumb?!"

His subject matter was obvious: Bhagwan. While neither of us seemed to feel much of a personal connection to him anymore, we still talked endlessly about what he'd been up to in Oregon. I wanted to forgive him now that he was dead, understand. Was there anything to forgive? Had Bhagwan been little more than a charismatic, convincing con-man all along, a rascal who duped thousands of people, a charming megalomaniac? There were, presumably, no easy answers.

"Bhagwan knew exactly what Sheela was like from the very beginning!" Kirti was telling me excitedly now, our *tratak* meditation forgotten. "How could he not, when you think about it? Where he went wrong was in thinking he could control her; he misjudged his own power. It never occurred to him that she'd tape their private talks and threaten to blackmail him."

"I'm sure her brother was behind...."

"Bipen was no fool," Kirti nodded in agreement. "He knew the Rajneesh movement was gonna be big, millions of dollars passing hands; there were bound to be other people who wanted a share of the action sooner or later. The only way he could safeguard his own interests was if Sheela was in control and *stayed* in control. He insisted that she protect herself: get something juicy on the big boy and she'd have nothing to worry about. It's how the game is played."

"Sheela loved Bhagwan, Kir...."

"I know, baby; that's not the point. Bipen had probably been pestering her for years to get the goods on the old man—he knew Bhagwan knew about the drug deals that were going on; they had him on that at least; all they needed was a way to prove it—but it wasn't until Chinmaya died that Sheela was ready to listen to him. After that...."

"You really think they killed Chinmaya, Kirti?" I'd toyed with the idea, yes. I still didn't want to accept it. "Why would Bhagwan...?"

"What's death to someone like him?" Kirti shrugged. "Chinmaya's days were numbered anyway. He was probably in a good space psychologically, spiritually even; maybe Bhagwan honestly cared about things like that; it was a good time for him to die. If he got any sicker—and he was bound to sooner or later—Sheela would get so obsessed with him that she'd be useless for the work. Bhagwan had been training her for years, he didn't want to lose her; he needed her. She was a perfect combination of eastern and western consciousness; she could play both games. And she was totally surrendered to him—or at least she seemed to be. Her willingness to do whatever the hell they did to Chinmaya would be the final proof of it."

"And it backfired, is that what you're saying?" Kirti nodded, reaching for a glass of wine. "Bhagwan convinced Sheela that it was for Chinmaya's own good, maybe it was for that matter, but she was disturbed by it; she loved Chinmaya. A tiny part of her mind suddenly began to question Bhagwan's scruples. Maybe Bipen was right: she had to protect herself."

"*And* make herself indispensable. Which she could only do...."

"...if Bhagwan moved to America," we both murmured in unison; it was so obvious. In America, Sheela would have ultimate control over the movement; Laxmi would become irrelevant.

"You think she got rid of me because I was a threat to her?"

Kirti shook his head emphatically. "Not by that time you weren't. She'd already taken over the work in America; you were nothing by then. If she'd really felt threatened by you, you'd have never left India alive. You were a test case, Sats; I'm convinced of it. First she made you sick, then she sent you back to your father, whom she knew was not only a doctor but negative to the ashram. When she didn't get any flack back about the condition you were in, she knew she'd gotten away with what they did to you. She could do the same thing now to Bhagwan: to convince him to leave India!"

"Hmmm." I closed my eyes pensively, slowly sipping the wine Kirti handed me. His hypothesis sounded convincing, I had to admit. My parents had told me recently that Sheela had maintained contact with them for years, sending them presents from time to time; safeguarding her "friendship" with them: she'd gotten away with it.

The similarities between Bhagwan's health problems at the time and my own were undeniable. I'd had neck problems. He'd had back problems. Both Deeksha and James Gordon (the psychiatrist/author of the *The Golden Guru*) claimed that Bhagwan was popping valiums and

quaaludes with great abandon in the months before he left Poona. He'd also, by all reports, been getting progressively weaker as the days went on.

His long-time personal (non-sannyasin) physician had been sent to the ashram medical center to see me. He, too, was fooled by what he saw, ordering mylograms and various other tests to be done to determine the reason for my steadily deteriorating condition. According to Deeksha I'd been poisoned (presumably via the special food that had been sent to the medical center for me from my "friends" in the office), but the prominent European-trained physician hadn't suspected a thing.

Meanwhile, other Lao Tzu women who might have functioned as spokespeople for Bhagwan were removed from the scene for "health" reasons and never allowed back again. Sampurna, who was well-known by this time through her published commentaries on Bhagwan's work, had left the house (with a cold) shortly after I left India, wasn't allowed back again and was prevented from moving to the ranch for several years. Men were less of a threat to Sheela: Bhagwan had spoken often about why he always chose women to run things. In the last two years of the ranch, nonetheless, attempts were made on the lives of both Bhagwan's doctor and dentist, the only Lao Tzu residents who might have been considered potential spokespeople. (Sheela, Puja and their Australian accomplice were convicted of attempted murder in the most easily proven of these cases.)

&.

"What have we got so far?" I asked Kirti the next morning as we sat eating breakfast at the Zen Cafe. "Sheela made it impossible for Bhagwan to remain in India," I recapped. "His health, the health of everyone at the ashram, the increasing acts of vandalism and violence that were happening; and promised him the world if he came to America. Then what?"

"First of all, it meant that Laxmi was out, obviously." Kirti stuffed a forkful of apple crepe into his mouth with great relish. "With enough money and power behind her now," he mumbled between chews, "Sheela could wheel and deal with unchallenged impunity. Do you remember how appalled Bhagwan was when he got to the ranch?"

"I wasn't there, then."

"Me neither, but I heard he hated the place. It was hardly the lush beautiful land Sheela had promised him."

"Why do you think...?"

Kirti put down his fork, shaking his head contemplatively. "I think

the castle in New Jersey was a big disappointment to Bhagwan," he mused. "A house that would hold...what? twenty sannyasins? fifty? a hundred even? It was hardly what Sheela had led him to expect in America. He gave her one more chance to find a place for him to do his work. If not, he'd go back to India, pay off the back taxes that were owed and begin again. His health, meanwhile, having improved remarkably once he got to the States—"

"...and was no longer being drugged, poisoned, whatever."

"Exactly. When he got to the ranch...." I accepted some more coffee from the waitress as Kirti went on. "...he may well have threatened to return to India again. Virtually overnight—don't you remember hearing about it, Sats?—the Lao Tzu compound was turned into an oasis with thirty-foot-high trees planted all around, rich grassy lawns and lush landscaped gardens. Flocks of swans and peacocks were bought; an indoor swimming pool was built. Bhagwan could have his American dream without stepping out of his house."

"It still doesn't explain why he stopped talking," I interjected. "It was his absence from the scene that screwed things up. Sheela had free rein to do what she wanted."

"That's exactly why she bought the ranch," my genius husband laughed; he'd obviously been up half the night thinking. "Buying a place that was zoned for farm use wasn't just shortsighted stupidity the way we always thought. It was deliberate, the whole thing. Bipen was the one who found the ranch. He knew exactly what he was doing; the place was perfect. Not only was it totally secluded, but from it's very inception it was built on a lie: that we were a farming commune, not a religious one. There was no way Bhagwan could resume lecturing again: he didn't know the first thing about farming. Sheela became the sole messenger of his words."

"It also meant that my books on meditation and therapy had to be taken off the market," I remarked thoughtfully as I hobbled to the car on my crutches a few minutes later, "and lessened the influence of the therapists. Only when Sheela was sure she could trust them did she begin using them in various ways."

"Meanwhile, of course," Kirti opened the car door and helped me inside, a laborious operation, "we were forced to skirt the law in a hundred different ways every day, creating an atmosphere of intrigue and subversion that prevented people from speaking up and questioning what was going on.

"It was brilliant," he commented dryly as he got into the car and started the engine. "They shut Bhagwan up, shut the rest of us up and pocketed the cash."

ૐ

Kirti and I spent the rest of the weekend unraveling threads, drawing conclusions, analyzing everything that had happened in Oregon, once again in the light of our latest revelations. Had Bhagwan, for all intents and purposes, been little more than a prisoner at the ranch, held incommunicado behind the barbed-wire fence that surrounded the Lao Tzu compound? Sheela had successfully prevented him from having personal contact with anyone other than his almost-equally-as-isolated caretakers, except when she was present, I knew. Perhaps Bhagwan had encouraged his physician Devaraj to marry Hasya (the Hollywood film producer who eventually replaced Sheela) in order to have a means of communicating with her if and when he needed to. While Devaraj lived in Lao Tzu House and Hasya didn't, the two of them saw each other constantly; there was no way Sheela could prevent it. Hasya's extreme wealth had enabled her to live a uniquely independent life at the ranch, coming and going as she chose; Sheela had no control over her.

What was curious, of course, was why Bhagwan kept Sheela in the role she was in for so many years. She was hopelessly out of her depth as a spokesperson, getting herself (and the community) into trouble every time she opened her mouth. There were only two possibilities that I could think of for Bhagwan's continued support of her: either she had something on him and he couldn't get rid of her, or he deliberately wanted to destroy the ranch.

If she did, in fact, have something on him, what was it? Tapes, presumably, of him condoning various illegalities from drug deals to marriages of convenience; evidence, perhaps, of his sexual activities. When he talked about his sex life in a lecture, he claimed Sheela was shocked—she could only love him if he was asexual. Perhaps it wasn't his sex life per se that shocked her as much as his sudden willingness to discuss it. If he publicly admitted everything she had on him, she could no longer manipulate him with threats of exposure.

Rascal that he was, Bhagwan was perfectly capable of talking openly in lectures about his knowledge of commune illegalities as well, "pointing the finger," in feigned innocence, in any direction he wanted. "What have I to do with money matters?" he'd have undoubtedly said in reference to alleged drug deals. "I leave this nonsense to my people." Sheela couldn't afford to wait for that to happen. She was forced to leave.

At what point (assuming my allegations are correct) did Bhagwan realize that Sheela intended to blackmail him if necessary? It's hard to say. When four old friends of ours left the ranch in the middle of the night in the early days of the commune? Perhaps. She told everyone in a gen-

eral meeting at the time that she'd begged Bhagwan to replace her, but he'd refused. What seems far more likely in retrospect is that he'd wanted to replace her and had tried to use the incident as an excuse to do it. Her public avowals over the years (the phones weren't tapped, etcetera) were usually the exact opposite of what was happening. Did she tell him what she had on him at this point, threatening to expose him if he tried to retire her (as he'd dispassionately retired Laxmi)?

Even if Bhagwan didn't know that his private living quarters were bugged, he obviously knew that Sheela was severely curtailing his access to information about the community as well as his ability to communicate directly with his disciples; everything went through her. The few Lao Tzu residents who worked outside the house, as well as the non-Lao-Tzu lovers of house residents, were never put into positions of power where they knew anything Sheela didn't want Bhagwan to know.

When he first began lecturing to small groups of people in Lao Tzu House, there was little Sheela could do to prevent it. She (or one of her subordinates if she was away, generally Savita or Vidya) was always present when he spoke. He gradually began to invite people other than Lao Tzu residents to his evening talks: therapists, Poona mediums, the Hollywood crowd. Soon representatives from every ranch department were taking turns attending the meetings; they were video-taped and shown to the community at large. When Sheela tried to stop Bhagwan from speaking, or the videos from being shown, ranch residents protested vehemently and she nearly had a revolution on her hands. She "compromised" by showing the videos at ten o'clock at night when few people had the energy or inclination to see them.

It was only when the commune was in dire need of money, and few new people were showing up to replenish the coffers, that Bhagwan was finally "allowed" to speak publicly again. Before it was announced that he'd be lecturing at the annual celebration in July '85, only a small number of people had registered for the festival: the community's major money-making event. Like it or not, Sheela still needed Bhagwan to keep the cold hard cash rolling in.

Which brings up the question of Bhagwan's infamous extravagance. Did he *really* want ninety-five Rolls Royces, or 365 for that matter? Honestly? If he loved cars so much, surely he'd have preferred a Lamborghini or two, or a Ferrari, a little variety in his collection, not identical car after car, ad nauseum.

Bhagwan's (or, to be precise, the Rajneesh Car Trust's) immoderate accumulation of Rolls Royces was something Sheela would undoubtedly have enjoyed. Like a rapacious little Indian servant girl, she lusted after the Maharaja's excessive accoutrements of wealth. The more Bhagwan

had (or appeared to have) in the way of personal possessions, the more successful and important he'd be in the eyes of the world and, by extension, the more powerful and influential Sheela would be as his secretary and spokesperson.

Perhaps, as Sheela's brother Bipen insisted on telling me, Bhagwan did demand more cars and diamond bracelets from Sheela continually, threatening to "leave the body" if she refused. Was it simple greed, or was he trying to bankrupt the movement that Sheela now controlled? If the commune needed money badly enough, Bhagwan would have to begin lecturing again. It was the one thing guaranteed to bring in the crowds, and the ready cash they brought with them.

Was Bhagwan covertly trying to destroy the ranch for years? What else could the Share-A-Home program and proposed AIDS colony have been about? They certainly weren't altruistic endeavors: Bhagwan had no use for Mother-Theresa-like, band-aid efforts to patch up society's problems. As an attempt to influence the outcome of local and federal elections in Oregon, the Share-A-Home program was doomed from the beginning; the numbers involved were far too insignificant to make an appreciable difference in what happened.

When Sheela told us at general meetings that Bhagwan had instructed her to be tough and aggressive with outsiders, I always assumed she was putting words into his mouth in an effort to defend her own unconscionable behavior, which had been caused by either gross ineptitude or a deliberate attempt to foster animosity between the commune and the outside world. The more hostility she created, the more restrictions she could force on ranch residents and the harder she could work us in the pursuit of her (or Bhagwan's) dreams.

Perhaps she was telling the truth, after all: Bhagwan *did* advise her to be aggressive. If so, was he, too, hoping to create an us-and-them situation so he could destroy civil liberties and squelch dissatisfaction, or did he have an ulterior motive? The fact was, the more obnoxious Sheela became, and the more difficult she made things for the community, the closer the ranch was to being destroyed and the easier it was for Bhagwan to leave America—in the satisfying guise of an unfairly persecuted martyr.

For Bhagwan to publicly admit that he'd been blackmailed by Sheela would have put him in a tenuous position with both government authorities and his own disciples. Admitting that he'd been blackmailed would have meant acknowledging that he had something to be blackmailed about. How could a Master of Masters confess to fear of exposure, much less to wrong-doing? It wasn't Bhagwan's way.

While a frivolous, not-particularly-bright Indian woman was hardly a

worthy nemesis for Bhagwan, he could honorably accept the consequences of having been defeated by "Ronald Reagan's America" (as he persisted in calling it). There was no way he could successfully fight the government's determination to destroy "his work" in America; he had no choice but to leave the country. He could leave with dignity: a man of freedom and principle, persecuted for his beliefs. It has always been thus, an eminently respectable position.

In the last few years of the ranch's existence, Sheela seemed to be fully prepared to wage a battle to the death with the American government. She and her personal entourage, naturally, would have escaped at the last moment via the underground escape route beneath Jesus Grove while the rest of us (including Bhagwan) died as martyrs to her cause. She would subsequently become the undisputed heir apparent to Bhagwan's throne, the titular head of a multi-national, multi-million dollar empire. The lists that Bhagwan made up of "enlightened people" who were to take over his work when he died must have shocked Sheela. She'd refused to make the lists public at first, only belatedly releasing the names after they'd been spread by word of mouth from Lao Tzu residents to the rest of the community; it was juicy gossip.

The American authorities, for their part, seemed as prepared as Sheela was to wage war, willing to descend upon the ranch with armed troops if necessary. The moment Sheela's "escape" became public knowledge, the Oregon National Guard was put on a twenty-four-hour-a-day readiness alert. The government may have known what to expect from Sheela (or felt they knew), but with her gone they had only her apocalyptic warnings to judge the mood of the community by; anything was possible.

Considering the magnitude of Sheela's confessed crimes, it's interesting how brief her prison sentence turned out to be. Curious, too, was the absence of public record at her trial concerning the tapes she claimed she had that proved Bhagwan was behind everything she did. More than one of her former deputies has admitted to hearing portions of the tapes: it was the means through which Sheela often recruited her accomplices; yet they were never openly mentioned at her trial.

In September 1990, when Vidya, Su, and two other ex-disciples of Bhagwan's were arrested in Europe and South Africa and extradited to the States on conspiracy charges in a 1985 plot to murder U.S. attorney (for Oregon) Charles Turner, Sheela was notably absent from the list of people arrested despite the fact that the alleged "assassination squad" had operated under her direct orders. She seemed to be protected from further prosecution by the American government. One can't help won-

dering why. Meanwhile, whatever immunity Vidya may have had in the past seemed to be invalidated by Bhagwan's death.

છે.

While I seem to have come full circle in my interpretation of events in Oregon in many ways, exonerating Bhagwan for much of what happened, there are serious questions that remain unanswered and profound criticisms inherent in my analysis. If an enlightened Master is one who has transcended his (or her) individual ego, transcended desire, Bhagwan seems to have fallen short of the necessary qualifications in obvious ways despite his undeniable effectiveness as a spiritual teacher.

Bhagwan's inordinate pride, his refusal to own up to his own poor judgement in having selected Sheela to do "his work," seems to me to be the root cause of much of the abuses that happened around him. His intense desire to affect a radical change in world consciousness through the dissemination of his ideas—"his work"—was all that mattered. If drug deals were needed to finance his movement, so be it. He didn't want to know, he didn't care, as long as "the work" happened.

On the other hand, I doubt strenuously that Bhagwan knew anything about the various arson and poisoning attempts that took place in India and Oregon. While he continually urged both Laxmi and Sheela to "do the needful"—anything that was necessary to advance his work and make his name into a household word— I doubt if he'd have wanted to know the particulars of what they did; it was safer not to know.

As for the "hit lists" that Sheela and Bhagwan allegedly made up at the castle in New Jersey, I can only surmise that Deeksha (who told me about them) had a different idea from Bhagwan about what it meant to "take care of people" who defected. Despite her paranoia, no one who left the movement seemed to be physically harmed as a result of it. While Sheela may well have used threats and intimidation in a vain attempt to keep people quiet about various "Bhagwan affairs" (either with or without Bhagwan's knowledge of her tactics), her efforts didn't prevent numerous ex-disciples from cooperating with the authorities in their legal case against the community.

Bhagwan scrupulously safeguarded his innocence by chosing not to know anything he didn't want to know. By refusing to address himself to, or apologize for, the abuses that went on around him, he continued to maintain an image of infallibility with his disciples if not with the rest of the world. Even on his deathbed, he couldn't resist one more chance to blame "Christian fundamentalists in the U.S. government" for his (and, by extension, the sannyasin community's) problems in America,

personally untainted and above reproach to the very end. Would it have made him any less a Master if he'd accepted some of the responsibility for what happened?

If my experiences at the ranch taught me anything, it's that one is equally as responsible for what one doesn't do (or say) as for what one does (and says). Neither powerlessness nor lofty spiritual surrender ("accepting what is") are an excuse for inaction or silence when people are being abused.

Billy lost his life because of his concern for the well-being of a stranger. He refused to avert his eyes and pretend he didn't see what was happening. Being powerless against an assailant twice his size didn't prevent him from acting morally and courageously. Bhagwan could have learned something from him.

If ranch sannyasins were guilty of abdicating responsibility for what happened in Oregon, so was Bhagwan. He bears as much of the blame as any of us (with the possible exception of Sheela and her crew). He could have acted out of courage and conviction, regardless of the personal risks involved, and things might have been different.

∾

As time passes, new insights into the Rajneesh movement and a greater understanding of my own personal involvement in it will undoubtedly come to me. As I sit at my desk day after day, trying to complete the writing of this long-overdue book that's been interrupted by death and near-death—painful addendums to the story of my years with Bhagwan—I wonder what startling new revelations the years will bring. Are my neat tidy little packages of supposition fact or theory, history or myth? I don't honestly know. They *feel* like the truth, but I've been wrong before.

While I struggle with imponderables, questions of right and wrong, responsibility and blame, life goes on in its own enigmatic, mystifying way. Babies are born and people die; flowers blossom, birds sing; the sun shines, it rains; there are earthquakes, wars, presidential elections, and holes in the ozone layer: an infinite number of things to rejoice in; infinite causes for despair.

If I'd once thought that I could trick fate by leaving my children before they left me, in an unbearable repetition of the past ("*...lifetime after lifetime of losing them in tragic ways: in pogroms and on the battlefield, through suicide and murder*"), I should have known better. If I'd imagined that I could drop Bhagwan from my consciousness forever, I was naive.

It's as impossible to run away from the past as it is from the future; from the inevitability of what was and what will be.

I no longer see yesterday's truths as infallible, yet the past still guides me. The lessons I've learned from life and death, from my mistakes and my tragedies, have become a permanent part of my being; the legacies of the past can never be forgotten.

I've learned much over the years, and have much to still learn. I know one thing though. Despite everything, there's an abundance of laughter and joy in the world, compassion and forgiveness. As Bhagwan taught through his words, and Billy through his example.

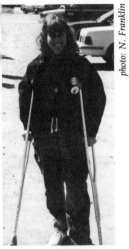

The author in Vancouver six months after being hit by a car in a near-fatal accident (1990).

The author with her two daughters (Nancy on left and Patti in center) in Providence, R.I. (October, 1990).

About the Author

Satya Bharti Franklin (née Jill Jacobs) grew up in Mount Vernon, New York, and was educated at Brown University and Sarah Lawrence College. A disciple of Bhagwan (Osho) Rajneesh for thirteen years, and the editor/compiler of his most widely translated works (including *Meditation: The Art of Ecstasy* and *The Psychology of the Esoteric*), Ms. Franklin has written two previous books about Rajneesh under the pen name Satya Bharti: *Death Comes Dancing* (Routledge and Kegan Paul) and *Drunk on the Divine* (Grove Press; published by Wildwood House in England as *The Ultimate Risk*).

After living in India for many years, Ms. Franklin is presently residing in Vancouver with her husband and working on a novel. She has three adult children (one recently deceased).